French Architectural and Ornament Drawings of the Eighteenth Century

French Architectural and Ornament Drawings of the Eighteenth Century

Mary L. Myers

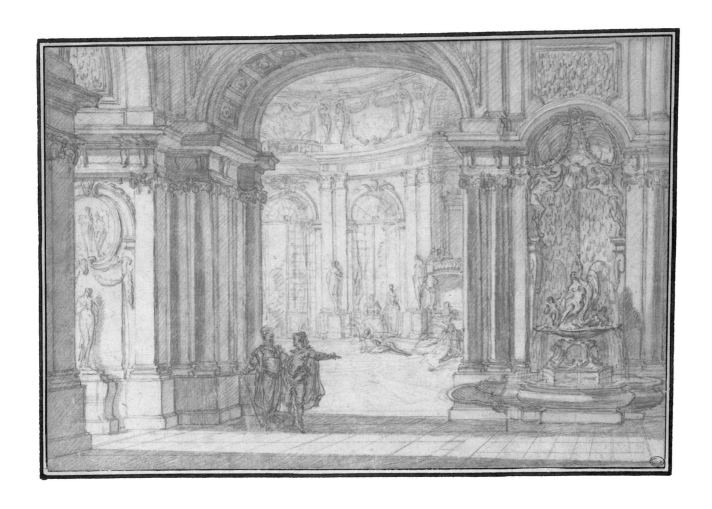

The Metropolitan Museum of Art, New York

Distributed by Harry N. Abrams, Inc., New York

This publication was generously supported by
The Drue E. Heinz Fund.

This publication is issued in conjunction with the
exhibition *French Architectural and Ornament Drawings
of the Eighteenth Century*, held at The Metropolitan
Museum of Art, New York, December 10, 1991, to
March 15, 1992.

Published by The Metropolitan Museum of Art

John P. O'Neill, Editor in Chief

Barbara Burn, Executive Editor

Ann Lucke, Editor

Abby Goldstein, Designer

Peter Antony and Matthew Pimm, Production

All photographs have been supplied by The Photograph
Studio, The Metropolitan Museum of Art.

Type set by Trufont Typographers, Inc.

Printed and bound by The Stinehour Press

Jacket/Cover Illustration: Étienne de Lavallée-Poussin,
Study for an Arabesque (No. 58)

Title Page Illustration: Jacques de Lajoüe, *Study for the
Rotunda of a Palace* (No. 54)

LIBRARY OF CONGRESS CATALOGING-IN-PUBLICATION DATA

Myers, Mary L.
 Architectural and ornament drawings : the French
eighteenth century / Mary L. Myers.
 p. cm.
 Exhibition schedule: The Metropolitan Museum of
Art, New York Dec. 10, 1991–Mar. 15, 1992.
 Includes bibliographical references.
 ISBN 0-87099-625-8.—ISBN 0-87099-626-6
(pbk.).—ISBN 0-8109-6411-2 (Abrams)
 1. Decoration and ornament—France—History—
18th century—Exhibitions. 2. Metropolitan Museum
of Art (New York, N.Y.)—Exhibitions. 3. Drawing,
French—Exhibitions. 4. Drawing—18th century—
France—Exhibitions. I. Metropolitan Museum of
Art (New York, N.Y.) II. Title.
NC246.M94 1991
741.944'09'0330747471—dc20 91-23492
 CIP

Contents

Foreword by Philippe de Montebello vii

Acknowledgments viii

Introduction ix

Colorplates xiii

Catalogue 1

Works Cited in Abbreviated Form 213

Abbreviations 215

Index 217

FOREWORD

Among the encyclopedic riches of The Metropolitan Museum of Art are the architectural and ornament drawings in the Department of Prints and Photographs. Our holdings in this field are the most extensive in the United States after those of the Cooper-Hewitt Museum in New York. They began to be acquired by the department's first curator, William M. Ivins, Jr., as adjuncts to the architectural and ornament prints and books in the collection and were added to by his successors, A. Hyatt Mayor, John J. McKendry, and Colta Ives. The architectural and ornament drawings enhance not only prints but also European and American sculpture and decorative arts objects in the Museum's collection. In addition to the drawings for a clock, a candelabrum, and a stand with jewel coffer in this exhibition catalogue, there are numerous other drawings that bear some connection with objects in the collections of the European Sculpture and Decorative Arts and American Art departments.

This catalogue of French architectural and ornament drawings of the eighteenth century follows two previous catalogues with exhibitions—*Renaissance Ornament Prints and Drawings*, by

Janet S. Byrne, and *Architectural and Ornament Drawings: Juvarra, Vanvitelli, the Bibiena Family, and Other Italian Draughtsmen*, by Mary L. Myers—that presented parts of our collections of architectural and ornament drawings to a public often unaware that our holdings contain such breadth of aesthetic genres.

Our collection of French eighteenth-century architectural and ornament drawings, which had grown slowly since the department's inception in 1916, was notably augmented in 1970, when the late Charles Wrightsman and Mrs. Wrightsman donated their large and beautiful collection. Mrs. Wrightsman's generosity has continued to the present. Those drawings have contributed important treasures to this exhibition and its catalogue.

I should like to acknowledge my gratitude for the generosity of the Drue E. Heinz Fund in supporting the research for this catalogue and the cost of its publication.

PHILIPPE DE MONTEBELLO
Director, The Metropolitan Museum of Art

ACKNOWLEDGMENTS

I am grateful to the Drue E. Heinz Fund for supporting the research and publication of this catalogue. I deeply appreciate the contribution of Alden R. Gordon, who has kindly provided the entry on the album by J.-C. Bellicard based on his article in the *Metropolitan Museum Journal*.

Many scholars and curators, here and abroad, have been most generous with their knowledge and research and with aid in using their collections. I would like to thank, in Paris, Roseline Bacou, Christian Baulez, Emmanuelle de Brugerolles, Jean Cailleux, Marie-Noël de Gary, Peter Fuhring, Serge Grandjean, Jean-Jacques Gautier, Annie Jacque, Pierrette Jean-Richard, Françoise Jestaz, Thierry Lefrançois, Françoise Magny, Christian Michel, Geneviève Monnier, Bruno Pons, Marianne Roland Michel, Monique Mosser, Madeleine Pinault, Pierre Rosenberg, Barbara Scott, Judith Schub, Arlette Sérullaz, and Françoise Viatte; in Saint Petersburg, Irina Grigorieva, Assia Kantor-Gukovskaya, Miliza Korshunova, Irina Novoselsskaya, and the late Anna Voronikhina; in London, Antony Griffiths, Alastair Laing, Julien Litten, and Sir Francis Watson; in Ottawa, Mimi Cazort; and in the United States, Kim de Beaumont, Richard Campbell, Cara Denison, Lyndel King, Ruth Kraemer, Suzanne Folds McCullogh, Robert Rainwater, Roberta Waddell, Stephanie Wiles, and Guy Walton. Special mention must be made of Elaine Evans Dee, who has been most generous in making the riches of the Cooper-Hewitt Museum's collections available to me. Her counsel on ornament drawings has always aided me and she has put the unpublished fruits of her research on Oppenord at my disposal.

Many colleagues in the museum have contributed much to this catalogue. I am grateful to Olga Raggio, of the European Sculpture and Decorative Arts Department, in making available the objects for the exhibition, to Clare Le Corbeiller, whose expertise in snuffboxes enriched these entries, to James Parker, whose knowledge of French eighteenth-century art, patrons, and collectors informs these pages, and to James David Draper, Johanna Hecht, Clare Vincent, Jessie McNab, and Daniëlle O. Kisluk-Grosheide. Jacob Bean has graciously allowed the Bouchardon and Pillement drawings to be in the exhibition and has answered my many questions over the years. Helen B. Mules, the late Lawrence Turčić, William M. Griswold, Henrietta Susser, and Calvin D. Brown have always kindly made the bibliographical and photographic resources of the Department of Drawings available to me.

I would especially like to thank Colta Ives for her support for this exhibition and for her perspicacious purchases that have enriched our collection of architectural and ornament drawings of the French eighteenth century. Janet S. Byrne has always been most generous with her extensive knowledge of ornament and has cleared up many uncertainties in the manuscript. My heartfelt thanks go to my other curatorial colleagues in the Department of Prints and Photographs— Suzanne Boorsch, David W. Kiehl, and Maria Morris Hambourg—and to Edmond Stack and David del Gaizo for their many efforts toward the exhibition. I am grateful to Emily Goldstein, Elizabeth Roth, the late Olga Sichel, and Monroe Warshaw for their aid with bibliographical tasks.

John P. O'Neill, Editor in Chief, and Barbara Burn, Executive Editor, have helped with many editorial matters, while Abby Goldstein created the elegant layout of the catalogue, and Peter Antony aided in its production. Last, but not least, I am deeply grateful to Ann Lucke for her work as editor of the catalogue. She has indefatigably checked sources and facts, clearing up many problems, and her felicitous phrases improved the text. She has been an ideal editor.

INTRODUCTION

In 1976 the Department of Prints and Photographs exhibited a group of eighteenth-century Italian architectural and ornament drawings under the title *Architectural and Ornament Drawings: Juvarra, Vanvitelli, the Bibiena Family, and Other Italian Draughtsmen*, the catalogue for which had been published the year preceding. Although there had previously been exhibitions of ornament prints and drawings—a major eighteenth-century design show in 1960, for example—prior to 1976 there had been no exhibitions accompanied by published catalogues that presented this extensive part of the collection of the Department of Prints and Photographs. Since then Janet Byrne has published our Renaissance architectural and ornament prints and drawings, attendant to which she organized an exhibition. It is as a natural sequel to the exhibition and catalogue of our eighteenth-century Italian architectural and ornament drawings that we present a selection of our eighteenth-century French architectural and ornament drawings.

I should explain why drawings for architecture and ornament are in the Department of Prints and Photographs. The reason is historical: the Department of Prints (as it was then known) was created in 1917, and the first curator, William M. Ivins, Jr., as well as his successor, A. Hyatt Mayor, considered that an important collection of prints would contain not only old master prints but also a comprehensive and encyclopedic collection of printed images in both loose sheets and illustrated books reflecting the history of Western art and culture. The collection therefore comprises five centuries of architectural treatises on the theory and practice of architecture and perspective as well as books that present the significant monuments of architectural history; prints and books on theaters and their sets, court, religious, and civic festivities, gardens, furniture, silver, porcelains, decorative hardware, costumes, including textile and lace designs, jewelry, and carriages; topographical prints and books; writing books; and even illustrated cookbooks. It is not surprising to find

such works as the illustrated volumes to Diderot and d'Alembert's *Encyclopédie* among such company. The next step was for Ivins and Mayor to collect the drawings related to all the above to complete the picture of the creation and evolution of the images and their concomitant ideas. John J. McKendry and Colta Ives have continued the tradition. Until the Department of Drawings was created, in 1960, figural drawings had entered the Metropolitan Museum's collection through the auspices of the curators of the European Paintings or Print departments. After the Drawings Department was founded, it seemed useful to maintain the unity of the collection of architectural and ornament prints, books, and drawings and to keep them together in the Print Department.

Another important facet of our collection of architectural and ornament studies is the way it complements those of such other departments in the museum as the American Decorative Art, the Twentieth Century Art, the European Sculpture and Decorative Arts, and the Drawings departments. For our collection of eighteenth-century drawings, the latter two departments are the most germane. We have drawings for items of silver, snuffboxes, and furniture that relate to objects in the Metropolitan Museum's collection. Several of these will be lent to the exhibition, as will be two drawings from the Drawings Department. This catalogue could not have been completed without the resources of those departments, which include the knowledge and assistance of their staffs as well as their libraries, research files, and photographs.

The Metropolitan Museums's collection of architectural and ornament drawings is not comprehensive, as we possess very few German, Netherlandish, Russian, or Scandinavian drawings. We do, however, have important groups of British, American, Italian, and French drawings. Our holdings of British eighteenth-century material include significant works by Robert and James Adam, James Wyatt, William Chambers and his shop—including Thomas Hardwick—

and Thomas Chippendale, as well as a notable group of nineteenth-century drawings by the Pugin family, some for Brighton Pavilion. Among our American drawings are an outstanding group by the nineteenth-century architect A. J. Davis, numerous works by the Tiffany studio, and one of the largest public collections of drawings by Frank Lloyd Wright. As the title of the Italian drawings exhibition suggests, our strengths in that field are works by Filippo Juvarra, Luigi Vanvitelli, and members of the Bibiena family. Our holdings of Giovanni Battista Foggini's work can be considered the largest and most important outside his native Florence; we also have a representative group of Bolognese draughtsmen, including drawings by Mauro Tesi, Flaminio Minozzi, and Carlo Bianconi. Besides those in this exhibition, our French drawings include what is known as the Scholz scrapbook, comprising drawings of such significant Roman monuments as Michelangelo's dome for Saint Peter's, Palazzo Massimi alle Colonne, and the Villa Giulia, executed by a Frenchman in Rome in the 1560s. We also have a large group of drawings by the nineteenth-century interior designers J.-E.-C. Lachaise and E.-P. Gourdet.

Although our collection of French eighteenth-century architectural and ornament drawings is smaller than some, it compares favorably in quality with the major collections of French eighteenth-century drawings of architecture and ornament in Paris at the Musée des Arts Décoratifs, the École des Beaux-Arts, the Bibliothèque Nationale, and the Archives Nationales; in Berlin at the Kunstbibliothek; in Stockholm at the Nationalmuseum; in Leningrad at the Hermitage; in Amsterdam in the private collection of Lodewijk Houthakker; and in New York at the Cooper-Hewitt Museum.

This exhibition includes as wide a selection of different types of drawings as possible. There are drawings, for example, of *hôtel particulier* exteriors as well as interiors, their components, such as ceilings, walls, and chimneypieces, and such ornamental elements of interior decoration as trophies and arabesques. Other architectural subjects are garden pavilions, tombs, stage sets, and temporary structures for court and civic festivities, as well as the ground plan for an entry in the Rome Grand Prix competition. There are

studies for fountains, furniture, a tapestry cover for a canapé, carpets, a panel for a folding screen, interior decorative hardware, silver and other fine metalwork, porcelain, vases, snuffboxes, a cane handle, and the ironwork grille for the chapel of an abbey. There are also drawings for publication in architectural treatises, histories of French architecture, and commemorative books of official festivities, as well as the decorative initials and vignettes for a weekly newspaper. There is even a study for a printed funeral ticket. Also included are studies with no utilitarian function, such as fantasy architectural capriccios.

There is also a cross section of the functions of architectural and ornament drawings. They range from drawings that, in the sketchiest form, represent the first conception of the artist to the completely worked-out idea in its final form ready for execution, including ground plan, elevation, sections, interior views, and exterior views. There are highly finished drawings that were made for presentation to the client for approval of the design or that were made as a kind of catalogue for the client to choose from. Other drawings are records of already existing architecture and interiors, which sometimes served as a starting point for an artist to create a new idea or for an architectural fantasy.

Special attention should be called to our drawings by Lequeu for Soufflot *le romain*'s Hôtel de Montholon. They are highly finished presentation drawings showing the exterior and the completely furnished interiors and, as such, are very important documents of executed interiors and furniture of the period. Equally important is Delafosse's *Grande Galerie*, an imaginary interior that is the largest and most imposing drawing known by the artist. The study for a garden pavilion for the palace at Saint-Cloud, signed and dated by Contant d'Ivry, records a building now destroyed. Drawings meant for publication include three by Blondel for his *Maisons de plaisance*, a preparatory drawing by Gabriel de Saint-Aubin for an engraving in Blondel's magisterial work, *L'architecture françoise*, and a study by Moreau *le jeune* for a print portraying the festivities in conjunction with the erection of a statue of King Louis XV. The finished drawings by Percier and Fontaine for the coronation of

Louis XVIII record the decor for an event that never took place. Important architectural fantasies include the two mysterious and eerie red-chalk sheets by Legeay and the frontispiece by Châtelet for a *recueil* of views of the Petit Trianon ordered by Marie Antoinette for the grand duke Paul of Russia. A fascinating album of drawings by Bellicard records the contemporary excavations at Herculaneum and views of architecture and sites in other Italian cities.

A group of enchantingly beautiful drawings by Belanger are preparatory for carpets and ceilings of the pavilion at Bagatelle and for the *hôtel* of the duchesse de Mazarin. There is also a fine ceiling by Marot. Included in the exhibition is a group of drawings thought to have been sent by dealers to Duke Albert of Sachsen-Teschen for aid in his purchases. It contains records—some of the most exquisite of the century—of pieces by Martin Carlin mounted with beautiful Sèvres plaques, of clocks, of porcelain—plain and mounted in ormolu—of candelabra, and even of the hardware for rooms and furniture. There is an important group of silver designs, both small, preliminary studies and life-scale finished sheets, by the sculptor Moitte and by Auguste, the most important silversmith of his period. A delicious study by Le Barbier for a candelabrum or torchère in porcelain and two small ornamental designs for metalwork by Meissonnier, one for a cane handle, also make an appearance. The Drawings Department has generously contrib-

uted a beautiful sheet with a design for a fountain by Bouchardon and a charming capriccio by Pillement. In addition, our collection contains significant holdings of the work of Oppenord, Lajoüe, Gravelot, Delafosse, Legeay, Percier, and Fontaine.

The preparations for an exhibition and catalogue have many dividends. Beyond the information gleaned from the research involved, the focus placed on the collection as a whole has put it in a different perspective. For instance, the French studies for the decorative arts—for furniture, silver, and ornamental metalwork, such as snuffboxes—are more extensive and weightier than our drawings on the same subject by Italian and British eighteenth-century artists and craftsmen. In addition, the visits of scholars to study the collection have yielded new identifications, such as those for the drawing by Saint-Aubin, two drawings by Oppenord, and two drawings by Lagrenée *le jeune*.

The collection has its strengths and weaknesses, and we hope to add further drawings as they appear; however, it has become increasingly difficult to acquire what we would like.

We hope that in this exhibition of French eighteenth-century architectural and ornament drawings, aside from presenting some of the treasures in our collection that are little known and rarely seen, those same objects will evoke—as only they can—the beauty of the physical world of French eighteenth-century life.

COLORPLATES

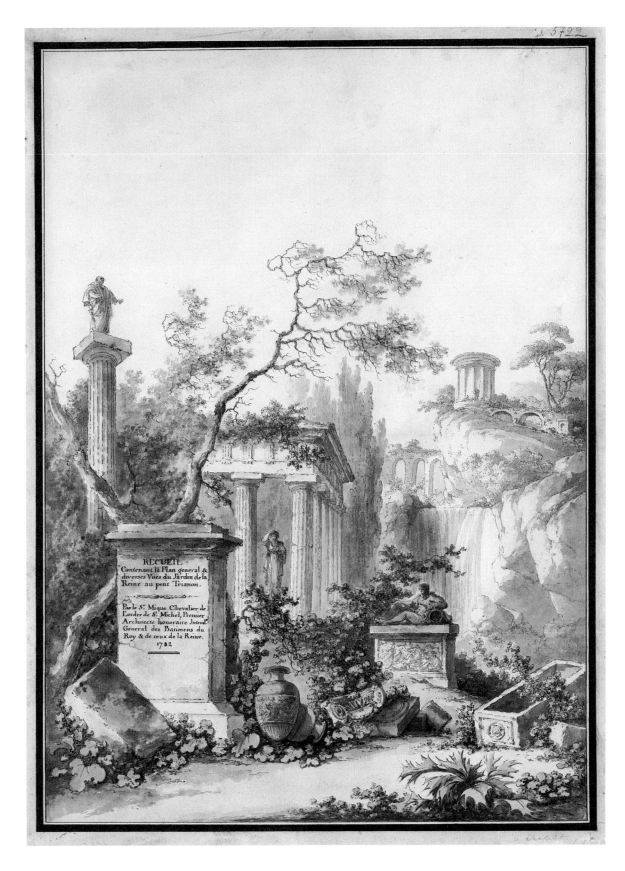

Within the illustration:

RECUEIL
Contenant le Plan general &
diverses Vues du Jardin de la
Reine au petit Trianon.

Par le Sr Mique Chevalier de
L'ordre de St Michel, Premier
Architecte honoraire Intend.l
General des Batimens du
Roy & de ceux de la Reine.
1782

Claude-Louis Châtelet (no. 25)

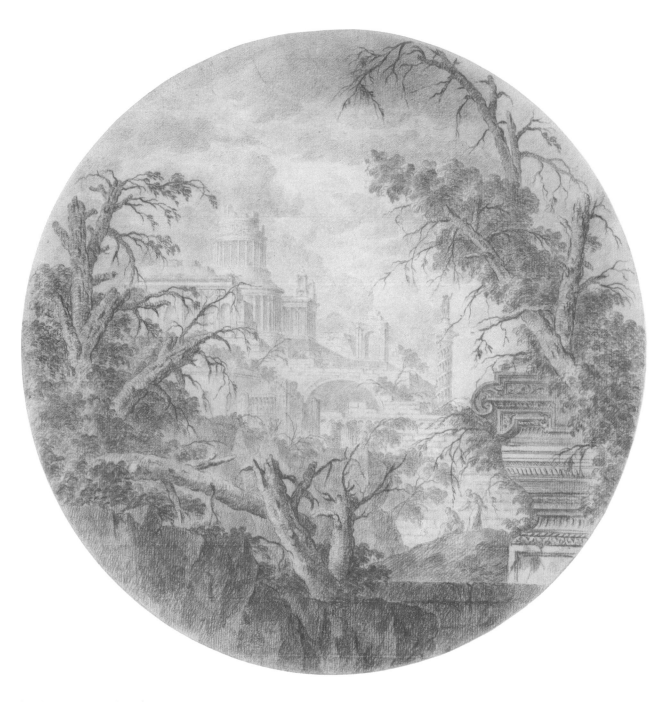

Jean-Laurent Legeay (no. 62)

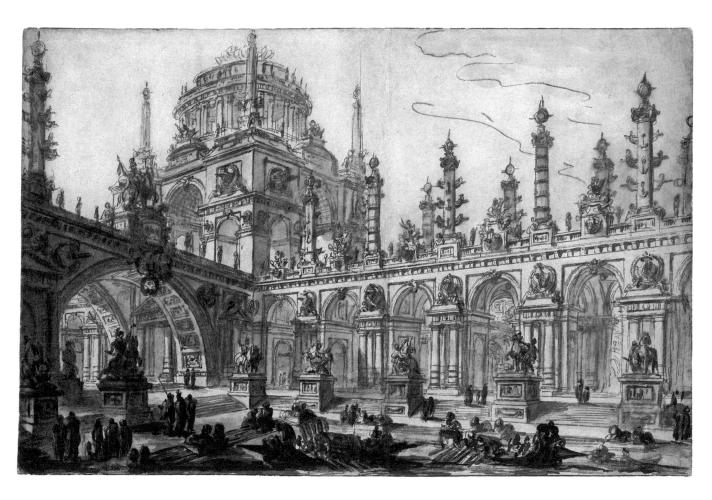

Charles-Michel-Ange Challe (no. 24)

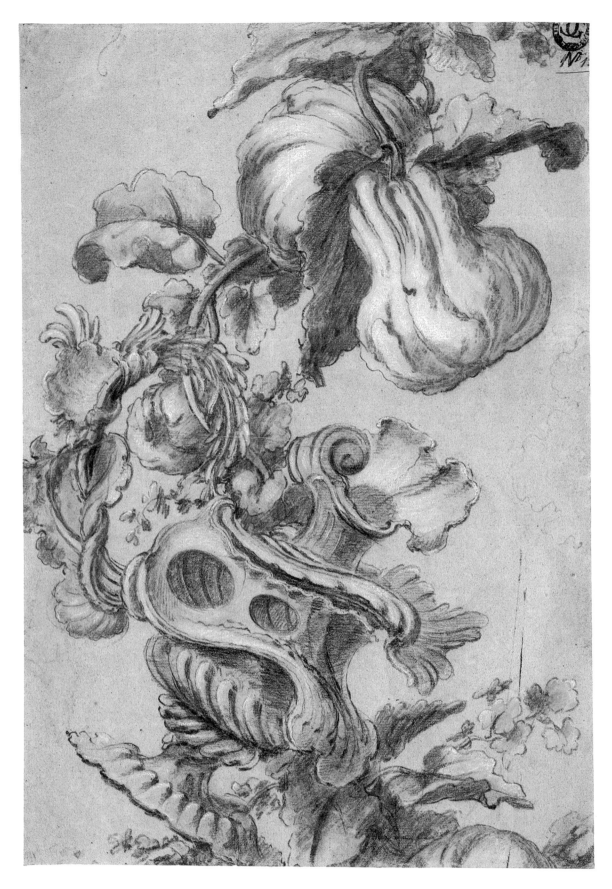

Alexis Peyrotte (no. 102)

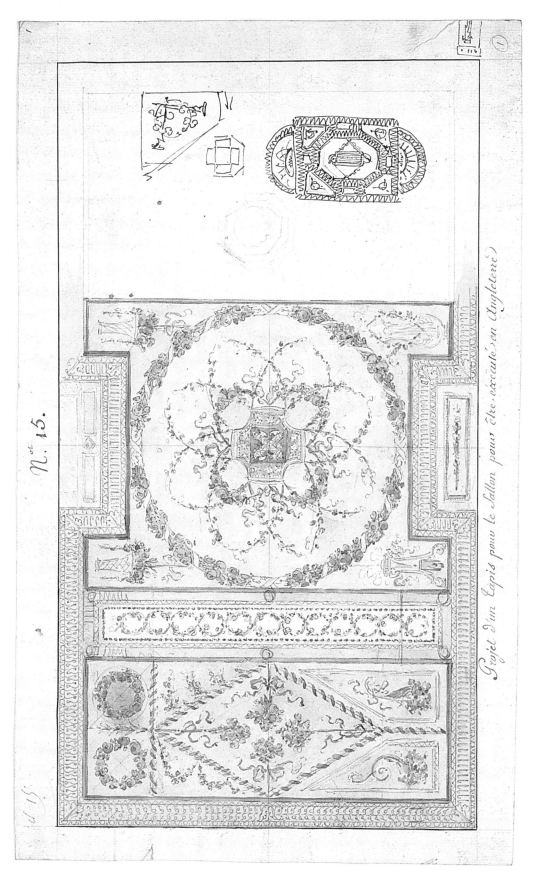

François-Joseph Belanger (no. 13)

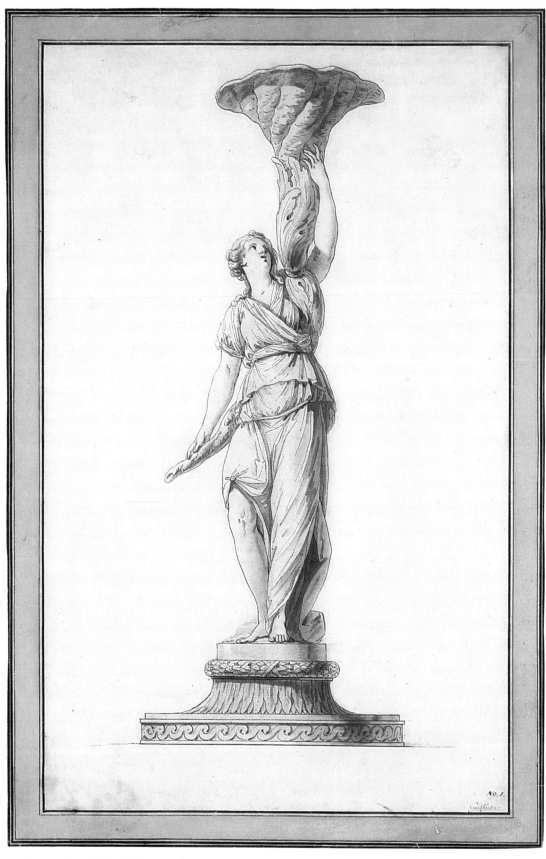

Jean-Jacques-François Le Barbier (no. 59)

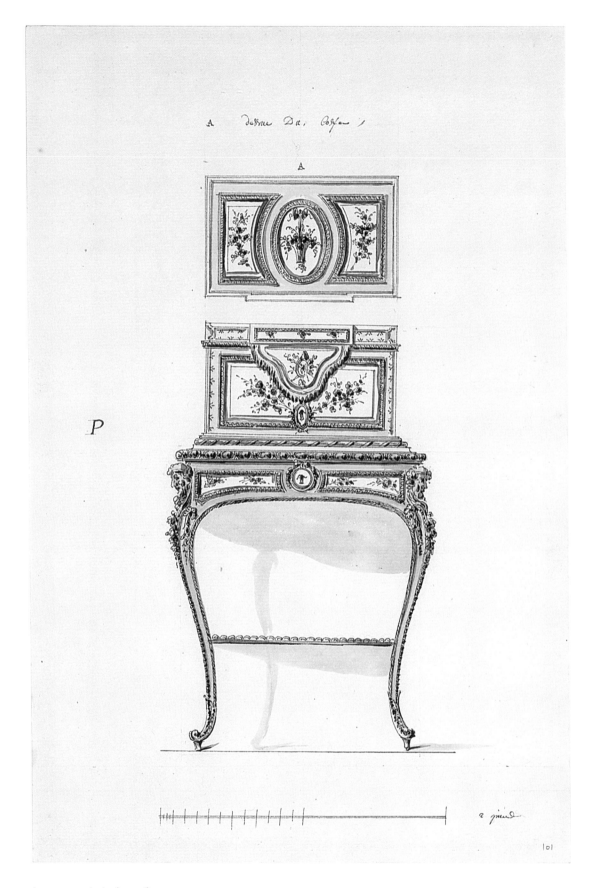

Anonymous Artist (no. 116)

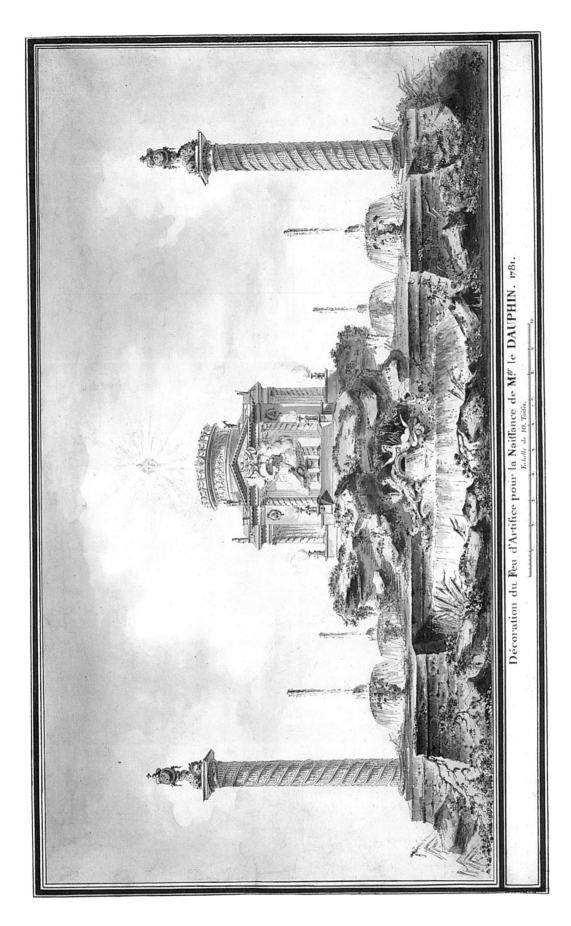

Décoration du Feu d'Artifice pour la Naiſſance de Mgr le DAUPHIN. 1781.

Echelle de 10. Toiſes.

Anonymous Artist (no. 115)

HÔTEL DE MONTHOLON.

Coupe Sur la largeur du Salon du Second, Côté de la cheminée.

Coupe Sur la largeur du Salon du Premier, Côté de la cheminée.

Coupe Sur la longueur du Salon du Second.

Coupe Sur la longueur du Salon du Premier.

Jean-Jacques Lequeu (no. 68)

xxiii

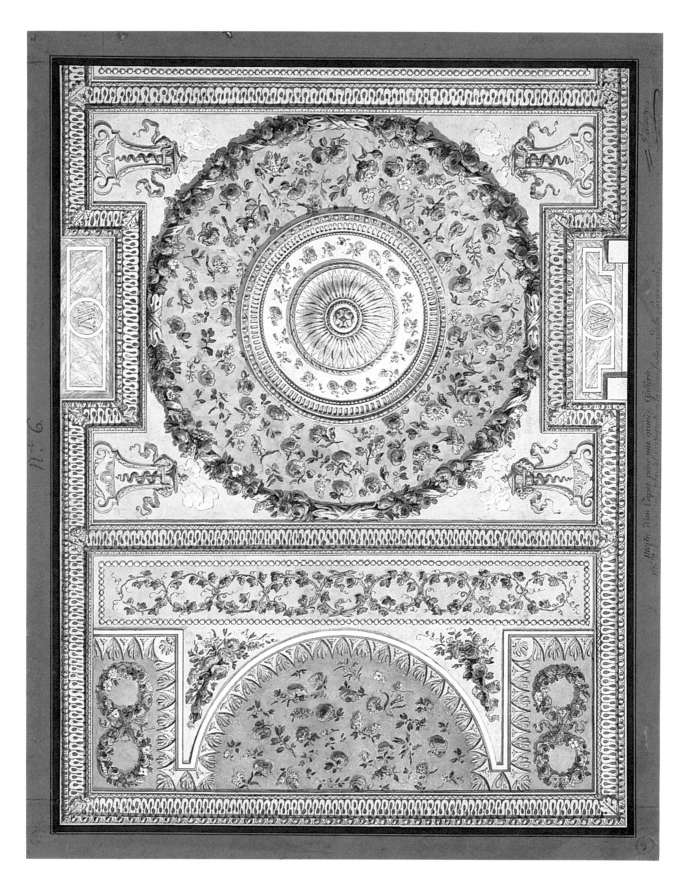

François-Joseph Belanger (no. 11)

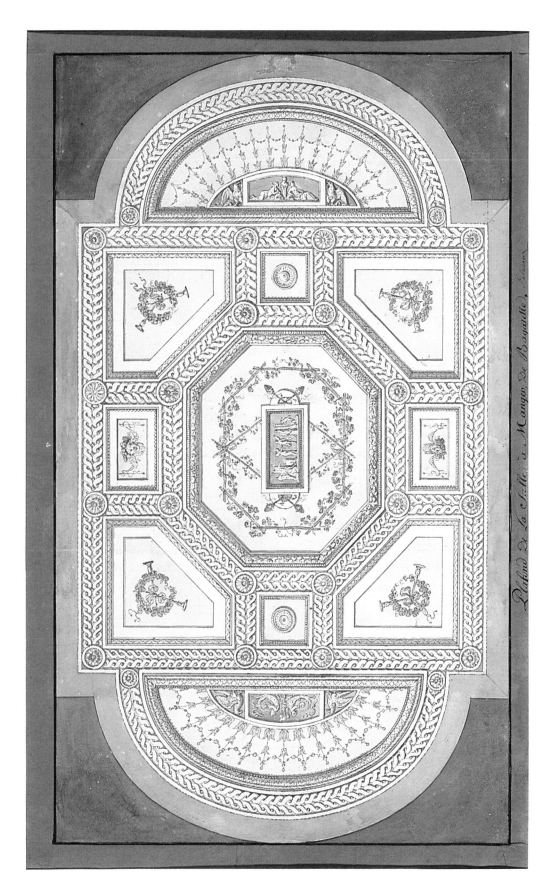

Plafond De La Salle à Manger De Bagatelle.

François-Joseph Belanger (no. 12)

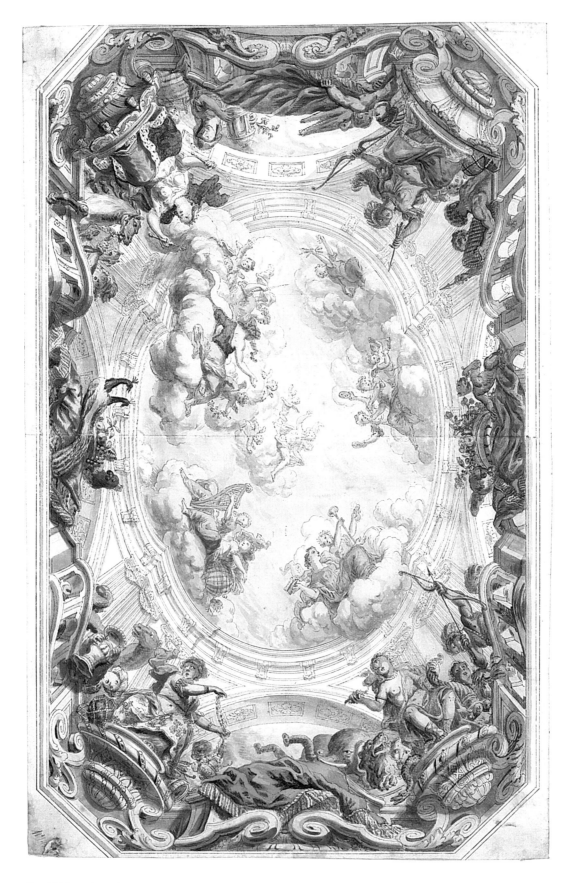

Daniel Marot (no. 71)

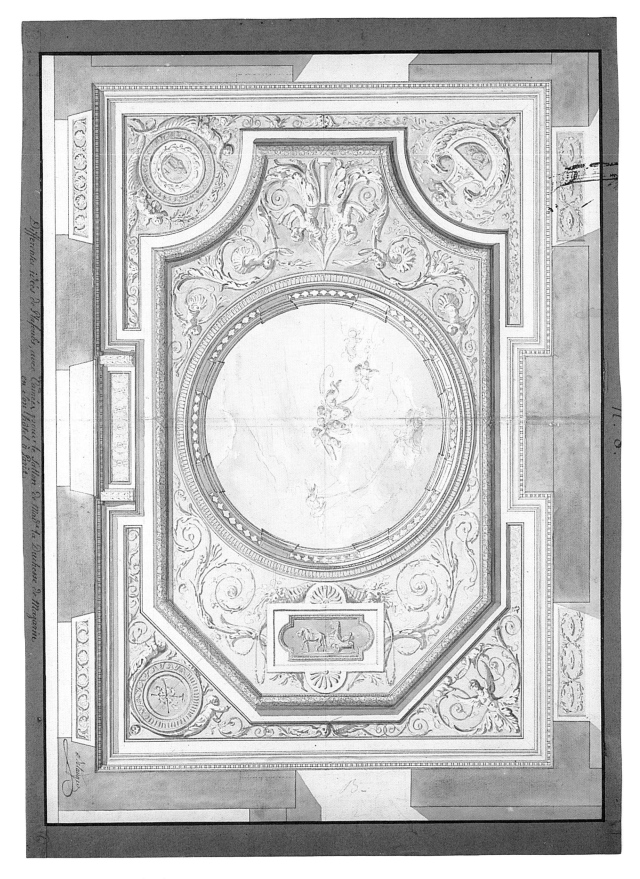

François-Joseph Belanger (no. 9)

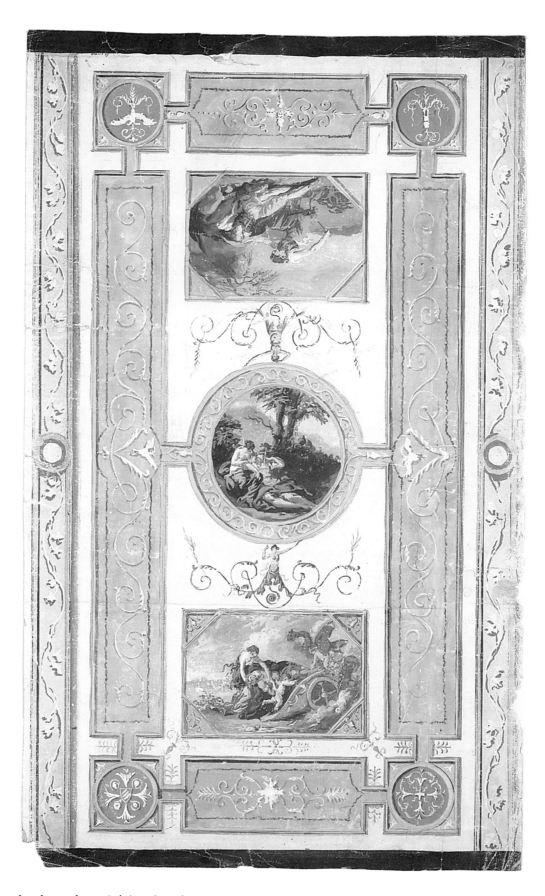

Jean-Jacques Lagrenée *le jeune* (no. 50)

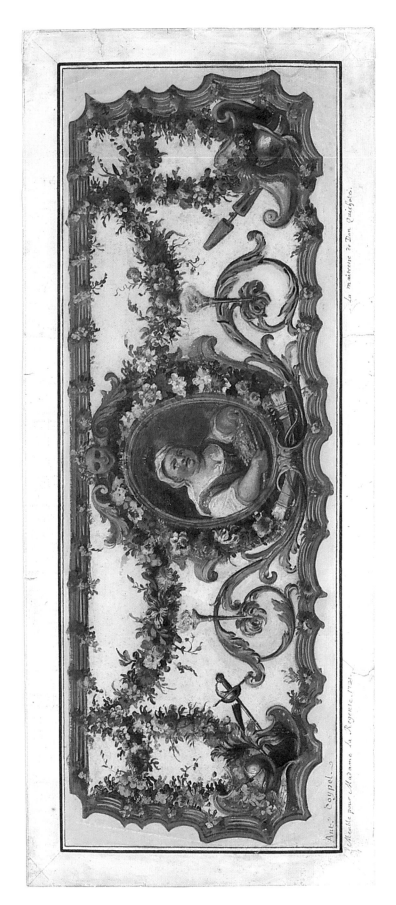

Charles-Antoine Coypel (no. 27)

Anonymous Artist (no. 123)

Catalogue

HENRY AUGUSTE

Paris 1759–Port-au-Prince, Haiti 1816

1. Design for a Covered Tureen on a Footed Stand

Pen, brown ink, and gray-brown wash. Two brown-ink framing lines. 7 $^{13}/_{16}$ × 5 $^{7}/_{8}$ in. (198 × 149 mm).

Signed in light brown ink below design at right, *H. Auguste*; inscribed in pencil at upper left above framing lines, *12*.

PROVENANCE: [Workart, Inc.]; purchased in Geneva.

The Elisha Whittelsey Collection, The Elisha Whittelsey Fund, 1978
1978.638.2

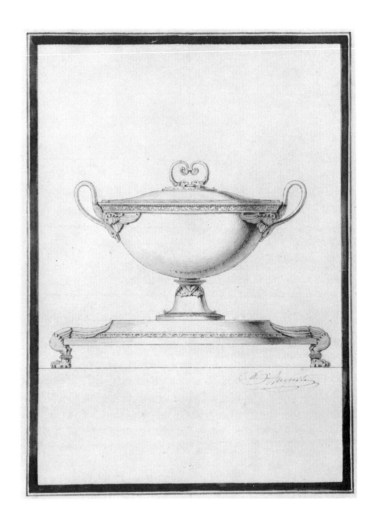

Henry Auguste became *orfèvre du roi* in 1785, the year he took over the family shop from his father, Robert-Joseph Auguste, also goldsmith to the king and one of the most celebrated of his era.[1] Henry was equally talented and successfully bridged, both politically and artistically, the period from Louis XVI to Napoleon. The heavy, austere, Neoclassic style of his father was lightened and made more elegant, and new motifs of decoration were introduced into his work. He was responsible for some of the most important works of the early Empire: he created the crown for Napoleon's coronation in 1804 and, in the same year, made the Grand Vermeil, an enormous service that was a gift to the emperor from the city of Paris, some pieces of which are preserved at the Château de Malmaison. However, he was incapable of handling the business affairs of his firm, and in 1806 his creditors forced him into bankruptcy, replacing him as director of his shop and giving him eight years to put his affairs in order. In late 1809, he was discovered trying to ship his stock to England and was arrested. He fled to England and thence to Haiti. The contents of his shop, including many drawings, were sold to his great rival, J.-B.-C. Odiot.[2] Some of the drawings from the Auguste shop in the archives of the Maison Odiot, all of which are stamped with the Maison Odiot inventory number, have been sold in recent years. Ten were acquired by the Metropolitan Museum (see Nos. 3–5, 75). However, this drawing and Number 2, which was acquired from another source, do not bear the Odiot stamp, and their provenance is unknown.

Auguste's shop employed a large number of draughtsmen, among whom were the architect Charles De Wailly (see No. 39) and the sculptors

Jean-Guillaume Moitte (see Nos. 74, 75) and Félix Lecomte. Signed drawings by Auguste have been the exception in the group that came from the Maison Odiot. One is a life-size, fully finished design for a ewer[3] with an elaborate handle formed by a trumpet that is held by a winged Victory, with the inscription *N. Demidoff*, alluding to Count Nicolas Demidoff (1773–1828), who bought a large service from Odiot in 1817.[4] A similar ewer with different surface ornamentation, signed and dated 1808, was in the collection of Lord Rosebery at Mentmore.[5] An earlier, full-size drawing, signed *Auguste fils à Paris*, is a design for a *pot à oille* (a covered circular dish on a stand),[6] which, with slightly different engraved ornamental friezes at the top of the tureen and on the stand, was executed for Prince Vladimir Golitzin, in 1789/90. Auguste did not hesitate to reuse this design for a piece in his Grand Vermeil. Auguste simply added the imperial insignia and changed the frieze on the stand.[7]

Although the present drawing is much smaller and is a design for a much simpler piece of domestic silver, it shares the characteristics of Auguste's draughtsmanship seen in the ewer and the *pot à oille*, which is competent, although stiff and quite dry. The elegant ornamentation is applied in discrete areas to a vessel of restrained, Neoclassic shape. The winged-lion's-paw feet of the stand in the drawing are less elaborate versions of the winged lions that support the stand of the tureen in the former Odiot drawing. A narrow frieze of foliate ornament decorates the rim of the tureen and the base. The handles in the form of swans, the emblem of Josephine, seen on silver made for her by Biennais and Odiot[8] and generally in silver of the period, point to a date of about 1804 to 1806 for the drawing.

NOTES

1 On Auguste, see C. Saunier, "Monsieur Auguste," *GBA* 3 (1910), pp. 441–460.

2 See the sale catalogue *Odiot: Maître-orfèvre du XIXe siècle*, Hôtel George V, Paris, October 6–17, 1975.

3 Sale, Sotheby Parke Bernet Monaco, November 26, 1979, lot 614, repr.

4 See Draper and Le Corbeiller 1978, nos. 156–159.

5 Sotheby Parke Bernet, Mentmore, Bucks., May 19, 1977, lot 675, repr.

6 Sale, Sotheby's Monaco, February 22, 1986, lot 179, repr.

7 See Dennis 1960, vol. I, nos. 11–12, repr.

8 For example, in a silver-gilt dressing table and service of 1812 by Odiot, for which see Helft 1966, pp. 298–299, repr.

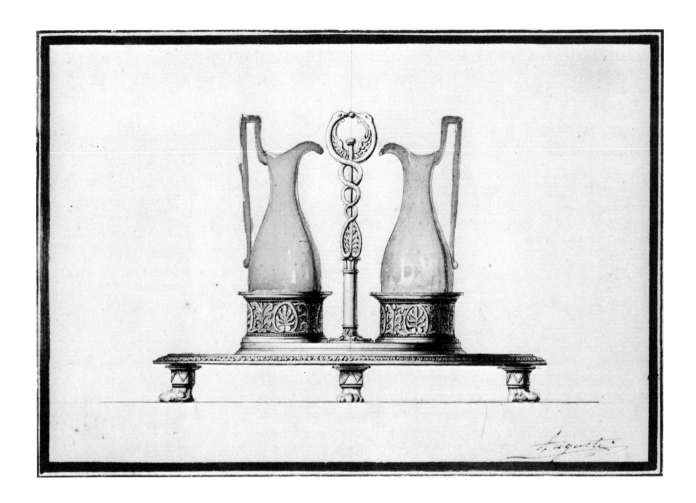

2. Design for a Cruet Frame

Pen, brown ink, with gray and gray-green wash. Two brown-ink framing lines. 5¾ × 7⅜ in. (146 × 187 mm).

Signed in brown ink at lower right above framing lines, *Auguste.*; inscribed in pencil at upper left above framing lines, *11*.

WATERMARK: GR with circular vine-leaf design within circle.

PROVENANCE: [Workart, Inc.]; purchased in Geneva.

The Elisha Whittelsey Collection, The Elisha Whittelsey Fund, 1978
1978.638.3

In contrast to the tureen by Auguste in which the ornamentation of the vessel is limited to a small proportion of the surface, here virtually the entire area is covered with decoration. Alternating palmettes cover the bottle supports, and a relatively wide leaf-and-dart frieze decorates the stand of the cruet, which is supported by stylized lions' paws. A caduceus rising from a palmette in the center of the stand completes the design. The gray-green wash covering the bottles may be a later addition.

HENRY AUGUSTE WORKSHOP
AFTER A DESIGN BY JEAN-GUILLAUME MOITTE

3. Candelabrum with Alternative Designs for Branches

Pen, black ink, and gray wash. Two black-ink framing lines. 25 1/16 × 19 1/2 in. (637 × 495 mm). Light brown stains around all edges. Lined.

Inscribed lower right in pencil, *C421.*

PROVENANCE: J.-B.-C. Odiot and Maison Odiot, Odiot stamp no. 421; [Galerie Fischer-Kiener]; [Adrien Ward-Jackson]; purchased in London.

BIBLIOGRAPHY: Draper and Le Corbeiller 1978, no. 85.

Rogers Fund and The Elisha Whittelsey Collection, The Elisha Whittelsey Fund, 1978
1978.521.4

This drawing was the pattern used by the Auguste shop for the execution of candelabra and, as such, is an important document. It actually provides two different designs for branches. Both alternatives in this drawing were carried out in vermeil. The left-hand design was executed in 1789 with three branches and four lights as a set of twelve for the second son of George III of England, Frederick Augustus, duke of York and Albany, whose arms are engraved on the base. Two from this set of twelve are in the Metropolitan Museum (fig. 1),[1] and four are in the California Palace of the Legion of Honor, San Francisco. A similar pair was recently on the New York art market.[2] The size of the Metropolitan's candelabra is just one-eighth inch larger than the drawing. Also dated 1789 is a vermeil candelabrum with three branches and

four lights, in the collection of Jacques Kugel,[3] which incorporates the rosette that terminates the acanthus-leaf round arm of the design at the right in the drawing.

Richard Campbell points out the similarity of the circular branches on the Metropolitan's candelabra to designs by Moitte:[4] the motif appears on the two candelabra on the Metropolitan's sheet of silver designs by Moitte (see No. 74). This drawing most likely is a replica of one that Moitte produced for Auguste.

NOTES

1 Acc. no. 21.61.1–2; see Dennis 1960, vol. I, p. 31, no. 10, repr.
2 Sale, Christie's, New York, April 18, 1991, lot 80, repr.
3 Helft 1966, pp. 248–249, repr.
4 Campbell 1983, p. 187.

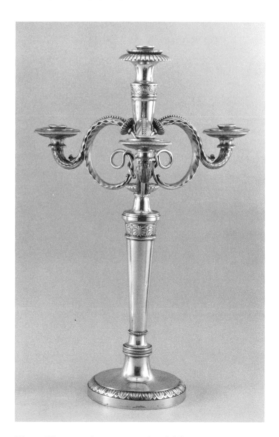

Fig. 1. HENRY AUGUSTE, Candelabrum, 1789–92. The Metropolitan Museum of Art, Rogers Fund, 1921

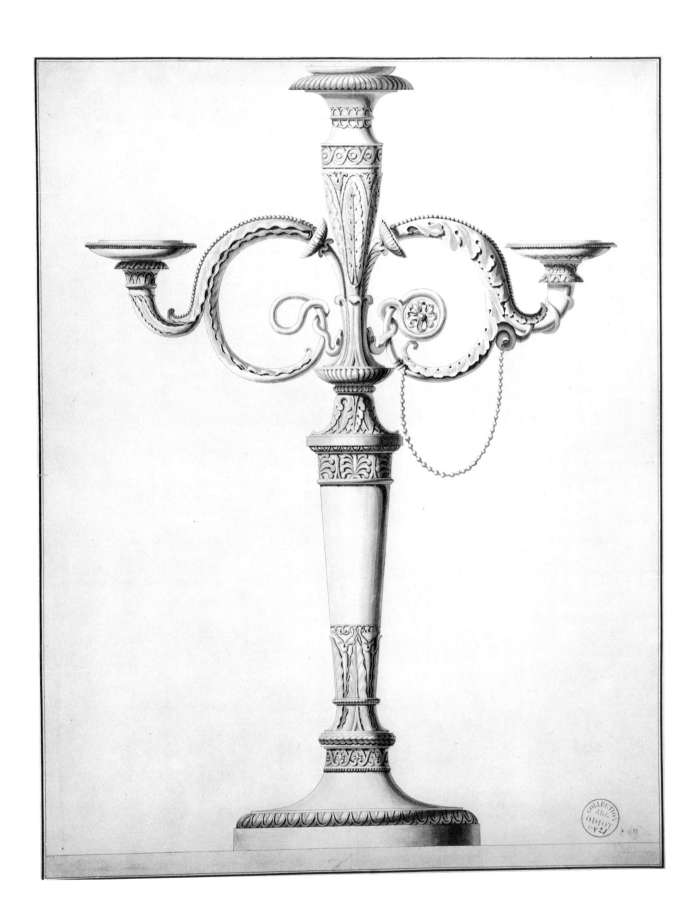

4. Design for a Covered Tureen on a Footed Stand

Pen, black ink, with gray wash. 17 13/16 × 23 1/16 in. (452 × 585 mm). Lined.

Inscribed verso on lining at upper right in brown ink, *Collection de dessins/par Auguste/ancien orfèvre de/L'empereur Napoléon*, and below and partly underneath, in lightly effaced pencil, *Soupière pour M. Damidoff.*

PROVENANCE: J.-B.-C. Odiot and Maison Odiot, Odiot stamp no. 138; [Galerie Fischer-Kiener]; [Adrien Ward-Jackson]; purchased in London.

Rogers Fund and The Elisha Whittelsey Collection, The Elisha Whittelsey Fund, 1978
1978.521.1

Clare Le Corbeiller has kindly pointed out a silver wine cooler by Auguste, dated 1789, that is decorated with the same frieze composed of entwined snakes with stylized flowers and, in the center, a rosette between pairs of serpent heads and with the same handles composed of female mascarons and snakes whose tails twist around the lower band of the frieze.[1] A drawing of a wine cooler by Moitte has the same frieze; its handle is composed of a curling serpent only, lacking the female mascaron depicted here.[2] The handle recalls, with variations, that used on a more elaborate tureen with footed stand, made in 1789–90 for Prince Vladimir Golitzin, the design of which was reused by Auguste for the service made for Napoleon in 1804.[3] About 1805, Auguste reused the motif of the female mascaron and serpent handle, with variations, on a tureen that has the same leaf decoration on a similar pedestal base as our sheet.[4]

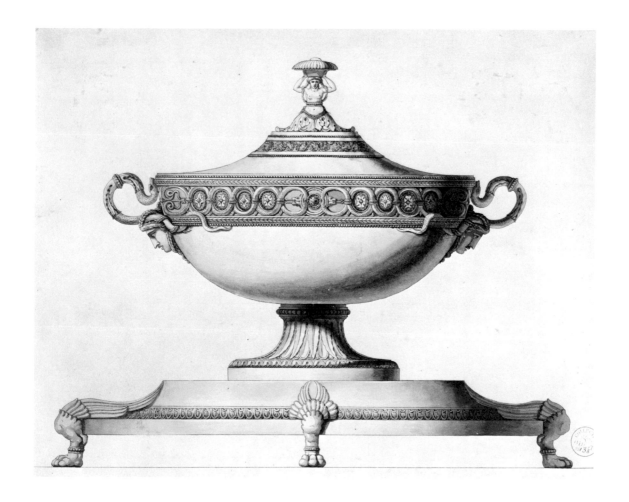

The inscription on the verso presumably refers to Count Nicolas Demidoff (1773–1828), whose large silver service supplied by Odiot in 1817 is renowned.[5] Demidoff's signature approving the design appears on a drawing of a ewer signed by Auguste that was formerly in the Odiot collection.[6]

NOTES

1 Sale, Christie's, London, November 15, 1961, lot 18, repr.
2 Sale, Sotheby Parke Bernet Monaco, November 26, 1979, lot 629, repr.
3 Dennis 1960, vol. I, pp. 32–33, nos. 11–12, repr.
4 Sale, Sotheby's, London, January 28, 1965, lot 109, repr.
5 See Draper and Le Corbeiller 1978, nos. 156–159.
6 See Number 1; sale, Sotheby Parke Bernet Monaco, November 26, 1979, lot 614, repr.

5. Design for a Wine Cooler

Pen, black ink, and gray wash. Two framing lines in black ink. 17⅜ × 16⅛ in. (441 × 410 mm). Lined.

Inscribed in pencil at lower right, *231*.

PROVENANCE: J.-B.-C. Odiot and Maison Odiot, Odiot stamp no. 231; [Galerie Fischer-Kiener]; [Adrien Ward-Jackson]; purchased in London.

BIBLIOGRAPHY: *Notable Acquisitions, 1975–1979*, pp. 61–62, repr.

Rogers Fund and The Elisha Whittelsey Collection, The Elisha Whittelsey Fund, 1978
1978.521.5

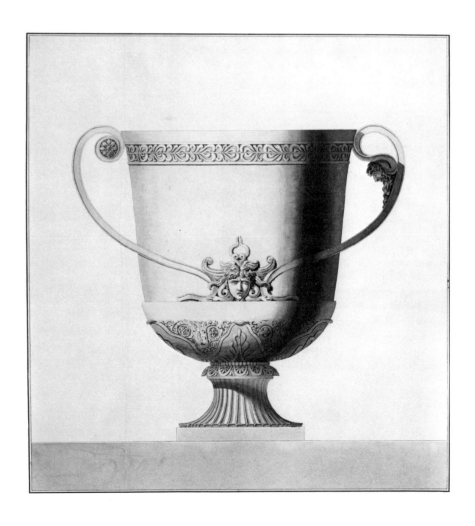

The original drawing by Moitte, of which this sheet is the replica made in Auguste's workshop, recently appeared at auction.[1] Like our sheet, its provenance was the Maison Odiot, and it bears the Odiot stamp no. 230. Inscribed in black ink on the verso of its early-nineteenth-century mount is *No. 18*. Like the number inscribed on the verso of our drawing by Moitte (see No. 74), this may be an inventory number of Auguste's shop.

Richard Campbell has pointed out the similarity of the wine cooler depicted on these sheets to one appearing in a drawing in the École des Beaux-Arts, Paris,[2] in which the handles are composed of satyr masks and rosettes together, not in alternative designs as here. Likewise, the same decorative elements—the gadroons, the palmettes, and the acanthus frieze—appear in the École des Beaux-Arts sheet, but on different areas of the wine cooler. Satyr masks also form components of the handles on one of the urns in another drawing by Moitte (No. 74). The placement of the frieze below the rim and the decoration on the base of the urn are similar to the treatment of the other urn depicted on the same sheet. Campbell cites variant designs for wine coolers,[3] one of which is now in the collection of the J. Paul Getty Museum;[4] and two more have recently appeared at auction.[5]

NOTES

1 Christie's, New York, February 26, 1986, lot 185, repr.

2 Campbell 1983, pp. 183, 300 n. 18; and E. Dacier, "L''athénienne' et son inventeur," *GBA* 8 (1932), p. 119, fig. 4.

3 Sotheby Parke Bernet Monaco, November 26, 1979, lot 629, repr.

4 Acc. no. 79.PC.182; see Gillian Wilson, "Acquisitions Made by the Department of Decorative Arts, 1979 to Mid 1980," *J. Paul Getty Museum Journal* 8 (1980), pp. 14–15, figs. 21–23.

5 Sotheby's Monaco, February 22, 1986, lots 182 and 184, repr. Lot 182 is marked with Odiot stamp no. 233 and is the same design as a drawing with Odiot stamp no. 232, with Galerie Fischer-Kiener, Paris, in 1978. From photographs it would appear that the latter was the original drawing by Moitte and the Sotheby's sheet the shop copy.

PIERRE-EDME BABEL

Paris 1700/1711–Paris 1775

6. Study for a Book Vignette

Pen, gray ink, and wash. Framing lines.
4 ¹³⁄₁₆ × 4 ¹⁵⁄₁₆ in. (122 × 125 mm).

Signed in gray ink at lower right, *Babel in. et S[culp]* (*culp* partially effaced).

PROVENANCE: [Galerie Cailleux, Paris]; purchased in Paris.

BIBLIOGRAPHY: Fuhring 1989, pp. 123–124, under no. 68.

Edward Pearce Casey Fund, 1985
1985.1116.1

Babel was both an engraver and a sculptor in wood. The Swedish court tried unsuccessfully to hire him in 1736 as a sculptor. He was received into the Académie de Saint-Luc in 1751, and in the 1760s he was paid many times by the French crown for sculptural works he had produced for it.[1] He was a prolific etcher as well, executing many works after both ornamental artists, such as J.-A. Meissonnier, and figure artists, such as François Boucher. He etched the plates for numerous architectural books, for example, C.-É. Briseux's *Art de bâtir des maisons de campagne . . .* (Paris, 1743), G.-G. Boffrand's *Livre d'architecture . . .* (Paris, 1745), and J.-F. Blondel's *Architecture françoise . . .* (Paris, 1752–56). In addition he composed the designs

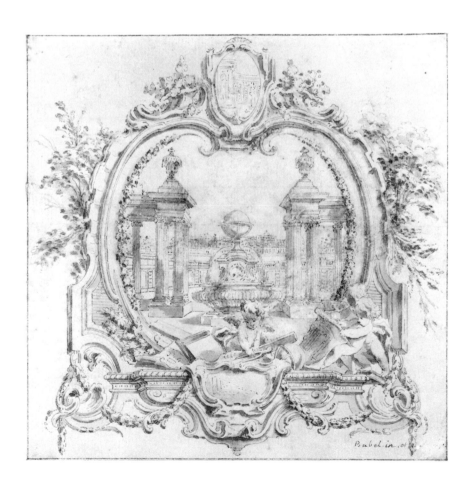

for vignettes, head-, and tailpieces for many volumes. All of these were executed in the Rococo style. In a break with that style, he etched a suite of undated Neoclassic designs for jewelry by the little-known artist Maria that probably dates to the late 1760s.[2]

This sheet is a study by Babel for his etched vignette in the volume by Edme-Sébastien Jeaurat, *Traité de perspective à l'usage des artistes* . . . (Paris, 1750).[3] Babel signed forty-six tailpieces in the volume, many of which appear in duplicate or triplicate. C.-N. Cochin *fils* designed and etched a tailpiece that was repeated once. Many of the unsigned tailpieces are very close to the style of Babel's work, but as he signed even the smallest design, it would have been uncharacteristic for him not to have signed them if they were his. Our vignette appears with changes as a tailpiece on page 130 for lesson 43 and is repeated on page 154 for lesson 58. The drawing differs from the finished print in that instead of the symmetrical design inside the cartouche of the drawing, the print has the colonnade at the right and a sweeping staircase with trees behind in the background at the left. Also, in the print two standing putti were added to the celestial globe surmounting the vase in the center of the cartouche. Within the cartouche at the top is an architectural design, an arcade, while the finished print has two putti reading. The print is the reverse of the drawing as is evidenced by the putti in the foreground.

The style of this delicate Rococo drawing is nearly unique in the group of drawings classed as Babel's (see the following entry). Only one other is known to me, a study in the Cooper-Hewitt Museum dated 1749, the year before the Jeaurat treatise was published.[4] It is the scheme for an entablature or pediment. In the center is an escutcheon with an obelisk around which a garland is wound and with a star on either side. Putti support the sides of the escutcheon. It is signed and dated and, like our drawing, was executed in pen, gray ink, and wash.

NOTES

1 S. Lami, *Dictionnaire des sculpteurs de l'école française au dix-huitième siècle* (Paris, 1910), vol. I, p. 37; and B. N., *Inventaire*, vol. I, pp. 368–382.

2 See B. N., *Inventaire*, vol. I, pp. 368–382.

3 A copy of which is in the Print Department of the Metropolitan Museum, acc. no. 1991.1073.29. See B. N., *Inventaire*, vol. I, p. 374, no. 22.

4 Acc. no. 1911.28.9.

7. Study for a Cartouche

Pen, brown ink, with brown and gray wash.
15½ × 10⅜ in. (394 × 264 mm).

Inscribed at lower left in brown ink, *Babel f.*,
and at bottom left, very lightly in pencil,
Babel f.

WATERMARK: Indecipherable.

PROVENANCE: A. Beurdeley (Lugt 471);
[R. M. Light & Co., Cambridge, Mass.]; pur-
chased in Cambridge, Mass.

BIBLIOGRAPHY: Carl J. Weinhardt, Jr.,
"Ornament Prints and Drawings of the
Eighteenth Century," *MMAB* 18 (January
1960), p. 146, repr.; A. Hyatt Mayor, "Practi-
cal Fantasies," *Apollo* (September 1965),
p. 246, fig. 8; Berckenhagen 1970, p. 242,
under Hdz 4401; Roland Michel 1984, p.
307, under DD. 20; Fuhring 1989, pp.
123–124, under no. 68.

Purchase, Anne and Carl Stern Gift, 1957
57.570

As distinct from the delicate draughtsman-
ship of the studies for book illustration, this
sheet partakes of the more usual components of
drawings associated with Babel's name. It is pure
rocaille, a style based on swirls and foliage with
shells and scrolls. Such drawings are in many
collections: the Kunstbibliothek, Berlin,[1] the Fine
Arts Museums of San Francisco,[2] and the
Cooper-Hewitt Museum, New York.[3] Further
drawings are at Waddesdon Manor, in the
École Nationale des Beaux-Arts, Paris, and in
the Houthakker collection, Amsterdam.[4] The
draughtsmanship of some of the other sheets—
executed with a kind of flickering pen work—is
less bold than that in this drawing. Even with
the inscriptions to Babel on these drawings, it is
difficult to assign them to the same artist as
the Babel who drew the tailpiece for the Jeaurat
treatise. Indeed, Alastair Laing has pointed out
that there are prints made after a drawing at

Waddesdon Manor that were etched in reverse
by P.-B. Dandrillon, one of which is signed by
P. Ludovik as designer. Fuhring has also pointed
out that there was a designer and modeler of
papier-mâché ornaments named Peter Babel,
who was born in France and went to England in
1733. How all these tangled threads will be
straightened out is impossible to foresee at this
stage, but it is important to emphasize the differ-
ence between the Jeaurat tailpiece and this draw-
ing and the others like it.

NOTES

1 Berckenhagen 1970, pp. 242–243, Hdz 4401, repr.
2 P. Hattis, *Four Centuries of French Drawings in the Fine
 Arts Museums of San Francisco* (San Francisco, 1977),
 no. 23, repr.
3 R. Wunder, *Extravagant Drawings of the Eighteenth
 Century* (New York, 1962), no. 73, repr.
4 Fuhring 1989, nos. 68–70, repr.

FRANÇOIS-JOSEPH BELANGER

Paris 1744–Paris 1818

8. Study for the Ceiling of a Salon in the Hôtel de Mazarin

Pen, gray ink, with gray and colored wash over black chalk. Lined, with blue paper border added, with framing lines.
16⅞ × 22¾ in. (429 × 578 mm).

Inscribed in black ink on mount at top, *No 7*, in black ink below on mount, *Plafond du Salon en Stuck que précéde la Gallerie*, in brown ink on drawing at bottom center, *La Duchesse de Mazarin*; signed in brown ink at lower right on drawing, *Belanger*, with paraph.

PROVENANCE: [B. T. Batsford, Ltd., London]; purchased in London.

BIBLIOGRAPHY: Dealer's cat., B. T. Batsford, Ltd., London, ca. 1932, no. 78.

Harris Brisbane Dick Fund, 1932
32.85.4

Belanger studied architecture with Julien David Leroy and Pierre Contant d'Ivry.[1] Instead of traveling to Italy, he was one of the very few French architects of the eighteenth century to visit England (Legeay was another; see Nos. 60–62). His career began in 1767 with his appointment as a *dessinateur* at the Menus Plaisirs under C.-M.-A. Challe (see No. 24). Through his liaison with Sophie Arnould, a singer at the Opéra, he was introduced to a circle of wealthy patrons. For one of these, the comte de Lauragais, he designed a pavilion in the antique style. In 1770 his friendship with the prince de Ligne led to the designs for the prince's châteaus in Belgium: the Château de Beloeil, for which he planned the landscaping, and the Château de

Baudour. In 1777 Belanger bought the position of *premier architecte* to the comte d'Artois, the youngest brother of King Louis XVI and the future King Charles X. In the fall of that year, the architect was occupied with the plans and building of Bagatelle, in the Bois de Boulogne, the garden pavilion resulting from a bet with the queen that the comte d'Artois could erect a château during the time the members of the royal family and the court were at Fontainebleau, before their return to Versailles. Belanger delivered his plans to the count in forty-eight hours, and the pavilion was erected in sixty-four days. However, the furnishing of the pavilion went on for several years, along with work on the garden. Near Bagatelle, in Neuilly, Belanger built, about 1780, the Folie Sainte-James, with its elaborate gardens, for Claude-Baudard de Sainte-James, who held the important post of the *trésorier général de la Marine*. At the end of his career, in 1808–13, he rebuilt the dome of the Halle au Blé, which had burned. His dome was the first ever executed in cast iron. Despite the innovation of this building, Belanger was noted on the whole more for the interior decoration of buildings than for their architecture.

This drawing is part of a group of ten sheets, eight of which are by Belanger and two by Jean-Jacques Lagrenée, that were acquired together as one lot (see Nos. 50, 51). Most of them are mounted on blue paper, and most are numbered on the mount. It is clear that they remained together in Belanger's studio and must have been sold from it, probably in his estate sale, June 15, 1818.[2] Eight of the drawings appear in this catalogue. The two that do not include one in pen, brown ink, and watercolor, inscribed *Plan d'un Pavillon à Bâtir à la Campagne . . . Aux Environs de Venise sur les Bords de la Brenta* (MMA acc. no. 32.85.12), and one in pen and brown ink over traces of black chalk for a coffered ceiling (MMA acc. no. 32.85.10), signed *bon S. Foy, le 21 May 1779*. Radix de Sainte-Foix was the *trésorier général* of the comte d'Artois. Barbara Scott has

kindly pointed out to me that Radix de Sainte-Foix bought a *hôtel* in 1779 that Alexandre-Théodore Brongniart had built in 1775 for Bouret de Vézelay, a financier, on the Basse-du-Rempart, site of the present Opéra.[3] It is probable that Sainte-Foix employed Belanger in 1779 for certain redecorations of the *hôtel* and that the drawing was part of that project.

The Hôtel de Mazarin,[4] on the quai Mala-quais, with which the drawing under discussion is connected, was built in 1630 and acquired by the duchesse de Mazarin in 1767 from the prince de Conti. The duchess was the daughter-in-law of the duc d'Aumont, the director of the Menus Plaisirs in Paris, where Belanger also worked. The duchess had some renovation work executed early in the period of her possession of the *hôtel*,[5] but it was not until 1780 that she began a serious campaign of renovation and redecoration.[6] She died unexpectedly, however, in March of the following year, with the renovations unfinished and debts outstanding on her estate. Her daughter,

the duchesse de Valentinois, sold the property in 1784. In 1845 the *hôtel* was demolished. The state acquired the land in 1855 and three years later began the erection there of the École des Beaux-Arts, completed in 1862, which remains on the site.

This study for a ceiling of a salon in the Hôtel de Mazarin was to be executed in stuccowork and painting. At the corners of the sheet are medallions with classical figures. Surrounding each medallion are putti emerging from foliated decoration. The greatest expanse of the ceiling is taken up by an octagon with two long sides, in the center of which is a circle with black-chalk sketches of flying putti. At each end of the octagon are three panels comprising two triangles and a square, within which is a diamond-shaped plaque enclosing a classical figure in a chariot. The sober Neoclassical design of this sheet, which was in the very latest style, was complementary to that employed in the carpets for the Hôtel de Mazarin (see Nos. 10, 11).

NOTES

1 On Belanger, see Stern 1930.
2 *Catalogue de gouaches, aquarelles et dessins, encadrés et en feuilles, estampes, planches gravées, et épreuves . . . composant le cabinet de feu M. Bélanger, dessinateur ordinaire de la chambre et du cabinet du roi . . . par F. Sallé.*
3 See Hautecoeur, vol. IV, 1952, p. 292.
4 I am grateful to Michael Snodin and Howard Coutts for the ground plan of the Hôtel de Mazarin, Archives Nationales, N.III 857 cited in Stern 1930, p. 153 n. 1.
5 Stern 1930, pp. 150–154.
6 A study for the elevation of an interior of a small salon is in the Victoria and Albert Museum; see H. Coutts, "French Eighteenth-Century Decorative Drawings in the Victoria and Albert Museum," *Apollo* (January 1986), pp. 26–27, pl. VII.

9. Study for a Ceiling of a Salon in the Hôtel de Mazarin

Pen, gray ink, with gray, brown, and colored wash over black chalk. Blue paper mount pasted over edges of drawing, with framing line in black ink. 18½ × 25¼ in. (470 × 641 mm).

Inscribed in rose ink on mount at top *N . [8]* (number cut with only half showing), and on mount at bottom, *Differentes idées de Plafonds, avec Camées pour le sallon de Made la Duchesse de Mazarin/en Son hôtel à Paris*; signed in brown ink at lower right on drawing, *Belanger*, with paraph.

PROVENANCE: [B. T. Batsford, Ltd., London]; purchased in London.

BIBLIOGRAPHY: Dealer's cat., B. T. Batsford, Ltd., London, ca. 1932, no. 78.

Harris Brisbane Dick Fund, 1932
32.85.5

This—like the previous entry—is a study for a ceiling in a salon of the Hôtel de Mazarin. Here, however, several variant possibilities are given, and a looser and sketchier style is employed. As in the other design, the center is a large circle with putti flying about in the heavens. For the field of decoration around the circle, two alternative shapes are shown: one end, as in Number 8, is defined by straight diagonal lines, while the other end is defined by concave curved lines. Each corner of the ceiling presents a different variation: a figure with foliage at the upper right; a small medallion containing crossed horns and flanked by putti and tendrils at the lower right; a shield shape framed by eagle heads with tendrils enclosing a scene with a reclining figure at the upper left; and a medallion containing a figure standing by an altar and surrounded by putti emerging from cornucopias at the lower left.

Like the other project, this was to have been executed in painted stuccowork.

10. Study for a Carpet for the Hôtel de Mazarin

Pen, gray ink, with gray and colored wash over black chalk. Lined with blue paper mount at top and bottom, with framing line in black ink. 17⁹⁄₁₆ × 30¹⁄₁₆ in. (446 × 764 mm). Creased vertically at left.

Inscribed in rose ink on mount at top, *No 5*, in rose ink on mount at bottom, *Tapis de la Gallerie de Ma[————] Mazarin, pour être éxécuté à la Manufacture de Beauvais*, and in brown ink on drawing at bottom center, *la Duchesse de Mazarin*.

PROVENANCE: [B. T. Batsford, Ltd., London]; purchased in London.

BIBLIOGRAPHY: Dealer's cat., B. T. Batsford, Ltd., London, ca. 1932, no. 78; Verlet 1982, pp. 146–149, fig. 89, p. 418 n. 112; Thornton 1984, p. 165, under no. 205; H. Coutts, "French Eighteenth-Century Drawings in the Victoria and Albert Museum," *Apollo* (January 1986), p. 26.

Harris Brisbane Dick Fund, 1932
32.85.8

9

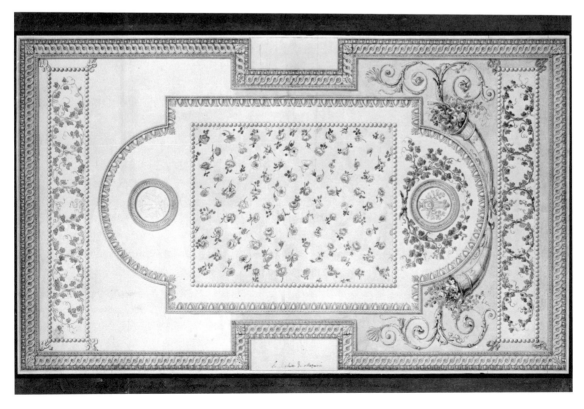

10

There are three studies for carpets in the group of Belanger designs. Two are projects for the duchesse de Mazarin and may have been intended for rooms in her *hôtel*, perhaps the "salons" for which Numbers 8 and 9 are ceiling studies, as they have similar indications for chimneypieces. The inscription identifies this carpet as for a "Gallerie," while that for Number 11 identifies it as for a "Grande Gallerie."

This project was to have been executed at Beauvais, the renowned tapestry works. Like the tapestries made there, the carpets were woven flat, as opposed, for example, to the high pile weaving at Savonnerie.

This rich and luxurious carpet was designed around a central rectangle filled with roses and edged with pearls. The central rectangle is surrounded by a larger rectangle with rounded ends that incorporate roundels, one of which contains a lyre and laurel branches and is surrounded by grapevines. An egg-and-dart motif borders this area. Cornucopias spill out a profusion of roses on one side. At both ends pearls surround a narrow rectangle containing round wreaths of grapevines. A guilloche encloses the entire design.

Pierre Verlet has dated this scheme and the other carpet studies to about 1777. Peter Thornton has suggested that this design or those for the two other carpets in the group are connectable with a design for a salon for the duchesse de Mazarin in the Victoria and Albert Museum, London.

11. Study for a Carpet for the Hôtel de Mazarin

Pen, gray ink, with brown and colored wash. Paper pieced at right. Blue paper mount pasted on paper with framing lines. 19 3/16 × 24 5/32 in. (487 × 615 mm).

Signed in black ink on mount, *Belanger*, with paraph; inscribed in black ink on blue mount at top, *No 6*, and at bottom, *Moitié d'un Tapis pour une grande Gallerie/ [---] Mad de Mazarin pour être éxécuté à la Manufacture de la Savonnerie*.

PROVENANCE: [B. T. Batsford, Ltd., London]; purchased in London.

BIBLIOGRAPHY: Dealer's cat., B. T. Batsford, Ltd., London, ca. 1932, no. 78, repr.; Verlet 1982, pp. 146–149, fig. 88, p. 418 n. 111; Thornton 1984, p. 165, under no. 205.

Harris Brisbane Dick Fund, 1932
32.85.7

This sumptuous design was planned for execution in the sumptuous technique of deep pile weaving at the royal Savonnerie works. Like the carpet design to have been executed at Beauvais, this study was intended for the duchesse de Mazarin's Hôtel de Mazarin, and like the Beauvais piece, it was inscribed as being for a *gallerie*. It is not certain if these carpet designs were for the same rooms as the ceiling studies for the Hôtel de Mazarin, as the latter were described as being for salons. Pierre Verlet has dated these carpet designs to 1777, which falls within the period of the redecorating of the Hôtel de Mazarin.

Three-quarters of the carpet is shown, while the one-quarter missing would have repeated the portion at the left. In the central panel, a large medallion is surrounded by a luxuriously abundant mélange of flowers on a blue ground, a

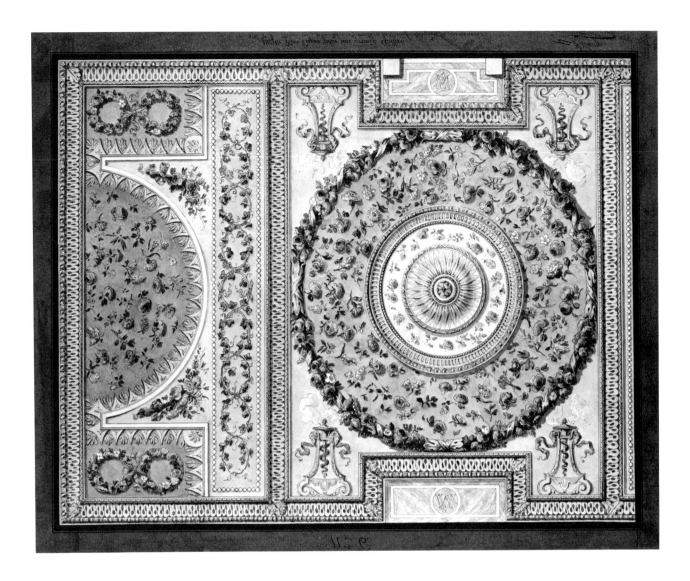

motif that recurs throughout most of the carpet design. Although not botanically correct, the flowers resemble roses, carnations, lilacs, pinks, periwinkles, daisies, and black-eyed Susans. In the four corners of the central panel, around the circle of flowers and on either side of the areas for the chimneypieces, are smoking braziers. At the left side of the design is a semicircle on a ground of blue filled with the motif of scattered-about flowers found in the central circle, and on either side of the semicircular area are two small rectangular panels containing two wreaths of flowers on a ground of blue. Between the semi-circle and the central panel is a long, narrow rectangle filled with intertwining grapevines, again on a blue background bordered with pearls.

Although the smoking braziers are typical Neoclassic motifs, the overall composition of the carpet owes much to the style connected with Marie Antoinette in the late 1770s and 1780s. It is a much more feminine and decorative style based on a superabundance of flowers and such other delicate elements as the pearl and guilloche borders.

12. Study for the Dining-Room Ceiling of the Bagatelle Pavilion

Pen, gray ink, with gray and colored wash. Lined with blue paper mount and framing line. 15 ¼ × 25 ⁷⁄₁₆ in. (387 × 646 mm).

Signed on mount, *Belanger*, with paraph; inscribed in black ink on mount at bottom, *Plafond de la Salle à Manger, De Bagatelle*.

PROVENANCE: [B. T. Batsford, Ltd., London]; purchased in London.

BIBLIOGRAPHY: Dealer's cat., B. T. Batsford, Ltd., London, ca. 1932, no. 78, repr.

Harris Brisbane Dick Fund, 1932
32.85.3

Despite the tradition according to which the pavilion of Bagatelle was built in sixty-four days in 1777 on a bet between the comte d'Artois, the youngest brother of Louis XVI and the future King Charles X, and Marie Antoinette, the completion of the furnishings and decoration extended over three to four years.[1] Payments to the painter Dusseaux that began in March of 1778 and continued through 1779 for the dining room, among other rooms, show that much more than two months was needed for the completion of the sumptuous pavilion.[2]

The pavilion still stands in the Bois de Boulogne, marred by the attic mezzanine story added in the nineteenth century. Much of the decoration is now lost, including the ceiling of the dining room. Our study conforms in all important ways with the descriptions of the dining-room ornamentation in the payment documents. The ceiling is divided into a central square with a half-oval at each end then further subdivided into compartments. The central compartment is a slightly elongated octagon. It has a scene of the wedding of Psyche in the center, made to resem-

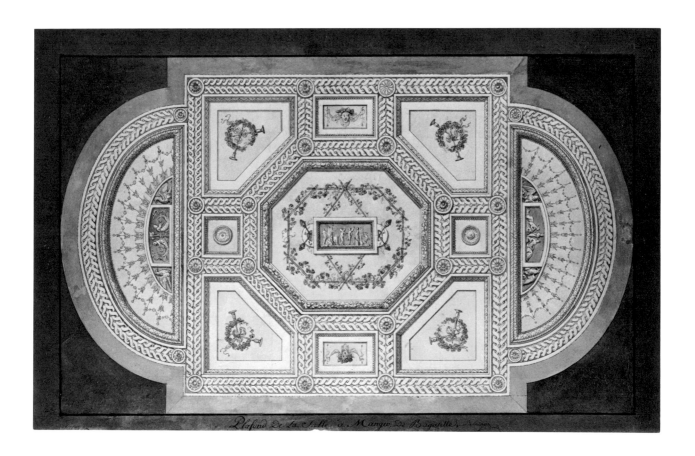

ble an ancient cameo. Around it are vines with flowers winding among wood stakes. Into these are placed crossed lances mounted with acorn caps. Above and below, in small rectangular compartments, are female masks. In the corner compartments are crossed horns tied with ribbons and encircled by wreaths. Guilloches, punctuated with rosettes, divide the compartment panels. In the oval ends are more cameo designs: at the right, a herm with a river goddess on either side, and at the left, putti emerging from foliage on either side of a flaming tripod brazier. Eagles flank each cameo. The payments by contrast state that antique quadrigas compose the cameo designs. The colors in the ceiling are quite sober: tones of gray cover the design except for the masks, cameos, and the horns and wreaths, which are in green, rose, blue, and beige.

A series of six landscape paintings by Hubert Robert, painted for a boudoir at Bagatelle, are in the Metropolitan Museum: *The Mouth of a Cave, The Fountain, The Swing, The Dance, The Bathing Pool,* and *Wandering Minstrels.*3 A drawing by J.-D. Dugourc, Belanger's brother-in-law, of the garden facade of Bagatelle in 1779 is also in the Metropolitan Museum.4

NOTES

1 On Bagatelle, see H.-G. Duchesne, *Le château de Bagatelle . . .* (Paris, 1909); [L. de Quellern], *Le château de Bagatelle: Étude historique et descriptive, suivie d'une notice sur la roseraie* (Paris, [1909]); Stern 1930; and J.-L. Gaillemin, ed., *La Folie d'Artois* (Paris, 1988). In the last, see especially J.-J. Gautier, "Décor et ameublement de Bagatelle," pp. 119–141.
2 Jean-Jacques Gautier kindly brought the payments to my attention, Archives Nationales, R1.320.
3 Acc. nos. 17.190.25–30; see K. Baetjer, *European Paintings in The Metropolitan Museum of Art by Artists Born in or Before 1865* (New York, 1980), vol. I, p. 156, repr.
4 Bean and Turčić 1986, no. 105, repr.

13. Study for a Carpet

Colored wash over black chalk, pen and brown ink at right. Border line in red-brown ink. 13 3/8 × 22 1/16 in. (340 × 560 mm).

Inscribed in rose ink at top, *No. 15,* and below, *Projet d'un Tapis pour le Sallon pour être éxécuté en Angleterre.*

PROVENANCE: [B. T. Batsford, Ltd., London]; purchased in London.

BIBLIOGRAPHY: Dealer's cat., B. T. Batsford, Ltd., London, ca. 1932, no. 78; Verlet 1982, pp. 146–149, fig. 90, p. 418 n. 113; Thornton 1984, p. 165, under no. 205.

Harris Brisbane Dick Fund, 1932
32.85.11

This unfinished study for a carpet to be made in England, as the inscription indicates, has a brown-ink sketch at the right, which may be identified as a preliminary design for the ceiling of the dining room at Bagatelle. Above the latter is a sketch for the horns and wreaths in the corner compartments of the Bagatelle ceiling. It is not clear whether this drawing is for a carpet for Bagatelle or for another carpet for the duchesse de Mazarin in addition to the two inscribed with her name. The crossed axes in the center of the study suggest a military theme, and the comte d'Artois did have a military background (minimal though it was); however, the fasces and ax were the Mazarin coat of arms.1 In addition, the lyre and flaming braziers are motifs portrayed in the two Mazarin designs. In any case, the dating is the same for all three carpets, 1777–78 for the Mazarin designs and 1777 for this one. Belanger was working on the two different projects at the same time, and it is impossible to say which this study is for.

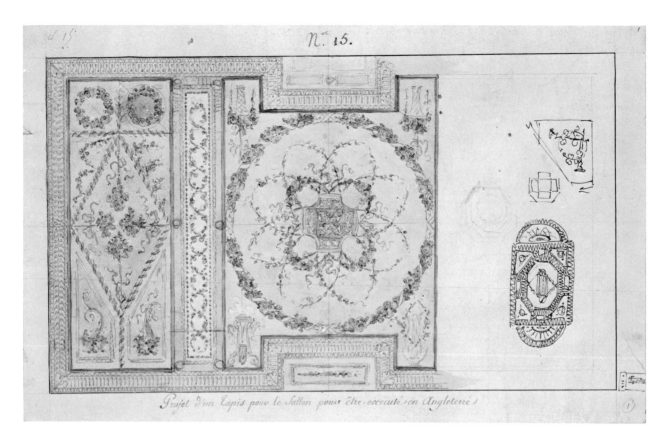

Projet d'un tapis pour le Sallon pour être exécuté en Angleterre

13

The drawing is divided into three sections: two ends and a center. The center is composed of the crossed axes with overlapping ovals of flowers and ribbons, encircled by a wreath of roses. In the corners are alternate designs for tall flower baskets, a lyre, and a flaming brazier. A narrow panel of small wreaths bordered by pearls divides the central compartment from the end compartment. There, a diamond-shaped form contains bouquets of roses with flying ribbons. In the corners, outside the diamond, are alternative designs for cornucopias and wreaths. Composing the outside border are alternate designs consisting of both guilloche and egg-and-dart motifs.

The colors are more understated than in the two previous carpet designs for the duchesse de Mazarin: the background is pink and green; the flowers are rose; and the borders, along with the lyre, brazier, and flower baskets, are yellow.

NOTE

1 Verlet 1982, p. 418 n. 113.

JÉRÔME-CHARLES BELLICARD

Paris 1726–Paris 1786

14. Notebook with Views of the
 Excavations at Herculaneum and of
 Other Italian Cities

Notebook of 55 pages on 29 leaves. Last
leaf is hinged onto blank leaf. Two leaves
are numbered 36 bis and 37 bis (in addition
to pages 36, 37). Four leaves are missing be-
tween pages 1 and 2; one leaf is missing be-
tween pages 7 and 8; two leaves are missing
between pages 23 and 24; two leaves are
missing between pages 39 and 40; two
leaves are missing between pages 41 and 42;
and one leaf is missing between pages 51
and 52. Late-eighteenth-century or early-
nineteenth-century sprinkled leather bind-
ing with marbleized endpapers. Loose front
cover: 8⅝ × 6⅜ in. (219 × 162 mm).
Leaves: Pen and brown ink. 8¼ × 6 in.
(209 × 151 mm).

WATERMARK: The lower part of what
appears to be a fleur-de-lis within a double
circle, on pages 10, 12, 14, 24, 48, and 54.

PROVENANCE: De Malleray; Whitney
Warren; Whitney and Lloyd Warren sale,
Parke Bernet Galleries, New York, May 1,
1940, no. 54. Inscribed in pencil on flyleaf,
*This book was offered to me in 1917,/by
Commandant de Malleray, of the/G. G. of
the French Armies at Marshal/Pétain's head-
quarters, Provins in souvenir of/many chats we
had together in those/troublesome times./
Whitney Warren/Architect/New York.* Blind
stamp of Lloyd and Whitney Warren, New
York, in center of leaf.

BIBLIOGRAPHY: Alden R. Gordon,
"Jérôme-Charles Bellicard's Italian
Notebook of 1750–51: The Discoveries at
Herculaneum and Observations on Ancient

and Modern Architecture," *MMAJ* 25
(1990), pp. 49–142.

Harris Brisbane Dick Fund, 1940
40.59.6

The illustrated notebook under discussion
here, of which the title inscription on the
first page is *herculea. Ville Soutteraine/decouverte
au pied du Mont/Vesuve*, served as the basis for
Jérôme-Charles Bellicard's[1] only important pub-
lication, *Observations upon the Antiquities of the
Town of Herculaneum, Discovered at the Foot of
Mount Vesuvius, with Some Reflections on the
Painting and Sculpture of the Ancients. And a Short
Description of the Antiquities in the Neighbourhood
of Naples.*[2]

Architect, engraver, and author, Bellicard
jointly authored the *Observations upon the Antiq-
uities . . . of Herculaneum* with C.-N. Cochin *fils*
(1715–1790). The book was based upon their mu-
tual experience traveling in 1750–51 as the com-
panions of Abel-François Poisson de Vandières,
marquis de Marigny. Bellicard won the Prix de
Rome in architecture in 1747 and, under the
sponsorship of the abbé de Lowendal, departed
Paris in late 1748 to take his place as a *pension-
naire* at the French Academy in 1749. In Rome,
Bellicard became actively involved with the an-
tiquarian movement. In 1750 he contributed
views of Rome to Venuti's *Roma* and collaborated
with Giovanni Battista Piranesi (1720–1778),
Jean-Laurent Legeay (see Nos. 60–62), and
Louis-Jean Duflos on the *Varie vedute di Roma.*

Marigny, as *directeur-général des Bâtiments*,
took Bellicard into his administration. Bellicard
served as comptroller of two important royal
châteaus, Compiègne and Fontainebleau. He was
received as a member into the Royal Academy of
Architecture in 1762, but his career as a practic-
ing architect was negligible.

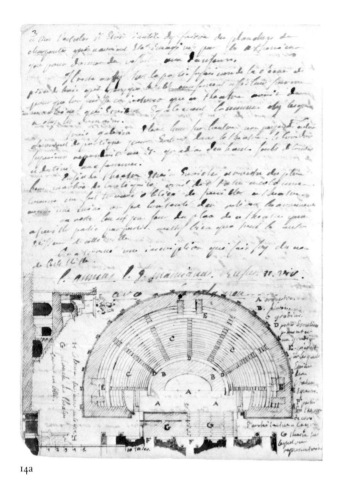

14a

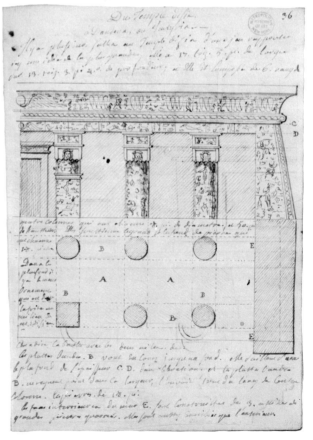

14b

14c

Bellicard began the notebook in November and December 1750 to circumvent the so-called secret of Herculaneum. Designed to prevent unauthorized publication of the archaeological discoveries, the secret was enforced by banning the use of pencils by visitors to the dig or to the royal museum at Portici. The part of the notebook devoted to Herculaneum is filled with drawings and notes, in part derived from memory and recorded shortly after visits to the site and in part derived from sources illicitly made available to the artist by unnamed conspirators. Such sheets as page 8 (No. 14b) are made up of rough, thumbnail-size drawings made from memory and a hastily written account of the fresco paintings found at Herculaneum and seen by Bellicard in the museum at Portici. The drawings are accurate enough only to identify the subjects: a satyr caressing a bacchante; a pair of figures; an image identified incorrectly by Bellicard as a Judgment of Paris; a cricket-charioteer driving a parakeet; and a bird standing beside a vase over which is balanced an inverted transparent glass bowl. The original Roman paintings after which these were drawn can be traced to the collections of the Museo Archeologico Nazionale in Naples. Such sheets as page 3 (No. 14a), which reconstructs the theater, are copied after other drawings. This is apparent as the site was explored in deep tunnels that permitted only fragmentary observation of the ruins. A comprehensive drawing like page 3 could have been compiled only by the excavation directors, who had access to measurements and the opportunity to assemble the partial evidence from many visits to the site.

Bellicard continued to use the notebook after his visits to Herculaneum. In late December of 1750 and up to early summer of 1751, Bellicard recorded a variety of material ranging from the natural volcanic phenomena of the Naples area to Gothic and modern architecture and industrial machinery found in cities north of Rome. One of the most unusual sheets (page 36; No. 14c) reproduces the Egyptian temple of Hathor at Dendera, the ancient Tentyra, which Bellicard incorrectly identifies as dedicated to Isis rather than to the cow-goddess, Hathor, sister of Isis, with whom she became conflated in late Egyptian mythology. The drawing is a very in-exact representation of the upper quadrant of the colonnade of the right half of the north facade of the temple. Bellicard has misunderstood the relationship of the squarish Hathor-head capitals to the round column shafts. He has also omitted the low curtain wall interrupted by the column shafts, which encloses the porch. His suggestion of the hieroglyphs is conceived in terms of the distribution of ornament across the surface and makes no indication of them as meaningful, ordered inscriptions. The plan in the lower part of the drawing is the principal interior space, which is described in the accompanying text. Bellicard certainly did not go to Egypt, so the existence of the drawing in his notebook poses a most provocative mystery about the date at which information and drawings of Egyptian sites were in circulation in eighteenth-century Europe.

In all, the 158 drawings in the notebook reveal the variety of historical, natural, mechanical, and architectural interests of Bellicard and are a reflection of the eighteenth-century empirical attitude at work.

Alden R. Gordon

NOTES

1 On Bellicard, see B. N., *Inventaire*, vol. II, pp. 295–298; and *Piranèse et les français*, p. 52.

2 The *Observations* were published in three English editions in London in 1753, 1756, and 1758 and in three French editions in Paris in 1754, 1755, and 1757.

JACQUES-FRANÇOIS BLONDEL

Rouen 1705–Paris 1774

15. Preparatory Study for Plate 34 in
Maisons de plaisance, Vol. II

Red chalk. 6¾ × 9⅞ in. (173 × 251 mm),
irregular. Tipped down at four corners of
an album leaf.

PROVENANCE: [Armin B. Allen, Inc.,
and Hobhouse Ltd., New York and Lon-
don]; purchased in New York.

BIBLIOGRAPHY: *An Exhibition of Or-
namental Drawings, 1520–1920*, Armin B.
Allen, Inc., and Hobhouse Ltd., New York,
1986, no. 23.

Edward Pearce Casey Fund, 1986
1986.1175.1

The importance of Jacques-François Blondel,
a pupil of his uncle Jean-François and of
Gilles-Marie Oppenord (according to Dezallier
d'Argenville; see Nos. 80–91), lay not in his few
executed buildings but in his very influential
writings.[1] The measure of his stature and influ-
ence in mid-eighteenth-century French architec-
ture and architectural theory is attested by the
fact that Diderot and d'Alembert chose him to
write the general article on architecture for the
Encyclopédie that appeared in the first volume,
published in 1751. Blondel was also responsible
for many of the articles on specific aspects of ar-
chitecture appearing in subsequent volumes. In
succeeding publications of his own, principally
L'architecture françoise (1752–56) and *Cours d'ar-
chitecture* (1771–77), he strongly promoted the
primacy of French classical architecture of the
previous century. He taught these principles at
his own school, which he established in 1746, and
later in the Royal Academy itself, where he be-
came professor in 1756. In championing French

classicism in these works published from the
1750s on, he inveighed mightily against the Ro-
coco and the work of Nicolas Pineau, Lajoüe
(see Nos. 52–56), and Meissonnier (see Nos. 72,
73), whom he saw as the creators of the *genre pit-
toresque* and thus as the subverters of the great
French classical tradition. However, his early
work coincided with the period when those art-
ists were most active. And as Alastair Laing
points out,[2] Blondel states in his preface to the
first volume of the *Maisons de plaisance*[3] that
Pineau ("the fecundity of whose genius has
made him so celebrated") provided him with
some designs for interior decoration, though
Blondel did not so identify them on any of the
engravings. The strong Rococo nature of
Blondel's own designs in the book should there-
fore not be very surprising despite his later de-
nunciations of the style.

 The first volume of the *De la distribution des
maisons de plaisance et de la décoration des édifices
en général*, a work on country houses that be-
came a model book for the architecture and gar-
dens of country estates of the rich bourgeoisie
and nobility in succeeding decades, was pub-
lished in 1737. It concerned primarily architec-
ture, while the second volume, which appeared
the following year, dealt with decoration and or-
namentation. The plates were all signed (with
very few exceptions; see below) *B. inv et f.*:
Blondel invented the design and engraved it.

 The three drawings by Blondel exhibited here
are from a recently discovered group, which are
all preparatory for engravings in the second vol-
ume. Blondel, whose oeuvre as an architectural
draughtsman and engraver as well as theoreti-
cian was far greater than his work as an archi-
tect, was still contributing plates to Mariette's
Architecture françoise . . . of 1727–38[4] when he
began his *Maisons de plaisance*, published by
Charles-Antoine Jombert. Laing hypothesizes
that the work was originally intended as the
promised third volume of plates for C.-É. Bri-
seux's *Architecture moderne* of 1728–29, published

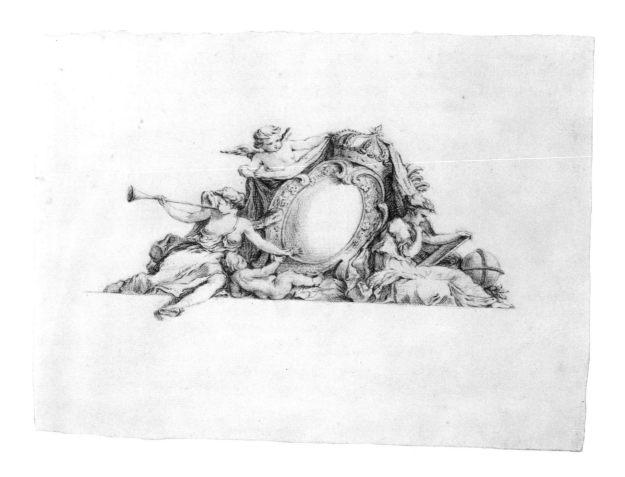

by Jombert under his own name.[5] As such, the volume would have been modest, with fewer plates. But when Blondel received the support of Michel-Étienne Turgot (the father of the future minister of finance), to whom the book is dedicated, a more lavish publication became possible.

Laing has identified a group of graphite drawings in the Musée des Arts Décoratifs, formerly thought to be copies after Blondel's engravings, as preparatory for the first and simpler project for the *Maisons de plaisance*. He maintains that these drawings, which I have not seen, are not slavish copies but contain variations and differences in detail from the prints, and many combine two separate halved designs to represent alternatives, which are whole in the engravings. He states that the scale of the graphite drawings is intermediate between that of the red-chalk drawings and the engravings: the red-chalk designs are about double the size of the engravings.

Laing's arguments for the attribution of the red-chalk designs to Blondel are convincing. Although they are in the same direction as the engravings, they display none of the characteristics

of exact copies. There are no indications of the means for transferring and enlarging the designs from the prints; for instance, there are no squaring and few compass marks. Most important, there are numerous details in most of the drawings that differ from the prints or are additions, and many of the strictly architectural details evident in the prints are reduced or omitted altogether. Although the draughtsmanship could not be termed loose and fluid, there is none of the rigidity coupled with a kind of hesitation typical of copies; it is graceful even in its sometime awkwardnesses, which add to its charm. Although Blondel was a very experienced engraver and could perhaps have worked directly from these drawings in reverse on the plate, Laing's suggestion that counterproofs were made from the drawings as intermediary images for his work on the plates makes sense.

There are further drawings that have been associated with the *Maisons de plaisance*. In the Kunstbibliothek, Berlin, is a group of drawings published by Berckenhagen that he connects with the *Maisons de plaisance*. Three drawings

are very sketchy preliminary studies of vases in pen and ink (two over red chalk and one over graphite) for plate 21 of volume II, but unlike our sheets and those in the Musée des Arts Décoratifs, one has a small detail (the curlicue-tail of a cartouche) in the opposite direction.[6] Their sketchiness would suggest that they represent first ideas by Blondel and that the Musée des Arts Décoratifs and our drawings are later, thought-out preparations. It may be that for rather simple images like vases a sketch was sufficient to work out the idea and then engrave directly from it, the problem of reversal being unimportant; while for a complex image like this pediment with sculpture or the architectural details in the following entries, he needed a highly detailed and finished drawing as a model to engrave from.[7]

That Blondel did produce free and sketchy pen-and-ink drawings (with wash in this case) for prints is confirmed by the thirteen studies for the head- and tailpieces and vignettes conserved in the Kunstbibliothek, which Berckenhagen convincingly identifies as Blondel's designs, engraved in the opposite direction by François Joullain, for the lavish 1734 edition of Molière's *Oeuvres*, with Boucher's full-page illustrations and with initials and vignettes by Oppenord. This work and Oudry's illustrated *Fables* by La Fontaine are considered the two greatest French illustrated books of the first half of the eighteenth century.[8] There has been no comprehensive study of Blondel's draughtsmanship, and its range and character are still to be determined. At the present, I believe that it is reasonable to use the drawings discussed as a basis for evaluating Blondel's draughtsmanship, although their exact position in the canon of his work may still be modified.[9]

This drawing is preparatory for the upper section of plate 34, opposite page 44, of part 1 (the published plate is mistakenly inscribed part 2), volume II, of the *Maisons de plaisance*. The plate is one of only three in volume II that were not engraved by Blondel. Along with plates 30 and 31, it was engraved by Pierre Soubeyran (Geneva; 1709–1775), who also engraved the frontispiece to volume I that was designed by Cochin. The three are designs with figures for sculptural decoration of pediments or crowning

features for exterior facades (as is plate 33, which Blondel engraved but which includes less sculpture and fewer figures, perhaps the reason Blondel was willing to engrave it, leaving Soubeyran to engrave the other, more demanding, three plates). Plate 34 is composed of two parts. The upper part is inscribed AMORTISE-MENT PICTORESQUE POUR LA DECORATION DES FAÇADES/DE BATIMENT (picturesque crowning design for the decoration of facades). The escutcheon, surmounted by a royal crown and flanked by the figures of Fame and Learning, was left blank to receive a coat of arms.

NOTES

1 On Blondel, see K. Harrington, *Changing Ideas on Architecture in the "Encyclopédie," 1750–1776* (Ph.D. diss., Cornell University, Ithaca, N.Y.; Ann Arbor, 1985), with previous bibliography.

2 Introduction to catalogue entries on the Blondel drawings, *An Exhibition of Ornamental Drawings, 1520–1920*, Armin B. Allen, Inc., and Hobhouse Ltd. (New York, 1986), n.p.

3 B. N., *Inventaire*, vol. III, pp. 46–49, no. 22.

4 Ibid., pp. 41–45, nos. 4–19; J. Lejeaux, in "L'oeuvre gravé des Blondel," *L'amateur d'estampes* (1928), pp. 106–114, associates the plates for Mariette with the work of Blondel's uncle, Jean-François, a suggestion not taken up by Roux in the Fonds Français or by Harrington, *Changing Ideas on Architecture*, p. 250. On the other hand, E. Kaufmann, in "The Contribution of Jacques-François Blondel to Mariette's *Architecture françoise*," *Art Bulletin* (1949), pp. 58–59, gives Blondel credit not only for engraving the plates but for planning as well. Blondel reused some of the plates in his own *L'architecture françoise*.

5 A third volume was announced on p. iv of volume I of the Briseux work, and Blondel referred on p. 185 (note) of his own book to the Briseux as having been the occasion for its publication.

6 Berckenhagen 1970, p. 251, Hdz 2173–2175, repr. p. 250. Berckenhagen published three further drawings, Hdz 2645, 3171 (repr.), and 3146, pp. 250–252, which are not convincing.

7 Berckenhagen also identifies red-chalk studies for vases, Hdz 3171 (p. 251, repr. p. 250), as the preliminary drawing for plate 22, but the designs are really generic studies and do not seem to be actual preparations, and are therefore questionable as Blondel's. He also connects Hdz 2645 and 3146, studies for gueridons (pp. 251–252), to Hdz 2173–2175, but as they are not reproduced, one cannot judge.

8 Berckenhagen 1970, pp. 249–250, Hdz 13–25, (two) repr.

9 Berckenhagen (1970, pp. 250–252) associates further drawings with the *Maisons de plaisance*, which, as they differ from the prints, are more difficult to accept as preparatory drawings.

16. Preparatory Study for Plate 41 in *Maisons de plaisance*, Vol. II

Red chalk. 8 15/16 × 11 11/16 in. (226 × 297 mm), irregular. Tipped down at four corners of an album leaf.

Numbered *17* in brown ink upper right.

WATERMARK: Bunch of grapes, partially cut off. On album sheet, larger bunch of grapes.

PROVENANCE: [Armin B. Allen, Inc., and Hobhouse Ltd., New York and London]; purchased in New York.

BIBLIOGRAPHY: *An Exhibition of Ornamental Drawings, 1520–1920*, Armin B. Allen, Inc., and Hobhouse Ltd., New York, 1986, no. 31, repr.

Edward Pearce Casey Fund, 1986
1986.1175.2

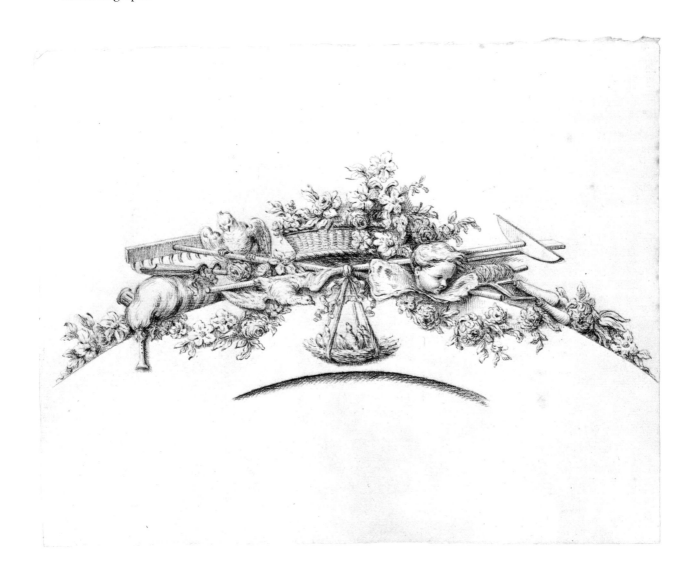

This sheet, like Number 15, is a preparatory study in the same direction for the upper section of plate 41, of part 1, volume II, of the *Maisons de plaisance*. Like all the plates in the volume, with the exception of three (see No. 15), the plate is signed *B. inv. et f.* It is inscribed TROPHEE REPRESENTANT LE PRINTEMS/*Servant de Claveau a un croisée*. On plates 41 through 44, Blondel designed eight trophies, two to a plate, representing the four seasons and the four elements, as the ornamentation for the crown of an arch. In his text, Blondel states that he has composed them with the appropriate attributes: here, illustrating spring, are flowers and gardening tools with doves and their fledglings in their nest. On the same engraved plate is also the trophy for summer.

There is a graphite drawing, in the same direction as our drawing and the etched plate, in the Musée des Arts Décoratifs.[1] There are slight variations between the drawings and the etching. The rake is raised on our drawing so that most of the prongs are visible, while in the graphite drawing and the etching, just the first prongs are visible. The sheet in the Musée des Arts Décoratifs also contains the trophy for summer, which is the lower section of plate 41, along with decorative keystone designs similar to those on plate 40.

NOTE

1 Inv. CD 1822. I would like to thank Marie-Noël de Gary and Annie Valentin for their help in obtaining photographs.

17. Preparatory Studies for Plates 90 and 91 of *Maisons de plaisance*, Vol. II

Red chalk over traces of black chalk. Horizontal black-chalk line at center, and round compass marks in black chalk on lower drawing. 8 15/16 × 10 1/16 in. (227 × 255 mm), irregular. Tipped down at four corners of an album leaf.

Numbered *4* in brown ink, upper right.

WATERMARK: On album sheet: F (or I?); a spade; G (or C?); the rest cut off.

PROVENANCE: [Armin B. Allen, Inc., and Hobhouse Ltd., New York and London]; purchased in New York.

BIBLIOGRAPHY: *An Exhibition of Ornamental Drawings, 1520–1920*, Armin B. Allen, Inc., and Hobhouse Ltd., New York, 1986, no. 42.

Edward Pearce Casey Fund, 1986
1986.1175.3

This is Blondel's preparatory study in the same direction for the decoration of the upper sections of windows on plates 90 and 91 following page 148 of part 2, volume II, of Blondel's *Maisons de plaisance*. Both plates 90 and 91 are signed *B. inv. et fec.* Plate 90 is inscribed COURONNEMENT DE CROISÉE DE MAÇONNERIE POUR LA DECORATION INTERIEURE, and plate 91 is inscribed VOUSSURE DE CROISÉE DE MENUISERIE POUR LA DECORATION INTERIEURE. Blondel has combined on this sheet the designs for the decoration of the keystone of an interior arch (most likely for a window frame) in plaster and carved wood, the latter to be gilded, he says in his text. In the etchings, half of the window frame and the panes of window glass are shown, along with the decorated cove of the lower design for plate 91 and ground plans. A drawing in the Musée

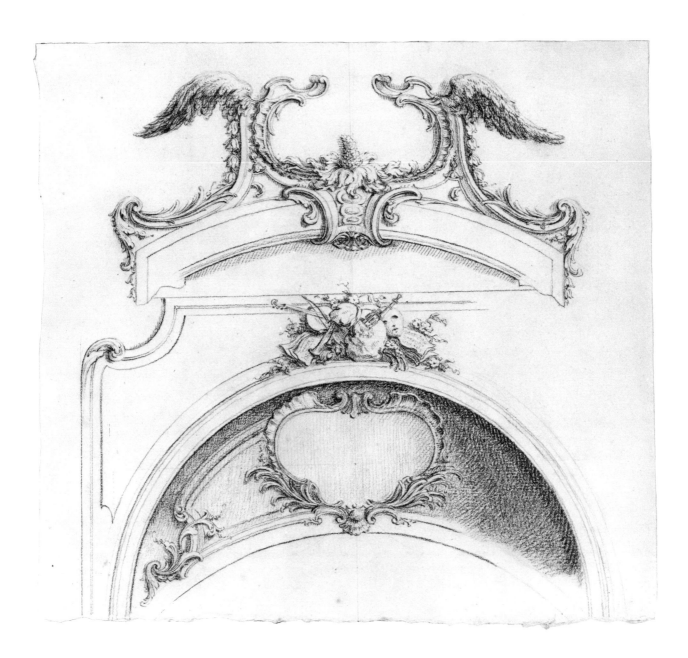

des Arts Décoratifs combines the two designs—virtually identical with the plates—in a horizontal format with their ground plans.[1] In this design, the trophy crowning the arch is composed of musical instruments, an appropriate complement to the subject of Apollo and Daphne, who are depicted in the cartouche (left blank in the drawing) on the engraved plate in the book. Whereas the right side of the cartouche in the arch is not defined in this drawing, the decoration is completed symmetrically in the print.

Blondel shows his debt to Pineau here with reminiscences of the Rococo, especially in his treatment of the curling foliage and shells that animate the cartouche.

NOTE

1 Inv. CD 4001D.

EDME BOUCHARDON

Chaumont (Haute-Marne) 1698–Paris 1762

18. Study for a Fountain Surmounted by Three Nymphs

Red chalk on beige paper. $16^{11}/_{16} \times 10^{3}/_{4}$ in. (424 × 273 mm). A pentimento on white paper, measuring $5^{5}/_{8} \times 7^{3}/_{16}$ in. (142 × 182 mm), has been affixed at lower center and includes the fountain base with dolphins. Creases at upper right and center left. Lined.

Inscribed in pen and brown ink on reverse of old mount, *Bouchardon*.

PROVENANCE: M.-G.-T. de Villenave; Villenave sale, Alliance des Arts, Paris, December 1, 1842, and following days, lot 617 (Lugt 61); [Galerie de Bayser]; [Ward-Jackson]; purchased in London in 1978.

BIBLIOGRAPHY: *Exposition de dessins et sculptures de maîtres anciens, 1977*, Galerie de Bayser, Paris, 1977, no. 5, repr.; *Annual Report, 1977–1978*, p. 37; Bean and Turčić 1986, no. 16, repr.

Harry G. Sperling Fund, 1978
1978.27
Department of Drawings

Bouchardon, a pupil of his father, also a sculptor, arrived in Paris after having already executed full-scale commissions. He won the first prize in the Academy in 1722 and the following year set off for Rome, where he remained until 1732. In Rome he competed unsuccessfully for the important commission for the Trevi Fountain but did succeed in receiving commissions for the busts of the diplomat and spy Philip Stosch and Pope Clement XII Corsini. He was considered by his contemporaries the comte de Caylus and

Pierre-Jean Mariette to be the greatest sculptor and draughtsman of the age. He combined in his art a cool classicism with a clear naturalism. His most important commission was an equestrian statue of Louis XV to grace the *place* of the same name (now the Place de la Concorde), but it was destroyed during the Revolution. His other great work for Paris was the fountain for the rue de Grenelle, a narrow street in which there is not enough space for the monumental fountain to have its full effect.

Bouchardon was a prolific draughtsman; there are, for example, more than 560 drawings, counterproofs, and works attributed to him in the Cabinet des Dessins of the Louvre.[1] These are all in chalk, mostly in sanguine. About four hundred of these are studies for Bouchardon's major work, the equestrian statue of Louis XV. Only in drawings for this project is there pen-and-ink work, in the inscriptions and studies for the base of the statue. Designs for fountains clearly interested the artist: there are twenty-four drawings for different fountain projects in addition to the more than eighteen studies for the Grenelle fountain.

Our drawing is composed of a rocaille base, at the bottom of which are dolphins. Above the base are shells supporting lionesses,[2] who, in turn, support a base on which three nymphs stand with water pouring from the vases they hold. On this sheet, a piece of paper, lighter in color than the rest of the sheet, has been pasted over the area of the dolphins and rocaille base. In the Cabinet des Dessins of the Louvre, there is a counterproof of this drawing[3] on which a hinged sheet at the lower center records the design for the base as in our drawing, but underneath the flap is the original design of rearing dolphins about to swallow entwined snakes.[4]

Also in the Louvre[5] is a study for a fountain with lions on a saucerlike basin and, above that, young men on a smaller basin supporting a vase from which water flows. That sheet and this one are nearly identical in size and format. It is prob-

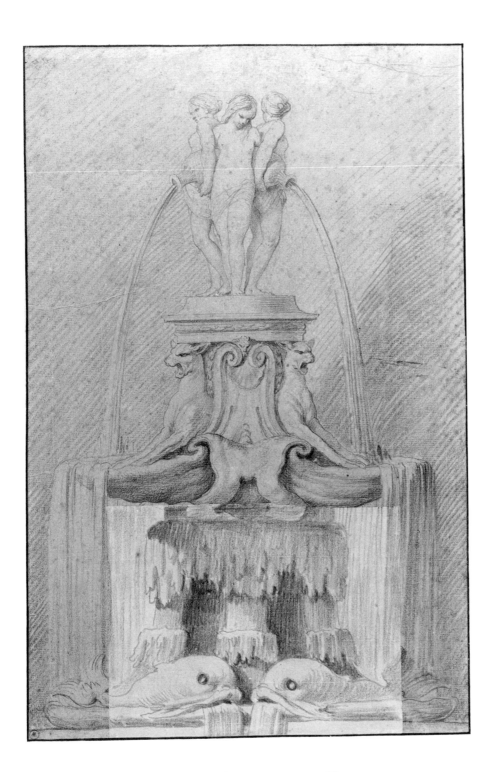

able that they were conceived as pendants, possibly to be included in a suite of fountain designs that were to be engraved, as were the two suites of vases that Huquier made after Bouchardon's designs (see succeeding entries).

There is another counterproof of this sheet in the collection of James A. de Rothschild at Waddesdon Manor.[6]

NOTES

1 Guiffrey and Marcel, vol. II, 1908, pp. 2–55.
2 Not wolves, as Guiffrey and Marcel describe for the Louvre counterproof.
3 Guiffrey and Marcel, vol. II, 1908, pp. 4–5, no. 801, repr.
4 Bean and Turčić 1986, no. 16.
5 465 × 305 mm; Guiffrey and Marcel, vol. II, 1908, no. 805, repr.
6 National Trust, Aylesbury, Bucks., inv. no. WM47, box 44.

CIRCLE OF BOUCHARDON

19. Study for Plate 7 of Bouchardon's *Premier livre de vases*

Pen, black ink, and gray wash. Framing lines. Red-chalk line along vertical center. 9⁷⁄₁₆ × 5⁷⁄₁₆ in. (237 × 139 mm). Inlaid into decorated mount. Tears, mended.

Inscribed in black chalk at upper right of mount, *No. 35*, and at lower left, *Ed. Bouchardon*.

PROVENANCE: Hippolyte Destailleur; Destailleur sale, Paris, May 19–23, 1896, lot 147 (album, now dismantled); [Martin Breslauer]; purchased in London.

Harris Brisbane Dick Fund, 1948
48.148 (35)

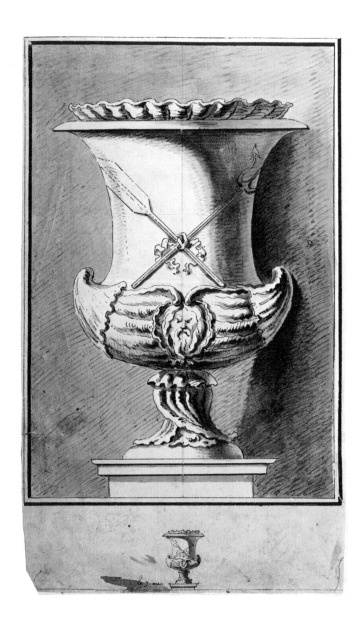

This extremely dry drawing would normally be thought a copy after Bouchardon's print (A-7),[1] which was etched by Huquier, were it not for the facts that the drawing is the reverse of the etching and the dimensions of print and drawing correspond exactly. It might be tempting to assign the drawing to Huquier, who etched two sets of vases after Bouchardon's designs, but the drawings generally associated with his name are much freer and more vibrant.

A red-chalk counterproof of a study for the fourth etching in the *Second livre de vases* (B-4), much larger than the etching,[2] is in a New York private collection and may shed some light on the situation. The counterproof is in the same direction as the etching and is squared for transfer. Therefore, the red-chalk drawing that the counterproof reversed would have been in the same direction as the pen-and-ink reduction of it and therefore would have been the original idea for the design.

NOTES

1 Berlin 1939, no. 1060; B. N., *Inventaire*, vol. XI, p. 455, no. 555.
2 15½ × 9¼ in. (395 × 240 mm); the etching is 7¼ × 4⁹⁄₁₆ in. (185 × 115 mm).

20. Study for Plate 7 of Bouchardon's *Second livre de vases*

Pen, black ink, and gray wash. Framing lines. Red-chalk line along vertical center. 9½ × 5³⁄₁₆ in. (241 × 132 mm). Tears, mended, and spots. Inlaid into decorated mount.

Inscribed in black chalk, upper right of mount, *No. 36*, and at lower left, *Ed. Bouchardon*.

PROVENANCE: Hippolyte Destailleur; Destailleur sale, Paris, May 19–23, 1896, lot 147 (album, now dismantled); [Martin Breslauer]; purchased in London.

Harris Brisbane Dick Fund, 1948
48.148 (36)

See preceding entry. A red-chalk study for the print connected with this drawing is in the Hermitage, Saint Petersburg (inv. no. 14629).

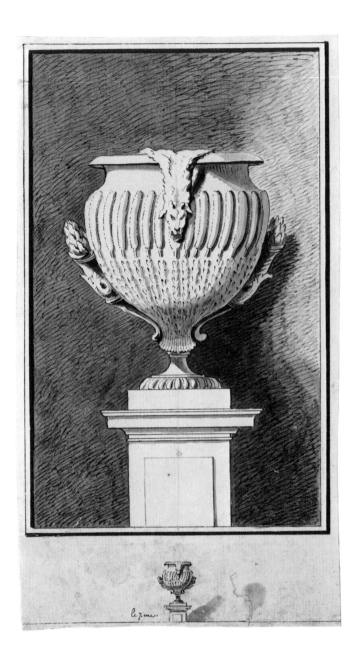

GILLES-PAUL CAUVET
Aix-en-Provence 1731–Paris 1788

21. Design for an Ornamental Panel for *Recueil d'ornemens*

Red chalk. 7⁹⁄₁₆ × 6¹⁵⁄₁₆ in. (192 × 176 mm).
Inlaid into decorated mount.

Inscribed in black chalk at upper right of mount, *No. 77.*

PROVENANCE: Hippolyte Destailleur;
Destailleur sale, Paris, May 19–23, 1896, lot
147 (album, now dismantled); [Martin
Breslauer]; purchased in London.

Harris Brisbane Dick Fund, 1948
48.148 (77).

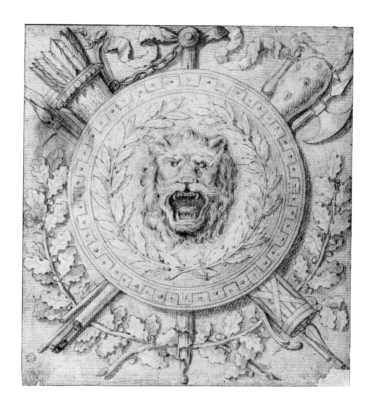

Sculptor, architect,¹ designer of ornament for interiors, furniture, and works of art, and occasional etcher of his own designs, Cauvet became director of the Académie de Saint-Luc in 1766. As he states in its title, he published his *Recueil d'ornemens à l'usage des jeunes artistes qui se destinent à la décoration des bâtimens* (Paris, 1777) for the use of young artists in the decoration of buildings. By the time he became sculptor to Louis-Stanislas-Xavier de Bourbon (called Monsieur)—the count of Provence and brother of Louis XVI—in 1774, Cauvet had already decorated the interiors and exteriors of many private Parisian *hôtels* with sculptured reliefs. Examples of his work include the three portals for the Palais Royal, the interior of the Hôtel de Mailly-Nesle on the quai Voltaire, the Hôtel de Noailles, and the interior of the Hôtel de Kinsky, where he acted as designer and architect during the years that he was designing the *Recueil*. Cauvet's role in the scheme of decoration was an important one, as Louis Hautecoeur notes, for between 1755 and 1775, sculpture began to prevail over painting in interior decoration, both in wood and, more often, because of its economy, in stucco.²

This change in type of interior decoration was concurrent with a general change in style. Before the 1760s, there was already a return to the *grand goût* of Louis XIV to counteract the asymmetry, curves, countercurves, and the "capriciousness" of the Rococo as propounded by artists, architects, and critics, such as C.-N. Cochin *fils* and J.-F. Blondel (see Nos. 15–17). The movement away from the Rococo could be seen in Le Lorrain (see Nos. 63, 64) and the furniture he designed for La Live de Jully in 1756 and in architects and decorators, such as Delafosse (see Nos. 29–38). Along with the development in the 1760s of a heavy, archaeologizing style based on the *grand goût* was a similar style based instead on the newly published discoveries at Herculaneum and

Pompeii. Hautecoeur points out that these new styles featured motifs of diverse provenance and very diverse handling according to the artists employing them.[3] Thus, for example, the gardening motifs of spades, shovels, watering cans, and scythes, which were dear to the sensibilities of those celebrating the *ruris Amor*, such as Marie Antoinette and Mme du Barry, and which earlier in the century Claude Gillot had employed in his *Portières* and *Principes d'ornemens*, were now disposed in a very different way. By the mid-1770s, these motifs and others common in the Régence and the Rococo were absorbed into the emerging style defined by symmetry, regularity, and the attenuation of forms, which became much lighter and more elegant. This style represented a move away from the heaviness of the strict *goût grec* satirized by Petitot, for example, in his *Mascarade à la grecque* of 1771.

This drawing is a study in the same direction for a plate in Cauvet's *Recueil d'ornemens . . .* and was identified as such by the late John J. McKendry. The military-like trophy employs such features as a sheath of arrows, spears, axes, and a club decorated by oak-leaf branches around the lower section of the medallion, on which a lion's head roars with open mouth. Around the lion's head is a wreath of laurel on the medallion, which is suspended by a wide ribbon. The drawing displays the fact that a great deal of the Louis XVI style was based on traditional, that is, Louis XIV, motifs. This study could almost be by Jean Lepautre.

The surface of this red-chalk study seems a bit soft. Since the etching after it is in the same direction, it may be that a counterproof was taken from the drawing for the etcher, Elise Caroline Liottier.

NOTES

1 Cauvet's work as an architect is little known; for a recent discovery, see J. Boyer, "Deux projets inédits de l'architecte Paul-Gilles Cauvet pour Aix-en-Provence," *BSHAF* (1976; pub. 1978), pp. 227–240.
2 Hautecoeur, vol. IV, 1952, p. 476.
3 Ibid.

22. Study for a Horizontal Frieze

Pen, brown and gray ink, and colored wash, heightened with white.
1 11/16 × 11 13/16 in. (43 × 300 mm). Lined with a decorated mount.

PROVENANCE: [Pierre Berès]; [Marlborough Rare Books]; Mr. and Mrs. Charles Wrightsman.

BIBLIOGRAPHY: *Bulletin Pierre Berès*, cat. no. 34, Paris, 1961, repr. (unpaged); *Marlborough Rare Books*, cat. no. 50, London, 1963, no. 74, repr.; Fuhring 1989, under no. 231.

Gift of Mr. and Mrs. Charles Wrightsman, 1969
69.690.3

The frieze is composed of sphinxes flanking a burning brazier, with garlands of flowers amid the rinceaux that extend from the central motif. The model for such a design is among

the ornamental etchings of the seventeenth century, especially those by Stefano della Bella, whose sojourn in France made him very well known there.

The draughtsmanship is so delicate that without magnification the line appears almost as if it were etched. Both the pen work and the areas of wash are equally fine. None of Cauvet's drawings known at this time look quite like this sheet. But he was capable of extremely delicate pen work, as can be seen in the plates he etched himself in his *Recueil*. Whether this study is by his own hand or by someone close to him, it is clear that the draughtsman was someone very well acquainted with Cauvet's work.

23. Album with Engraved Frontispiece and 53 Drawings on 35 Leaves

Drawings in black chalk, graphite, red chalk, pen and brown ink, pen and black ink, all laid down on album sheets. 10⅜ × 7⅝ in. (264 × 194 mm). Nineteenth-century binding with green embossed velvet.

Inscribed on title plate, *1731–1788, Dessins et Croquis/de G. P. Cauvet, d'Aix en Provence,/Sculpteur et Architecte de S. A. R. Monsieur, frère du Roy.*

PROVENANCE: See Number 22.

BIBLIOGRAPHY: See Number 22.

Gift of Mr. and Mrs. Charles Wrightsman, 1969
69.690.1

23a

This album is said to have been assembled in the nineteenth century by some of Cauvet's descendants. Whatever its origins, it presents a large variety of subjects and drawing styles, many similar to plates in the *Recueil*.[1] There are

23b

designs for fountains in black chalk; arabesques
in various dimensions and techniques, of which
two were engraved for his *Recueil* and certain
others inscribed as for the arts and sciences, such
as astrology, music, poetry, and architecture; de-
signs for silver dishes, candlesticks, clocks, and
vases and ewers, seven of which were also en-
graved for the *Recueil*;[2] furniture designs, such
as stools and a cabinet; and some studies of fig-
ures, which are quite awkward and may be by
members of his studio. Many of the studies in
black chalk are drawn very lightly and are some-
times difficult to decipher. The designs in pen
and brown ink for silver objects are clearer and
more precise; for example, one covered cup in-
cludes measurements. There are certain leaves
executed with rapid and free pen-and-ink
strokes.[3] A similar diversity of subjects and
draughtsmanship is displayed in the collection of
Cauvet sheets in the Hermitage, Saint Petersburg;
a smaller number of drawings are in the Musée
des Arts Décoratifs and the École des Beaux-
Arts.

a. (Leaf 4) Black-chalk arabesque. Etched in the
same direction by Liottier. One of our copies of
the *Recueil* is printed in red as if the original
drawing had been in red chalk. In the print, a
young woman instead of the putto of the draw-
ing holds a dolphin on a leash. Whereas in the
drawing the base of the fountain is unadorned

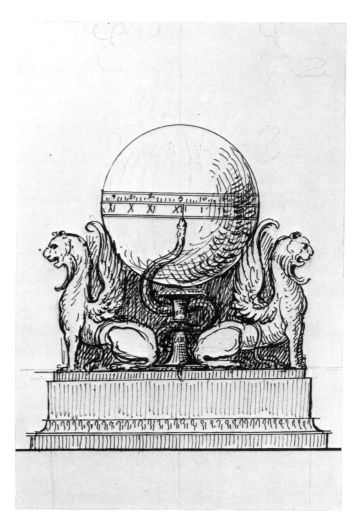

23c

23d

23f

except by the crossed trident and paddle, in the print it is covered by a mask. The border of the drawing is more elaborated. The loose and free draughtsmanship in this sheet is typical of many of Cauvet's chalk designs.

b. (Leaf 16) Black-chalk study for a frieze with gardening tools and with flowers and foliage, all attributes of summer.

c. (Leaf 17) Study for a clock in pen and brown ink with black chalk. Two griffins flank a globe that has a serpent coiled around the base who points the hour on the face of the globe. The draughtsmanship is typical of Cauvet's studies in ink, such as a study for a clock at Waddesdon Manor[4] and two drawings for silver in the Hermitage, Saint Petersburg.[5]

d. (Leaf 24) Black-chalk study of a vase, etched for the *Recueil* by Antoine-François Hémery. The etching is very faithful to the drawing ex-

23e

cept for the two dolphins with tails entwined
about a trident that are missing from the draw-
ing. James Parker has kindly pointed out that a
celadon vase with ormolu mounts in the Louvre
can be compared with this drawing: in the
Louvre vase, two nereids act as handles as they
do in this sheet, except that their arms do not
meet at the neck of the vase as they do in the
drawing, and their hair and draperies are in an
Egyptian mode. Also, the body of the Louvre
vase is floriated porcelain instead of bearing the
design of a sea nymph, probably Venus, riding in
a vessel drawn by a putto astride two dolphins.[6]

e. (Leaf 27) Black-chalk study for a fountain.
Dolphins and a nereid support a basin on which
two putti hold aloft another dolphin whose tail
in turn supports the smaller upper basin.

f. (Leaf 32) Black-chalk study for an arabesque
symbolizing architecture. The ruler, calipers, and
triangle all contribute to identifying the subject.

NOTES

1 I would like to thank Christian Baulez, who generously
 shared his Cauvet material. See his entry on Cauvet and
 the Hôtel Kinsky in the exhibition catalogue *Le faubourg
 Saint-Germain, la rue Saint-Dominique: Hôtels et amateurs*,
 Musée Rodin (Paris, 1984), pp. 113–133.
2 There are drawings in pen and ink for silver, including a
 clock similar to our design, at Waddesdon Manor, for in-
 stance, inv. nos. 500b, 501, and 502.
3 Two sketches in the Houthakker collection are similarly
 free sketches; see Fuhring 1989, no. 231.
4 Inv. no. 502.
5 Inv. nos. 28272, 28289.
6 See C. Dreyfus, *Musée du Louvre: Les objets d'art du
 XVIIIe siècle* (Paris, 1923), pl. 33.

CHARLES-MICHEL-ANGE CHALLE

Paris 1718–Paris 1778

24. Architectural Fantasy

Pen, brown ink, with brown, gray, and black wash. 16⅞ × 26³⁄₁₆ in. (429 × 666 mm). Creased vertically at center; torn and repaired.

Signed lower left on base of equestrian statue, *Challe in. Roma.*

PROVENANCE: Sale, Christie's, London, July 6, 1977, lot 97, repr.; [Galerie Cailleux]; purchased in Paris.

BIBLIOGRAPHY: *Notable Acquisitions, 1979–1980*, pp. 52–53. repr.

Edward Pearce Casey Fund, 1979
1979.572

First a student of architecture, Challe changed to painting and studied under François Lemoine and Boucher.[1] After two unsuccessful attempts, Challe won the Prix de Rome in 1741, departing the following year for Rome, where he remained beyond the usual three-year term, until 1749. While in Rome he made the acquaintance of Giambattista Piranesi, who greatly influenced his work. Challe then returned to Paris, became a member of the Royal Academy in 1753, exhibited paintings at the Salon, and was named professor of perspective in 1758. In 1764 he was named *dessinateur de la Chambre et du Cabinet du Roi*, in which role he designed all the royal fetes, theatrical decor, and catafalques. Many of the catafalques were engraved.

More than any other draughtsman, Challe was the interpreter par excellence of Piranesi. The grandiose scale and complexity of the architecture and the bravura draughtsmanship with dra-

matic contrasts of light and shade were essential components of Piranesi's drawings and prints. Our sheet is closest to Piranesi's *Parte di ampio magnifico Porto*, published in 1750, with three preparatory drawings, one in Dresden, one in Copenhagen, and the final one in the J. Paul Getty Museum, Malibu.[2] Piranesi's composition is far more complex, while possessing the same elements—the intersecting semicircular arcades, the triumphal arches, the rostral columns, and the stairs leading down to the turbulent, boat-filled water below. In our sheet, at the intersection of two arcades, a monumental triumphal arch rises, surmounted by a circular colonnaded temple with obelisks at each corner. Atop the arcades are rostral columns aligned with the paired columns on either side of the arches of the first story. Gigantic statues of horse tamers and rearing steeds set upon low bases are placed in front of the arcade and on the stairs leading down to the water, which is filled with boats and peopled with Challe's typical shadowy, undelineated figures composed with a broad swipe of the brush. Although Piranesi's *Ampio magnifico Porto* was printed after Challe left Rome, the preparatory drawings are thought to date earlier and, in any case, are typical of Piranesi's draughtsmanship.

Our sheet is comparable in its large horizontal format and compositional elements to two of Challe's drawings executed in Rome: one, now in the Pierpont Morgan Library, New York, dated 1747,[3] and another, now in the Centre Canadien d'Architecture, Montreal, dated 1746.[4] The compositions of all three sheets have receding arcades, but with different elements of ancient architecture. While the triumphal arch with circular temple dominates our scene, in the Montreal sheet a Parthenon-like structure is most prominent, and in the Morgan drawing there are three massive pyramids. Both our drawing and the Montreal sheet contain architecture rising from a river foreground filled with distinctive boats.

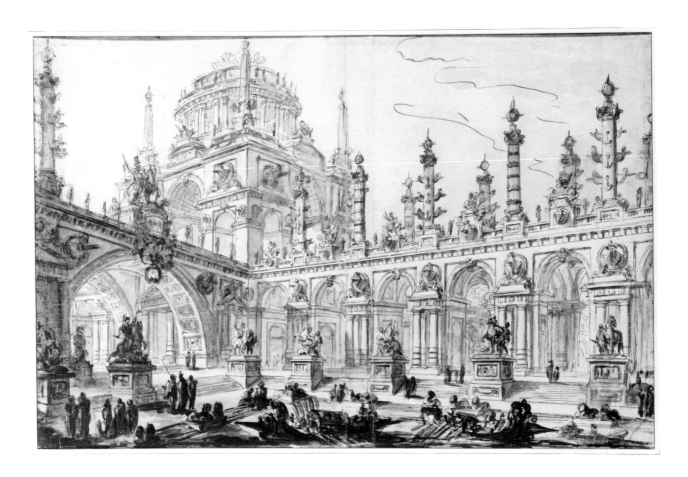

NOTES

1 On Challe, see R. P. Wunder, "Charles Michel-Ange
Challe: A Study of His Life and Work," *Apollo* (January
1968), pp. 22–33; and *Piranèse et les français*, pp. 69–82.

2 See A. Robison, *Piranesi, Early Architectural Fantasies: A
Catalogue Raisonné of the Etchings* (Washington, D.C., and
Chicago, 1986), pp. 36–37, no. 26. The Getty sheet was
unknown at the time of Robison's publication.

3 *Piranèse et les français*, no. 23, repr.

4 *French and Italian XVIIIth Century Drawings and Prints*,
cat. no. 28, William H. Schab Gallery (New York, [1960]),
no. 13, repr.

CLAUDE-LOUIS CHÂTELET

Paris 1753–Paris 1795

25. Architectural Fantasy: Frontispiece
for a *Recueil des vues du Petit Trianon*

Pen, brown and gray ink, brown and gray
wash, watercolor. Framing lines in pen and
black ink, with pink wash outside line. Im-
age with framing lines: 17⁹⁄₁₆ × 12¹⁵⁄₁₆ in.
(447 × 329 mm); paper: 18⁹⁄₁₆ × 13¹⁵⁄₁₆ in.
(471 × 355 mm). Creased horizontally at
center. Repairs at each edge of sheet. Traces
of glue around entire outer edge of verso.

Inscribed in pen and brown ink at lower
left on plinth, RECUEIL/*Contenant le Plan
general &/diverses Vues du Jardin de la/Reine
au petit Trianon./Par le Sr. Mique Chevalier
de/L'ordre de St. Michel, Premier/Architecte
honoraire Intendt./General des Batimens
du/Roy & de ceux de la Reine./1782*; in
graphite, below framing line at lower right,
Chatelet/4537(?); on verso in pen and
brown ink at lower center, *979/41 × 60*; on
verso in graphite, below, *Chatelet*(?) and
130, and upper left, direction reversed,
36 × [effaced].

WATERMARK: D & C BLAUW, with a
simple fleur-de-lis to the right; near Hea-
wood 1828 (a fleur-de-lis in an escutcheon;
ours has no surround).

PROVENANCE: Czar Paul I; Pavlovsk
Palace Library; Stieglitz Library (Museum);
Hermitage Museum; Hermitage sale, C. G.
Boerner, Leipzig, May 4, 1932, no. 19; sale,
Sotheby's, London, March 27, 1969, lot 132,
repr.; private collection; [William H. Schab
Gallery, Inc.]; purchased in New York
in 1984.

BIBLIOGRAPHY: *Master Prints and
Drawings of Five Centuries*, cat. no. 67,

William H. Schab Gallery, Inc., New York,
[1984], no. 8, repr.

Edward Pearce Casey Fund, 1984
1984.1150

Little is known of Châtelet's life: no records
exist of his study at the Academy or in the
shops of any painters. The primary fact known
about his life is its grisly end on the guillotine on
May 7, 1795.[1] His reputation rests entirely on his
work and, above all, on the many drawings
made in Italy between late 1777 and early 1779
that he contributed to the abbé de Saint-Non's
*Voyage pittoresque; ou, Description des royaumes de
Naples et de Sicile*, published in Paris between
1781 and 1786, one drawing of which is in the
Metropolitan Museum.[2] While remaining a
faithful recorder of monuments and their sites,
Châtelet imbued his views with a luminous at-
mosphere and emphasized the picturesque quali-
ties of the scenes he depicted.

Our drawing[3] is unsigned, but it conforms
entirely to Châtelet's draughtsmanship in its
rapid, nervous line combined with a delicate,
sure handling of the wash applied in small, sepa-
rate touches in the foliage and in broad, translu-
cent strokes in the architecture and landscape.
Moreover, the inscription on the plinth identifies
the purpose for which the drawing was intended
and links it with some of Châtelet's most impor-
tant royal commissions that survive today.

Ange-Jacques Gabriel had built the château of
the Petit Trianon, one of his greatest master-
pieces, for Madame de Pompadour, but it was
completed only in the year of her death, 1764,
and was made a gift to Marie Antoinette in 1774.
Marie Antoinette valued it above all else as her
retreat from the rigid formality of life at Ver-
sailles and set out to change the formal French
and botanical gardens along the lines of her own

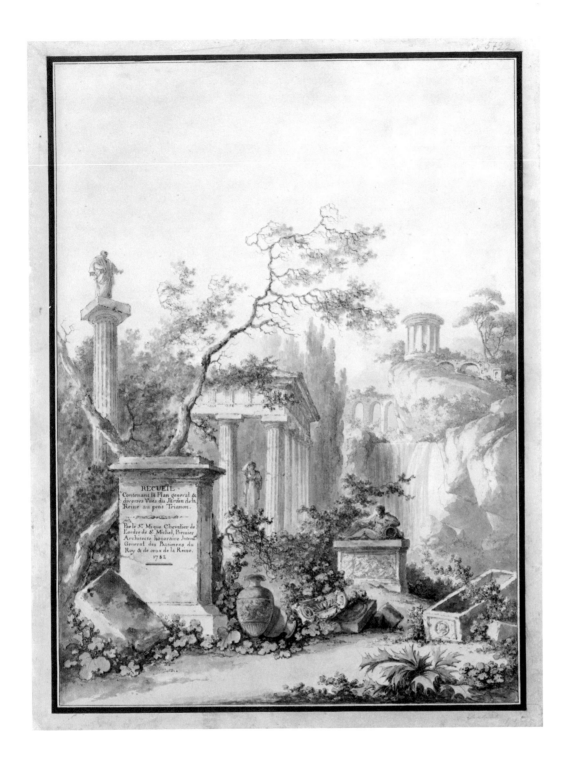

more informal taste, which coincided with the current fashion for the picturesque garden *à l'anglais*. Richard Mique, the architect to the king and queen, designed a new garden in 1777 at the Petit Trianon and, probably with the advice of Hubert Robert, *dessinateur des jardins du roi*,

spent over a decade building the small pavilions in the garden: the Temple de l'Amour, the Jeu de Bague, the Belvédère, the Rocher, and the Grotto, as well as the famous Hameau, begun, as was the Tour de Marlborough, in 1783. The gardens and pavilions have suffered changes, the Jeu de

Bague has disappeared, and the Grotto lies in ruins. What is seen today gives an inadequate idea of the bucolic charm and beauty of the ensemble of pavilions and gardens that Marie Antoinette and her guests enjoyed. It is fortunate for us that she was so proud of the treasure which she had created and that her guests were so enchanted with it that the queen ordered albums of views of the château, pavilions, and gardens as mementos. Payments record that it was Châtelet who was charged with executing these drawings.[4]

Three of the albums, or *recueils*,[5] are known today: one in the Royal Library, Stockholm;[6] another, dated 1781 on its title page, formerly in the collections of the counts Harrach of Vienna and Raphael Esmerian and now in a private collection;[7] and the last, dated 1786 on its frontispiece, now in the Biblioteca Estense, Modena.[8] They are sumptuous volumes, bound in gilt-embossed leather, with covers lined in rich silk. They were considered treasures then and are more so now in that they record the Petit Trianon and its garden as they were conceived and built.

Our frontispiece, like that in the Modena *recueil*, is a landscape and architectural capriccio (both differ from the nonpictorial title page of the Esmerian *recueil*) with the title prominently displayed on an important compositional element—on the plinth in the left foreground in our drawing. Across the sheet Châtelet scatters monuments and views he knew from his sojourn in Italy. The Doric temple at the left is nearly the same as the one in the foreground in his view of the temples at Paestum, which he had drawn for the third volume of the *Voyage pittoresque*,[9] while the aqueduct he drew at Corigliano, Calabria,[10] could have inspired the one seen in the far distance of this drawing. The Temple of the Sibyl and the Cascade at Tivoli, reminiscences of which appear in the right background of the sheet, were the subjects not only of several drawings by Châtelet,[11] but also of two paintings by him owned by Mique and in the inventory of the latter's effects after his death on the guillotine the year preceding Châtelet's own death.[12] The allusion to the Column of Trajan seen at the left was probably taken from a drawing Châtelet had made in Rome and retained to be used in just this way. Sarcophagi, classical statues, urns, and

ruins, including an Ionic capital, fill the foreground of a landscape softened by the gray wash that sheds a silvery tonality to the blues, greens, and yellows and sets the scene further into the realm of fantasy.

The dates of the Esmerian and Modena albums coincide with the visits of distinguished royal guests to the Petit Trianon: Marie Antoinette's brother the emperor Joseph II, in July 1781, and another brother, Archduke Ferdinand, governor of Lombardy, with his wife, Maria-Beatrice d'Este of Modena, in May 1786.[13] The *recueils* were certainly made as mementos of their visits, especially for the emperor, who greatly desired one, along with measured drawings of the garden, as his correspondence with Mercy-Argenteau, his minister in Paris, reveals.[14]

In May and June of 1782, Grand Duke Paul Petrovitch, son of Empress Catherine II of Russia and the future Czar Paul I, and his wife, Maria Fyodorovna, born a countess of Württemberg, traveling incognito as the comte and comtesse du Nord, visited Paris and Versailles. A sumptuous fete in their honor was given at the Petit Trianon on June 6.[15] It included performances of an opera and a ballet, followed by a supper and, according to one observer, the most splendid illuminations ever seen in the gardens.

Châtelet made views for several *recueils* in 1782. He was paid 1,800 *livres* on October 26 of that year for "diverse views [for] *recueils*" ordered by the queen as well as for two paintings he executed of the "terrain of the garden" and for "the efforts that he made at the time of the fete in the garden for the comte du Nord."[16] The "efforts" are his designs for the illuminations for the fete.[17] Châtelet continued his work on drawings for the *recueils*, for he was paid again on April 15, 1783, the sum of 1,320 *livres* for "dessins qu'il a fait de diverses Vues des recueils."[18]

In view of the Russian provenance of our drawing and the political importance of the Russian royalty, the possibility had been raised that our frontispiece was made for a *recueil* for the grand duke and duchess. It is true that the payments to Châtelet of 1782–83 cite the name of the grand duke in relation to the festivities in his honor, but they do not mention him otherwise—for instance, as the recipient of an album of views of the Petit Trianon. Neither memoirs of

the period, such as those by the baroness d'Oberkirch[19] and the duc de Croÿ,[20] nor the correspondence of Marie Antoinette or that between Mercy-Argenteau and Joseph II[21] include such a reference. Although the sheet does not bear the mark of Paul I, who organized the imperial collection of prints and drawings into a proper prints-and-drawings cabinet and stamped the rectos of his drawings with his mark,[22] that is not proof it did not once belong to him or to Maria Fyodorovna since it presumably was bound into the *recueil* at that time, thereby escaping the disfiguring stamp.

Information has recently come from the Soviet Union to the effect that a *recueil* has been discovered in the library at Pavlovsk Palace and identified as Châtelet's by Miliza Korshunova. Miss Korshunova kindly communicated that it contains a plan of the area, a view of the Petit Trianon from the side of the entrance into the park, a view of the château from near the Chinese village, the Temple de l'Amour, a view of the Belvédère, two views of the Grotto, and two sheets of landscape architecture. Most important, there is no frontispiece. Thus, it can be deduced that our frontispiece was part of an album made for Maria Fyodorovna and Grand Duke Paul as a gift from Marie Antoinette.

Notes

1 On the correct date of his death, see P. Jarry, "Une précision sur Claude-Louis Chatelet," *BSHAF* (1928), pp. 351–352.

2 See Bean and Turčić 1986, no. 55.

3 The drawing was presented in a short communication at the Colloque Versailles, October 1985.

4 See Nolhac 1914, pp. 175–177; Desjardins 1885, pp. 237, 302–303.

5 On the *recueils* and their documents, see Desjardins 1885, pp. 302–303.

6 Although Châtelet was paid on May 16, 1780, for views of the Petit Trianon, presumably for the *recueil* that was sent in 1779 to Gustave III, it was generally agreed by those who saw the album recently exhibited in Paris that the drawings in the *recueil* in the Royal Library, Stockholm, are certainly too stiff, hard, and naive to be the work of Châtelet. See *Versailles à Stockholm: Dessins du Nationalmuseum. Peintures, meubles, et arts décoratifs des collections suédoises et danoises*, exh. cat., Institut Culturel Suédois, Hôtel de Marle, Paris ([Stockholm], 1985), pp. 217–220, nos. T-1, T-2, repr.

7 See the sale catalogue, *Bibliothèque Raphaël Esmerian*, Palais Galliera, Paris, June 6, 1973, vol. III, no. 65, pls. XLI–XLIV.

8 The Modena album was first published in a brief description by Nolhac (1914, p. 176), who identified Châtelet as its author, reproducing the views of the château and the pavilions in their garden setting. In a short article on the development of the garden, E. de Ganay ("Plaisirs de Trianon," *Jardin des arts* 58 [August 1949], pp. 612–623) reproduced Châtelet's views, as did P. Huisman and M. Jallut, in *Marie Antoinette* (New York, 1971), pp. 132–136. It was the subject of John Bandiera's communication at the Colloque Versailles, October 1985.

9 The engraving is opposite p. 156. The drawing is in the British Museum and was published in *Piranèse et les français*, no. 31.

10 Also in volume III, the engraving after Châtelet's drawing is opposite p. 94.

11 *French Drawings from a Private Collection: Louis XIII to Louis XVI*, exh. cat., Fogg Art Museum (Cambridge, Mass., 1980), no. 58, repr.

12 Jarry, "Une précision sur Chatelet," p. 352.

13 See Gruber 1972, pp. 175, 179, for the documents relating to the festivities of the respective visitors, and p. 177 for the visit of Gustave III of Sweden in 1784. Another *recueil* of views is documented as having been ordered for him on the occasion of this visit, but it has not been found in the royal Swedish collections or elsewhere.

14 D'Arneth and Flammermont, eds., *Correspondance secrète du comte Mercy-Argenteau avec l'empereur Joseph II et le prince de Kaunitz* (Paris, 1889), pp. 57–58, 76.

15 On the fete, see Desjardins 1885, pp. 217–220, 375, and notes on pp. 383–404; and Gruber 1972, p. 176.

16 Archives Nationales, Paris, O1 1877: payment for "dessins qu'il a fait de diverses Vues des recueils qui ont eté ordonné par Sa Majesté; de deux tableaux devant servir pour l'execution sur le Terrain et autres peines qu'il s'est donné lors de la fete pour le comte du Nord, dans le dte. Jardin."

17 Archives Nationales, Paris, O1 1877: Châtelet received payment on March 5, 1782, "pour les peines et soins qu'il s'est donné dans divers illuminations que Sa Majesté avoit ordonné dans le dit Jardin."

18 Archives Nationales, Paris, O1 1877: Châtelet was paid also for "deux tableaux et autres peines qu'il s'est donné lors de la fete pour le Comte du Nord dans le Jardin."

19 *Mémoires de la baronne d'Oberkirch sur la cour de Louis XVI et la société français avant 1789*, ed. and ann. Suzanne Burkard (Paris, 1982).

20 Vicomte de Grouchy and Paul Cottin, eds., *Journal inédit du duc de Croÿ; publié d'après le manuscrit autographe conservé à la Bibliothèque de l'Institut . . .*, 4 vols. (Paris, 1906–7).

21 As cited above in n. 14, pp. 110–113.

22 Lugt 2061.

PIERRE CONTANT D'IVRY

Ivry-sur-Seine 1698–Paris 1777

26. Plan of the Roof and Section of a Pavilion in the Château de Saint-Cloud Gardens

VERSO. Study for the Exterior with Partial Plan of the Pavilion

Pen, brown and gray ink, and light brown wash over traces of black chalk (recto). Black chalk (verso). 17½ × 11½ in. (445 × 292 mm). Inlaid into modern mount.

Signed and dated in brown ink on recto, lower right, *a paris le 22 Janvier 1750/Contant*; inscribed upper left, *profil de la charpente du/Comble et de la decoration/Interièur du Sallon/Suivant l'elevation/marqué D d'autre part*, within lantern of the roof, *vide pour/placer l'orloge/ A*, lower left, *plan de l'a[----?]/qui recoit les [----]/[----?] tue sur le plan/il faut obsserver de/laisser la place marqué/A pour placer l'orlorge/suprimes le poinion/dans cette parties*, and lower right, above signature, *plan du plafond avec/les Corniches*.

WATERMARK: (Difficult to decipher: two lines of text, probably an Auvergne mark.)

PROVENANCE: Hippolyte Destailleur; Destailleur sale, Paris, May 19–23, 1896, lot 79; Alfred Beurdeley (his mark, Lugt 421); Beurdeley sale, Paris, May 31, 1920 (4e vente), lot 12; A. Decour; Decour sale, Hôtel Drouot, Paris, April 10–11, 1929, lot 65; Charles Mewès; [W. R. Jeudwine, London]; Mr. and Mrs. Charles Wrightsman.

BIBLIOGRAPHY: Harris 1969, pp. 248–249, fig. 6; Berckenhagen 1970, p. 230, under entry for Hdz 3178; F. J. Kretzsch-

mar, "Pierre Contant d'Ivry: Ein Beitrag zur französischen Architektur des 18. Jahrhunderts," Ph.D. diss., University of Cologne, 1981, pp. 114, 248 n. 289, p. 337, fig. 114; Gabrielle Joudiou, "Pierre Contant d'Ivry," in *Chevotet-Contant-Chaussard: Un cabinet d'architectes au Siècle des Lumières*, Lyons, 1987, p. 131, repr.

Gift of Mr. and Mrs. Charles Wrightsman, 1970
1970.736.31

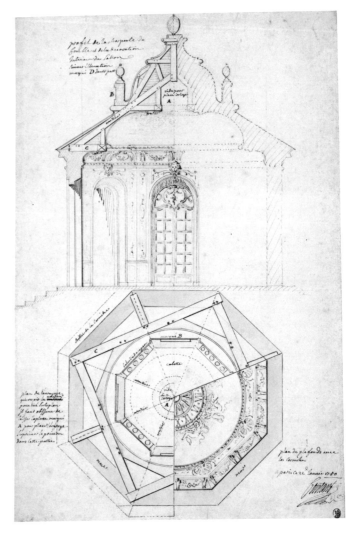

26

Contant studied with Nicolas Dulin, a member of the Royal Academy of Architecture and *contrôleur des Bâtiments du Roi*. Through his early commissions, Contant quickly entered the mainstream of French architectural circles, became a member of the Academy in 1728, and was made a full member ("membre de la première classe") fourteen years later. The great private patronage that helped make his name was that of the house of Orléans; the duc de Chartres first employed Contant in 1748 and made him his *premier architecte* in 1752, when he succeeded to the title of Duc d'Orléans. The duke was the greatest private patron of the period. Contant's most notable work for him was his interior decorations for the Palais Royal. The grave and stately style that predominates met with general approbation among the more conservative set, receiving praise from Blondel, who included the interiors among his plates for the *Encyclopédie*. Contant, however, was able to combine that style with a more fluid, almost Rococo decoration epitomized in his justly renowned staircase there. He also worked with Boffrand on the Hôtel Soubise interiors. He received major commissions, both public and private, for palaces, châteaus, and important ecclesiastical works, notably the great church of Saint-Vaast at Arras, Pas-de-Calais (Normandy). Contant's work on the gardens at Saint-Cloud began in 1743 under the duc de Chartres's father, the then duc d'Orléans, and lasted until 1768.

Dezallier d'Argenville, in writing about Saint-Cloud's gardens and architecture, provided the only documentation of the small garden pavilion, which was demolished between 1768 and 1779 and which he called a "Belvedere," until our drawing came to light: "En face du bassin des cygnes est une grand allée qui conduit à la nouvelle cascade. Deux escaliers de gazon conduisent ensuite vers le Belvedere, élevé par M. Contant, et orné d'une balustrade de pierre, d'où vous découvrez la vûe du monde la plus agréable; la plûpart des allées du Parc y aboutissent. . . ."[1]

The drawing shows a pavilion consisting of just one octagonal room in one story that is raised on four steps. It has French doors with arched tops on each of the eight sides. Above the slanted roof is an ogival, or onion, dome. On the exterior, rising above the cornice, are raised ovals framed by C-scrolls surmounted by a ball and flanked by flame-shaped finials that are visible on the verso. An alternative design for above the cornice level is lightly sketched in at the center bay, where a decorated semicircle replaces the ovals. Surmounting the lantern is a globe with an unidentifiable large bird. No pilasters or columns are placed between the doors to break the shallow surface of the exterior facade. In the interior, flanking the doors, is a narrow decorated area. The keystone of the doorway on the interior is surmounted by an antique mask that rises and extends into the cove, which is decorated with foliated ribs and garlands. The interior of the lantern is decorated with putti surrounding a ceiling clock located in the center.

26, verso

Kretzschmar argues that this pavilion can only be for Saint-Cloud. In January 1750, the date of our drawing, Contant was working almost exclusively for the duc de Chartres at Saint-Cloud. Furthermore, there are no documents linking Contant with garden pavilions for any other commission. In fact, this is one of the very few pieces of garden architecture that are known to have been executed by Contant. The Rococo elements—the lightness of the design promoted by the eight French doors and the delicate decoration—are particularly appropriate for a pleasure-garden kiosk.

NOTE

1 A. N. Dezallier d'Argenville, *Voyage pittoresque des environs de Paris* . . . (Paris, 1755), as cited in Kretzschmar, "Pierre Contant d'Ivry," p. 114.

CHARLES-ANTOINE COYPEL

Paris 1694–Paris 1752

27. Design for a Tapestry Sofa Seat

Gouache with oil. Silhouetted and laid down on mount with soft yellow wash surround within two black-ink border lines. 5³⁄₁₆ × 14¹³⁄₁₆ in. (132 × 376 mm).

Inscribed in brown ink on mount, lower left within border lines, *Ant. Coypel.*, lower left below border lines, *Meuble pour Madame La Regente. 1721*, and at lower right below border lines, *La Maitresse de Don Quichote.*

PROVENANCE: Mr. and Mrs. Charles Wrightsman.

BIBLIOGRAPHY: Edith A. Standen, "The Memorable Judgment of Sancho Panza: A Gobelins Tapestry in the Metropolitan Museum," *MMAJ* 10 (1975), pp. 102–103, fig. 5.

Gift of Mrs. and Mrs. Charles Wrightsman, 1970
1970.522.1

Charles-Antoine Coypel was a member of one of the most distinguished families of painters of the late seventeenth and first half of the eighteenth centuries. His father, Antoine Coypel (1661–1722), was *premier peintre du roi* and director of the Academy, and Charles-Antoine distinguished himself as well, by following in his father's footsteps and becoming *premier peintre* and director of the Academy in 1747. He studied with his father and entered the Academy young, at only twenty-one. Unlike many aspiring French painters of the time, he never went to Italy. He had a second major interest and career as a dramatist, and this interest in the theater was apparent in his art, which was very dramatic. Major commissions came early, the most important about 1714 for the designs for a large set of Gobelins tapestries representing episodes from *Don Quixote*, a particularly popular subject in France in the eighteenth century.[1] In all, Coypel executed twenty-eight paintings for the series, completing the last one in 1751, the year before his death. The series was one of the most successful at the Gobelins manufactory; it was continuously woven throughout the century. One of the tapestries from the series, *The Memorable Judgment of Sancho Panza*, is in the Metropolitan Museum (acc. no. 52.215).

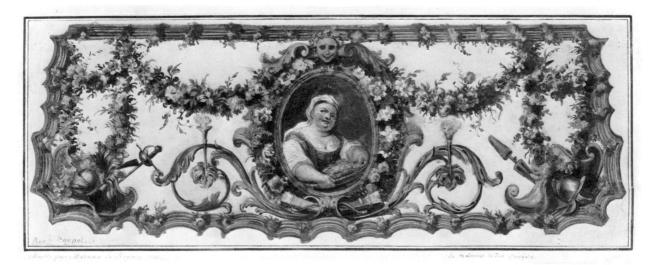

In addition to tapestry wall coverings, chair and sofa seats were executed on the theme of Don Quixote as well. In 1758, through the marquis de Marigny, a set of tapestries representing the history of Don Quixote, including weavings for twelve chairs and two sofas, were ordered for the Russian count Michael Illarionovich Vorontsov. The backgrounds of the Vorontsov tapestries were elaborate, executed with yellow *mosaïque d'ornements* grounds, whereas that on our drawing is a plain, very light blue. Four drawings for sofa backs and seats in the Musée des Arts Décoratifs, Paris, however, do have a background corresponding to the Vorontsov weavings, and two of them correspond to a sofa formerly on the New York art market.[2] Although the ground differs in our drawing, the *alentour*—the decorative surround consisting of the elaborate garlands hung from the central oval cartouche, which is surmounted by a mask, and the decorative elements in the lower corners— is similar to those in two of the designs in the Musée des Arts Décoratifs. On our sheet, there are a sword and a helmet in the lower left and a lance and helmet in the lower right, motifs symbolizing Don Quixote.

The subject of our sofa seat is Dulcinea separating the wheat from the chaff. Thierry Lefrançois has kindly communicated that there is a preparatory cartoon in oil on canvas for this subject conserved in the Mobilier National, but its condition is very poor.[3] There is no known woven canapé cover corresponding to this design. However, there is a canapé design representing Cupid wearing Mambrino's helmet that was listed under the year 1719 in the inventory the *État des ouvrages de peinture faits pour le roi de 1716–1729*, which mentions "un tableau représentant un amour ayant en tête l'armet de Mambrin suite de la même Histoire de Don Quichotte . . . 235 livres."[4] A drawing of this subject was on the Paris art market.[5] Lefrançois says that although our drawing is connected with the composition of Cupid wearing Mambrino's helmet, the date of 1721 on our drawing is difficult to verify.

Whereas the Paris drawings are classified as after Coypel, our drawing is perhaps by the master himself. The facial type of Dulcinea and of the mask surmounting the oval cartouche is very close to that in Coypel's drawings, and the *alen-*

tour looks as if it were done by the same hand: there is no visible differentiation between the draughtsmanship of the cartouche and the garlands and other decoration.

The *alentours* for the early weavings of the set were designed by one Jean Baptiste Blin de Fontenay, assisted by Claude Audran III, but by about 1720 a variant *alentour* was designed by Claude Audran under the supervision of Coypel, with the assistance of de Fontenay *le jeune* and François Desportes for the animals. The scheme is similar to that on our drawing, where garlands are suspended from the top of the central cartouche, but in the tapestry, they are suspended from the central framed picture. Symbols of Don Quixote are also found in the corners of the tapestry: in the Metropolitan's tapestry, Don Quixote's lance is prominently placed at the lower right.

The curious inscription on the drawing's mount is muddled on several counts and cannot be accepted. The duchesse d'Orléans would never have been referred to as "Madame la Regente." It would have been either "Madame" or the "duchesse d'Orléans." Whoever made the inscription knew that Coypel was not only a designer of the Don Quixote tapestries but also a painter to the duc d'Orléans. Coypel's father had also been employed by the duke, for whom he had created his greatest work, the decoration of the Galerie d'Enée in the Palais Royal.

NOTES

1 On the tapestry series, see Edith A. Standen, "The Memorable Judgment of Sancho Panza: A Gobelins Tapestry in the Metropolitan Museum," *MMAJ* 10 (1975), pp. 97–106.
2 Ibid., p. 102, figs. 6–9.
3 Mobilier National, Beauvais, 318/2.
4 Archives Nationales, 01/1921^A, fol. 3, verso.
5 Bérard sale, Hôtel Drouot, February 21, 23–25, 1891, [lot 511].

JACQUES-LOUIS DAVID

Paris 1748–Brussels 1825

28. Study of a Pyramid

Brown wash over graphite. $3\frac{5}{8} \times 6\frac{1}{16}$ in. (92 × 154 mm). Laid down at the corners on the original album sheet.

Inscribed in brown ink on album sheet, 227 *quatre dessins*; initialed *E D* and *J. D.* in brown ink at lower left of the drawing by the artist's two sons, Eugène and Jules (Lugt 839 and 1437). Stamp in black ink, *A. 10.*

PROVENANCE: David studio sale, Paris, April 17, 1826, no. 66; second David sale, Paris, March 11, 1835, no. 16; A. Chassagnolle (uncle and adopted father of J.-L. Jules David, the grandson and biographer of the artist); Marquise de Ludre (great-great-granddaughter of the artist); sale, Galerie Charpentier, Paris, March 15, 1956, no. 11; [Germain Seligmann, New York (his mark not in Lugt)]; sale, Christie's, London, July 4, 1978, no. 118, repr.; [Yvonne ffrench]; purchased in London.

BIBLIOGRAPHY: *Notable Acquisitions, 1979–1980*, p. 53, repr.

Edward Pearce Casey Fund, 1979
1979.617

After three consecutive unsuccessful and embittering attempts, David finally won the Prix de Rome in 1774. He arrived the following year with his teacher Vien, who had just been named director of the French Academy in Rome, and remained for five years. The sojourn marked a fundamental realignment of his art. As a contemporary biographer notes: "The study of the antique absorbs all his faculties. Michelangelo, Raphael, Poussin have become his models.

Always with a pencil and a notebook, he gathers in all he can. . . .".[1] The products of this passionate and incessant study were a large number of small sketches collected together and pasted into twelve albums that were sold in the two David studio sales. Of the twelve albums, two are in the Louvre, one is in Stockholm, and one is in the Fogg Art Museum, Cambridge. A fifth, designated album 11, recently appeared on the market.[2] It and another two, designated albums 6 and 10, have been dismantled.[3] The remaining albums are lost. Arlette Sérullaz has kindly pointed out that our drawing was pasted on the last page, 22, in album 10, which presumably explains the *A. 10* stamp on the mount, as it appears on at least one other drawing from the album, a study of a classical female statue in the R. Holland collection.[4]

Most of David's small landscape sketches, executed, like this drawing, in ink wash over graphite (or, in some cases, over chalk), are views drawn in the open countryside of the Roman Campagna. An example is the view of a small town in the Heinemann collection, also from album 10.[5] The pyramid of Caius Cestius in Rome, which David also drew in a straightforward topographical view,[6] was clearly the inspiration for the present sketch, but this is not by any means an accurate view, as the actual Roman monument is embedded in the Aurelian city wall at the Porta San Paolo. It also lacks the temple-front entrances seen in the drawing. The latter motif was popular among the *pensionnaires* in the Piranesi circle in the 1740s, and some were executed as prints. In 1747 in Rome, Nicolas-Henri Jardin (1720–1799) drew a similar temple-fronted pyramid with columns, which he later published as *Élévation en Perspective d'une Chapelle Sépulcrale*;[7] in 1752 Jérôme-Charles Bellicard (see No. 14) used the motif in his frontispiece for Blondel's *Architecture françoise*;[8] while about 1762 Pierre Moreau etched his imposing and monumental version, which, like David's pyramid, is overscale and fills its space.[9]

22γ quatre dessins) A.10

28

Pure architectural drawings, as distinct from landscape drawings that include architecture, are rare in David's work. Other architectural drawings are in the Louvre[10] and in Rouen.[11] The Louvre drawings resemble ours, especially in their overscale architecture composed of simple and undecorated masses dominating the space. Such drawings demonstrate David's sensitivity to architecture, displayed also in the importance and subtlety of the architectural backgrounds in the ensemble of his great paintings, the *Oath of the Horatii*, the *Paris and Helen*, and the *Brutus*, which reflect both contemporary architecture and theory. Crozet has noted that David came from a very serious architectural background: he was raised by his two maternal uncles, both architects, was a pupil of the architect and academician Sedaine, married the daughter of a contractor, and had an architect as a brother-in-law.[12] David knew De Wailly, who is supposed to have conferred with him on the architecture of the *Oath of the Horatii*, and probably Brongniart, but it is not known if he knew Ledoux, whose architecture he would have greatly admired, as is evident in this drawing.

NOTES

1 Quoted in Sérullaz, van de Sandt, and Michel 1981, p. 64; my translation.
2 Sale, Sotheby's Monaco, February 22, 1986, no. 106, repr.
3 On the David sketchbooks, see Sérullaz, van de Sandt, and Michel 1981, pp. 42–70, esp. p. 67 nn. 14, 15, and p. 68 n. 19, for album 10, which contained our drawing.
4 See *Italian and Other Drawings, 1500–1800*, exh. cat., University of London, Courtauld Institute Galleries (London, 1975), no. 121 (Witt photograph, 747/68[2a]), cited in Sérullaz, van de Sandt, and Michel 1981, p. 68 n. 19.
5 F. Stampfle, C. Denison, and J. B. Shaw, *Drawings from the Collection of Lore and Rudolf Heinemann*, exh. cat., The Pierpont Morgan Library (New York, 1973), no. 8, repr.
6 In album 11, sold Sotheby's Monaco, February 22, 1986, no. 106, repr.
7 See entry by G. Erouart, in *Piranèse et les français*, no. 77, pp. 155–158, repr.
8 Erouart 1982, p. 189, fig. 195.
9 Ibid., p. 190, fig. 197.
10 Cabinet des Dessins, 26.081 and 25.081 ter: Guiffrey and Marcel, vol. IV, 1909, nos. 3212–3213, repr.; 26.082 bis: *French Landscape Drawings and Sketches of the Eighteenth Century: Catalogue of a Loan Exhibition from the Louvre and Other French Museums*, exh. cat., British Museum (London, 1977), p. 97, no. 128, repr.
11 Pierre Rosenberg and François Bergot, *French Master Drawings from the Rouen Museum: From Caron to Delacroix*, exh. cat., International Exhibitions Foundation (Washington, D.C., 1981–82), no. 25, pl. 87.
12 René Crozet, "David et l'architecture néo-classique," *GBA* 45 (1955), pp. 211–220.

JEAN-CHARLES DELAFOSSE

Paris 1734–Paris 1791

29. Design for a Chimneypiece

Pen, black ink, with gray wash.
15⁹⁄₁₆ × 11⁹⁄₁₆ in. (395 × 294 mm).

PROVENANCE: [Baderou]; purchased in
Paris in 1967; transferred from the Draw-
ings Department in 1985.

Rogers Fund, 1967
67.851

Jean-Charles Delafosse began his studies as a
sculptor, then turned to architecture.[1] He was
employed as a professor at the Académie de
Saint-Luc and later became a member of the
Academy of Bordeaux. A draughtsman of prodi-
gious output and variety, he produced countless
drawings for architecture and ornament, such as
trophies, furniture, vases, and chimneypieces, to
name a few. The basis of Delafosse's draughts-
manship was a fertile imagination that expressed
itself in the Neoclassical style; indeed, his work
contributed significantly to the development of
the Louis XVI style. Delafosse's importance for
the invention and spread of Neoclassicism is im-
mediately grasped when comparing the number
of entries afforded him in the 1972 exhibition in
London, *The Age of Neo-classicism*, where he had
six entries under his name (Adam, the great
English Neoclassical architect and designer,
had only two), a number surpassed only by
Napoleon's great architects, Percier and Fontaine,
and by Piranesi. It was Delafosse's work of the
early 1760s that is described in that catalogue as
being of seminal importance in the development
of the Louis XVI style. Delafosse used the vo-
cabulary of Neoclassical design consisting of
heavy, ropy garlands, swags, scrolls, rosettes, me-
ander patterns, and other paraphernalia dis-
played in a geometrical and rectilinear matrix.

Delafosse's influence derived especially from the
publication of many of his drawings in 1768 as
the *Nouvelle iconologie historique*, some plates of
which he engraved himself; a second, enlarged
edition was published in a different format in
1771. Delafosse was criticized by his contempo-
raries for designs that were considered too heavy
and that made excessive use of Greek motifs,
and Blondel especially inveighed against him,
warning young artists and students to beware his
influence.

A group of drawings for chimneypieces simi-
lar to ours is in the Musée des Arts Décoratifs,

and a further design is in the Kunstbibliothek, Berlin.[2] They all recall Piranesi's set of prints *Diverse maniere d'adornare i cammini e ogni altra parte degli edifizi* of 1769. While Piranesi's prints display diverse ways to adorn chimneypieces, Delafosse's are primarily *à la grecque*, although one is in the Egyptian style.

Our chimneypiece has military details, as do those in the Musée des Arts Décoratifs. In our drawing, there is a battle scene above the mantel, which consists of a central roundel composed of a silhouette of a female head, flanking helmets, and heavy garlands that hang from the roundel. On either side of the fireplace are fasces. Greek triglyphs and metopes with rosettes form the cove.

NOTES

1 On Delafosse, see M. Gallet, "Jean-Charles Delafosse, architecte," *GBA* 61 (1963), pp. 157–164; and G. Levallet, "L'ornemaniste Jean-Charles Delafosse," *GBA* 1 (1929), pp. 158–169.
2 *Piranèse et les français*, p. 113, nos. 54 a–e, repr.; and Berckenhagen 1970, pp. 338, 340, Hdz 4409, repr.

30. Design for a *Grande Galerie*

Pen, black ink, with gray and brown wash over traces of black chalk. 14¾ × 32⁷⁄₁₆ in. (375 × 824 mm).

Signed lower left in brown ink, *J.C. Delafosse Inv. fecit. 1769*; inscribed at lower center in brown ink, *Grand Galerie de L'ordre Corinthien avec/Sallon aux Extremités/Echelle de 12 pieds.*

PROVENANCE: [Seiferheld Gallery, New York]; purchased in New York.

BIBLIOGRAPHY: *Notable Acquisitions, 1965–1975*, p. 204, repr.

Purchase, Joseph Pulitzer Bequest, 1973
1973.638

There are relatively few interiors drawn by Delafosse, and certainly none is as large and complete as this example. Most of his drawings are small; portray components of decorative ensembles, such as designs for trophies, vases, frieze panels, urns, and ewers; and were probably intended for the engraver. Delafosse's architectural drawings are generally for exteriors or parts of interiors, such as the chimneypiece (see No. 29) or the drawing in the Musée des Arts Décoratifs for part of an interior including a bed alcove,[1] but none is comparable to this design in conveying the monumentality and grandeur of Delafosse's conception of a complete architectural interior. The elements of decoration seen in Delafosse's other drawings (and the engravings after his designs) are here combined in a brilliant ensemble that epitomizes how an architect-

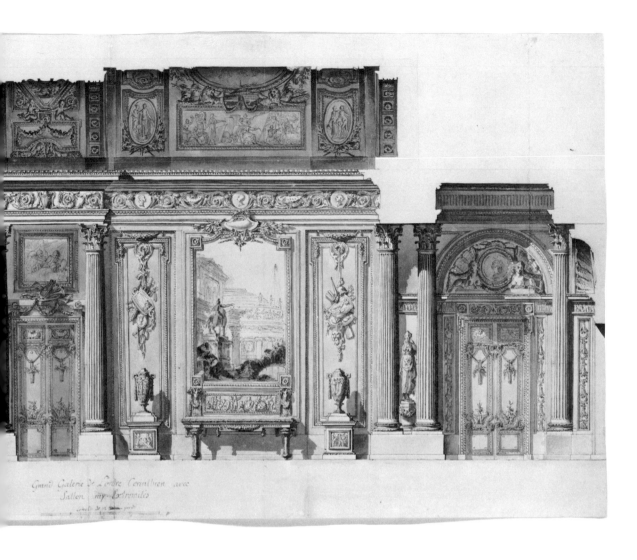

Grand Galerie de L'ordre Corinthien avec
Sallon

decorator would join various decorative compo-
nents to create a felicitous whole. The fluted col-
umns with Corinthian capitals; the heavy swags
that surmount the decorative painted panels con-
taining classical capriccios in the style of Hubert
Robert or Gian Paolo Panini; the narrow relief
panels with classical trophies and urns that flank
the painted scenes; the classical frieze with me-
dallion silhouette busts; the deep cove with hori-
zontal frieze designs representing the Arts
flanked by narrow dividing panels with oval
medallions containing classical figures: all pre-
sent a Neoclassical interior par excellence.

Not only is this study unique in Delafosse's
oeuvre,[2] but it is unusual for most architects.
Many such large-scale studies are either prepara-
tory for actual building projects or studies for
student competitions in the Academy. Christo-

pher Riopelle has pointed out[3] that it was
Delafosse's habit to work up projects that had
been suggested for the students in the Royal
Academy as a kind of statement of his own tal-
ent and abilities.[4]

NOTES

1 Inv. no. 22353.
2 Christopher Riopelle, who is preparing a monographic
 study of the artist, has kindly pointed out that there is
 not now known any other such large and monumental
 study by Delafosse.
3 Verbal communication January 30, 1990.
4 In 1765, the subject for the *prix d'émulation* for November
 was the "interior decoration of the gallery of a great no-
 bleman's palace," which was won by Louis-Jean Desprez;
 see Pérouse de Montclos 1984, p. 81.

31. Design for a Ewer

Pen, black ink, and gray wash. 9⁹⁄₁₆ × 5⁹⁄₁₆ in. (243 × 141 mm).

Signed in brown ink lower left, partially erased, *J. C. Delafosse*.

PROVENANCE: [James Jackson Jarves]; Cornelius Vanderbilt; transferred from the Drawings Department in 1985.

Gift of Cornelius Vanderbilt, 1880
80.3.663

Delafosse's ewer with a sea nymph and putti disporting themselves amid garlands of flowers and fruit is sedate and composed, like the more classical vase and ewer designs by Lepautre, Boucher, Bouchardon, Saly, and others and in contrast to the "eccentric" and imaginative designs of Petitot's vases (see No. 100).

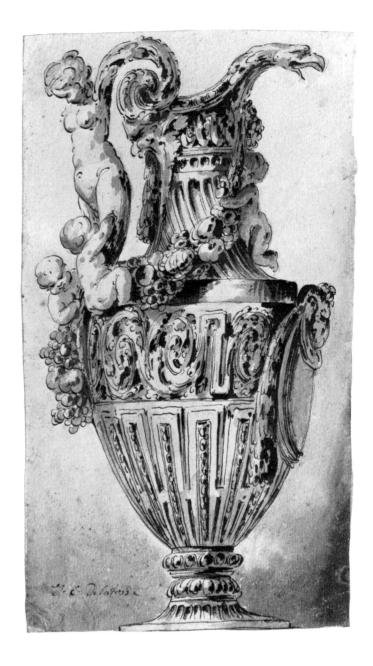

32. Design for a Ewer

Pen, black ink, and gray wash. 9⁹⁄₁₆ × 5³⁄₁₆ in. (243 × 132 mm).

Signed in brown ink lower left, *J.C. Delafosse*.

PROVENANCE: [James Jackson Jarves]; Cornelius Vanderbilt; transferred from the Drawings Department in 1985.

Gift of Cornelius Vanderbilt, 1880
80.3.664

In composition, this ewer, with its intertwined figures of sea nymphs, satyr, and swan (an allusion to Leda?), like the previous example basically conforms to the long tradition of vase and ewer design. The garlands forming the handle, the swag across the body of the ewer, the medallion portrait, and the straight lines of the fluting in the body of the ewer are the only elements that announce this design as Neoclassical.

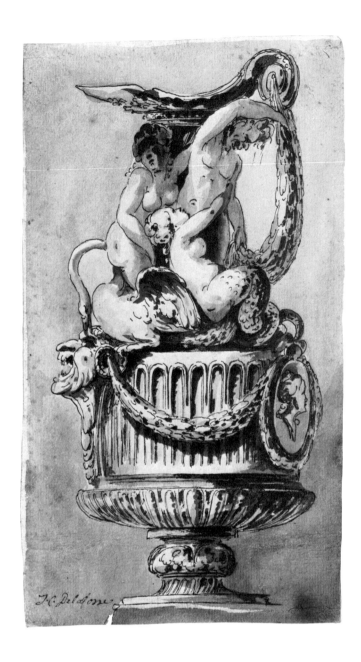

33. Design for a Trophy

Pen, black ink, and gray wash. Three framing lines. 14¾ × 8⁹⁄₁₆ in. (375 × 218 mm). Inlaid into mount. Hole in center, patched.

Signed in pen and brown ink at lower left, *J. C. Delafosse*; inscribed in lower oval, *Le tartares/et les/traces.*, at upper right, *140*.

WATERMARK: Fleur-de-lis in an escutcheon.

PROVENANCE: [Prouté, Paris]; S. Kaufman, London; [W. R. Jeudwine, London]; purchased in London.

BIBLIOGRAPHY: Kaufman and Knox 1969, no. 19; Fuhring 1989, under no. 81.

Purchase, Harris Brisbane Dick Fund and Joseph Pulitzer Bequest, 1971
1971.513.39

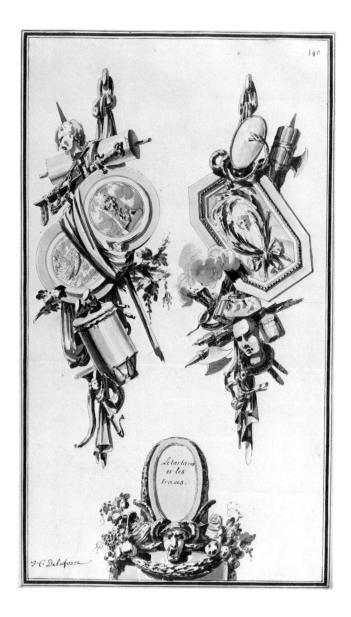

In the first edition of his *Nouvelle iconologie historique*, Delafosse stated that his trophies were original and composed so that other artists could use them for their historical and allegorical elements. In his second edition, he designed a series of trophies dedicated to European and Asian peoples that could also be sold as separate cahiers. The left-hand trophy was published reversed in the *Nouvelle iconologie* as plate 54, with certain changes. The right-hand trophy was published reversed with changes as plate 50. Other similar trophies are found in the Houthakker collection,[1] the Musée des Arts Décoratifs in Paris, the Musée des Arts Décoratifs in Lyons,[2] and the Cooper-Hewitt Museum in New York;[3] one was formerly in the Bérard collection.[4]

NOTES

1 Fuhring 1989, p. 129, no. 81.
2 *Dessins du XVIe au XIXe siècle de la collection du Musée des Arts Décoratifs de Lyon*, exh. cat. (Lyons, 1984–85), no. 90, repr. with twelve others.
3 Acc. no. 1911.28.301, *Le Lapidaire/et/l'Orfèvrerie*.
4 Bérard sale, Hôtel Drouot, Paris, February 21–25, 1891, lot 107, nos. 98, 201.

34a. Design for a Trophy

Pen, black ink, and gray wash. 4⁵⁄₁₆ × 5½ in. (110 × 140 mm).

PROVENANCE: [Mrs. Blanche Crosby]; purchased in New York.

Harris Brisbane Dick Fund, 1933
33.104.2512

34b. Design for a Trophy

Pen, black ink, and gray wash. 3⁷⁄₁₆ × 5¼ in. (87 × 133 mm).

PROVENANCE: See Number 34a.

Harris Brisbane Dick Fund, 1933
33.104.2523

34c. Design for a Trophy

Pen, black ink, and gray wash. 4¹⁵⁄₁₆ × 4⁹⁄₁₆ in. (125 × 116 mm).

PROVENANCE: See Number 34a.

Harris Brisbane Dick Fund, 1933
33.104.2511

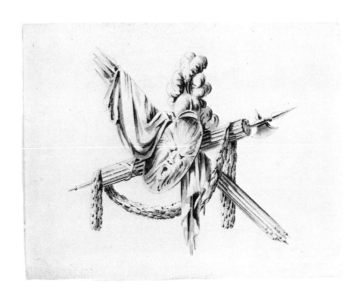

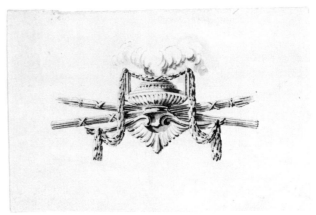

All three of these designs were engraved in reverse by Joly as plate 1 of the forty-third cahier of *Trophées divers*. Despite the title *Trophées divers*, the components of these trophies are essentially military: lances, axes, shields and plumes, flaming torches, and helmets, and they are very much simplified in comparison to the large trophies, such as Number 33.

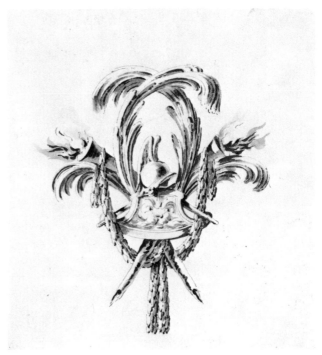

34c

35. Study for a Caricature of an Engraver

VERSO. Sketch for a Caricature

Pen, black ink, gray and colored wash, over black chalk (recto). Black chalk (verso). 7½ × 4⅝ in. (191 × 118 mm).

Inscribed, *Le graveur* (recto).

PROVENANCE: [Emil Hirsch]; purchased in New York.

BIBLIOGRAPHY: M. Roland Michel, *Le dessin français au XVIIIe siècle*, Paris, 1987, pp. 139–140, fig. 150.

The Elisha Whittelsey Collection, The Elisha Whittelsey Fund, 1960
60.576.5(2)

This drawing, one of a group of six caricatures of trades of which four are illustrated here, was attributed at the time of its acquisition to Petitot (see No. 100), reflecting the fame of his *Mascarade à la grecque*, published in 1771, which itself satirized Delafosse's *Nouvelle iconologie historique; ou, Attributs hiéroglyphiques qui ont pour objet les elemens, les saisons, les quatre parties du monde, et les diverses complexions de l'homme*. The tradition of representing different trades has a long history, from the Cries and Trades of Annibale Carracci through those by Bouchardon in the eighteenth century. It may have been Delafosse's intention to add the trades as some of the *diverses complexions de l'homme* in his *Nouvelle iconologie*. Several of Delafosse's hieroglyphic images, including *L'antique noblesse; ou, Le fantôme de la noblesse*; *Le colosse à tête d'or et pieds d'argile; ou, L'antique momie du clergé*; and *L'âge de fer; ou, Le règne de la fraude, la sédition, la désunion, l'erreur, l'ambition, la chicane, etc., etc.*, are in the Musée Carnavalet.[1]

35

35, verso

The four trades illustrated refer to printing. A fifth portrays a child's tutor,[2] and the sixth portrays a sculptor.[3] (Sculpture was the trade in which Delafosse first began his studies.) In this sheet entitled *Le graveur*, the engraver's plates fill the top of a vaselike vessel; a sheep's head with engraver's tools protrudes from each side; and a piece of drapery hung between the sheeps' heads supports a number of oval portraits. The black-chalk sketch on the verso shows a figure with variant sketches for the arms, one variation of which has them folded in front of the torso and another of which has them in the form of engraver's burins hanging down at the side. Indistinguishable tools fill a hat on the head.

NOTES

1 See M. Mosser, "Trois colonnes hiéroglyphiques, de J.-C. Delafosse," *Revue de l'art*, no. 73 (1986), pp. 65–66.

2 60.574.5(4).

3 60.576.5(1).

36. Study for a Caricature of an Engravings Printer

Pen, black ink, with gray and colored wash over traces of black chalk. 7 ¹/₁₆ × 4 ¹/₁₆ in. (179 × 103 mm).

Inscribed, *L'imprimeur en taille douce.*

PROVENANCE: See Number 35.

The Elisha Whittelsey Collection, The Elisha Whittelsey Fund, 1960
60.576.5(3)

The caricature uses a donkey to represent a copperplate printer. The shoulders are the handles for turning up the pressure on the printing press. The hands, gloved in oval-shaped fabric, represent dabbers, instruments for spreading ink on the engraved plate.

37. Study for a Caricature of Engravers *à la Grecque*

Pen, black ink, with gray and colored wash over traces of black chalk. 7⅝ × 4⅞ in. (194 × 124 mm).

Inscribed, *Les graveurs a la grec.*

PROVENANCE: See Number 35.

BIBLIOGRAPHY: K. G. Pontus Hultén, *The Machine* . . . , exh. cat., The Museum of Modern Art and University of St. Thomas, New York and Houston, 1968, p. 19, repr.

The Elisha Whittelsey Collection, The Elisha Whittelsey Fund, 1960
60.576.5(5)

The drawing of engravers *à la grecque* is Delafosse's caricature of practitioners of the Greek style, probably referring specifically to Petitot's *Mascarade à la grecque*. The bald head of the figure at the left is a bag filled with rosin, which is spread on the grounded plate to create a mottled effect when the plate is printed, as in an aquatint. The arms attached to the body with screws are the printer's tools for engraving, called gravers. The body of the creature is covered with different printed images—of foliage, ornament, parts of the face, a nose, and a hand. The figure at the right has the same graver for arms, a vessel on the head filled with engraver's tools, and, on the body, more prints of such subjects as eyes, noses, and more long strips of ornament.

38. Design for a Caricature of a Printseller

Pen, black ink, with gray and colored wash over traces of black chalk. 6⅝ × 3¹⁵⁄₁₆ in. (168 × 100 mm).

Inscribed, *Le Md. D'estampes*.

PROVENANCE: See Number 35.

The Elisha Whittelsey Collection, The Elisha Whittelsey Fund, 1960
60.576.5(6)

A chicken wearing a box with drapery hanging from it holds the prints that the printseller offers for sale.

CHARLES DE WAILLY

Paris 1730–Paris 1798

39. Study for Decoration of the Obelisk at Port-Vendres

Pen, black ink, with gray and green wash. Framing lines in brown and black ink and wash. 9³⁄₁₆ × 14³⁄₁₆ in. (233 × 360 mm). Lined. Brown spots.

Signed in dark brown ink at lower right, *De Wailly delineavit 1783*; inscribed in dark brown ink above the design, LA MARINE

RELEVÉE, below the design, DEUX ESCADRES SORTANT DES PORTS DE L'OCÉAN ET DE LA MÉDITERRANNÉE/REPRÉSENTÉES AU PIED DU TROPHÉE ÉLEVÉ A LA GLOIRE DU ROI PAR LES DIEUX DES DEUX MERS, and at bottom left, *Bas-relief de l'obelisque du Port Vendre/Coté de la gauche.*

PROVENANCE: [Heim Gallery, London]; Mr. and Mrs. Charles Wrightsman.

BIBLIOGRAPHY: Harris 1969, p. 249.

Gift of Mr. and Mrs. Charles Wrightsman, 1970
1970.736.47

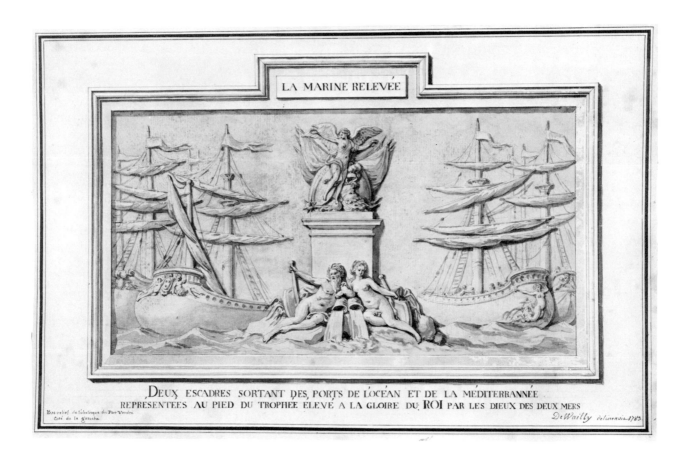

A pupil of Blondel (see Nos. 15–17), J. Legeay (see Nos. 60–62), and G. N. Servandoni, De Wailly won first prize for architecture in 1752 and in 1754 left for Rome, where he remained for two years. In 1767 he became a member of the Royal Academy of Architecture, and in 1771, he received a very unusual honor when he also became a member of the Royal Academy of Painting and Sculpture. His most famous work was the erection, with Antoine-Marie Peyre, of the Théâtre de l'Odéon, now much changed. The esteem in which he was held at the time is evident from the fact that engravings of two of his works were ordered by Diderot and d'Alembert for the *Encyclopédie*. He was patronized by monarchs across Europe, such as Catherine II of Russia, and there are also many works by De Wailly in Germany.

In 1779–80 the comte de Mailly, commander in chief of the department of Roussillon, commissioned De Wailly to do extensive work on the port of Port-Vendres,[1] on the Mediterranean coast of France, south of Perpignan, near the Spanish border. Especially prominent among the commissions was an obelisk to be set in a square decorated with stairways and fountains, which the king had granted permission to designate a royal square. De Mailly ordered four designs for bronze reliefs from De Wailly, one for each side of the base of the obelisk: *La servitude en France abolie* (*Servitude Abolished in France*), *Le commerce protégé* (*Commerce Protected*), *L'Amerique indépendante* (*Independent America*), as well as ours, *La marine relevée* (*The Navy Exalted*).

Of the extensive plans for Port-Vendres, only the obelisk was executed. The bronze plaques were cast by one Guiart after De Wailly's designs, but the name of the sculptor is unknown. They were engraved in the work *Le voyage pittoresque de la France* by de La Borde.[2]

Three versions of each drawing were made. One group is in a private collection; another is in the collection of the Louvre, on deposit at the Musée de Blérancourt; and the third group, now dispersed, includes our drawing as well as another, *La servitude en France abolie*, now in the Musée de la Révolution Française in Grenoble.

NOTES

1 On the Port-Vendres project, see S. Pressouyre, "Un ensemble néo-classique à Port-Vendres," *Monuments historiques de la France*, no. 4 (October–December 1963), pp. 199–222; M. Mosser and D. Rabreau, *Charles De Wailly, peintre architecte dans l'Europe des Lumières*, exh. cat., Caisse Nationale des Monuments Historiques et des Sites (Paris, 1979), pp. 72–73, 119, nos. 286–288; and Hugh Honour, *The European Vision of America*, exh. cat., National Gallery of Art and Cleveland Museum of Art (Washington, D.C., and Cleveland, 1975), no. 210, repr.

2 (Roussillon, 1786), vol. III.

CHARLES-DOMINIQUE-JOSEPH EISEN

Valenciennes 1720–Brussels 1778

40. Study for a Tailpiece

Red chalk. 3¼ × 4⁹⁄₁₆ in. (83 × 116 mm).
Lined.

Signed and dated in black chalk lower left,
Ch. Eisen invenit et fecit / 1774 .

PROVENANCE: [A. Moatti, Paris];
purchased in Paris.

The Elisha Whittelsey Collection, The
Elisha Whittelsey Fund, 1979
1979.591.2

One of the four greatest book illustrators in France during the eighteenth century, Eisen was a pupil first of his father and later of Jacques-Philippe Le Bas. A draughtsman, etcher, and painter, Eisen became the drawing master to Mme de Pompadour and *dessinateur du roi*. His masterpiece was the *fermiers généraux* (roughly a rank of farmers who were allowed to collect taxes) edition of La Fontaine's *Contes et nouvelles*, published in 1762.

Our tailpiece was designed for Jean-François Marmontel's *Chefs-d'oeuvre dramatiques; ou, Recueil des meilleures pièces du théâtre françois . . .*, dedicated to the dauphine, Marie Antoinette, and published in Paris in 1773.[1] The *Chefs-d'oeuvre dramatiques* was a compilation of distinguished dramas. Marmontel (1723–1799), a lesser literary talent close to Voltaire and protected by Mme de Pompadour, was named editor of the *Mercure* in 1758 and wrote most of the literary articles in the *Encyclopédie*. The tailpiece appears in the last drama, a work by Jean de Rotrou (1609–1650), *Venceslas, tragedie*. Rotrou's drama, first performed in 1647, was one of his thirty-five plays that appeared between 1628 and 1649. The tailpiece[2] was printed on page 108, at the end of the

fifth and last act and the ninth and last scene. In the drawing, two men embrace, King Wenceslas of Poland and his son, Prince Wladyslaw; the king has forgiven Wladyslaw's earlier transgressions and is awarding him the crown.

The tailpiece, free of Rococo flourishes, is typical of the style of the seventies. The small scene is framed by the straight sides of an octagon surrounded by laurel leaves growing amid Greek frets and flourishes. Above the scene are raised flags surmounted by a crossed sheath of arrows and a flaming torch. The print was engraved by Nicolas Delaunay (1739–1792), and Eisen signed his name with the date, 1774, the same as on the drawing. Although the book is dated 1773, it was evidently not finished that year. Only one volume appeared of this work.

NOTES

1 Cohen 689; V. Salomons, *Charles Eisen, Eighteenth Century French Book Illustrator and Engraver* (London, 1914; reprint, Amsterdam, 1972), pp. 135–136.
2 B. N., *Inventaire*, vol. XII, p. 496, no. 118.

GRAVELOT (HUBERT-FRANÇOIS BOURGUIGNON)

Paris 1699–Paris 1773

41. Design for an Oval Gold Box

Pen, gray and black ink over graphite, with yellow and rose wash on top. 4⅞ × 3³⁄₁₆ in. (124 × 81 mm). Incised. Stained; lower right corner torn. Laid down on Roederer mount.

PROVENANCE: Marquis de Fourque-vaulx; Emmanuel Bocher; Louis Olry-Roederer; [A. S. W. Rosenbach]; purchased in Philadelphia in 1944.

BIBLIOGRAPHY: Alice Newlin, "The Celebrated Mr. Gravelot," *MMAB* 5 (October 1946), p. 61, repr. (detail: top).

Fletcher Fund, 1944
44.54.42

Gravelot was one of the greatest designers of book illustration in an age that had perfected it. His narrative scenes combined figures of fashionable grace and charm with beautiful contemporary interiors that provide accurate views of aristocratic life of the time. His range was broad: in addition to great works of literature, among which were a 1757 edition of Boccacio's *Decameron*, Voltaire's *Oeuvres* of 1768, Rousseau's *Nouvelle Héloïse* of 1766, a 1744–46 edition of Shakespeare, as well as Racine and Corneille, he illustrated almanacs, travel descriptions, and a geographical work by his brother, J.–B. Bourguignon d'Anville (1697–1782). He excelled at all aspects of book illustration, and in his vignettes, headpieces, tailpieces, and the decorative framing of the illustrations, he revealed a special talent for designing ornament that went beyond the book page. During Gravelot's sojourn of 1732–45 in England, to which he traveled after studying in the studios of Restout and

Boucher, the engraver and art historian George Vertue remarked that he was an excellent draughtsman who drew designs for ornament in great taste.[1] Vertue repeatedly mentioned Gravelot's designs for gold and silver along with his illustrations, so ornament design must have constituted a significant part of his output in England. Presumably he was active in this genre throughout his life, for his brother pointed out in his eulogy that "he displayed much taste in designing ornament in the forms appropriate to

goldsmiths' work and jewelry."[2] Gravelot's drawings for works of art are found in many collections, such as the Musée des Arts Décoratifs, Paris; the British Museum; the Ashmolean Museum, Oxford; the Hermitage, Saint Petersburg; the Houghton Library at Harvard University; and the Rosenbach Foundation, Philadelphia.

Few of his drawings are connected with actual objects. One exception is a drawing in a private collection for the lid of a gold box in the Wrightsman Collection in the Metropolitan Museum, chased in London and signed by George Michael Moser in 1741.[3] Of the approximately twenty-three drawings in the Metropolitan's collection that seem to be designs for goldsmiths' work, only one (44.54.58), a design for a medal or possibly a watchcase, is dated (1767). All come from the Roederer collection, which had been in the artist's portfolio at the time of his death. While Gravelot certainly took drawings he had made in England back to France with him, it is probable that most of the drawings date from after his return to France.

This design for an oval snuffbox showing the lid and a partial elevation of a side would have been executed in gold. The central panel depicting a recumbent Venus with Cupid would have been enameled, and the chased scrollwork of the outer border would have had enameled pink flowers. The sides of this box would have had enameled rectangular panels within chased gold scrollwork with enameled flowers similar to the top. The combination of the still-Rococo forms of the scrolls interlaced with shells at the four corners of the oval top with the design for the sides, which are straight instead of bombé and therefore more Neoclassic, suggests a date in the 1760s. Clare Le Corbeiller has kindly pointed out a gold snuffbox by the maker Louis Charonnet, marked 1767, with just such a combination of elements in a very similar design.[4]

Gravelot, like many of the designers of goldsmiths' work of the period, adapted Boucher's figural compositions to his designs. In a drawing in the Musée des Arts Décoratifs, Paris, with twelve designs for boxes, all have figures dependent on Boucher.[5] The Venus and Cupid here are similar to many of Boucher's representations of recumbent females with putti, such as the

figures engraved by Daullé erroneously entitled *The Muse Clio* after an overdoor representing Terpsichore that Boucher painted for Madame de Pompadour in 1756[6] and a nude engraved by Petit after a drawing by Boucher.[7]

NOTES

1 Cited by A. Newlin, "The Celebrated Mr. Gravelot," *MMAB* 5 (October 1946), p. 62. On Gravelot, see Goncourt, vol. II, 1882, pp. 7–47; and Portalis 1877, vol. I, pp. 270–294.

2 J.-B. Bourguignon d'Anville, "Éloge de Monsieur Gravelot," in *Nécrologie des hommes célèbres de France* (Paris, 1774), p. 135.

3 Watson 1970, pp. 185–186, no. 25, repr.; F. Watson, "An Historic Gold Box by Moser: Some Problems of Cataloguing Gold Boxes," *Burlington Magazine* (January 1976), pp. 26, 29, fig. 34; Snodin 1984, H 5.

4 Sale, Sotheby's, London, June 5, 1972, lot 149, repr.

5 Inv. no. 368 bis; Snowman 1966, fig. 49.

6 Jean-Richard 1978, p. 164, no. 558, repr. This motif was used on a navette at Waddesdon Manor, for which see Grandjean 1975, no. 60.

7 Jean-Richard 1978, no. 1459, repr.

42. Design for a Cartouche-shaped Gold Box

Pen, brown ink, with red chalk and yellow wash over graphite. Incised, especially on horizontal and demarcation lines from the top to the side elevation. $3\frac{7}{8} \times 3\frac{1}{16}$ in. (98 × 78 mm). Creased vertically at center with red-chalk line. Rubbed and stained. Laid down on Roederer mount.

PROVENANCE: Marquis de Fourque-vaulx; Emmanuel Bocher; Louis Olry-Roederer; A. S. W. Rosenbach.

Gift of A. S. W. Rosenbach, 1944
44.66.3

The cartouche was a shape particularly favored by designers of the high Rococo, which lasted from about 1735 to 1750. A Parisian box of a very similar cartouche shape, with one flat side to receive a hinge, a border of intertwined scrolls decorated with flowers, and a circular painted enamel plaque, is dated about 1736.[1] One of the earliest cartouche boxes, dated 1728–29, executed in gold with bold scroll, laurel, and shell motifs and carrying the arms of Maria Anna of Bavaria-Neuburg, the wife of Charles II of Spain, is by one of the originators of the Rococo, the great designer and architect Juste-Aurèle Meissonnier (see Nos. 72, 73), who published a number of his snuffbox designs in his *Oeuvre*.[2] Other examples of similar cartouche-shaped boxes include one, dating between 1732 and 1738, by Daniel Govaers of Paris, irregular in shape, enclosing a cartouche with a putto and two children, asymmetrical shells, and scrolls, now in the Wrightsman Collection in the Metropolitan Museum;[3] a similar box but decorated with diamonds, also by Daniel Govaers, dating between 1733 and 1734, is also in the Metropolitan.[4]

The sides of the above boxes curve out from the lid and then back in again at the bottom, in a shape known as bombé. The sides of the box in Gravelot's design are straight or, rather, recede in a straight line slightly inward toward the bottom. The straightening of the lines from the bombé shape is a feature that distinguished the end of the Rococo style and can be seen in such boxes as the Parisian Jean Moynat's oval gold cartouche box, dating to 1754–55, with scrolls surrounding a central panel enameled with a floral bouquet. Its sides are composed of Rococo cartouches. Its overall form can be contained in a simple shape: the sides are straight, and the scrolls of the lid's now-tame Rococo cartouche barely break the shape of the oval contour.[5] The cartouche in the present drawing is still rather curved and irregular, suggesting a date in the early to mid-1750s. Like the design with Venus and Cupid (No. 41), panels on the sides are reserved for pictorial or ornamental motifs.

NOTES

1 In the Hermitage, Leningrad; see Snowman 1966, fig. 160.
2 In a private French collection; see Snowman 1966, figs. 137–139.
3 Snowman 1966, figs. 150–151; Watson 1970, pp. 113–114, no. 1, repr.
4 Le Corbeiller 1966, fig. 10; Snowman 1966, fig. 148; Watson 1970, p. 114, repr.
5 Snowman 1966, pl. 296, lower.

43. Design for a Gold Watchcase Showing Front and Elevation

Pen, gray ink, over graphite. Incised.
3⅞ × 2⅛ in. (98 × 54 mm). Rubbed and
smudged with brown ink. Laid down on
Roederer mount.

PROVENANCE: Marquis de Four-
quevaulx; Emmanuel Bocher; Louis Olry-
Roederer; A. S. W. Rosenbach.

BIBLIOGRAPHY: Snodin 1984, I 14,
repr., I 19.

Gift of A. S. W. Rosenbach, 1944
44.66.1

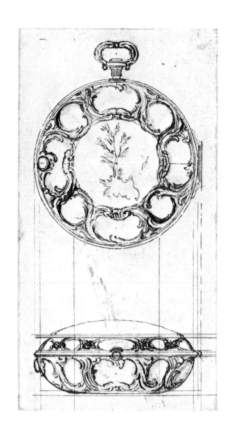

The rocaille, foliate, interlaced scrollwork that
forms the cage of this watch design has
been compared by Michael Snodin to frames of
Gravelot's English satirical prints and to the de-
sign of an English rectangular snuffbox with six
compartments surrounding the center that, how-
ever, was made much later, about 1765.[1] An
English gold snuffbox even closer in design is
also rectangular but, as in the drawing, has eight
compartments that are set with moss agates sur-
rounding the central one. It dates from about
1760 to 1765.[2] It should be noted that although
there are no drawn lines in the outer compart-
ments on our study, there are incised lines
suggesting moss agates.

Serge Grandjean has kindly pointed out a
very similar cagework watchcase in the Louvre
of chased gold set with five plaques of moss
agate.[3] It has very similar but more elaborate
decoration consisting of foliate scrollwork inter-
rupted at the sides of the four outer oval com-
partments by rocaille intertwined floral and shell
designs. Although the movement is signed *Jn.
Ml.* (Jean Etienne?) *Vieusseux*, who was active in
Geneva, the case itself is not signed. Louvre
records date the watchcase to about 1750.

NOTES

1 Snodin 1984, I 19; Le Corbeiller 1966, fig. 287.
2 Snowman 1966, fig. 456.
3 OA.8372.

44. Design for a Navette

Pen, brown ink, over traces of graphite.
4⁹⁄₁₆ × 2¹⁄₁₆ in. (116 × 52 mm). Stained.
Laid down on Roederer mount.

PROVENANCE: Marquis de Four-
quevaulx; Emmanuel Bocher; Louis Olry-
Roederer; [A. S. W. Rosenbach]; purchased
in Philadelphia in 1944.

Fletcher Fund, 1944
44.54.44

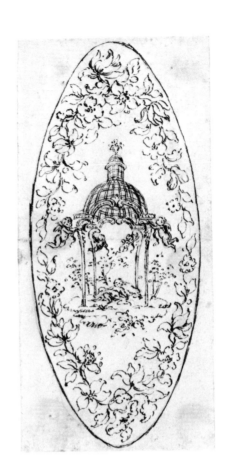

Navettes, or shuttles, were used by ladies of the highest aristocracy in the mid-eighteenth century to make tatting, a kind of lace created by looping and knotting heavy thread wound by hand on the shuttle. Shuttles were composed of two identical oval elements connected by a central support that held the thread to be tatted. They were made not only of gold but also of porcelain, ivory, and other materials.[1] Our design depicts putti flying around a latticework canopied pavilion and a border of flowers. When executed, the shuttle would very likely have had the appearance of a gold box made in 1750, probably by Jean-Charles Ducrollay.[2] As in this design, a continuous band of entwined flowers borders the top of the box; the flowers are enameled en plein on a gold engraved ground. The center of the design is an enameled landscape scene with architecture.

The drawing must date to after Gravelot's return to France, probably to the early 1750s. A shuttle is mentioned in documents for the first time only in 1748, when the *marchand-mercier* Lazare Duvaux repaired one.[3]

NOTES

1 Grandjean 1975, p. 133.
2 Sale, Sotheby's, London, July 28, 1964, lot 106, repr. Clare Le Corbeiller kindly brought this box to my attention.
3 Grandjean 1975, p. 133.

45. Design for the Headpiece of the *Gazette de France*

Black and red chalk. Paper folded and incised vertically down center, within design, and at edge of paper forming border lines. Counterproofed and retouched with black and red chalks. 7⅞ × 5 in. (200 × 127 mm); irregular. Laid down on Roederer mount.

Inscribed in red chalk within plaque, GAZETTE DE FRANCE.

PROVENANCE: Marquis de Fourquevaulx; Emmanuel Bocher; Louis Olry-Roederer; [A. S. W. Rosenbach]; Louis H. Silver, Chicago; sale, Sotheby's, London, November 11, 1965, lot 70; [Lucien Goldschmidt, New York]; purchased in New York; transferred from the Drawings Department in 1985.

Rogers Fund, 1966
66.759.3

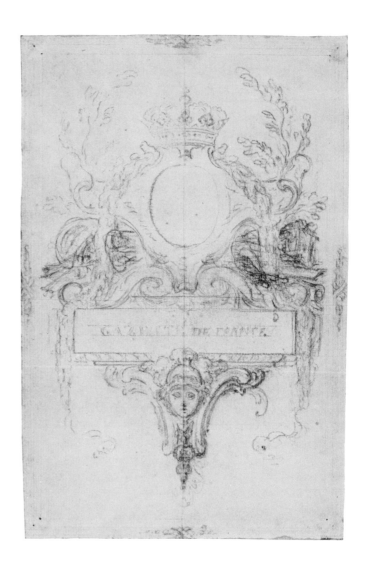

The *Gazette de France*, first published in 1631 as a weekly and called simply the *Gazette*, was devoted primarily to the political issues of the times, whereas the *Mercure de France* was concerned more with news relating to the arts and literature. In 1762, when the *Gazette* was made an official organ of the government and given royal patronage, it became a biweekly, and its name was changed to the *Gazette de France*.

This drawing is one of a group of five depicting a cartouche surmounted by a French royal (or, as in two of the drawings in the group, ducal) crown above an architectural design. Inscribed on the mount of one of the drawings in brown ink is *Frontispiece pour le Journal/La Gazette de France. Année 1766.* This is probably Roederer's handwriting recording what was on the verso of the drawing before it was covered by his mount. An examination of the *Gazette de France* for the years 1762 to 1771 did not reveal any designs remotely like this or the four others

in the group. The only ornamentation for the *Gazette*'s columns of type were small horizontal headpieces, designed and printed in quite a primitive manner, unlike this bold and handsome composition.

46. Design for a Funeral Ticket

Pen, gray ink, and wash. Framing line.
6⅛ × 7¹⁵⁄₁₆ in. (156 × 202 mm). Lined with
decorative mount.

Signed on tab, bottom right, in gray ink,
H. Gravelot inv. & delin.; inscribed in car-
touche, *Nomen laudesque manebunt.*; in-
scribed verso in pencil, *Original drawing by
Gravelot for a funeral ticket. It was engraved
by J. Tinney & published Sept. 4, 1746 by
Wm. Clifton.*

PROVENANCE: Sir Robert Mond, his
mark verso, Lugt Suppl. 2813a; S. Kauf-
man; [W. R. Jeudwine, London]; purchased
in London.

BIBLIOGRAPHY: T. Borenius and R.
Wittkower, *Catalogue of the Collection of
Drawings by the Old Masters Formed by Sir
Robert Mond*, London, n.d., no. 319, pl.
LIX(A); Kaufman and Knox 1969, no. 87,
repr.

Purchase, Harris Brisbane Dick Fund and
Joseph Pulitzer Bequest, 1971
1971.513.91

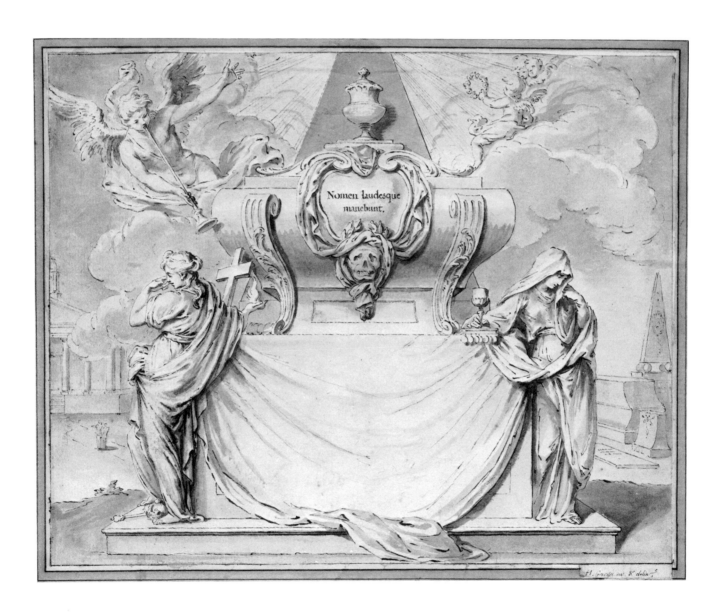

Although the print after this drawing has not been located,[1] the precision of the inscription naming Tinney as the engraver and giving the publication date indicates that it was engraved. Like most ephemera, such prints have become rare. They were made only for middle-class funerals and were given out to acquaintances and the pallbearers. The tickets were printed for the funerary trade generally by a commercial stationer, in this case William Clifton, who must have commissioned the ticket from Gravelot. No prints relating either to Gravelot or to funeral tickets by the little-known engraver John Tinney, active in London from 1729 until his death in 1761, have survived so far as we know.

On either side of the base supporting the sarcophagus stand mourning figures with symbols of faith and redemption. The figure at the left, juxtaposed with a cross, steps on a scepter and orb, while the figure at the right holds a chalice. In the cartouche on the sarcophagus is the phrase *Nomen laudesque manebunt* (The name and praise will endure). In the sky, above and to the left of the sarcophagus, is a figure of Fame, and above and to the right are putti with a wreath. In the background at the right is a tomb, and at the left is the eternal church, further allusions to death and eternal life through faith in the church.

NOTE

1 I am grateful to Antony Griffiths and Julien Litten for searching in the collections of the British Museum and the Victoria and Albert Museum, respectively, for the print. Further, I would like to thank Julien Litten for his information on funeral tickets.

Laurent Hubert

Paris, active ca. 1749–1776/86

47. Study for a Chimneypiece and
 Overmantel with a Clock

Red and black chalk. 14⅛ × 7⅞ in.
(359 × 200 mm); irregular. Creased horizontally at center. Traced in graphite on
verso: bunch of grapes (watermark).

WATERMARK: Near Heawood 2100.

PROVENANCE: Private collection,
Switzerland; [Seiferheld Gallery, New
York]; [Phillips, London]; Mr. and Mrs.
Charles Wrightsman.

BIBLIOGRAPHY: Fitz-Gerald 1963, no.
1, repr. on front cover.

Gift of Mr. and Mrs. Charles Wrightsman,
1970
1970.736.65

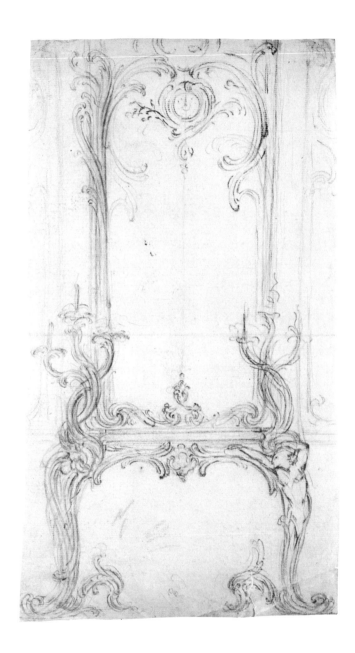

Laurent Hubert is an artist known only
through documents and inscriptions on two
drawings. He was mentioned in the *Mercure* in
1767 as a member of the Académie de Saint-Luc
and in 1775 as an adjunct professor there. He exhibited clay and wax models and small bronzes
in the Salons of 1752, 1753, and 1756. His address
has been established through an inscription on a
drawing, *Quai Dorleans isle St. Louis Notre
Dame.*[1]

This sheet was attributed to Juste-Aurèle
Meissonnier when it was exhibited among a
group of unsigned drawings in 1963 in New
York at the Seiferheld Gallery.[2] In the catalogue
for the exhibition, Desmond Fitz-Gerald compares our study with such leaves in Meissonnier's
Oeuvre as the engraving of a chimneypiece and
overmantel in the "Cabinet de Mr. le Comte

Bielenski."[3] Fitz-Gerald also connects the drawing with other plates in Meissonnier's *Oeuvre*, such as the designs for the house of M. Brethous in Bayonne.[4] While our drawing and the Meissonnier designs share the same strong rocaille style, Meissonnier's works are marked by a more contained and ponderously heavy, almost late Baroque character. There is a distinct difference between the lighter, sinuous, intertwining forms in the Hubert, especially the figure at the right growing out of foliage, and those of Meissonnier.

Two drawings signed by Hubert have been published that share the same distinctive qualities of the figural style of our sheet.[5] The sinuous bodies, which mold themselves around the forms they enclose, and the facial profiles with their characteristically sleek, almost unbroken contours are the same in all three sheets. As Richard Wunder observes about a signed Hubert drawing in the University of Michigan Museum of Art, which he identifies as for a *surtout de table*, it has nothing to do with the hand of Meissonnier as it is known from surviving drawings.

As is typical with Rococo design, Hubert has conceived the chimneypiece and overmantel as one organic unit, the parts flowing and almost curling into one another. The sconces emerge from the chimneypiece, while the foliate ornament at the top of the overmantel supports and envelops a clock. The sheet probably dates from the 1740s.

NOTES

1 *Architectural, Ornament, Landscape, and Figure Drawings Collected by Richard Wunder*, exh. cat., Middlebury College (Middlebury, Vt., 1975), p. 51, no. 75.
2 Fitz-Gerald 1963, no. 1, repr. on cover.
3 See Nyberg 1969, fol. 45, repr.
4 See ibid., fol. 5, repr.
5 Richard P. Wunder, *Architectural and Ornament Drawings of the 16th to the Early 19th Centuries in the Collection of the University of Michigan Museum of Art*, exh. cat. (Ann Arbor, 1965), nos. 32–33, repr.; and *Architectural, Ornament, Landscape, and Figure Drawings*, no. 75, repr.

48. Study for a Festival Machine

Black and red chalk. 12⁹/₁₆ × 17⁹/₁₆ in. (319 × 446 mm). Rubbed at top. Watermark traced in graphite on verso.

WATERMARK: FIN/NORMANDIE/I [heart] I OUVRIER[?] / 1740 (not found in Briquet, Heawood, or Churchill).

PROVENANCE: [Seiferheld Gallery, New York]; [Yvonne ffrench, London].

BIBLIOGRAPHY: Fitz-Gerald 1963, no. 5, repr.

The Elisha Whittelsey Collection, The Elisha Whittelsey Fund, 1968 68.729.3

This bravura sheet is a mystery that has been impossible to solve up to this point. It is seemingly a design for a festival *décor*. A highly decorated colonnaded structure in red chalk with wreaths and festoons between the garlanded columns is the background for a scene with dynastic implications. In the center a female figure with a scepter holds a baby toward the outstretched hands of another female kneeling on the wide staircase of the structure. Just below her is a figure swimming with what appears to be a childlike putto. In the left foreground, Neptune with his trident sits astride two sea horses. At the right are two river gods. The watery symbols are important in this scene but do not provide a clue to the solution of the problem. This study represents what seems to be an important celebration. The festivity could be for something like the commemoration of the birth of the duc de Bourgogne, Louis XVI's older brother, in 1751.

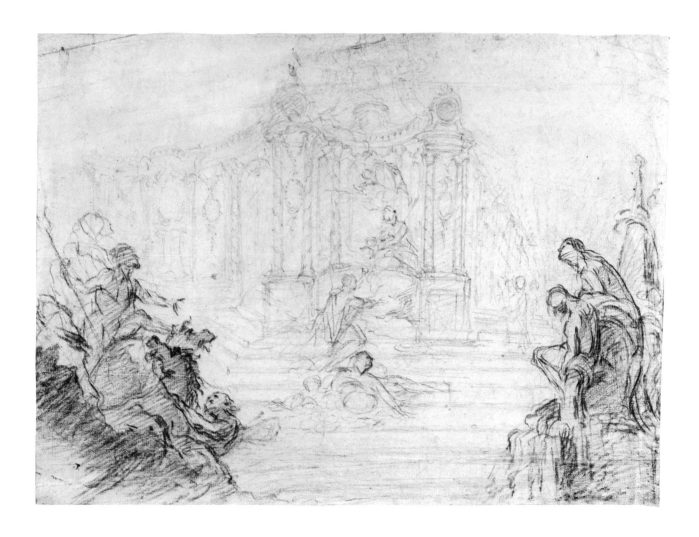

JEAN-JACQUES HUVÉ
Magnanville 1742–Paris 1808

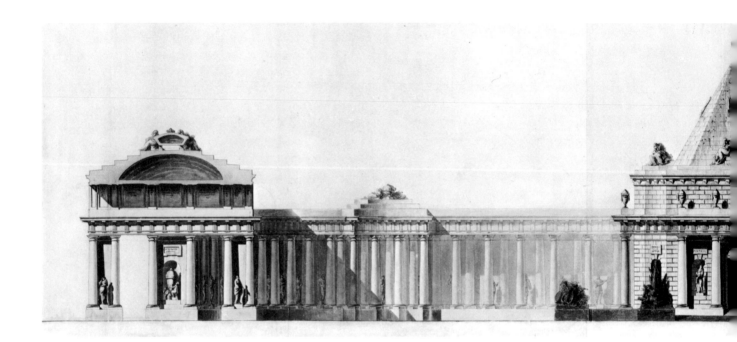

49. Elevation of a Monument

Pen, gray ink, with gray and brown wash.
15¾ × 65¹³⁄₁₆ in. (400 × 1672 mm). Central
portion of paper replaced, 15¾ × 14⅜ in.
(400 × 365 mm). Creased vertically in three
places. Lined. Scale in *toises*.

PROVENANCE: [Seiferheld Gallery,
New York]; Mr. and Mrs. Charles
Wrightsman.

BIBLIOGRAPHY: Harris 1969, pp. 247,
249, fig. 3; *Notable Acquisitions, 1965–1975*,
p. 202, repr.

Gift of Mr. and Mrs. Charles Wrightsman,
1970
1970.736.51

In 1759 Huvé was admitted as a student into
the Royal Academy of Architecture. There he
studied with Blondel, who had him provide
plans for the Hôtel de la Monnaie, the Mint. In
1770 Huvé won the grand prize for a project for
an arsenal. During 1774 and 1775, he was a *pen-
sionnaire* in Rome. On his return, *Directeur Général
des Bâtiments du Roi* d'Angiviller named him an
inspector of work at the Bâtiments du Roi at
Versailles. In addition to his official duties, he
built a number of private houses, including those
for the vicomte de La Rochefoucauld and for
the comtesse de La Suze on the rue de Varennes
between 1777 and 1780. He became mayor of
Versailles in 1792, just before being imprisoned.
After he was freed, he was named curator of a
museum in Versailles, but he left the position to
live in Paris, where he died in 1808.

John Harris has identified this design, show-
ing a pyramidal central pavilion fronted and

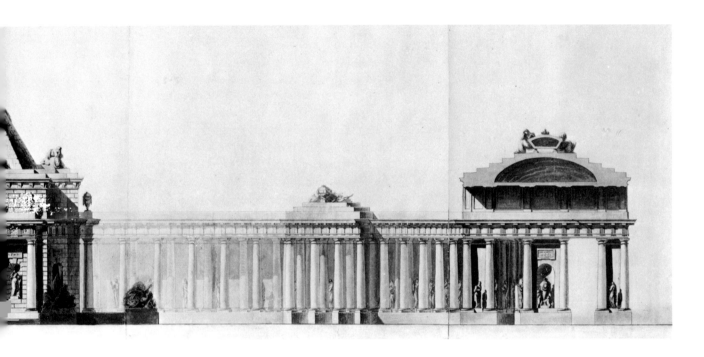

flanked by Doric colonnades with setbacks and
end pavilions with shallow domes, as a mauso-
leum on the basis of its close relationship to a
project by Desprez that was a *prix d'émulation* of
June 1766.[1] That design, which was later en-
graved, was for a mausoleum for kings and great
men and was dedicated to Voltaire. The central
portion was a pyramid, as in our study, although
it is to be noted that the central portion of our
sheet has been pasted over, suggesting that this
was not the original design. Harris conjectures
that the figure whose head is crowned with lau-
rel may be Voltaire and that, therefore, this pro-
ject is also dedicated to him. Although this
drawing has not been connected with any of the
Academy projects, it was probably intended for
such an end instead of for an actual building.

NOTE

1 See Pérouse de Montclos 1984, p. 83.

JEAN-JACQUES LAGRENÉE LE JEUNE

Paris 1739–Paris 1821

50. Study for a Ceiling

Gouache. 28⅛ × 17½ in. (714 × 445 mm). Lined in patches. Edges uneven and torn; color slightly abraded.

Signed at upper left, *Lagrenée*.

PROVENANCE: [B. T. Batsford, Ltd., London]; purchased in London.

BIBLIOGRAPHY: Dealer's cat., B. T. Batsford, Ltd., London, ca. 1932, no. 78.

Harris Brisbane Dick Fund, 1932
32.85.6

Jean-Jacques Lagrenée[1] was a pupil of his brother, Louis-Jean-François, who was sixteen years his elder. When Louis was invited to Russia by Empress Elizabeth in 1760, Jean-Jacques accompanied him. After having won a second prize in the Academy, in 1765 Jean-Jacques traveled to Rome, where he remained until April 1769. The year of his return, he was *agrée* in the Royal Academy of Painting and Sculpture and was received with full membership in 1775. Lagrenée's reception piece, *Winter*, was a painting that was to decorate the Galerie d'Apollon in the Louvre, the room in which the Academy met, and is still in place there. He is well known for his painting of Apollo among the Graces and the Muses on the ceiling of the theater of the Petit Trianon at Versailles. He was an etcher who produced a substantial body of work, the earlier pieces having been executed after works by his brother and Italian painters. His later works were based on his own designs and took the form of etchings executed in the wash manner. He also worked at the Manufacture de Sèvres.

This and the drawing in the following entry are part of a group of ten drawings, the remainder of which are by François-Joseph Belanger (see Nos. 8–13). The drawings in the group are similar in size and shape and are projects for carpets and ceilings, with the exception of an especially large plan by Belanger for a Palladian villa and its gardens. The inclusion of two drawings by Lagrenée with a group of eight by Belanger suggests that the Lagrenée studies were for ceilings in a Belanger-designed building. In the monograph on Belanger by Jean Stern, however, only one building is listed on which the two worked together: the magnificent *hôtel* of 1779 on the Place Vendôme belonging to the *trésorier général de la Marine* M. Claude-Baudard de Sainte-James, for whom Belanger had also designed an exceptional *folie* in Neuilly, surpassing, some said, that at Bagatelle.[2] Although the building of M. de Sainte-James's *hôtel* still exists (now the site of the jewelry firm Chaumet), the ceilings have been removed. Causing further difficulty in identifying the ceiling is the date on the drawing in the following entry, which seems to read *176–*; if it is correct, and it very well may not be, it most likely would have been 1769, just after Lagrenée's return from Rome, while he was still in the earliest years of his career. Although there is no evidence at present for the suggestion, these designs for ceilings may be for the Hôtel de Mazarin, where, during the year 1780, in the grand salon, tapestries representing the subjects Rinaldo and Armida covered the walls.[3]

This study for a ceiling is divided into three panels, two rectangular panels at either end and a circular panel in the center. Narrow panels in green with curling tendrils bordered by yellow fill the long sides, and they are connected at the corners by square panels with blue medallions and white ornaments. The long sides are bordered by yet more narrow yellow bands filled with decorative foliage. The decorative elements around the central circle, delicate figures entwined with swirls of foliage, derive partly from

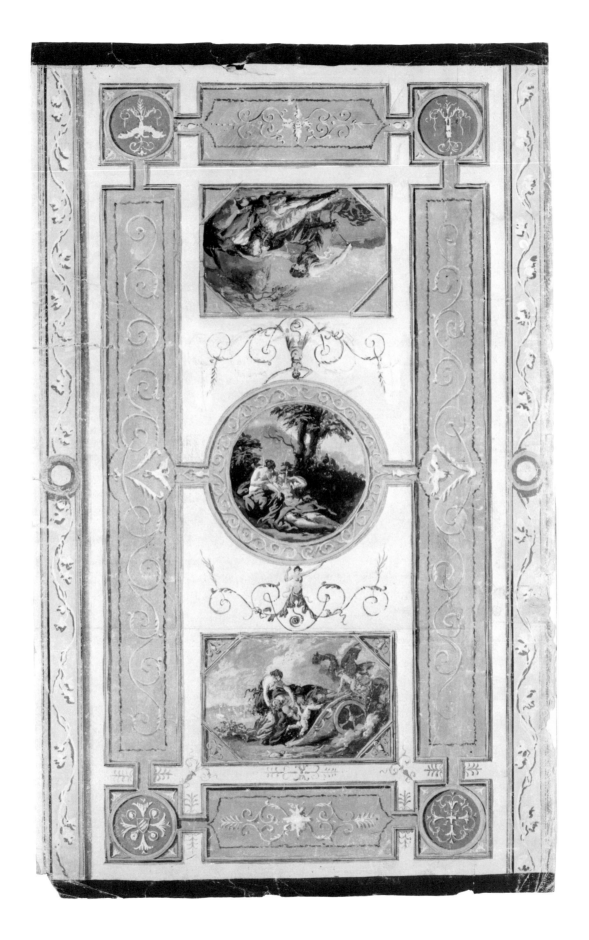

the arabesques of Berain but probably owe a closer debt to the wall paintings at Pompeii and Herculaneum.

The scenes represented here and in the following entry tell the story of Rinaldo and Armida, from Torquato Tasso's *Gerusalemme liberata*.[4] Rinaldo, a Christian knight (garbed in red) on his way to liberate Jerusalem, is found sleeping by the enchantress Armida (dressed in blue), who draws her dagger to kill him (top); looking into his face, she falls in love with him and then abducts him in her chariot (bottom); in the central roundel, the lovers recline in her enchanted garden. A subsequent scene is represented in the drawing in the following entry.

NOTES

1 Marianne Roland Michel was responsible for identifying this and the succeeding drawing as by Lagrenée.
2 Stern 1930, p. 145.
3 Ibid., p. 153.
4 I am grateful to James D. Draper, who identified these scenes. On Tasso and the visual arts, see R. W. Lee, "*Ut Pictura Poesis:* The Humanistic Theory of Painting," *Art Bulletin* (December 1940), pp. 197–269; and R. W. Lee, "Armida's Abandonment: A Study in Tasso Iconography Before 1700," in M. Meiss, ed., *Essays in Honor of Erwin Panofsky* (New York, 1961), pp. 335–349.

51. Study for a Ceiling

Gouache. Edges lined with blue paper mount, with framing line. 15¼ × 26¾ in. (387 × 680 mm).

Signed in brown ink at lower left edge, *La grenée le cadet plafond* [– –––––––] *?176[?]*.

PROVENANCE: [B. T. Batsford, Ltd., London]; purchased in London.

BIBLIOGRAPHY: Dealer's cat., B. T. Batsford, Ltd., London, ca. 1932, no. 78.

Harris Brisbane Dick Fund, 1932
32.85.9

This study is composed of a central square enclosing a scene and narrow panels with garlands and swags of blue on a yellow ground along the long sides of the design. Panels with blue-and-green backgrounds and a motif of curling tendrils are disposed along the short sides of the design. Small squares with white decoration on a blue ground are placed on the diagonal at each corner. On either side, between the central square and the borders, are cagelike designs in which figures are set, the man garbed in red, the woman in blue. These figures are Rinaldo and Armida (see preceding entry) from Tasso's *Gerusalemme liberata*.

In the central square is a scene consisting of four figures and a tree on which a large golden shield is hung. This scene follows those represented in the preceding entry. Rinaldo, alone after Armida has set off for her daily errands of magic, is spied asleep in her enchanted garden by his fellow Christian knights Carlo and Ubaldo. They awaken Rinaldo. To break his enchantment, the two knights put the magic shield before him. Rinaldo sees his depraved body and soul reflected in the shield and, in his shock and disgust, is restored to his former self. To the right of the central square Rinaldo reclines, asleep, and Armida stands, swaying away from him, while to the left, Rinaldo stands with his two arms extended as if to put off Armida, who rushes toward him with arms outstretched. The story ends with Rinaldo abandoning Armida to return with his friends to the holy war, and, like Dido abandoned by Aeneas, Armida watches him from the shore as he sails away. Presumably, the representations of Armida and Rinaldo at the left refer to his flight and her efforts to stop him.

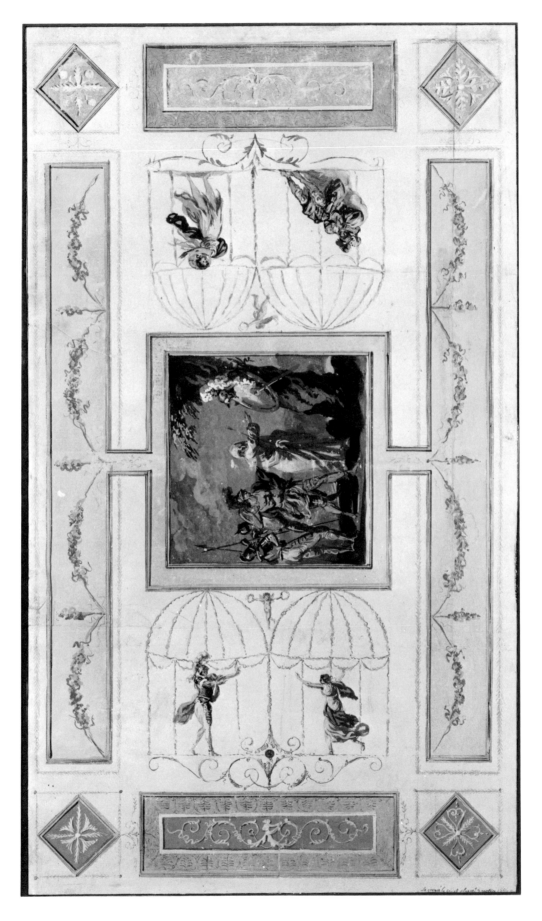

JACQUES DE LAJOÜE
Paris 1686–Paris 1761

52. Study for a Stage Set

Pen, gray ink, with gray and colored wash over traces of black chalk and graphite. Framing line. 10 ⅟16 × 16 ⅟16 in. (256 × 407 mm).

Signed at bottom right in gray ink, *Lajoüe*.

PROVENANCE: [E. Parsons & Sons, London]; purchased in London.

BIBLIOGRAPHY: J. Scholz and A. Hyatt Mayor, *Baroque and Romantic Stage Design*, New York, 1950, no. 66, repr.; C. J. Weinhardt, Jr., "Ornament Prints and Drawings of the Eighteenth Century," *MMAB* 18 (January 1960), p. 151, repr.; Roland Michel 1984, p. 282, D. 207, fig. 289.

Harris Brisbane Dick Fund, 1935
35.76.1

Jacques de Lajoüe's father was a master mason and architect, so the young man grew up among plans for architecture. Although he never built in three dimensions, he was a master with paintbrush and pen, producing grand schemes for architecture and landscape on canvas and paper. He was criticized by J.-F. Blondel, who had himself created work in the Rococo style, as being, along with Meissonnier and Pineau, an inventor of the *genre pittoresque*, or the Rococo, which had already passed out of fashion when Blondel wrote in 1774. Despite the harsh words of Blondel, Lajoüe had a successful career, and in the words of Marianne Roland Michel, in a certain way he was the only true painter of the rocaille. He was accepted into the Royal Academy in 1721 and exhibited there regularly until

1753, the year he painted an allegory of King Louis XV for Madame de Pompadour. The influence of Lajoüe's art was spread throughout Europe by the more than 180 prints after his designs, along with his drawings and paintings.

Mme Roland Michel has suggested that this sheet and its pendant (the following drawing) are studies for theater decor. Certainly the dark foreground architecture that frames the scene, with garlands hanging from its center, is theatrical. In the middle ground are trelliswork, staircases, and fountains. The trellises frame the view of a garden in the far background.

53. Study for a Stage Set

Pen, gray ink, with gray and colored wash over traces of black chalk and graphite. Framing line. Creased vertically at center, creased line enhanced by black chalk. 10 ⅟16 × 16 ⅟16 in. (256 × 408 mm).

Signed in gray ink at bottom right, *Lajoüe*.

PROVENANCE: See Number 52.

BIBLIOGRAPHY: J. Scholz and A. Hyatt Mayor, *Baroque and Romantic Stage Design*, New York, 1950, no. 67, repr.; A. Czére, "The Influence of Stage Scenery on Non-Theatrical Works by European Masters in the Seventeenth and Eighteenth Centuries," in A. Schnapper, ed., *La scenografia barocca*, Atti del XXIV Congresso Internazionale di Storia dell'Arte, Bologna, [1982], pp. 165, 168, fig. 141; Roland Michel 1984, p. 282, D. 208, fig. 291.

Harris Brisbane Dick Fund, 1935
35.76.2

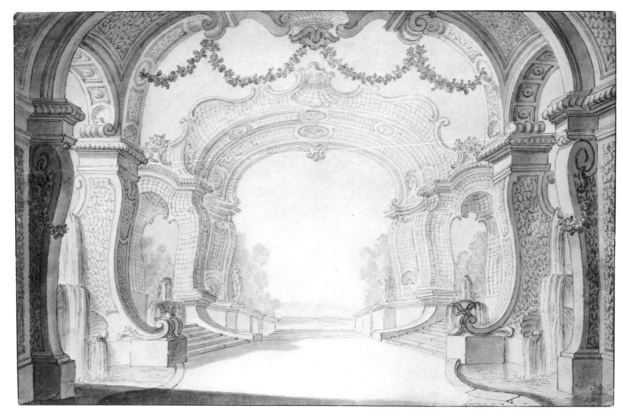

52

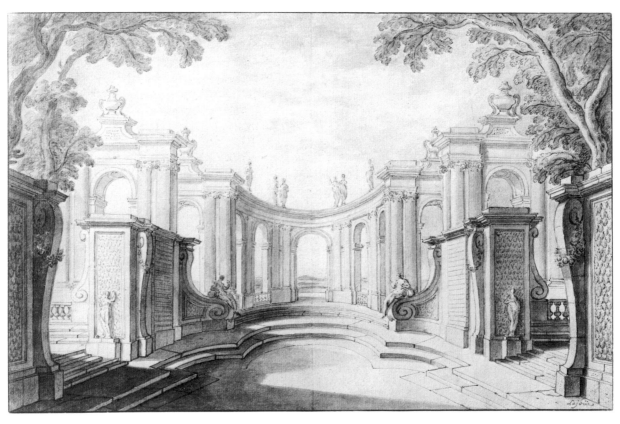

53

This study for a stage set is much more architectural than its pendant. Trees and architecture frame the scene, which is set apart by three steps from the portico that partially closes the background. The latter is merely hinted at by ribbons of gray wash. Lajoüe's typical figures, with small heads and billowing draperies decreasing to a narrow band around the feet, populate the foreground and middle ground of the scene.

Marianne Roland Michel has pointed out that the architecture recalls that of the *Dessein de la décoration pour les tragédies du Collège Louis le Grand* by Le Maire dating from 1732.[1] Furthermore, she compares this drawing and its pendant with two engraved *vues d'optiques* representing the decoration of a theater and a view of a garden of delights.[2]

NOTES

1 B. N. Estampes, coll. Hennin, t. 94.
2 B. N. Estampes, Li 72, t. 9.

54. Study for the Rotunda of a Palace

Red chalk, with wash in red chalk. Framing lines in black ink on mount. 8 15/16 × 13 7/16 in. (227 × 341 mm). Lined.

Inscribed in brown ink on mount, *La Joüe*.

PROVENANCE: Perhaps one of "six vues de Sallons d'architecture, perspectives et décorations de jardins; desseins à la plume, à la sanguine et lavés à l'encre de chine" in the Huquier sale, November 9, 1772, no. 559; [Galerie Cailleux, Paris; its mark, *C . . x* within an oval, not in Lugt]; purchased in Paris.

BIBLIOGRAPHY: *Notable Acquisitions, 1975–1979*, p. 61, repr.; Roland Michel 1984, p. 296, D. 263, fig. 272, p. 292, under D. 248.

Purchase, Anne Stern Gift, 1978
1978.508

This sheet is one of the very few works by Lajoüe in red chalk, among which are one in the Kunstbibliothek, Berlin, and another whose present location is unknown.[1] In place of his usual ink and wash, in these studies Lajoüe uses fine hatching as well as some red-chalk wash.

Two figures in oriental garb stand in the foreground, which also has a fountain in a grotto-niche to the right. An arch separates the foreground from the background, which is a rounded *salon à l'italienne* with arched French doors and statues and figures either standing or seated on the ground. Marianne Roland Michel has noted the similarity of this architecture to that of the Salon de Crozat at Montmorency as it was painted by Lancret. The Metropolitan sheet and the one in Berlin have such features in common as the large fountain and a perspective view, although this design is an interior and that in Berlin is an exterior with an arcaded pavilion

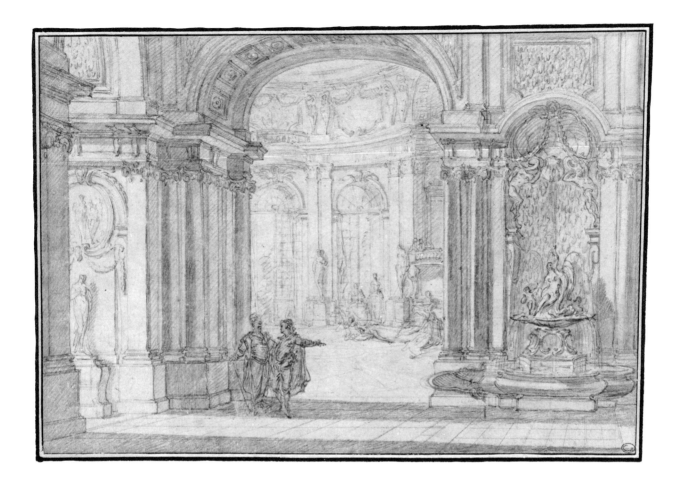

giving onto a terrace with a fountain. The composition of the Berlin drawing has affinities with Lajoüe's reception piece for the Academy of 1721, a painting on deposit from the Louvre in the Musée Baron Martin, Gray, thus suggesting a date early in Lajoüe's career, between 1720 and 1725, for both the Berlin sheet and for our own.[2]

The architecture in the Metropolitan drawing is very close to another Lajoüe sheet, whose present location is unknown,[3] which Mme Roland Michel has compared to a perspective study that is attributed to Robert de Cotte but is perhaps also by Lajoüe.[4] Mme Roland Michel suggests that the Berlin drawing and our own are studies for interior and exterior perspective scenes but also underlines that the purpose of the two sheets, whether they were for the theater or were fantasy capriccios, is undetermined.

NOTES

1 Roland Michel 1984, D. 248, D. 239.
2 Ibid., P. 184, fig. 161.
3 Ibid., D. 212, fig. 273.
4 B. N. Estampes, B2b Rés, p. 24; Roland Michel 1984, fig. 183, under P. 235, and p. 105.

55. Design for a Folding Screen

Pen, gray ink, and wash over traces of black chalk and graphite. Framing lines. 13⅞ × 4⅝ in. (353 × 117 mm). Lined with decorative mount.

Signed in gray ink at bottom right, *Lajoüe*.

WATERMARK: Fleur-de-lis and an escutcheon with 4 above, W below (visible in raking light on recto).

PROVENANCE: [Prouté, Paris]; S. Kaufman, London; [W. R. Jeudwine, London]; purchased in London.

BIBLIOGRAPHY: Kaufman and Knox 1969, no. 17, repr.; Roland Michel 1984, p. 274, D. 185, fig. 255.

Purchase, Harris Brisbane Dick Fund and Joseph Pulitzer Bequest, 1971
1971.513.3

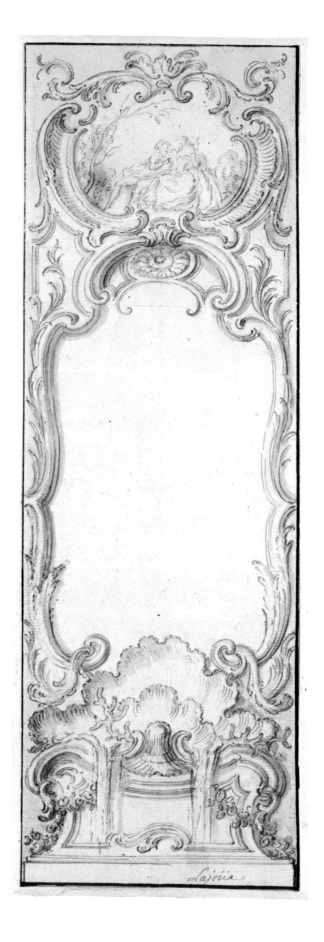

This is a study for a panel of a folding screen, as Marianne Roland Michel has noted. However, Kaufman and Knox published it as a design for paneling. It is to be compared with a folding screen of six panels in the Dutuit collection at the Petit Palais[1] or with drawings in the Robert de Cotte albums, in which the compositions, like our sheet, are divided into three registers. The first register consists of a base with scrolls on which shellwork and coral are placed and from which water flows down the base. The empty middle register is bordered by scrolls of leafy foliage. In the cartouche in the upper register, a young woman sits next to a young man, an image taken from Watteau's *Le printemps*, from a set of Four Seasons designed for a screen and etched by Boucher.[2] Mme Roland Michel points out that the empty cartouche leaves much of the composition to the wishes of the ultimate owner, a very Rococo device. Kaufman and Knox note the symmetry of the composition, which they find in the works of Pineau dating to 1733 and which Roland Michel compares to the set of

prints after Lajoüe, *Recueil nouveau de differens cartouches*, for which reason she dates the drawing to about 1735.

NOTES

1 Roland Michel 1984, P. 57a–f, figs. 88–99.
2 See E. Dacier and A. Vuaflart, *Jean de Jullienne et les graveurs de Watteau au XVIIIe siècle* (Paris, 1922), vol. III, nos. 68–71 (no. 70, *Le printemps*).

56. Study for the Corner of a Decoration

VERSO. Late-Eighteenth- or Nineteenth-Century Sketch of Monumental Building with Four Temple-Front Entrances

Pen, dark gray ink, and gray wash, with parallel diagonal lines and scale in black chalk, and with incised lines squared off in lower part of sheet (recto); pen, gray ink over black chalk (verso). Framing lines on bottom and right side (recto). 10¾ × 16⅛ in. (273 × 410 mm).

Signed lower center of recto in dark gray ink, *Lajoüe*.

PROVENANCE: [Galerie Cailleux, Paris]; purchased in Paris.

Edward Pearce Casey Fund, 1985
1985.1116.2

The design incorporates, at the right, a tall vase with a broad, leafy plant perched on a bit of scrollwork around which is entwined a garland of flowers and more foliage and, at the left, or, rather, in what would be the center of the design, a low vase filled with flowers.

This sheet resembles the decoration in the two sets of prints, *Nouveaux tableaux d'ornements et rocailles* and *Second livre de tableaux et rocailles*, by Huquier after Lajoüe,[1] especially the left-hand side of plate 11, which has vases on scrollwork, garlands, and foliage. Marianne Roland Michel dates the sets to about 1740, based partly on Huquier's address on the prints, which corresponds to his residence between 1738 and 1748. This study is less exuberant than that in the *Livres de tableaux et rocailles*, and therefore I would think it earlier, about 1730.

NOTE

1 Roland Michel 1984, G. 150–167, figs. 438, 445–459, 461.

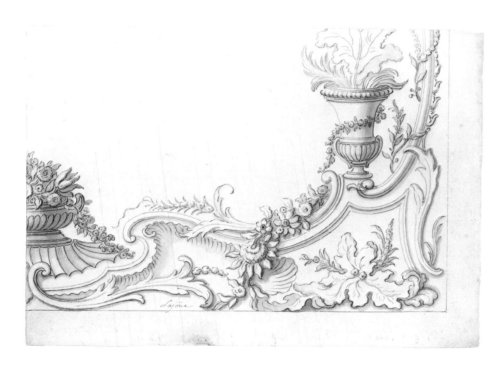

LOUIS-FÉLIX DE LA RUE

Paris 1731–Paris 1765

57. Designs for the Top and Bottom of a Small Rectangular Box

Pen, dark brown ink, light brown wash, over black chalk. Framing line around each design. 7 1/16 × 4 7/16 in. (179 × 113 mm). Lined, with added piece of paper 5/16 × 4 7/16 in. pasted on drawing at bottom. Creased horizontally above center.

Inscribed above upper scene, *desus de la boete lamour et* [*himen?*]/*de bas lief*, at lower right of upper scene, *de bas lief*, and above lower design, *desous*.

PROVENANCE: Mr. and Mrs. Charles Wrightsman.

Gift of Mr. and Mrs. Charles Wrightsman, 1978
1978.621

In 1750 Louis-Félix de La Rue won the first prize in sculpture at the Royal Academy, having studied with Lambert-Sigisbert Adam, the uncle of Clodion. He subsequently spent a brief period, from 1754 to 1755, in Rome as a *pensionnaire* and was admitted to the Académie de Saint-Luc in 1760. Before his Roman sojourn, he had worked for the royal porcelain manufactory at Sèvres, producing small groups of children after Boucher's designs. Many of his etchings and many of the prodigious number of his drawings depend on Boucher,[1] whereas his sculpture owes much to Clodion.[2]

La Rue's drawings nearly always depict classical themes.[3] In this design, the scene of a sacrifice at a smoking altar of Love is typical of La Rue's near-mania for the antique. This theme—a sacrifice at a burning altar—was a particular favorite of the artist.[4] The long, attenuated figures

with their saucerlike gazes and the pudgy putti are also characteristic of the peculiar style of his draughtsmanship.

Many of his drawings are for ornamental objects. In the Hédou Collection in the Musée des Beaux-Arts, Rouen, are two sheets with sketches for oval boxes, one showing winged figures leaning on altars with vases and the other with altars supporting coats of arms.[5] In the Musée des Beaux-Arts, Lille, is a project for a clock, depicting the Three Fates around a smoking altar supporting a vase with the clock's movement and a putto to indicate the time.[6] In the Kunstbibliothek, Berlin, a series of twenty-five sheets of ornamental subjects including candelabra, funeral monuments, furniture, and vases[7] were models for some of the plates Parizeau etched between 1772 and 1775 as the *Suite de vases, trépiés, autels, tables, chandeliers, etc. Dans le gout antique*, which appeared as seven sets of seventy-four prints after La Rue's premature death at thirty-four.[8]

No box executed after these designs has been traced. Clare Le Corbeiller points out a rectangular gold and enamel box made by Jean-Joseph Barriere of Paris in 1765 that displays La Rue's classical theme and motifs in the manner in which they would probably have been realized. Its cover has at its center a grisaille miniature showing Venus receiving an arrow from Cupid, and the sides of the box are decorated with such other classical motifs as putti hanging laurel festoons from antique vases.

NOTES

1 See Jean-Richard 1978, nos. 1257–1311; B. N., *Inventaire*, vol. XII, pp. 424–426.
2 See S. Lami, *Dictionnaire des sculpteurs de l'École française au dix-huitième siècle* (Paris, 1911), vol. II, pp. 31–34, which gives a list of some of his sculptures.
3 The drawings are found in many collections; for example, the Louvre (Guiffrey and Marcel, vol. VII, 1912, pp. 100–104, nos. 5665–5698); the Kunstbibliothek in Berlin (Berckenhagen 1970, pp. 320–321); the Musée des Arts

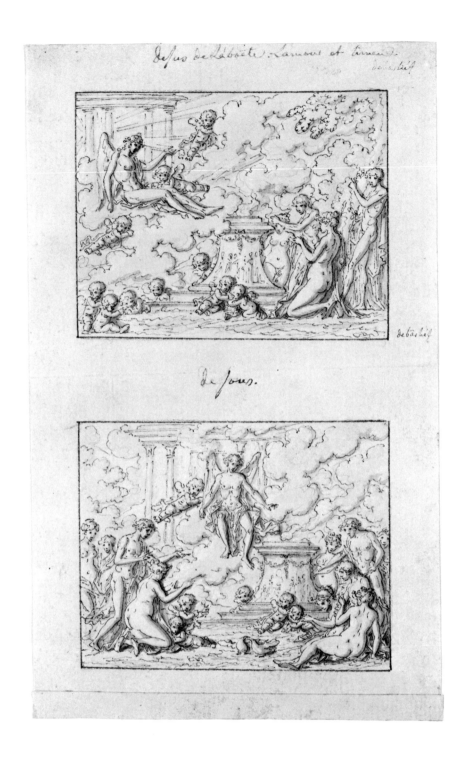

Décoratifs in Lyons (*Dessins du XVIe au XIXe siècle de la collection du Musée des Arts Décoratifs de Lyon* [Lyons, 1984–85], no. 82, repr., and others not published); to name a few.

4 Examples can be found in the Musée des Arts Décoratifs, Lyons, inv. nos. 4508/a and 5710/a; Witt Collection, Courtauld Institute, London, inv. no. 2633A; sale, Christie's, London, June 28, 1966, lot 67; Musée des Beaux-Arts, Poitiers, published in Jean Lacambre et al., *Le Néo-classicism français: Dessins des musées de province*, exh. cat., Grand Palais (Paris, 1974), nos. 87–88, repr.

5 Pen, brown and gray ink, 79 × 125 and 84 × 124 mm; unpublished.

6 *Autour de David: Dessins néo-classiques du Musée des Beaux-Arts de Lille*, exh. cat. (Lille, 1983), no. 111, repr.

7 Berckenhagen 1970, pp. 320–321, Hdz 2467, 1–25. A sheet with female figures supporting clocks is illustrated.

8 Berlin 1939, no. 1092.

ÉTIENNE DE LAVALLÉE, CALLED LAVALLÉE-POUSSIN

Rouen 1722–Paris 1802

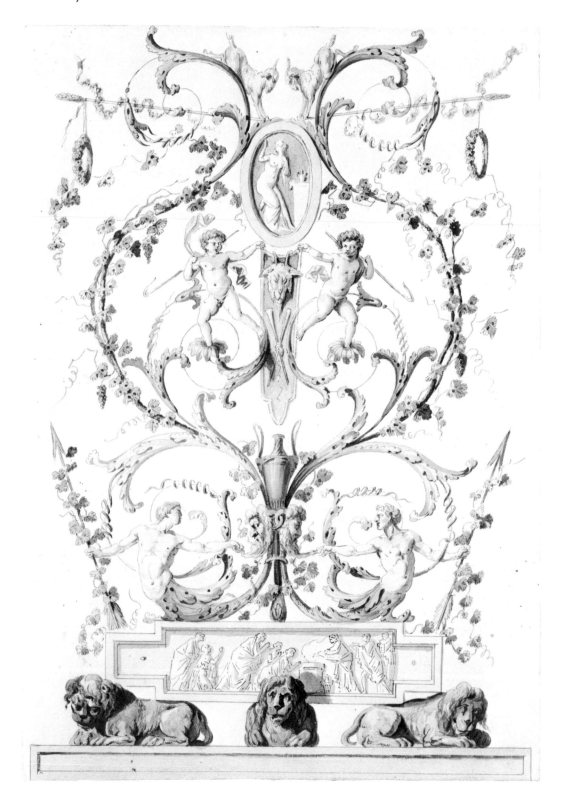

58. Study for an Arabesque

Pen, gray and brown ink, with colored
wash. 15 1/16 × 10 5/8 in. (383 × 270 mm).
Lined with decorated mount.

Inscribed on verso in ink at lower right,
Lavallée-Poussin.

PROVENANCE: [Guiot, Paris]; S. Kauf-
man, London; [W. R. Jeudwine, London];
purchased in London.

BIBLIOGRAPHY: Kaufman and Knox
1969, no. 20, repr.

Purchase, Harris Brisbane Dick Fund and
Joseph Pulitzer Bequest, 1971
1971.513.40

Lavallée-Poussin, so called because of a claim
to relationship with Poussin, entered the stu-
dio of J.-B. Pierre in 1755 and won the Prix de
Rome in 1759.[1] He did not immediately set out
but instead stayed in Paris, where he studied as
an *élève protégé* until 1762. He was a *pensionnaire*
at the French Academy in Rome and then re-
mained in Italy until 1777. In Rome he made the
acquaintances of Piranesi and C.-L. Clérisseau
and decorated the residence, called the Jardin de
Malte, of the *bailli de Breteuil*, the ambassador of
Malta, with *arabesques à l'antique*. They were a
grand success. Arriving back in Paris in 1777, he
established himself as a decorator of residences
and painted the *hôtels* Grimod de la Reynière,
Louvois, Bullion, and Louveciennes in the
new taste.

Lavallée-Poussin's first essay in printmaking
was carried out in Rome when he illustrated a
small book of poetry published to honor the visit
of the financier Watelet and Madame Lecomte
in 1764.[2] He made few prints himself, and his
name now is associated with a volume entitled
*Premier cahier d'arabesques et de décorations propres
aux artistes de ce genre, dessinées par Mr. J. M.
Moreau et à Rome par Mr. Lavallé Pousin*, pub-

lished in Paris by Laurent Guyot with designs
from others as well.

Our drawing bears a striking resemblance to
various motifs in the *Cahier d'arabesques*. There is
always a ground line for the elements of the ara-
besque to rest upon; here, it is the frieze with
classical figures supported by couchant lions.
Above it the male figures issuing from foliage
and holding spears with vines wound about
them pull the beards of masks. A vase between
them divides the foliage that grows up and sup-
ports two putti on either side of a panel with
crossed horns and a ram's head. The panel is
surmounted by an oval containing a scene of a
female next to an altar, which in turn supports
two rams jumping from the uppermost foliage.
Two lions similar to those supporting the frieze
appear in cahier 6, plate 4, of the *Cahier d'ara-
besques*, while a figure growing out of foliage ap-
pears in cahier 2, plate 1. Plate 2 in cahier 6 has a
vase similar to that in our drawing. It is sup-
ported by a classical frieze also similar to our
drawing's.

In these designs there is a solidity of both the
figures and their supports that is quite distinct
from the more airy arabesques of Cauvet or the
earlier anonymous arabesque (see No. 112). Two
drawings with the same design vocabulary in the
Kunstbibliothek, Berlin, are attributed to Cauvet
but surely must be by Lavallée-Poussin.[3]

NOTES

1 On Lavallée-Poussin, see *Piranèse et les français*, pp.
 169–170; and B. N., *Inventaire*, vol. XIII, pp. 64–68.
2 B. N., *Inventaire*, vol. XIII, pp. 65–67, no. 1.
3 Berckenhagen 1970, p. 324, Hdz 3517.

Jean-Jacques-François Le Barbier

Rouen 1738–Paris 1826

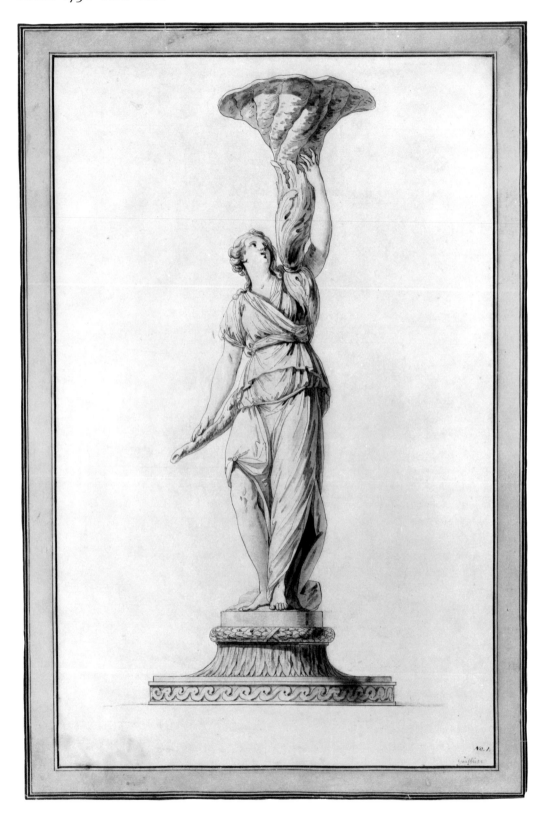

59. Design for a Candelabrum or Torchère

Pen, dark brown ink, with lighter brown wash. Brown framing lines with green wash. 18½ × 12³⁄₁₆ in. (470 × 310 mm).

Inscribed in dark brown ink at lower right, *No. 1.*, and below, in lighter brown ink, *Gouthiere*.

WATERMARK: Heawood 1838: Amsterdam, ca. 1769.

PROVENANCE: Sale, Sotheby's New York, January 16, 1985, part of no. 156, as Gouthière; [Armin B. Allen, Inc.]; purchased in New York.

BIBLIOGRAPHY: Armin B. Allen, Inc., *The Art of Design, 1575–1875 . . .* , New York, 1985, no. 99, repr.

The Elisha Whittelsey Collection, The Elisha Whittelsey Fund, 1986
1986.1007.2

This design for a candelabrum or torchère to be executed in porcelain was identified as a Le Barbier by Elaine Dee of the Cooper-Hewitt Museum because of its strong resemblance to two similar drawings for candelabra by Le Barbier in the collections there, one signed *LeBarb* on the drawing and the other with *LeBarbier* printed on the mount.[1] As is the case for the present design, colored wash was used for the former Cooper-Hewitt drawing, as if it were to be executed in porcelain, except for the yellow and brown of the base, which probably indicate that portion of the candlestick that was to be executed in gilt bronze. The second sheet at the Cooper-Hewitt is in dark yellow and brown wash, as if to emulate ormolu for the entire figure.

The large scale of this drawing—probably the same size as the candlestick—suggests that it was the model for the finished candelabrum, as was the case with the large-scale drawings for silver by Moitte and members of Auguste's workshop (see Nos. 3–5, 75).

NOTE

1 Inv. nos. 1911-28-203 and 1911-28-204, respectively.

A t the age of seventeen, Le Barbier won the first prize for drawing and architecture in the Academy in Rouen and left for Paris, where he became a pupil of J.-B.-M. Pierre (1713–1789). Although he never won the first prize in the Royal Academy, he seems to have gone to Rome at his own expense. In 1776 he was sent to Switzerland to sketch that country's most notable landscape sites. He exhibited at the Academy beginning in 1781 and was received as a full member in 1785 at the advanced age of forty-seven. He continued to show there regularly until 1814. His style was influenced by a lyrical and sentimental view of antiquity but was also imbued with a clear classicism that owed much to the example of Le Brun and other great artists of the seventeenth century. In addition to being a painter, he was a designer of book illustrations, especially for the works of his Swiss friend Salomon Gessner, and a designer of tapestries.

JEAN-LAURENT LEGEAY

Paris ca. 1710–Rome after 1788

60. Architectural Fantasy

Red chalk. 16¼ × 19¼ in. (413 × 488 mm).
Creased vertically at center and horizontally
one inch from bottom where image termi-
nates. Lower right corner torn and
repaired.

Inscribed in pen and brown ink at lower
left, *Giuseppe Poussin. fecit.*

WATERMARK: Fleur-de-lis above coat of
arms with bend; on other half of sheet, the
words ROTEN SCHL[end of word cut off].

PROVENANCE: [Lynven, Inc., New
York]; purchased in New York.

BIBLIOGRAPHY: Erouart 1982, no. 50
bis, fig. 60.

Edward Pearce Casey Fund, 1982
1982.1111

It is as a draughtsman and etcher of some of
the most original, even bizarre and exagge-
rated, visions of landscape and architectural fan-
tasies produced by a Frenchman during the
eighteenth century that Legeay is known today.
A winner of the Prix de Rome in 1732, he took
up residence in the French Academy in Rome
only in the autumn of 1737, remaining until
early January 1742. There he contributed etch-
ings to a set of Roman views published by
F. Amidei, along with his fellow *pensionnaires*
J.-C. Bellicard (see No. 14) and P.-F. Duflos, as
well as Piranesi, who etched most of the plates in
the set (and reworked one of Legeay's views for a
later edition). As Piranesi arrived in Rome in late
1740, his residence coincided with that of Legeay

for somewhat over a year, and given their work
on the same set of prints, it is probable that
they knew each other. Although Kaufmann[1]
and other writers have argued that Piranesi's
grandiose architectural visions of ancient monu-
ments, often massed claustrophobically, were
based on Legeay, that argument has been thor-
oughly disproved. It was Piranesi who decisively
influenced Legeay.

Lacking commissions on his return to Paris,
Legeay turned principally to teaching. He passed
on his own revolutionary architectural ideas as
well as those of Piranesi to his students, who be-
came the most innovative and brilliant archi-
tects of the next generation: Boullée, De Wailly
(see No. 39), Peyre, and Moreau-Desproux
(see No. 79).

In 1748 Legeay left Paris for Germany, where
he was architect to the duke of Mecklenburg-
Schwerin, remaining until 1756, when he
contrived to be named *premier architecte* of
Frederick the Great of Prussia. Owing to his dis-
putatious and megalomaniac nature, Legeay
quarreled with Frederick and was discharged in
1763, having built relatively little for him. He de-
parted Berlin and at an unknown date arrived in
England, where he remained through the de-
cade. There he was in contact with the architect
William Chambers and moved in antiquarian
circles. While there, he also made four sets of
etchings, the *Fontane*, dated 1767,[2] the *Rovine*, of
1768,[3] the *Tombeaux*, of 1768,[4] and the *Vasi* (un-
dated).[5] In these prints, Legeay upset all rules of
architecture, mixing different styles and encrust-
ing the vases, tombs, and fountains with dense
ornament composed of weird, fantastic mon-
sters, reptiles, caricatures, and plaques with
hieroglyphic-like inscriptions jumbled all to-
gether in stifling proximity and discontinuous
space and set in wild, decaying woods. The four
sets of prints were published in 1770 in Paris by
Mondhare.

Legeay failed again to establish himself in
Paris; he spent his last years in southwest-
ern France, in Toulouse, in small towns in
Languedoc, and in Marseilles, all the while writ-
ing imploring letters to his former patrons and
to the Academy and ministries in Paris asking
for work or money. Legeay did achieve one poi-
gnant wish: he had written "Rome cest la ville

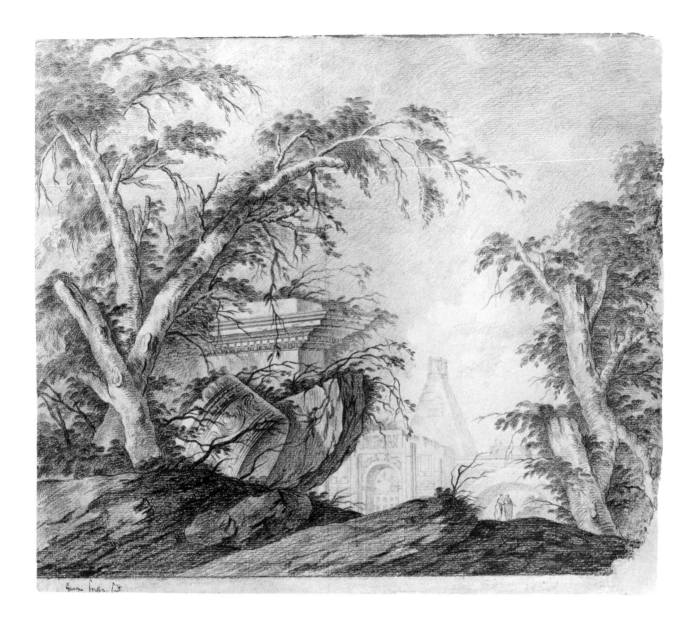

que je choisie pour ma dernière Dernière
Demeure étant le lieu le plus favorable pour
L'Étude" (Rome is the city I chose for my final
Final Abode, as it is the spot most conducive
to study);[6] his quixotic letter to the widow of
Frederick the Great asking for his unpaid salary
of a quarter of a century earlier, dated Rome,
1788, is the last record of one of the most origi-
nal but tragic architects of his time.

Legeay's favored medium was red chalk, ap-
plied in this drawing with bold and vigorous
strokes. The viewpoint of the architectural fan-
tasy is low, so that the gigantic trees in the fore-
ground loom even larger above the spectator.
The clumps of trees, with broken limbs and jag-

ged stumps, seem to grow from rocks and boul-
ders and to form a visual arch through which
the fragments of ruins and architecture are seen
receding in deep perspective to the right. The
slightly threatening atmosphere and the tension
between nature and ancient architecture is
expressed by the round fragment of a ruin, am-
biguously undefinable as to its architectural
function, that has fallen behind the group of
trees at the left, seeming to have split and dis-
lodged the huge rock behind it, which itself has
become a natural ruin. The architectural ruins
include a triumphal arch with a frieze contain-
ing figures, a bridge on which a horizontal
block is placed, with figures sitting on either

end, and a truncated pyramid surmounted by small figures at each corner who support a flat slab. Two small figures are silhouetted standing under the arch of the bridge. Such tiny creatures, dwarfed by both nature and architecture, are common features of Legeay's designs, as are the frieze decorated with sketchy figures on the triumphal arch and the truncated pyramid, a motif often favored by other artists of the period.

Our drawing, though narrower, is similar in composition and motifs to five large red-chalk horizontal landscape architectural fantasies by Legeay, of which four are in Berlin: three in the Kupferstichkabinett, Dahlem,[7] and one in the Kunstbibliothek.[8] The fifth is in Chicago.[9] Erouart dates this group to about 1757, when Legeay was resident in Berlin, because they share both the technique and themes of a series of eleven round red-chalk counterproof landscapes, dated 1757, now in Zurich.[10] Like our sheet, one of the Dahlem drawings[11] is unsigned, which Erouart maintains is exceptional in Legeay's landscapes. The Metropolitan Museum's pair of round landscape architectural fantasies (see the two following entries), also unsigned, were unknown at the time Erouart wrote.

The inscription *Giuseppe Poussin* may refer to Gaspard Dughet, known as Gaspard Poussin (1615–1675), who lived in Rome and was noted for his dramatic landscapes. Before Legeay's draughtsmanship was better known, such a misidentification was possible: although the Chicago drawing was signed by Legeay, it had been designated seventeenth-century French.[12]

NOTES

1 E. Kaufmann, "Three Revolutionary Architects, Boullée, Ledoux, and Lequeu," in *Transactions of the American Philosophical Society*, n.s., vol. 42, pt. 3 (1952), pp. 450–453.

2 Erouart 1982, nos. 127–132.

3 Ibid., nos. 139–144.

4 Ibid., nos. 133–138.

5 Ibid., nos. 145–150.

6 Ibid., p. 84.

7 Ibid., nos. 46, 49, 50.

8 Ibid., no. 48.

9 Ibid., no. 47.

10 Ibid., nos. 33–43.

11 Ibid., no. 46.

12 Noted by Pierre Rosenberg, as cited by Erouart 1982, under no. 47.

61. Architectural Fantasy

Red chalk. Diam. 12¾ in. (324 mm).

Inscribed in graphite on recto at upper left (now removed by conservation); on verso at upper right, *50*.

WATERMARK: Near Heawood 1849.

PROVENANCE: Lord Elgin; sale, Sotheby's New York, January 16, 1986, lot 106, as Pernet; purchased in New York.

Edward Pearce Casey Fund, 1986
1986.1017.1

This sheet and its pendant (No. 62) are drawn on English paper and have an English provenance. For that and for stylistic reasons, the drawings may be dated to the late 1760s while Legeay was still in England, the period during which he executed his four sets of prints, the *Fontane*, *Rovine*, *Tombeaux*, and *Vasi*, of 1767–68. It is probable that these drawings were meant to be engraved, as was a red-chalk roundel in the Louvre, a design for a title piece, inscribed *Varie Inventioni/de Paese Bosci/et Cascade; di Giovani Lorenso Le Geay/Primo Architetto del/re et intagliate da/lui stesso* (Various inventions of landscapes, woods, and cascades by Giovani Lorenso Le Geay, first architect to the king and engraved by himself).[1] This title-piece design is connected with a set of eleven round red-chalk counterproofs of fantastic landscapes, signed and dated 1757 and 1761, of fantastic landscapes, in the Kunsthaus, Zurich,[2] for which no prints are known. The Metropolitan's drawings are about 36 millimeters smaller than the Zurich counterproofs and are clearly not connected with them, for those landscapes have very few architectural elements. However, our drawings share many of the characteristics of the etchings of the *Rovine*, of 1768, which often have bits of architecture with ragged trees framing distant, lightly drawn architecture and contain bizarre, caricature-like faces, such as the one at the lower left of the present work. Typical also are the small figures set amid and dwarfed by the crumbling architecture, as is the ambiguity of the plaque on the cliff at the right, which is inscribed in deliberately indecipherable letters. From that cliff extends a beam with a hanging cage, a motif—used in one of the Zurich counterproofs[3]—that evokes the ghoulish tradition of displaying enemy or criminal heads in a cage and also recalls the sinister hanging lanterns and broken pulleys in Piranesi's *Prisons*. The piled-up architecture in the distance, partially in ruins, also recalls Piranesi's *Antichità romane*.

A pair of red-chalk roundels by Legeay of landscapes with ruins with the same measurements as this pair recently appeared on the New York art market.[4] Presumably they were part of the same series.

NOTES

1 Erouart 1982, no. 32, repr.
2 Ibid., nos. 33–43, repr.
3 Ibid., no. 38, fig. 183.
4 Sale, Christie's, New York, January 11, 1989, lot 143, repr.

62. Architectural Fantasy

Red chalk. Diam. 12¾ in. (324 mm).

Inscribed in graphite on recto at upper left (now removed by conservation); on verso at upper right, *51*.

WATERMARK: Near Heawood 3548.

PROVENANCE: See Number 61.

Edward Pearce Casey Fund, 1986
1986.1017.2

See Number 61.

LOUIS-JOSEPH LE LORRAIN

Paris 1715–Saint Petersburg 1759

63. Frontispiece for a Suite of Vase Designs

Pen, gray ink, brown wash. 7⁹/₁₆ × 5¹/₁₆ in. (192 × 129 mm). Creased vertically at center. Inlaid on decorative mount.

Inscribed in gray ink on base of vase, SUIE DE/VASE; signed below in gray ink, *Lelorrain*; inscribed on mount at lower left, *Lelorrain*, and at top right, *no. 37.*

PROVENANCE: Hippolyte Destailleur; Destailleur sale, Paris, May 19–23, 1896, lot 147 (album; now dismantled); [Martin Breslauer]; purchased in London.

BIBLIOGRAPHY: *Piranèse et les français*, pp. 212–214, repr.; Rosenberg 1978, pp. 184–185, fig. 48, p. 200 n. 78.

The Elisha Whittelsey Collection, The Elisha Whittelsey Fund, 1948 48.148(37)

Le Lorrain, a pupil of the architect Jacques Dumont le Romain, won the Grand Prix for painting in 1739 and took up residence in Rome as a *pensionnaire* in December 1740, remaining in Rome for eight years.[1] Among his fellow students were Joseph Vernet, Joseph-Marie Vien, the sculptor Jacques Saly, and the inventive and talented group of forward-looking young architects including Gabriel-Pierre-Martin Dumont, Jean-Laurent Legeay (see Nos. 60–62), Nicolas-Henri Jardin, and Charles-Michel-Ange Challe (see No. 24), who were instrumental in shaping the coming shift in style toward Neoclassicism.

Le Lorrain was multitalented: he painted, etched, and designed architecture and decorations. In Rome he painted still lifes and made very fine and accomplished etchings after the paintings of Pierre Subleyras and of the director of the Academy, Jean-François de Troy. His etching skill was most brilliantly displayed in the bravura etching representing a ball that took place in the Teatro San Carlo published in the *Narrazione delle solenni reali feste fatte celebrare in Napoli da Sua Maestà il Re delle Due Sicilie . . . per la nascita del suo primogenito* (Naples, 1749), the lavish commemorative book for the festivities celebrating the birth of the first son of the king of Naples.[2] Le Lorrain was in close contact with Piranesi, as attested by his etching the vignette for the frontispiece of Piranesi's *Opere varie*, published in 1750, the year after Le Lorrain left Rome.[3] He demonstrated his innovative architectural gifts in the temporary structures he designed for the Roman festival the Chinea. This was an annual event that celebrated the tribute rendered by the king of Naples through his ambassador to the pope, Prince Colonna, in the form of a white mare, the *chinea*, which carried a casket containing 7,000 ducats. The highlight of the celebrations was a fireworks display set off from an elaborately decorated structure, the *macchina*; the temporary *macchina* was regularly recorded in an etching. In the decade of the 1740s, these *macchine* were designed by members of the French Academy in Rome. Between 1744 and 1748, Le Lorrain designed five and also etched them. The last three were memorably original, featuring monumental colonnaded temples with shallow domes against whose bare and flat walls were disposed the heavy, ropy swags that prefigured the ornament of the *goût grec*.

Le Lorrain was *agrée* in the Royal Academy as a history painter in 1752, exhibited there for the first time the following year, and was elected a full member in 1756. But it was in the field of architecture and decoration that he made his mark in history. In 1754, through the influence of the comte de Caylus, he was commissioned to provide the decorations and furniture for the Swedish country house of Count C. G. Tessin at

Åkerö, which he designed in very advanced, Neoclassical fashion.[4] And in the years 1756–57, he produced a suite of furniture for La Live de Jully[5] marked by such heavy bronze mounts that they were said at the time to be in the style of André-Charles Boulle. The decoration of the monumental furniture was remarkable, featuring heavy ropelike swags, lions' heads, fretwork, and Vitruvian scrolls in an utter departure from the prevailing Rococo. They were widely acclaimed and credited with initiating the *goût grec*. Along with Legeay, Le Lorrain was considered the principal impetus toward the shift to Neoclassicism in the decade of the 1750s. In 1759 the artist died in Saint Petersburg, where he had been called by Empress Elizabeth in the previous year to help found an academy of art.

This frontispiece for a suite of vase designs was never engraved. However, a set of rare vase designs by Le Lorrain, dedicated to Madame Geoffrin, was etched by the distinguished amateur Claude-Henri Watelet with the Italian title *Raccolta di vasi dedicata al signora Geoffrin* in 1752 (one of them is dated 1753).[6] Dispersed among the Musée des Arts Décoratifs, the École des Beaux-Arts, and the Berlin Kunstbibliothek is a large group of drawings, some in black chalk and others in brown wash, of which some were preparatory for the prints, but many others were not. All have monumental, solitary images against blank backgrounds, combining ancient, Baroque, and auricular styles and featuring Le Lorrain's distinctive, elegantly elongated figures, which both decorate and form integral parts of the vases.

Similar suites of vase designs had been made in Italy by Le Lorrain's fellow *pensionnaires* Jacques Saly in 1746[7] and Jean-Baptiste-Marie Pierre in 1749 (which were etched by Watelet)[8] under the influence of the two sets of prints by Bouchardon.[9] Although Le Lorrain's prints were published in Paris, the drawings are thought to have been executed earlier, in Italy.

Our frontispiece shows a short, rounded vase that is decorated with classical masks connected by a grapevine from which hang heavy garlands. The garlands are caught up at the base by the putti who support the vase. The vase stands on a long, low wall on which the title and Le Lorrain's name are inscribed. A figure sits at the base of the wall, while two figures at the lower right point up at the vase. The figures and vase are set in a dense, wooded landscape, a distinctive feature of Le Lorrain's design; Bouchardon's, Saly's, and Pierre's suites all display vases against blank backgrounds. The Italianate setting suggests that the drawing dates from Le Lorrain's Roman period.

NOTES

1 On Le Lorrain, see Rosenberg 1978, pp. 173–202, with previous bibliography; and *Piranèse et les français*, pp. 201–217.
2 See Rosenberg 1978, pp. 177–178, fig. 22, p. 199, n. 56.
3 Ibid., pp. 177, 180, fig. 28.
4 See ibid., p. 188, figs. 56–58.
5 See S. Eriksen, "Lalive de Jully's Furniture 'à la grecque,'" *Burlington Magazine* (August 1961), pp. 340–347.
6 Rosenberg 1978, p. 184, figs. 41–47; *Piranèse et les français*, pp. 212–214, no. 111, repr.
7 Berlin 1939, no. 1064.
8 Ibid., no. 1067.
9 Ibid., no. 1060.

64. Study for a Leaf in a Suite of Vase Designs

Pen, gray ink, brown wash. 7¹³⁄₁₆ × 4¾ in. (198 × 121 mm). Creased vertically at center. Inlaid on decorative mount.

Inscribed on mount at top right, *no. 38.*

PROVENANCE: See Number 63.

BIBLIOGRAPHY: Rosenberg 1978, pp. 184–185, fig. 49, p. 200 n. 78.

The Elisha Whittelsey Collection, The Elisha Whittelsey Fund, 1948 48.148(38)

This design for another sheet in the suite of vases of which Number 63 is the frontispiece shows a monumental vase on a pedestal. The vase's shape is a simple oval with a nearly unbroken outline. It is decorated with a frieze of classical figures, a running scroll design, and heavy ropelike garlands. Such a decorative scheme is common in Le Lorrain's oeuvre, approximating the format he used in his three classical-temple Chinea designs. As in the frontispiece, the vase is set against a landscape background.

PIERRE LÉLU

Paris 1741–Paris 1810

65. Design for the Corner of a Coved Ceiling

VERSO. Sketches of Figures and Dolphins

Pen, brown ink, with brown wash and touches of gray wash over traces of black chalk (recto). Black chalk (verso). Framing line in brown ink. 15 11/16 × 6 11/16 in. (399 × 170 mm). Inlaid.

Signed in brown ink at lower right of recto, *P. Lelu*; inscribed in black chalk on verso, *amours ou tritons*.

WATERMARK: Partial escutcheon with fleur-de-lis.

PROVENANCE: Charles Mewès, his stamp, lower left (not in Lugt); [W. R. Jeudwine, London]; purchased in London.

BIBLIOGRAPHY: Bean and Turčić 1986, under no. 163.

The Elisha Whittelsey Collection, The Elisha Whittelsey Fund, 1968 68.635

Lélu was a pupil of François Boucher and Gabriel-François Doyen. He went to Italy in 1762 to study and to copy the great masters of the Renaissance and the Baroque, especially Raphael, the Carracci, and Domenichino. In the 1770s he entered the service of the ambassador of France in Portugal and from there traveled throughout Europe, especially Spain and Italy, and received commissions from the king of Spain. On his way to Paris in 1778, he passed through Marseilles, where the Academy made him a member by acclamation for the drawings he brought from Italy. He made a third trip to Italy in 1789 but remained just a short time. Upon his return to France, he received a commission from the prince de Condé to decorate his palace with paintings; the work was never completed due to the Revolution. After the Revolution he was employed by the collector and antiquarian the comte de Saint-Morys to document in drawings the patrimony of Medieval and Renaissance churches and works of art, some damaged in the Revolution.[1]

Lélu, who left few paintings, is now known primarily through his very numerous drawings and seventy-five etchings.[2] This sheet depicts a winged figure of Victory Triumphant for the corner of the cove of a ceiling. The Victory, one foot on a globe, is borne aloft in clouds above spears bunched around a turbaned bust that is topped with a crescent moon. On either side of the bust is a slave. Below is a ship with dolphins. The turbaned bust with crescent moon must refer to the Turks; therefore, this must commemorate a sea victory over the Turks, probably by a maritime power. The style of the painted ceiling is of the 1780s, but the particular building for which the study was intended has not been identified.

NOTES

1 F. Arquié-Bruley, "Un précurseur: Le comte de Saint-Morys (1782–1817), collectionneur d'"antiquités nationales," *GBA* 96 (1980), pp. 109–118. The drawings were sold in 1970 by Prouté (*Pierre Lelu*, cat. no. 52 [Autumn]); the Bibliothèque Nationale purchased thirteen sheets.
2 See B. N., *Inventaire*, vol. XIV, pp. 47–77. A sketchbook is in the Kunstbibliothek, Berlin, for which see Berckenhagen 1970, pp. 371–372. The Louvre possesses ten drawings, for which see Guiffrey and Marcel, vol. IX, 1921, pp. 15–16, nos. 8650–8659.

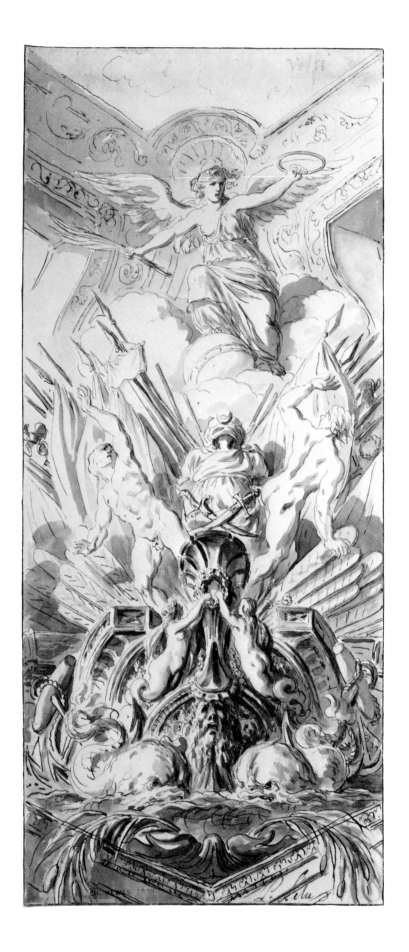

JEAN-JACQUES LEQUEU

Rouen 1757–Paris 1825(?)

66. Elevation of the Facade of the Hôtel de Montholon, Paris

Pen, black and gray ink, gray and blue wash. Two framing lines in black ink around image and around inscription. 18½ × 27¼ in. (470 × 692 mm). Lined.

Inscribed in black ink at bottom, ÉLÉVA-TION GÉOMETRALE DE L'HÔTEL DE MONTHOLON/*Situé à Paris Boulevard mont-matre, Construit sur les desseins de Frcs Soufflot le Romain.*

PROVENANCE: Nicolas de Montholon; Marquis de La Grange, by descent in the family; [Didier Aaron]; purchased in New York.

BIBLIOGRAPHY: *French Master Drawings, 16 May–9 June 1984,* Didier Aaron, Inc., New York, 1984, nos. 41–43, repr.; *Notable Acquisitions, 1983–1984,* pp. 78–79, repr.

Purchase, Mr. and Mrs. Charles Wrightsman Gift, 1984
1984.1084.1

Jean-Jacques Lequeu is usually mentioned as one of a triad with Boullée and Ledoux, and his architecture, like theirs, has been categorized as revolutionary, as Emil Kaufmann puts it.[1] However, unlike the other two, Lequeu built very little, of which nothing survives. Instead, he is known exclusively through the albums of drawings that he gave to the Bibliothèque Nationale. His eccentric personality is expressed in his very original and sometimes pornographic drawings. He was born in Rouen, the son of a cabinetmaker who dabbled in architecture and landscape design. The younger Lequeu showed a talent for architecture early and studied at the Academy in Rouen, winning prizes in 1776 and 1778. He was supported in his desire to study in Paris by the director of the Academy, the painter Descamps. In Paris, Lequeu called upon Soufflot, who allowed him to work in his office, as did his nephew François Soufflot, called *le romain* after his studies in the Holy City. Soufflot *le romain* eventually succeeded his uncle as super-intendent of the construction of Sainte-Geneviève (later, the Pantheon). In 1783 Lequeu traveled to Italy with his protector, the comte de Bouville, and in 1786 he was named an associate adjunct member of the Rouen Academy. He claimed to have built two country houses in the form of an-tique temples, but nothing further is known about them. The drying up of architectural com-missions during the Revolution was felt partic-ularly severely by Lequeu, who ceased being an independent architect. From 1793 to 1801, he worked in the Paris Registry Office, and from 1801 to 1815, he worked as a cartographer in the Ministry of the Interior. His last years must have been penurious, for he tried to sell his draw-ings three times, finally donating them to the Bibliothèque Nationale in 1825, which is the last date that is known for him. It is assumed that he died shortly thereafter.

In 1786 Lequeu was asked by the younger Soufflot to assist him in the construction of a grand *hôtel* for the wealthy magistrate and later president of the Parlement of Normandy, Nicolas de Montholon, on the boulevard Montmartre, now 23, boulevard Poissonnière. The *hôtel* stands there today: it is one of the very few distin-guished private houses of its time to have sur-vived the nineteenth-century reconstruction of Paris. However, it is sadly changed. The ground-floor space has been filled with small shops, and most of the interior decoration of the main floors has been pulled down to accommodate the offices of a bank and an insurance firm. The Hôtel de Montholon was renowned in its own

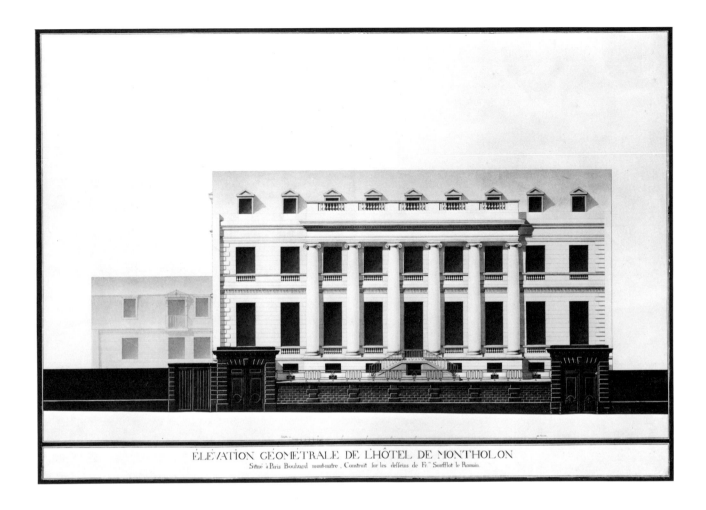

ÉLÉVATION GÉOMÉTRALE DE L'HÔTEL DE MONTHOLON
Situé à Paris Boulvard mont-matre . Construit fur les deffeins de Fr.ᵒⁱˢ Soufflot le Romain.

time: Thiéry described it in his guide written the year after it was built,[2] and Krafft and Ransonnette published its elevation and plans.[3]

The Metropolitan Museum is fortunate to possess five drawings for the Hôtel de Montholon through the generosity of Mr. and Mrs. Charles Wrightsman: a large elevation of the exterior, two large longitudinal and cross sections of the salons and dining rooms of the first and second stories, and two drawings of the sections and plans of an antechamber or small dining room. The first three drawings, which were acquired together, must be the presentation drawings for the structure, for they are very precise and highly finished; further, a note on the back of one of the frames states that the drawings were acquired with the *hôtel* on the death of M. de Montholon in 1791 by the marquis de La Grange, a general in the king's armies and the great-great-grandfather of the writer of the note, which is dated 1905. The *hôtel* was sold by the

family of the marquis de La Grange in 1829, but they evidently kept the drawings.

Although the two sheets of the interiors are signed by Soufflot *le romain*, it is normal practice for the architect of the project to sign presentation drawings, even when they are supplied by another. The drawings conform not only to Lequeu's draughtsmanship but also to a volume of drawings in the Bibliothèque Nationale by Lequeu that has letters between Soufflot and himself concerning the building of the *hôtel*, including notes and drawings for all manner of architectural details, and even furniture.[4] In fact, the furniture drawings are detailed enough to construct from and are key documents for furniture of the Louis XVI period.[5]

The *hôtel* is set back from the street behind a brick wall with gates that today open onto shops. The severity of the two end bays of the structure contributes to the monumentality of the projecting block of six double-storied, semiattached

Ionic columns (plain in the drawings but fluted on the building), which support a balustrade at the attic level that enriches the facade. Thiéry writes: "The Ionic order . . . unites with a noble and grave manner . . . the severe and pure style of antiquity."[6] Thiéry goes on: "The interior decoration does not allow him any less honor, with its richness of ornament and the taste with which it has been disposed."[7] The facade, though marred by the ground-level shops, and the salons, despite their losses, have been designated *classé*, that is, they have been granted landmark status and cannot be further changed.

Two sketches on leaf 1 of the Bibliothèque Nationale album are preliminary studies for the facade and the ground plan. The second facade sketch was the one chosen for execution.

Notes

1 See Kaufmann 1952, pp. 538–559. Also on Lequeu, see P. Duboy, *Lequeu: An Architectural Enigma* (Cambridge, Mass., 1987), with previous bibliography.

2 L. V. Thiéry, *Guide des amateurs et les étrangers voyageurs à Paris . . .* (Paris, 1787), vol. I, p. 462.

3 J.-Ch. Krafft and N. Ransonnette, *Plans, coupes, élévations des plus belles maisons et des hôtels construits à Paris et dans les environs* (Paris, [1802]), pls. 67, 68. See also M. Gallet, *Demeures parisiennes: L'époque de Louis XVI* (Paris, 1964), p. 31, pls. 91–94.

4 B. N. Estampes, Ve 92 fol.

5 E. Molinier, *Histoire général des arts appliqués à l'industrie . . .* , vol. 3, *Le mobilier au XVIIe et au XVIIIe siècle* (Paris, [1898]), pp. 204–209.

6 As quoted in A. Braham, *The Architecture of the French Enlightenment* (Berkeley and Los Angeles, 1980), p. 231.

7 Thiéry, *Guide des amateurs*, vol. 1, p. 462; my translation.

67. Longitudinal and Cross Sections of the Dining Rooms of the Hôtel de Montholon

Pen, black and gray ink, gray and colored wash. Black border line. 15¾ × 21⅝ in. (400 × 549 mm).

Signed at lower left, *Soufflot le romain invenit f. 17[??]*; inscribed at top, HOTEL DE MONTHOLON.; and below each design: at upper left, *Coupe Sur la longueur de la Sale à manger du Second.*, at upper right, *Coupe Sur la largeur de la Sale à manger du Second.*, at lower left, *Coupe Sur la longueur de la Sale à manger du Premier.*, and at lower right, *Coupe Sur la largeur de la Sale à manger du Premier.*; and at bottom to left of scale, *Souf [flot partially effaced] le Romain Inv[enit] 17[--]*.

WATERMARK: Near Heawood 3268.

PROVENANCE: See Number 66.

BIBLIOGRAPHY: See Number 66.

Purchase, Mr. and Mrs. Charles Wrightsman Gift, 1984
1984.1084.2

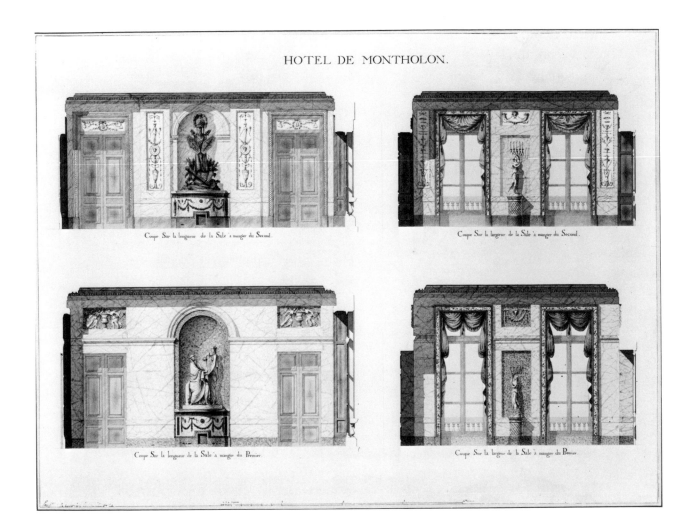

Coupe Sur la longueur de la Sale à manger du Second.

Coupe Sur la largeur de la Sale à manger du Second.

Coupe Sur la longueur de la Sale à manger du Premier.

Coupe Sur la largeur de la Sale à manger du Premier.

Represented here are longitudinal and cross sections of the dining rooms of the first and second floors of the Hôtel de Montholon. Lequeu has not only drawn the rooms and their decoration but has also designed the fixtures, such as the stoves (the eighteenth-century equivalents of radiators), which are set into niches and used instead of fireplaces, as well as gueridons and draperies. The walls are painted in *faux marbre*, and figures in classical garb and arabesques decorate the walls. There are a number of preliminary sketches for the dining rooms in the Bibliothèque Nationale. These include wall elevations for the second floor, two varying sketches for the gueridons, and a large study for the first-floor stove, which consists of two very elongated female figures, one pouring water for the other to wash her hands.

The color scheme for the ground-floor dining room is green and gray, while that for the second-floor dining room is blue and gray.

68. Longitudinal and Cross Sections of the Salons of the Hôtel de Montholon

Pen, black and gray ink, gray and colored wash. 15 11/16 × 21 11/16 in. (398 × 551 mm).

Signed in brown ink at lower left above border lines to left of scale, *Soufflot le Romain invenit f.*; inscribed at top, HOTEL DE MONTHOLON.; and below each design: at upper left, *Coupe Sur la longueur du Salon du Second.*, at upper right, *Coupe Sur la largeur du Second, Coté de la cheminée*, at lower left, *Coupe Sur la longueur du Salon du Premier.*, and at lower right, *Coupe Sur la largeur du Salon du Premier, Coté de la cheminée.*

WATERMARK: Near Heawood 3268.

PROVENANCE: See Number 66.

BIBLIOGRAPHY: See Number 66.

Purchase, Mr. and Mrs. Charles Wrightsman Gift, 1984
1984.1084.3

The transverse and cross sections of the salons on the first and second floors are as equally detailed and precise as the drawings for the dining rooms. On the first floor are gueridons between the windows and narrow vertical pilasters of arabesques above them. Ionic capitals top the pilasters and extend into the cornice of the cove. The same vertical arabesque pilasters flank the mirror on the side wall above the chimneypiece, which on the first floor is arched.

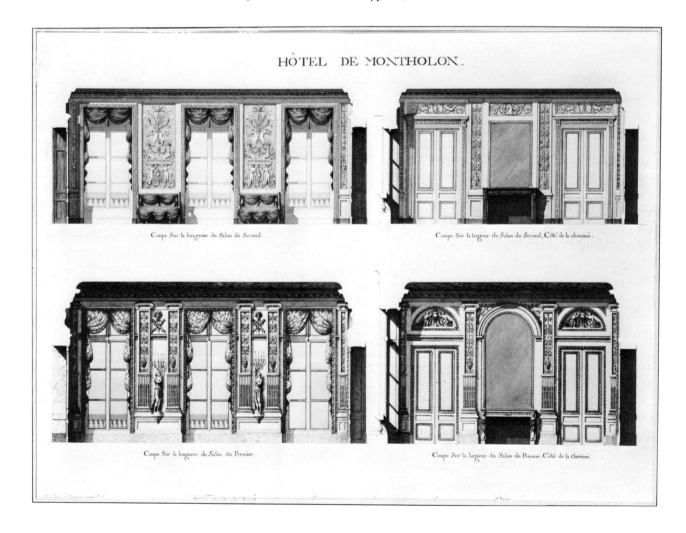

HÔTEL DE MONTHOLON.

Coupe Sur la longueur du Salon du Second.

Coupe Sur la largeur du Salon du Second, Coté de la cheminée.

Coupe Sur la longueur du Salon du Premier.

Coupe Sur la largeur du Salon du Premier, Coté de la cheminée.

The arched pediments above the two sets of doors are composed of female figures in classical garb on either side of a tripod with festoons. The decoration of the second story is equally rich. There are no gueridons; instead, small sofas are set in the spaces between the windows, and arabesques fill the walls above them. The color scheme is blue and white, whereas on the first floor it is yellow, perhaps signifying that the moldings were meant to be gilt.

In the Bibliothèque Nationale album are sketch studies for the wall treatments and very detailed studies for the gueridons, as well as studies for the end wall with the chimneypiece, with its Egyptianizing details. The Egyptian decor has been much noted, as its appearance here considerably predates Napoleon's campaign, which was so important in the decorative arts. It has been thought that Piranesi's *Diversi maniere*, with its many Egyptian details on chimney-pieces, was the decisive influence on Lequeu.

69. Section and Plan of the Small Dining Room of the Hôtel de Montholon

Pen, black and gray ink, with gray and beige wash. Black-ink border line. Blue mount with black lines added around sheet. 9⁵⁄₁₆ × 7³⁄₄ in. (237 × 197 mm). Stained at right side.

Inscribed at top of drawing in black ink, *Hôtel de Montholon*, and between section and plan, *Esquisse du Second Antichambre, ou petite Sale à Manger, Côté du pöele*.

PROVENANCE: [Benjamin Weinreb, London]; Mr. and Mrs. Charles Wrightsman.

BIBLIOGRAPHY: Harris 1969, p. 249.

Gift of Mr. and Mrs. Charles Wrightsman, 1970
1970.736.44

70. Section and Plan of the Small Dining Room of the Hôtel de Montholon

Pen, black and gray ink, with gray and beige wash. Black-ink border line. Blue mount with black lines added around sheet. 9⁵⁄₁₆ × 7⁵⁄₈ in. (237 × 194 mm). Stained at left.

Inscribed at top in black ink, *Hôtel de Montholon.*, and between section and plan, *Esquisse du Second Antichambre, ou petite Sale à Manger, Coté de la grande/Cour.*

PROVENANCE: [Benjamin Weinreb, London]; Mr. and Mrs. Charles Wrightsman.

BIBLIOGRAPHY: See Number 69.

Gift of Mr. and Mrs. Charles Wrightsman, 1970
1970.736.45

The small dining room is much more sober than the more ornate large dining room. This view of the stove wall shows a herm holding garlands above the stove. Antique masks, also with garlands, are in the two plaques above the doorways. The color scheme is beige and gray.

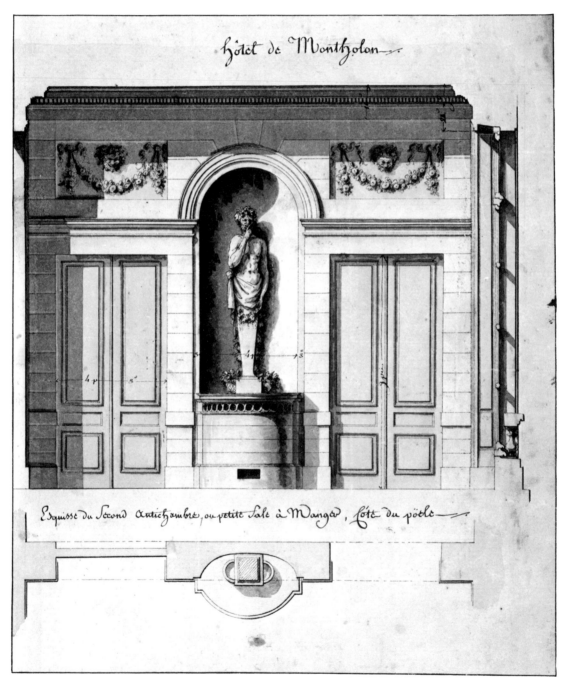

Hôtel de Montholon

Esquisse du Second Antichambre, ou petite Sale à Manger, Côté du pôële

69

The wall opposite the stove in the small dining room is equally sober. Between the two windows giving onto the courtyard is a nymph pouring water into a goblet. Above her is a wreath.

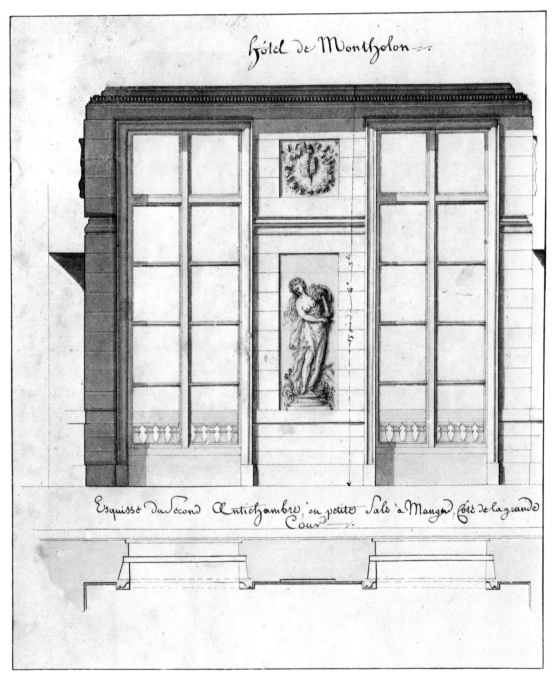

Hôtel de Montholon

Esquisse du second Antichambre, ou petite Salé à Mangé, côté de la grande Cour

70

DANIEL MAROT

Paris 1663–The Hague 1752

71. Study for a Ceiling

Pen, gray ink, with brown, gray, and colored wash. 12⁷⁄₁₆ × 18⁷⁄₈ in. (316 × 479 mm). Stained from glue at the four corners. Creased vertically at the center.

WATERMARK: A fleur-de-lis in an escutcheon.

PROVENANCE: S. Kaufman, London; [W. R. Jeudwine, London]; purchased in London.

BIBLIOGRAPHY: Kaufman and Knox 1969, no. 29, repr.; Fuhring 1989, under no. 411.

Purchase, Harris Brisbane Dick Fund and Joseph Pulitzer Bequest, 1971
1971.513.48

Daniel Marot, a Huguenot, left France for Holland in 1685 after the revocation of the Edict of Nantes. He continued on to England, where he became "France's loss and England's gain," as commented A. Hyatt Mayor.[1] Multitalented as an architect, a designer of interiors and objects, and an engraver and designer of countless prints, he was in the employ of Prince William of Orange of the Netherlands, later King William III of England.[2]

The subjects of the prints after Marot's designs give an inkling of his many talents: there are studies for wall paintings, staircases, overdoors, room interiors, especially with elaborate designs for beds and their hangings, embroidery, paneling, chimneypieces, wall panels of arabesques, ironwork, goldsmiths' work, snuffboxes, clocks, gardens, including garden parterres, fountains, trelliswork, statues, urns and vases, and triumphal arches.

Marot executed a number of drawings and engraved designs for illusionistic ceilings.[3] Among them the theme of the four continents frequently recurs. In our sheet, figures with their attributes signifying the four continents fill each corner of the rectangular design, while within the oval, which opens up illusionistically into the sky, are the figures of Apollo and the Muses inhabiting the heavens. Related ceiling studies include a drawing in the Houthakker collection that is signed and dated July 1, 1712;[4] a drawing in the École des Beaux-Arts, Paris,[5] that is sim-

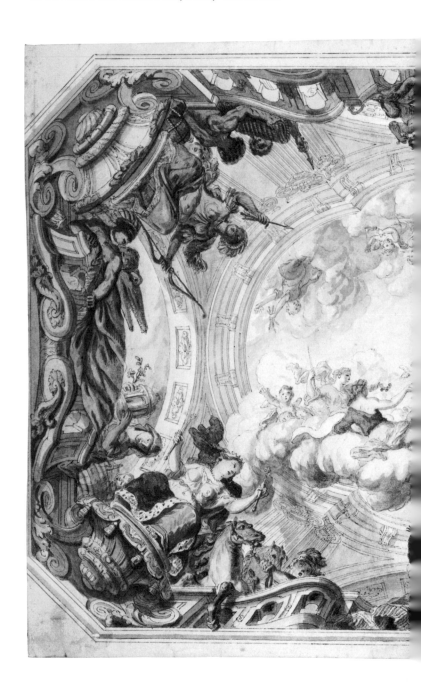

ilarly signed and dated August 6, 1712; two
drawings in the Kunstbibliothek, Berlin;[6] and
a drawing in the National Gallery of Canada,
Ottawa.[7]

NOTES

1 In an exhibition label.
2 See the monograph by M. D. Ozinga, *Daniel Marot, de
 schepper van den hollandschen Lodewijk XIV stijl* (Amster-
 dam, 1938); A. Guérinet, ed., *L'oeuvre de Daniel Marot*,
 2 vols. (Paris, n.d.); Guilmard 1880, pp. 103–106, no. 50;
 and the recent exhibition catalogue, R. Baarsen et al.,
 *Courts and Colonies: The William and Mary Style in Hol-
 land, England, and America*, Cooper-Hewitt Museum
 (New York, 1988), especially no. 27, which is Fuhring
 1989, no. 411.
3 A. Bérard, *Catalogue de toutes les estampes . . . de Daniel
 Marot . . .* (Brussels, 1865), pp. 37–39.
4 Fuhring 1989, no. 411.
5 Baarsen et al., *Courts and Colonies*, no. 26, repr.
6 Berckenhagen 1970, p. 155, Hdz 2961, and pp. 155–156,
 Hdz 4146.
7 A. E. Popham and K. M. Fenwick, *European Drawings in
 the Collection of the National Gallery of Canada* (Ottawa,
 1965), no. 214, repr.

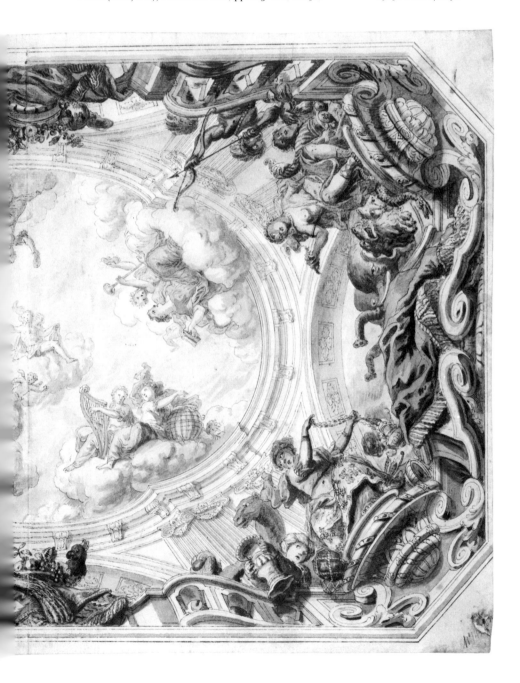

JUSTE-AURÈLE MEISSONNIER

Turin 1675–Paris 1750

72. Ornament Design

Pen, brown ink, with touches of gray wash over traces of graphite. 5¾ × 3⁵⁄₁₆ in. (146 × 84 mm).

PROVENANCE: D. David-Weill, Paris; sale, Sotheby's, Geneva, November 14, 1984, part of lot 197; [Armin B. Allen, Inc.]; purchased in New York.

BIBLIOGRAPHY: *The Art of Design, 1575–1875 . . .* , Armin B. Allen, Inc., New York, 1985, no. 23, repr.

Rogers Fund, 1986
1986.1032.1

One of the greatest proponents of what was called the *genre pittoresque*, known today as the Rococo, Meissonnier studied with his father, a silversmith and sculptor, and went to Paris about 1718.[1] There he met with success, in being named *orfèvre du roi* in 1724 and later, succeeding Jean Berain, *dessinateur de la Chambre et du Cabinet du Roi*, the post in charge of designing the court festivals. In addition to these roles, he styled himself painter, sculptor, and, especially, architect.

Meissonnier's architectural work and most of the rest of his production are known through his *Oeuvre*, the large suite of prints made after his designs and published by Huquier. The *Oeuvre* had been first issued in small sets by another publisher, the widow Chereau, and then was combined into a huge volume by Huquier. Meissonnier designed the title page and his own portrait. The variety of subjects in the *Oeuvre* bears witness to the correctness of his designating himself in the multifarious role of painter, sculptor, and architect, as well as goldsmith and designer of festivals. There are drawings for candlesticks (a pair of which are still extant in the Musée des Arts Décoratifs), snuffboxes, sword handles, tureens (a magnificent pair are divided between Cleveland and the Thyssen collection in Lugano), mirror frames, frames for pictures, ciboria, clocks, altars, interior decoration, and the architecture of entire palaces. In addition, he designed sets of ornament prints; the advertisement for one of these in the *Mercure de France* by the publisher, the widow Chereau, defines the *genre pittoresque*: "There has appeared a suite of engravings *en large*, in the taste of Stefano della Bella, which should pique the curiosity of the public and of the inquisitive of better taste. These are of fountains, cascades, ruins, *rocailles*, and shell work, of *morceaux* of architecture which create bizarre, singular, and picturesque effects, by their piquant and extraordinary forms, of which often no part corresponds to any other, without the subject appearing less rich or less pleasing. There are also [different] kinds of ceilings, with figures and animals grouped with intelligence, of which the frames are extremely ingenious and varied. The cartouche which serves as a frontispiece, carries this title: Book of Ornaments, invented and drawn by J. O. Moissonnier [*sic*], *Architecte, Dessinateur de la Chambre et Cabinet du Roy*."[2] The published objects by Meissonnier are no less rich and varied in their forms. No lines are straight, and each object is composed of curves and countercurves, which were called *contraste* by contemporaries.

Meissonnier's drawings have not been extensively studied, and many drawings have been falsely attributed to him (see Hubert, No. 47). There is a group of snuffbox designs in the Musée des Arts Décoratifs that is generally accepted as by his hand.[3] These drawings are virtual models for the engraved snuffboxes in the *Oeuvre*.[4] In them he typically uses a broad pen with brown and gray ink and wash, and the de-

signs are drawn with intricately curved and countercurved forms. Our drawing is clearly by the same hand, and its authenticity has been accepted by Peter Fuhring through photographs.

The object for which this design was made is not completely certain. It resembles a small perfume flask in gold at Waddesdon Manor in which there are rocaille forms, although the flask itself is not asymmetrical.[5] However, the treatment of the scenes within the design is in the manner of Meissonnier, according to prints in the *Oeuvre*. Another flask at Waddesdon Manor, with its flamelike design and heavy gold shell base, clearly owes much to Meissonnier.[6]

On the other hand, Marianne Roland Michel has suggested that our drawing is for a *pomme de carrosse*, a kind of finial for a carriage.[7] It is true that the base of the object is small, almost too small to support a flask upright. This ambiguity between the drawing and its final product mirrors the ambiguity in many ornamental designs. The many sets of prints of ornament were created to give ideas to students, painters, sculptors, architects, furniture designers, goldsmiths, and so forth, and one example could often serve various ends, as is perhaps the case with this drawing.

NOTES

1 On Meissonnier, see Nyberg 1969, with previous bibliography.

2 Nyberg 1969, pp. 33–34, her translation.

3 See ibid., pp. 9, 11, 13, 15.

4 Fols. 18 and 19 in Nyberg 1969.

5 Grandjean 1975, p. 30, no. 5. Warden's mark for Paris, 1731–32.

6 Ibid., p. 53, no. 20. No marks are on the flask, and it is supposed that the design may be English, ca. 1740.

7 M. Roland Michel, "Ornemanistes," in *Encyclopaedia Universalis* (Paris?, 1989), vol. 17, p. 123, repr.

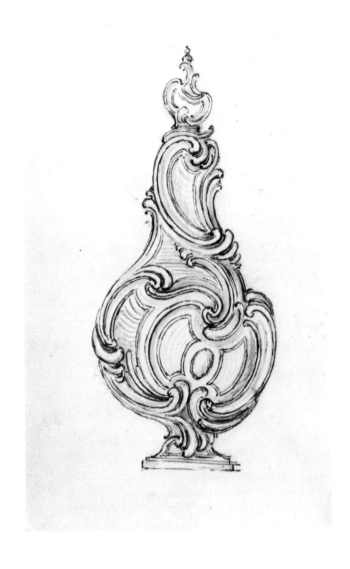

73. Design for a Repoussé Cane Handle

Pen, light and darker gray ink, and wash, with touches of graphite. $3\frac{7}{16} \times 1\frac{11}{16}$ in. (87 × 43 mm).

PROVENANCE: D. David-Weill, Paris; sale, Sotheby's, Geneva, November 14, 1984, part of lot 197, repr.; [Armin B. Allen, Inc.]; purchased in New York.

BIBLIOGRAPHY: *The Art of Design, 1575–1875 . . .* , Armin B. Allen, Inc., New York, 1985, no. 20, repr.

Rogers Fund, 1986
1986.1032.2

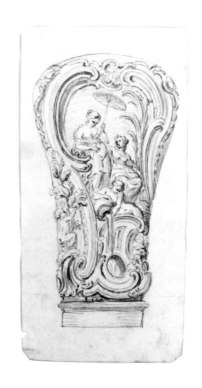

There are two designs for cane handles in Meissonnier's engraved *Oeuvre*. One shares the engraved plate with scissors and their cases as well as with a watchcase, to give an idea of the variety in Meissonnier's production. It is decorated, striated, and, typically, asymmetrical.[1] The other is much more asymmetrical and is composed of foliagelike curves in a repoussé design.[2] Neither contains figures as does ours, but many designs for snuffboxes and watchcases do contain small figures. Our drawing more closely resembles these latter designs.

The scene shows a female shaded by a parasol seated next to another female figure, below which a river god with a vase pours water down the design. On the left, a small putto climbs up foliage. The pen work here is much more delicate than in our other study by Meissonnier in order to convey the details of the scene. Fuhring also accepts this drawing as by the hand of the master.

NOTES

1 Nyberg 1969, fol. 16.
2 Ibid., fol. 20.

JEAN-GUILLAUME MOITTE

Paris 1746–Paris 1810

74. Designs for Silver

Pen, black ink, with black and gray wash. Two framing lines in black ink. 7 15/16 × 12 7/8 in. (202 × 327 mm). Creased vertically at center.

Inscribed in black ink in upper register, at left, *Trépied*, at center left, *Sceau a demie bouteille*, at center right, *Sceau à glace*, at right, *vase à fruit*; in brown ink on verso, *No. 77*.

WATERMARK: VAN DER LEY

PROVENANCE: [Workart, Inc.]; purchased in Geneva.

The Elisha Whittelsey Collection,
The Elisha Whittelsey Fund, 1978
1978.638.1

The son of an engraver and a pupil of the sculptors Pigalle and J.-B. Lemoyne, Moitte won the Academy's first prize for sculpture in 1768.[1] He went to Rome as a *pensionnaire* in 1771, but poor health forced him back to Paris in 1773. The study of antique sculpture during his years in Rome remained the decisive source for his art throughout his life. Some of his most notable works have been destroyed, such as the sculptural reliefs of 1792 in the pediment of the Pantheon and the reliefs on Ledoux's *barrières*

of 1787–89 (with the exception of the *barrière* at the Place Denfert-Rochereau), while the reliefs of 1784 that decorate the Hôtel de Salm are still in situ. A friend of Jacques-Louis David and a committed participant in artistic enterprises during the Revolution and Empire, Moitte had a successful career, receiving official commissions during the last decade of the eighteenth and the first decade of the nineteenth centuries.

Moitte was also busily employed by the goldsmith Henry Auguste (see Nos. 1–5), providing designs for his shop. An early biographer claims he made more than a thousand drawings for Auguste, and Moitte was praised as the most gifted of the Auguste concern's draughtsmen. Indeed, he gained international attention for this work: William Beckford owned a sizable collection of silver designed by Moitte for Auguste, which Beckford prized highly.[2] Although Moitte retained some of his drawings, and they appeared in sales of his possessions, most were preserved in the contents of Auguste's shop, which was purchased by Odiot (see No. 1).

This unsigned drawing was acquired along with the signed Auguste drawings (Nos. 1, 2) and was identified by Richard J. Campbell. Campbell points out the similarity of the classical forms and the style of draughtsmanship with other drawings by Moitte, both in the Odiot and in other collections. The elegant, sensitive handling of the pen, with a distinctive application of the wash in layers, the last of which is applied almost in a series of splotches, is typical of Moitte and distinguishes his drawings for silver from others. The elongated proportions of the figure of the caryatid supporting the candelabrum in the lower register, as well as the linear abstraction of her feet and hands and the emphatic verticality of the folds of her drapery, are typical of Moitte's figural canon, evolved, according to Campbell, for the reliefs for the Ledoux *barrières*. The handling of the faces of the handles on the two wine coolers is typically Moitte's: they are severe, composed of a straight line running from the forehead to the end of the nose, and the hair is arranged in classical braids. The draughtsmanship, the figural style, and the types of vessels depicted are analogous to those in a signed drawing in the École des Beaux-Arts, Paris,[3] that represents a kind of fantasy compilation of goldsmiths' work set about a room and on a table elaborately fitted with ormolu work.

Of the Moitte drawings for Auguste from the Odiot collection that have appeared on the market, a recently auctioned work has the greatest affinity with our drawing.[4] A larger and more highly finished drawing than our delicately sketched sheet, it, too, is on Van Der Ley paper and has a number, 78, inscribed on its verso, in this case in brown ink. These successive numbers were probably the Auguste shop's inventory numbers. The drawing represents different pieces of silver on two registers, two silver *tazze* above and two deep silver dishes below. In the center is a large, elaborate candelabrum in the form of a female figure in classical robe supporting an urn and five lights. The *tazza* on a support consisting of rams' legs and a central pedestal and with an acanthus frieze and rams' heads at the base of the cup, here depicted on the bottom register at the far right, differs from the *tazza* at the upper left in the Odiot drawing only in that the latter has a tripod base composed of three rams' legs. The caryatid candelabrum design on the Odiot sheet is far more elaborate than our drawing's. The motif was a favorite of Moitte's: he designed an even more elaborate candelabrum for five lights in which a classically draped female whose head supports a vase stands holding cornucopias.[5] That caryatid's left leg is crossed in front of the right, the same stance as the caryatid in our drawing. Campbell relates this pose to a figure Moitte sculpted for the frieze of the *Allegory of History* on the Barrière d'Enfer. Moitte's transposition of designs for monumental sculpture to the art of the silversmith is certainly one component of his greatness as a silver designer. Campbell discusses another candelabrum in which the figure is reduced to a herm[6] and points out that the branches of it and of our candelabrum, formed of acanthus and round with a rosette in the center, are similar. He suggests that a drawing described as "un candélabre" that Moitte exhibited at the Salon of 1789 may have resembled these also.

With the exception of the treatment of the handles, a design for a wine cooler from the Odiot collection, now in the Getty Museum, is a large-scale, finished version of the one in the upper register of this sheet.[7] Instead of the snakes

that curl out from the female mascaron in our drawing, the handle on the urn of the Getty sheet is composed of a female mascaron supporting a volute ending in a rosette. The friezes at the top of both urns are composed of putti entwined in acanthus. The Getty drawing is identified by Wilson as a design for a wine cooler in the Grand Vermeil service that Auguste made in 1804 for presentation to Napoleon by the city of Paris. The handles of the wine cooler as executed[8] differ from those of the Odiot sheet: as in our sketch, they are composed of snakes issuing from the head of the female mascaron, but in the vermeil object the snakes coil up and in to meet the rim of the urn, whereas in our design they coil out from the edge of the rim.

Elaborate pieces of silver with supports composed of sculptural figures in the round, such as the shallow covered dish at the upper left on supports of winged sphinxes, were designed both for official commissions, as in Auguste's Grand Vermeil service for Napoleon, in which the *nef*, or the container for the emperor's flatware and napkins, rests upon two river gods,[9] and for private commissions, such as the covered serving dishes supported by kneeling winged females in Odiot's Demidoff service.[10]

The motif—the handles composed of satyr masks from which issue curled serpentine forms—that decorates the wine cooler on the lower register was used by Auguste several times. It appears on a wine cooler signed and dated 1804.[11] The female mascaron, in the drawing situated in a narrow frieze at the top, set off by a bead molding, and centered between garlands hanging from rosettes, appears as well on the Auguste piece, but there it is larger, unconfined to a frieze, and set off above swags of fruit and flowers. The satyr mascaron handles appear again on a much more elaborate and important piece, the large wine cooler commissioned by Napoleon as a gift for Feth Ali, the shah of Persia, finished between 1806 and 1809.[12]

The branches of the three-light candelabrum at the right, like those in the caryatid candelabrum, are round, formed by acanthuses curving around rosettes, a design that Moitte used repeatedly (see No. 3).

Campbell points out that in Moitte's drawings of 1784–89, the elements of the Directoire and Empire styles are already present, and that the masterpieces of Empire silver Auguste produced for Napoleon were based on Moitte's designs of more than ten years earlier. This drawing, dating to the late 1780s, clearly demonstrates the thesis.

NOTES

1. On Moitte, see Campbell 1983, especially chapter 8, "The Auguste Drawings," with previous bibliography.
2. M. Snodin and M. Baker, "William Beckford's Silver I," *Burlington Magazine* (November 1980), pp. 735–748, and "William Beckford's Silver II," *Burlington Magazine* (December 1980), Appendix C, *French Silver*, pp. 826–827.
3. Campbell 1983, pp. 182–183, fig. 38; and E. Dacier, "L'athénienne' et son inventeur," *GBA* 8 (1932), p. 119, fig. 4.
4. Christie's, New York, February 26, 1986, lot 184, repr., Odiot stamp no. 294; discussed in Campbell 1983, pp. 186–187, 301 n. 30.
5. Sotheby Parke Bernet Monaco, November 26, 1979, lot 624, repr., discussed in Campbell 1983, pp. 38, 186, fig. 14.
6. Sotheby Parke Bernet Monaco, November 26, 1979, lot 632, repr.; Campbell 1983, p. 186.
7. Acc. no. 79.PC.182; see G. Wilson, "Acquisitions Made by the Department of Decorative Arts, 1979 to Mid 1980," *J. Paul Getty Museum Journal* 8 (1980), pp. 14–17, figs. 21–23.
8. Ibid., fig. 24.
9. Helft 1966, p. 275, repr.
10. Draper and Le Corbeiller 1978, no. 156, fig. 32.
11. Sale, Sotheby's London, March 31, 1966, lot 95, repr.
12. Helft 1966, pp. 272–273, fig. 1.

75. Design for a Candelabrum

Pen, black ink, with gray wash. Framing
line in black ink. 22⅞ × 17½ in.
(581 × 445 mm). Light brown staining at
top. Lined.

Inscribed in pencil lower right, *C 420*.

PROVENANCE: J.-B.-C. Odiot and
Maison Odiot, Odiot stamp no. 420;
[Galerie Fischer-Kiener]; [Adrien Ward-
Jackson]; purchased in London.

Rogers Fund and The Elisha Whittelsey
Collection, The Elisha Whittelsey Fund,
1978
1978.521.3

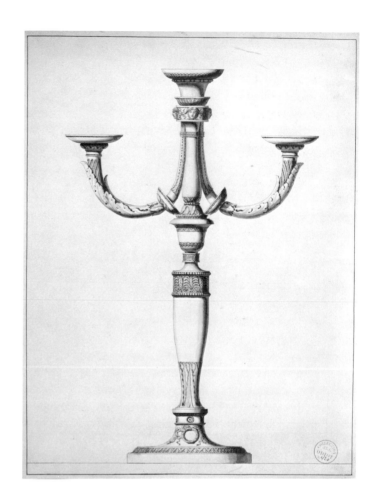

Acquired with the group of Auguste shop
drawings from the Maison Odiot (Nos.
3–5), this hitherto anonymous drawing, with its
lively, sensitive pen work and ink wash, stands
out. Although it is a highly finished drawing in
scale with the finished candelabrum, its distinc-
tive draughtsmanship may be compared with the
small sheet of sketches by Moitte (No. 74). The
female mascarons that decorate the frieze at the
base of the bobeche are entirely consistent with
Moitte's style. They are severely classical, with
braided coiffures and profiles close to those that
decorate the candelabrum and wine cooler in
Number 74, and to those in the sheet of silver
designs featuring a large caryatid candelabrum
with two *tazze* and two wine coolers.[1] The
wreath with streaming, crinkled ribbons that
decorates the base is a motif favored by Moitte. It
is depicted, for example, on the wall in a draw-
ing of a room of silver and ormolu furniture,
now in the École des Beaux-Arts.[2] Other decora-
tive elements on the candelabrum, such as the
palmette frieze set off by a bead molding, the
acanthus-sheathed branch, and the leaf-and-
tongue frieze are motifs also typical of Moitte.

A slightly larger replica of this drawing, with
Odiot stamp number 419, appeared at auction as
attributed to Henry Auguste.[3] Since a number of

replicas of Moitte's drawings for Auguste are ex-
tant along with the originals (see Nos. 3–5), it
may be suggested that it was the practice of the
Auguste shop to make copies of Moitte's draw-
ings as patterns for the craftsman to use, while
the originals were probably those shown to
the clients.

NOTES

1 Christie's, New York, February 26, 1986, lot 184, repr.,
 Odiot stamp no. 294; discussed in Campbell 1983,
 pp. 186–187, 301 n. 30.
2 Campbell 1983, pp. 182–183, fig. 38; E. Dacier,
 "L'athénienne' et son inventeur," *GBA* 8 (1932), p. 119,
 fig. 4.
3 Sotheby Parke Bernet Monaco, November 26, 1979,
 lot 633, repr.

JEAN-MICHEL MOREAU, CALLED MOREAU LE JEUNE

Paris 1741–Paris 1814

76. Design for the Engraving *Réjouissances du Peuple . . . à Reims le 27 aout 1765*

Pen, black ink, black and gray wash. 17¾ × 24⁹⁄₁₆ in. (451 × 625 mm). Strip of paper ¾ × 24⁹⁄₁₆ in. added at top. Creased vertically at center. Two tears at lower left edge, mended.

Signed and dated lower left on musicians' stand, *J Moreau/le jeune/1767.*

PROVENANCE: Mme Decourcelle; Decourcelle sale, Paris, March 25, 1925, lot 74, repr.; René Fribourg; Fribourg sale, Sotheby's, London, October 16, 1963, vol. VI, lot 592, repr.; [William H. Schab Gallery]; purchased in New York.

BIBLIOGRAPHY: P. Huisman and M. Jallut, *Marie Antoinette*, New York, 1971, p. 61, repr.; *Six Centuries of Graphic Arts: Prints and Drawings by Great Masters*, cat. 38, William H. Schab Gallery, New York, n.d., no. 150, repr.; Gruber 1972, pp. 32–35, 185, fig. 10; *Notable Acquisitions, 1965–1975*, p. 199, repr.

Harris Brisbane Dick Fund, 1967
67.524.1

Jean-Michel Moreau *le jeune*,[1] a brother of the landscapist Louis Moreau, accompanied his teacher, Le Lorrain (see Nos. 63, 64), to Saint Petersburg in 1758, where Moreau *le jeune* was asked to teach drawing at the Academy. Upon Le Lorrain's death in 1759, he returned to Paris and entered the atelier of the engraver Jacques-Philippe Le Bas. He succeeded Cochin as *dessinateur des Menus Plaisirs du Roi* and later be-

came *dessinateur et graveur du Cabinet du Roi*. He was made a member of the Royal Academy in 1789 and later a member of the Revolutionary Art Commission. One of the greatest and most productive book illustrators of the eighteenth century, he illustrated Rousseau's *Nouvelle Héloïse* and the works of Molière and furnished drawings for the second and third parts of Restif de La Bretonne's *Monument du costume*, which became a kind of visual encyclopedia of the life and customs during the ancien régime.

The drawing is in the same direction as the print by the Varin brothers,[2] dated 1771, that documented some of the festivities that took place from August 26 to 28, 1765, to celebrate the erection of the statue of King Louis XV by Pigalle in the recently built Place Royale in Reims.[3] The bronze statue, portraying the king standing in an antique pose addressing his people, was destroyed in the Revolution. Three other prints by the Varin brothers after drawings by Louis-Nicolas van Blarenberghe record other parts of the festivities, which were particularly well documented by contemporary accounts.[4] The *idée* of the festivities, as the iconographic program of the ephemeral structures was called in the eighteenth century, was by M. de Saulx, and the architecture was by J.-F. Clermont.

The scene portrayed here shows an illuminated triumphal arch surmounted by a gigantic illuminated lyre, at the base of which are a fleur-de-lis and laurel leaves. Capping the magnificent lyre is a five-pointed star atop an Ionic capital. Gruber notes that Clermont's lyre owes much to the illuminated lyre that the Slodtz brothers designed for the festivities for the marriage of Madame Première in 1739. On either side of the arch are illuminated yew trees. The arch and lyre served as a portal to an allée leading to the *salle de bal*. Stands with servants handing out or, one might say, even throwing, food and drink to the crowd are placed on either side of the triumphal arch. Violinists and other musicians perform on a stand in the lower left, while the

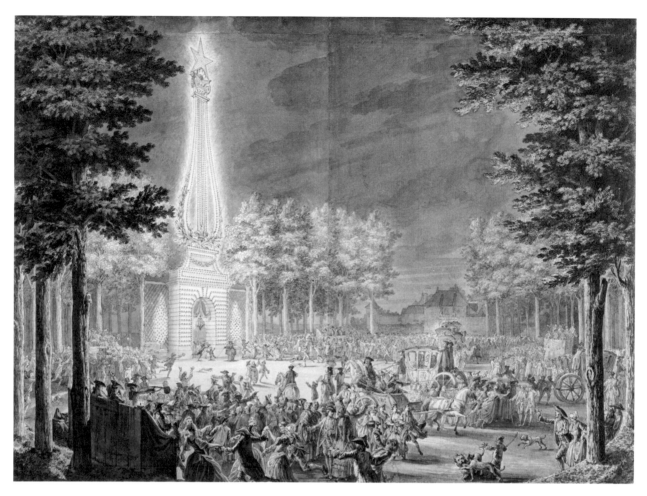

76

crowd dances to their music. To the right are
fine carriages.

The queen, Marie Leszczyńska, was to have
traveled to visit her father, then resident in
Lunéville, near Nancy, which would have had
her passing by way of Reims and attending the
fete. At the last minute her trip was canceled, but
the festivities in Reims took place without her.

NOTES

1 See M.-J.-F. Mahérault, *L'oeuvre gravé de Jean-Michel
 Moreau le jeune (1741–1814)* (Paris, 1880); and E. Bocher,
 Jean-Michel Moreau le jeune, 2 vols., 6th fasc. of *Les
 gravures françaises du XVIIIe siècle* . . . (Paris, 1882).

2 *Réjouissances du Peuple près de la Pyramide d'illumination,
 élevée sur l'Esplanade de la Porte de Mars* . . . *à Reims le 27
 aout 1765*; see Bocher, *Jean-Michel Moreau le jeune*, vol. I,
 no. 242.

3 See Louis Le Gendre, *Description de la Place de Louis XV
 que l'on construit à Reims* . . . (Paris, 1765).

4 See Gruber 1972, pp. 31–37, figs. 8–10.

PIERRE MOREAU (ATTRIBUTED TO)

Paris, active ca. 1750–77

77. Designs for an Etui and a Chatelaine

Pen, gray and black ink, with rose, violet, yellow, blue, and green wash. Two black-ink border lines. 6½ × 4½ in. (165 × 114 mm). Lightly pasted down at the four corners on a sheet of wove paper from an album, measuring 9½ × 5⅞ in. (241 × 149 mm).

Inscribed on mount in brown ink at lower right, *22*.

PROVENANCE: From an album comprising twenty-nine leaves, probably composed in the early twentieth century; sale, Hôtel Drouot, Paris, February 15, 1984, lot 52, repr.; [Kate de Rothschild, London]; purchased in London in 1984 with three other drawings from the album.[1]

Purchase, Anne Stern Gift, 1984
1984.1175.1

Most designs for *objets de vertu*, or such luxury items as jewelry, watchcases, snuffboxes, cane heads, eyeglass cases, and, as represented here, chatelaines and etuis, are by anonymous artists or artisans working in a goldsmith's shop (Nos. 124, 125). Less often they were designed by highly talented artists, such as Gravelot (see Nos. 41–44), for craftsmen who in turn executed the objects. Still more rarely known are drawings by exceptionally gifted goldsmiths, such as Meissonnier (Nos. 72, 73), for work they may have carried out themselves.

This sheet and the entry following have been attributed to one Pierre Moreau on the basis of their resemblance to some drawings that are re-

lated to two sets of prints for goldsmiths' work, jewelry, and enamels, the *Nouveau et IVe cahier concernant l'orphèverie, bijouterie, et emeaux . . . composé et gravé par P. Moreau* (Paris: Crepy, [1771]) and a fifth cahier of 1771.[2] Nothing concrete is known about him beyond the fact that he signed and dated these two sets *P. Moreau Inv. & Sculp. 1771*, and signed other ornament prints,

including sets for carriage designs (1776),[3] ironwork,[4] and balconies.[5] His also are two designs for chimneypieces, one plate signed *moreau Jnv. Et fecit* and another *Moreau f.*, in the second set of six plates of the *Divers décorations de cheminée*, published by Daumont.[6] There are, in addition, engraved plates in a number of architectural treatises signed *P. Moreau* or simply *Moreau*: in C.-É. Briseux's *Art de bâtir des maisons de campagne . . .* (1761);[7] G.-G. Boffrand's *Livre d'architecture . . .* (1745);[8] J.-F. Blondel's Paris edition of Vignola (1752);[9] and G.-P.-M. Dumont's *Suite de projets . . . de salles de spectacles particulières . . .* (1766).[10] In addition, he signed designs for gardens in P.-J. Galimard's *Architecture de jardins . . .* (ca. 1775).[11]

Although all the works signed Moreau have at times been considered to be by the same artist,[12] it is highly unlikely that the engraver of the ornament prints is the one who created the architectural ones. One distinct personality, or at least one whose artistic existence is documented beyond merely the signature on prints, is a Pierre (or Jean) Moreau who entered the *concours* of the Royal Academy of Architecture in 1738, winning the prize in 1743. He was in Rome as a *pensionnaire* from 1746 to 1751 and was mentioned by the director, de Troy, in his official correspondence. He died in 1762. To this P. Moreau are attributed etchings in Dumont's *Suite des ruines d'architecture . . .* , published in Rome between 1763 and 1765.[13]

In view of the lack of firm documentation and precise information for this large body of varied printed architectural and ornament work, scholars have associated the etched architectural plates with the documented, architectural *pensionnaire* Moreau and the ornament designs with the otherwise unidentified Moreau. The possibility also remains that other hands may have been at work in these groups of prints. Because of the similarity in names, there has been further confusion with the artists Moreau *le jeune* (see No. 76) and Moreau-Desproux (see No. 79), both of whose work is quite distinct from that discussed above.

The attribution of the goldsmiths' drawings to Pierre Moreau is an equally tangled situation. Alfred de Champeaux was the first to publish a large group of drawings in the Musée des Arts Décoratifs, in Paris, some of which were from an album comprising leaves by dissimilar hands.[14] Champeaux ascribed them to Moreau.[15] None of the drawings in the album are signed, but the binding of the album is inscribed *P. Moreau*.[16] What other evidence led Champeaux to identify the drawings as Moreau's and specifically for La Maison de Julien Le Roy can no longer be found. Julien Le Roy was one of the great makers of clock and watch movements in Paris in the middle of the eighteenth century, and his son also won renown in the same profession.[17] While some of the drawings are for watchcases, they would not have been drawn by one of the two Le Roys, who were only the makers of the movements and not the designers of the cases. In any event, the drawings are for a large variety of *objets de vertu*, including snuffboxes, etuis, shuttles, and cane handles, not just watchcases, and the name Julien Le Roy has not turned up in any other context.[18] What sustains the attribution is the resemblance of many of this large group of drawings in the Musée des Arts Décoratifs to the two sets of prints of goldsmiths' work signed *P. Moreau*. To this core were added ten similar drawings in the Kunstbibliothek, Berlin,[19] essentially on the basis of what was considered to be their similarity to some of the drawings in the Musée des Arts Décoratifs, as were the group of drawings of which this sheet is a part. Although there is no secure evidence that these drawings are by the elusive Pierre Moreau, the attribution to Moreau is retained until a firm identification can be made because of their similarity to the groups of drawings connected with that name.

A chatelaine is very rarely of French manufacture. In the collection of the Louvre, for example, there are no French chatelaines. However, there is one thought to be English.[20] The French royal arms on the etui do not mean that this was necessarily designed for one of the female members of the royal family, since it is unlikely that one of them would have taken up housekeeping tasks, unless in a playful way. Jessie McNab has pointed out that the chatelaine and the etui are not necessarily connected, unless to demonstrate how the etui might hang from the chatelaine or be

detached. She notes that if they were en suite, the design might have been intended as a gift from the king to one of his mistresses (note the flaming hearts on the chatelaine).

NOTES

1 Fifteen of the remaining sheets were dispersed at a sale, Sotheby's, Geneva, November 14, 1984, lots 229–43, repr. The remaining drawings were offered by Kate de Rothschild (see *Exhibition of Old Master Drawings, June 24th–July 5th 1985* [London, 1985], no. 30). Three of the drawings are in the Houthakker collection, for which see Fuhring 1989, nos. 586–588, repr.

2 Berlin 1939, no. 873; Cahier IV and pl. A-6 of Cahier V are in the Metropolitan (acc. nos. 33.123.31 and 33.123.31[1]). These titles imply the existence of Cahiers I to III, which, however, are not known (Guilmard 1880, p. 235).

3 *Ier [3e] cahier de voitures dessinées par Moreau et gravées par Juillet en 1776;* see Berlin 1939, no. 1429(1). The Berlin Kunstbibliothek also has a plate from a fourth cahier, with the number 24 (each cahier had six plates), signed *Moreau inv. et sculp. 1777* (no. 1429[2]).

4 *Nouveau recueil de serrurerie . . . inventé et dessiné par Moreau, 1762. À Paris chez Mondhare . . . J. Pelletier fecit.* Title and five plates, as described in Berlin 1939, no. 1364.

5 *Ier cahier de nouveaux balcons dessinés par Moreau et gravés par Juillet* (Paris, Le Pere et Avaulez). Six plates, according to Guilmard; Berlin 1939, no. 1367.

6 Berlin 1939, no. 3808. The first set of six plates was by Jean Mansart *l'aîné* (Paris, N. J. B. de Poilly).

7 Berlin 1939, no. 2401.

8 Ibid., no. 2402.

9 Ibid., no. 2404.

10 Ibid., no. 2792.

11 Ibid., no. 3468.

12 By the cataloguers of the Berlin ornament catalogue, for example.

13 Erouart, in *Piranèse et les français,* pp. 235–237, who attributes to him several other architectural prints, including one of the portals of Saint-Merry in Paris. Although Moreau died before the publication of Dumont's work, his authorship of the plates bearing his name can be assumed since the plates were certainly finished earlier.

14 Musée des Arts Décoratifs, inv. nos. 4198–4249.

15 *Portefeuille des arts décoratifs, publié sous le patronage de l'Union Centrale des Arts Décoratifs . . .* (Paris, 1888–98); followed by L. Deshairs, *Dessins originaux des maîtres décorateurs* (Paris, 1914), nos. 179–237, pls. 69–76.

16 I would like to thank Marie-Noël de Gary and Annie Valentin for furnishing this information.

17 Alphonse Maze-Sencier, *Le livre des collectionneurs* (Paris, 1885), vol. I, pp. 269, 275, 278.

18 The sources consulted were Thieme-Becker; the catalogues of gold boxes in the collection of the Louvre (H. Nocq and C. Dreyfus, *Tabatières, boîtes, et étuis . . . du Musée du Louvre* [Paris, 1930]; S. Grandjean, *Catalogue des tabatières, boîtes, et étuis . . . du Musée du Louvre* [Paris, 1981]); at Waddesdon Manor (Grandjean 1975); in the Wrightsman Collection, MMA (Watson 1970); in the Thyssen-Bornemisza Collection (Somers Cocks and Truman 1984); and in the studies by Le Corbeiller (1966) and Snowman (1966).

19 Berckenhagen 1970, pp. 286–287, Hdz 324–333, repr.

20 Grandjean, *Catalogue des tabatières, boîtes, et étuis,* no. 481, repr.

78. Two Separate Designs for the Top and Bottom of a Rectangular Gold Enameled Box with Canted Corners

Pen, black ink, with blue, rose, crimson, green and gold wash. Above: 2⁹⁄₁₆ × 3⁹⁄₁₆ in. (65 × 91 mm); below: 2⅝ × 3⁹⁄₁₆ in. (67 × 91 mm). The two lined and lightly pasted down at the four corners on the same mount, a sheet of wove paper from the same album as Number 77.

Inscribed on mount in brown ink at lower right, *44*.

PROVENANCE: See Number 77.

Purchase, Anne Stern Gift, 1984
1984.1175.2

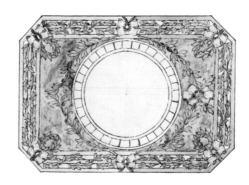

The colors in these designs are brighter and more transparent than those used in the designs for an etui and a chatelaine (No. 77), representing what would have been very delicate, translucent enamels. Clare Le Corbeiller has kindly pointed out the similarity in design of our drawings with a rectangular four-color gold box with canted corners made by Pierre-François-Matis de Beaulieu in Paris in 1770.[1] In contrast to our designs, in which it has been left blank, the central medallion of the Beaulieu box is filled with allegorical trophies of Love, Music, and Gardening. A ribbon decorates the upper half of the surround of the medallion, and laurel branches and swags complete the lower half. The decorative surround of the medallion on the upper portion of our sheet—also consisting of laurel branches wrapped with a ribbon at the top—differs from the Beaulieu box, where the design is very regular and stylized and more Neoclassical, in that here the branches poke out of the edge of the medallion instead of following the contour of the medallion as do those of the Beaulieu box. The same irregularity and the freer handling of the decorative motifs constituting the surround of the medallion characterize the lower design, with its branches and bows, indicating the possibility of a date earlier than that for the Beaulieu box, perhaps between 1760 and 1765.

NOTE

1 Sale, Christie's Geneva, May 11, 1982, lot 182, repr.

79. Façade of the Hôtel de Chavannes,
Paris

Pen, black ink, and gray and colored wash.
Three framing lines. 15 11/16 × 17 13/16 in.
(400 × 453 mm). Stained, dirty, and some
tears. Creased vertically at center. Verso
with plan of a circular room.

Inscribed at top in brown ink, *Maison Ap-
partente a Monsieur de Chabanne, située sur le
Boulevard de la Porte du Temple à Paris, de
Monsieur Morau/Architecte du Roy.*

PROVENANCE: Charles Mewès; [W. R.
Jeudwine, London]; Mr. and Mrs. Charles
Wrightsman.

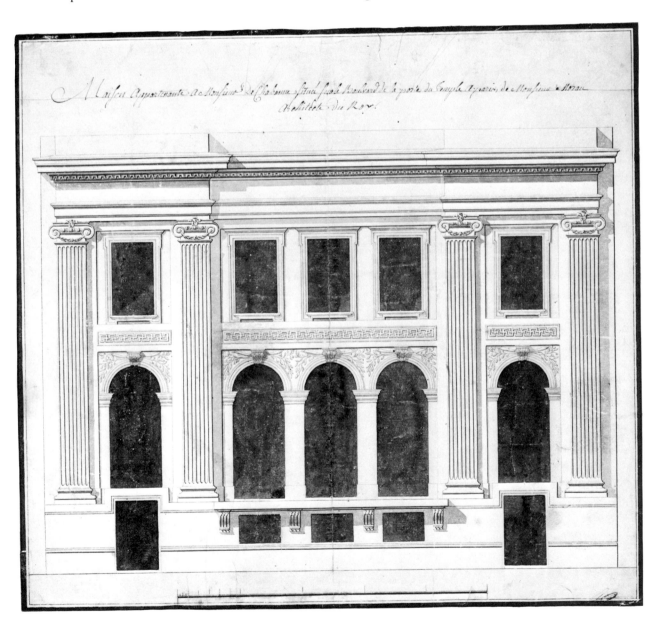

BIBLIOGRAPHY: Harris 1969, pp. 246–247, repr.

Gift of Mr. and Mrs. Charles Wrightsman, 1970
1970.736.23

NOTES

1 M. Gallet, "Dessins de Pierre-Louis Moreau-Desproux pour des édifices parisiens," *Bulletin du Musée Carnavalet* (November 1961), pp. 6–7, repr.
2 D. 6671. The Carnavalet drawing is 350 × 435 mm, while ours is 400 × 453 mm.

Although he competed for the Prix de Rome three consecutive times, in 1750, 1751, and 1752, Moreau-Desproux (1727–1793) never won above second prize. However, his friend Charles De Wailly offered to share the first prize with him so that Moreau could go to Rome. Moreau and De Wailly were there between 1754 and 1757 to study antique and Renaissance architecture. In 1757 Moreau returned to Paris, where in 1763 he became *maître des bâtiments de la ville de Paris*.

As his first private commission, in August of 1758 he designed the Hôtel de Chavannes, near the Porte du Temple, for the magistrate Jacques de Chavannes. The *hôtel* was destroyed in 1846. In his *Observations sur l'architecture* (1765), the polemicist Père Laugier praised the building for the advanced style of its architecture (which became the *goût grec* of the 1760s), but he found it wanting in other respects: for instance, Laugier would have preferred columns instead of pilasters on the facade. But for this and several other details, Laugier continued, it would have been a true model of architecture.[1] The facade consists of five bays, the outer two of which are projecting and enclosed by two colossal fluted Ionic pilasters. The cornice between the ground and second floors is decorated with a meander pattern (another item Laugier criticized), and a frieze runs across the top under the plain projecting cornice.

The building was begun in 1758 and finished in May of 1760. A drawing of the facade in the Musée Carnavalet has nearly the same inscription as ours (*Maison appartenant à Monsieur de Chabanne, situé sur le Boulevard de la porte du Temple à Paris, exécuté sur les dessins de M. Moreau, Architecte du Roy*).[2]

GILLES-MARIE OPPENORD

Paris 1672–Paris 1742

80. Study for a Decorated Initial *A* with the Annunciation

Pen, dark brown ink, heightened with white, on beige paper. Framing line in brown ink with some gold. 5⅛ × 4⅛ in. (130 × 105 mm). Lined.

PROVENANCE: [F. and G. Staack, Camden, Maine]; purchased in Camden, Maine.

Harris Brisbane Dick Fund, 1948
48.4.6

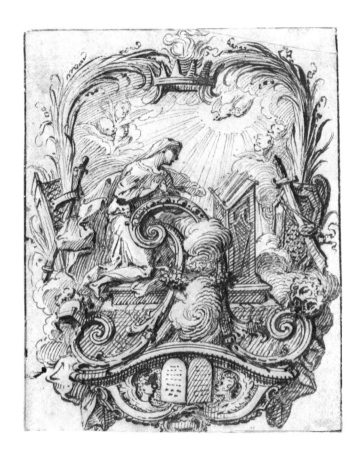

A pupil of his father, an *ébéniste du roi* with quarters in the Louvre, Oppenord grew up amid the artists and craftsmen in royal service.[1] Although he was a pupil of Jules Hardouin Mansart for a short time, Oppenord's real teacher was Italy, especially Rome, where he was at first an unofficial and, after two years, from 1694, an official *pensionnaire* through the good offices of the marquis de Villacerf, the *surinten-dant des bâtiments*. He resided in Italy until 1699, during which time he avidly studied by drawing the art and monuments about him, especially the architecture by Bernini and Borromini. He was the official architect of Philippe, duc d'Orléans, the regent from 1715 until 1723, when Louis XV came of age, and became the *directeur général des bâtiments et jardins*. He worked extensively on the Palais Royale, the seat of the duc d'Orléans, and on other *hôtels particuliers*, including that of the great collector and connoisseur Pierre Crozat on the rue de Richelieu. He executed the altar for Saint-Germain-des-Prés and was the official architect for Saint-Sulpice, but little of his work there was executed. His compulsion for working with pen and chalk produced an abundance of drawings, more than two thousand of which were owned by Gabriel Huquier, the engraver-publisher, who published many of them in the series known familiarly as the *Petit Oppenord,* the *Moyen Oppenord,* and the *Grand Oppenord.* It was through this series that Oppenord's work, especially his absorption of the Roman Baroque, was spread in France and, indeed, throughout Europe and contributed significantly to the development and evolution of the Rococo.

There are a number of studies for the engraver apart from this energetically worked drawing of the letter *A,* each, like this, in reverse for printing: there is an initial *B* in the Kunstbibliothek Berlin;[2] there are four in the Louvre, two each representing *C* and *D*;[3] and there are three in the Cooper-Hewitt Museum

for the letter *B* and a fourth in which the initial is difficult to decipher, but since it includes the figure of a bull, it may very well be a *T* for *taureau*. All the studies are in very dark brown ink.[4] Further studies for illustrations are in the Pierpont Morgan Library.[5]

NOTES

1 On Oppenord, see G. Huard, "Oppenord," in Dimier, vol. I, 1928, pp. 311–329; and E. E. Dee, in the *Macmillan Encyclopedia of Architects* (London, 1982), vol. III, pp. 324–327, with previous bibliography. I would like to thank Mrs. Dee for generously sharing her knowledge and material on Oppenord.

2 Berckenhagen 1970, p. 175, Hdz 2405a, repr.

3 L. Duclaux, *Inventaire général des dessins école français* (Paris, 1975), vol. XII, pp. 111–112, nos. 199–202, repr.

4 1911-28-230 a, b, c. I would like to thank E. E. Dee for making these known to me.

5 See E. E. Dee, in the *Fourteenth Report to the Fellows of the Pierpont Morgan Library, 1965 and 1966* (New York, 1967), pp. 120–122.

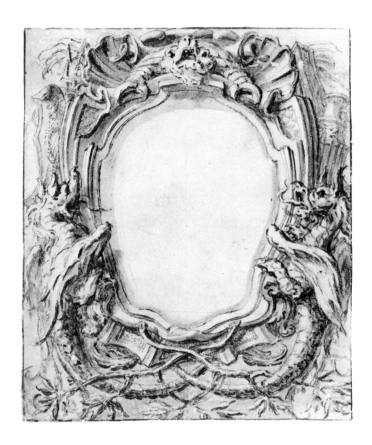

81. Study for a Cartouche

Pen, black ink, with gray wash, on beige paper. Framing line. 5 × 4¼ in. (127 × 108 mm). Lined.

PROVENANCE: [F. and G. Staack, Camden, Maine]; purchased in Camden, Maine

Harris Brisbane Dick Fund, 1948
48.4.1

VIIIe livre de M. Oppenort contenant des cartouches, propres aux édifices et aux ouvrages de tous les beaux Arts.[1] The variety of uses for which cartouches such as this could have been adapted is pointed out in the suite's title. Twelve plates of cartouches incorporating motifs of putti, eagles, dogs, nymphs, lion skins, and papal arms, among others, constitute the suite.

NOTE

1 B. N., *Inventaire*, vol. IV, p. 603, no. 30; vol. XI, p. 501.

A work of energetic draughtmanship, this design for a cartouche consisting of dragons intertwined with foliage and branches was engraved in reverse with virtually the same dimensions by C.-N. Cochin *père* as plate 8 of the eighth book of the *Moyen Oppenord*. Huquier published the eighth book of the *Moyen Oppenord* in 1737–38 under the title

82. Study for a Cartouche

Pen, black ink, with gray wash, on beige paper. Framing line. 5 × 4 5/32 in. (127 × 107 mm). Lined.

Signed and inscribed in brown ink within cartouche, *A Premier/Livre de/Cartouche/dans le du chevalier/Bernin,/inventé par Gi/Marie Oppenort/directeur Directeur/Gnl des des Bat/jardins de/S. A. R. Re/du Royaume;* at lower left, *gout.*

PROVENANCE: [F. and G. Staack, Camden, Maine]; purchased in Camden, Maine.

BIBLIOGRAPHY: Eidelberg 1968, p. 451 n. 22.

Harris Brisbane Dick Fund, 1948
48.4.2

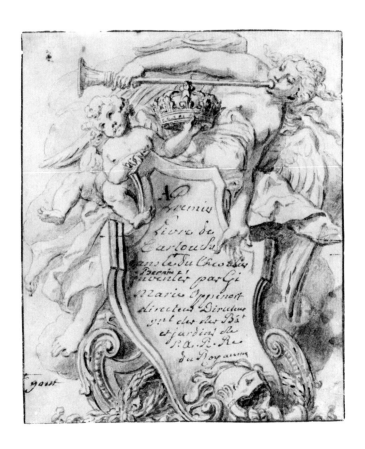

Although Oppenord's inscription on this drawing describes it as for the first set of cartouches in the style of Bernini, it was engraved by Cochin in reverse as the first plate of the second set of cartouches and published in 1737–38 in the ninth book of the *Moyen Oppenord.*[1] While in his inscription Oppenord names himself the director general to the regent for the royal buildings and gardens, he lets the image—of Fame blowing her trumpet over a putto who holds the royal crown of France—explain itself.

NOTE

1 B. N., *Inventaire*, vol. IV, p. 603, no. 30; vol. XI, p. 501.

83. Design for a Cartouche

Pen, black ink, with gray wash, on beige paper. Framing line. 5 × 4 ¼ in. (127 × 108 mm). Lined.

PROVENANCE: [F. and G. Staack, Camden, Maine]; purchased in Camden, Maine.

Harris Brisbane Dick Fund, 1948
48.4.3

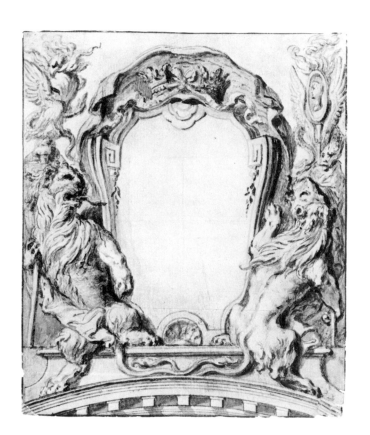

This study, in which rampant lions flank a cartouche surmounted by a ducal crown, was engraved by Cochin in reverse and published by Huquier in 1737–38 as plate 2 of the ninth suite of prints in the *Moyen Oppenord*.

NOTE

1 B. N., *Inventaire*, vol. IV, p. 603, no. 30; vol. XI, p. 501.

84. Study for a Cartouche

Pen, black ink, with gray wash, on beige paper. Framing line. 5 × 4 ⁵⁄₃₂ in. (127 × 107 mm). Lined.

Signed and inscribed in brown ink within cartouche, *B/Second/Livre de/Cartouches dans/le gout du Chevalier/Bernin, inventés par/Gi. Marie Oppenord/premier Architecte/et Directeur general/des Batiments et jardins/de S. A. R. Regent/du Royaume.*

PROVENANCE: [F. and G. Staack, Camden, Maine]; purchased in Camden, Maine.

BIBLIOGRAPHY: Eidelberg 1968, p. 451 n. 22.

Harris Brisbane Dick Fund, 1948
48.4.4

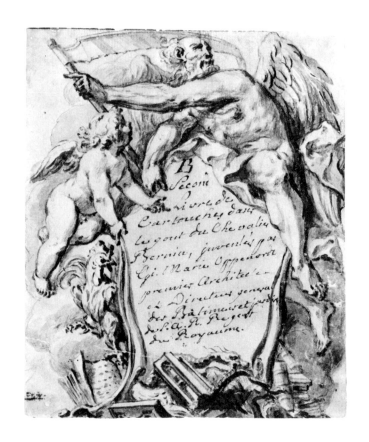

The figure of Time, his scythe in hand, sits astride a cartouche, while at the left a putto points to the words on the cartouche. Below the putto is the *coq gaulois*, the French cock, and a serpent coils around Time's hourglass. This study was engraved by Cochin in reverse as plate 5 of the ninth set of the *Moyen Oppenord*, published by Huquier.[1]

NOTE

1 B. N., *Inventaire*, vol. IV, p. 603, no. 30; vol. XI, p. 501.

85. Study for a Cartouche

Pen, black ink, with gray wash. Framing line. 5 × 4 ¼ in. (127 × 108 mm). Lined.

PROVENANCE: [F. and G. Staack, Camden, Maine]; purchased in Camden, Maine.

Harris Brisbane Dick Fund, 1948
48.4.5

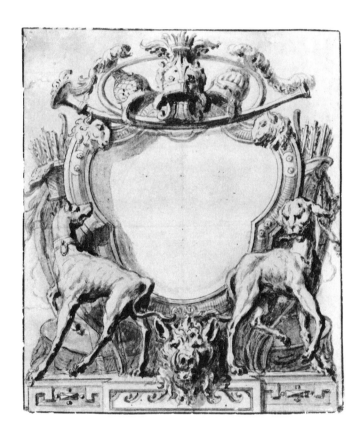

Symbols of the hunt enrich this cartouche. Elegantly posed hunting dogs flank the blank cartouche, while behind them on each side are bows and quivers with arrows. Crossed hunting horns and helmets surmount the design, and a boar's head is placed at the bottom center. This study was engraved by Cochin in reverse as plate 11 of the ninth set of the *Moyen Oppenord*, published by Huquier.[1]

NOTE

1 B. N., *Inventaire*, vol. IV, p. 603, no. 30; vol. XI, p. 501.

86. Study for a Garden Capriccio

Red chalk. 10⅜ × 7½ in. (264 × 191 mm).

Inscribed verso at top in black chalk,
Bought by Hubert Robert.

WATERMARK: Indecipherable.

PROVENANCE: [Galerie Cailleux,
Paris]; purchased in Paris.

Edward Pearce Casey Fund, 1985
1985.1116.3

This study for what must be a fantasy garden scene features half of a wall fountain consisting of a rusticated niche within which is a vase with a dolphin handle. At the left side of the niche, a satyr plays on pipes. In the left foreground, an urn is set on a high columnlike base, while in the left background, sketchy trees form a schematic landscape. This red-chalk study is related to a group of about forty red-chalk drawings and counterproofs for fountains in the Nationalmuseum in Stockholm that once were attributed to Watteau but have since been identified by Martin Eidelberg as Oppenord's.[1] Eidelberg establishes that the group of drawings, referred to as the Cronstedt set after the Swedish count who purchased it in Paris and took it to Sweden after 1735, was at one time owned by Watteau. During his trip to Paris in 1715 the Swedish count Tessin noted in his diary that Watteau had shown him the drawings, stating that they were by Oppenord. The latter point is important because even in recent times the Cronstedt drawings have been attributed to Watteau himself.[2] J. Mathey and C. Nordenfalk in their article of 1955 connected the Cronstedt drawings with other Watteau drawings in various collections as well as with the set of prints of fountains after Oppenord that were etched and published by Gabriel Huquier in the *Moyen Oppenord*, which was printed within Oppenord's lifetime and during the period when the Cronstedt drawings were still in Paris and available to Hu-

quier. Essentially, Mathey and Nordenfalk argued that the Cronstedt group were studies by Watteau after clearly identified Oppenord designs, a thesis that has by now been firmly disproved.

While many of the drawings in the Cronstedt group share motifs that Oppenord reworked frequently, this drawing has no specific reference. However, it may be compared with a drawing in the Musée des Arts Décoratifs for a fountain with nymphs and satyrs around a central rock mass on which a satyr playing pipes is seated,[3] which is a very close variant of one of the Cronstedt sheets in Stockholm.[4] The latter drawing is the model for one of the fountains in the group engraved by Huquier in the *Moyen Oppenord*.[5] The schematic forms of the figures, their broken contours, and the rough slashes for hatching of shadows or delineations of the shape of the basin of the fountain are characteristics

shared by both our drawing and the above-mentioned two.

Elaine Dee has pointed out that there is a copy of this drawing in the Hermitage, Saint Petersburg.[6]

NOTES

1 Eidelberg 1968, pp. 447–456.
2 J. Mathey and C. Nordenfalk, "Watteau and Oppenort," *Burlington Magazine* (May 1955), pp. 132–139; Parker and Mathey 1957, vol. I, pp. 29–33, nos. 193, 198–203, 206–234, repr.; J. Cailleux, "Newly Identified Drawings by Watteau," *Burlington Magazine* (February 1967), pp. 56–63.
3 Eidelberg 1968, fig. 17.
4 Parker and Mathey 1957, no. 233; Eidelberg 1968, fig. 20.
5 Mathey and Nordenfalk, "Watteau and Oppenort," fig. 4.
6 Inv. no. 30522 (oral communication).

87. Study with a Tomb and Flaming Brazier

Pen, black and gray ink, with gray wash. Framing line. 12 15/16 × 15 5/16 in. (329 × 389 mm). Lined with blue paper. Inlaid into decorative mount.

PROVENANCE: [W. R. Jeudwine, London]; purchased in London.

BIBLIOGRAPHY: *Exhibition of Old Master Drawings*, W. R. Jeudwine and L'Art Ancien, London, 1968, no. 96.

Rogers Fund, 1968
68.773.4

Bruno Pons identified this formerly anonymous drawing as by Oppenord. Suggestions that it was by a Neoclassical artist had previously been advanced. The restrained architecture of the room, with a colonnade, a shallow frieze, and a shallow niche that contains a figure in classical garb, and the sober design of the tomb support such a thesis. However, there are drawings by Oppenord in the Robert de Cotte albums in the Cabinet des Estampes in the Bibliothèque Nationale that are similar to this sheet.[1] They are imaginative studies: two are interiors showing bedchambers, and the third is a capriccio drawing for a pavilion with a colonnaded porch, herm pilasters, and a classical frieze. They are executed in gray and black ink and wash as is this design. They also convey the same sense of sparsely decorated spaciousness, and the figures' stances, their faces covered with drapery, bear affinities to those of our sheet.

The drawing has analogies with plates 40 through 45 of the *Livre de Mr. Oppenord contenant des tombeaux*, in the *Grand Oppenord* of 1748–51.

NOTE

1 Ha 18, vol. II, leaves 9, 10, 12.

88. Design for the Wrought-Iron Entrance Grille of a Chapel

Pen, gray ink, with gray, brown, red, and blue wash, on heavy paper. 23 13/16 × 11 1/16 in. (605 × 281 mm). Creased horizontally at center; tears and holes, repaired. Stained.

PROVENANCE: [Lucien Goldschmidt, New York]; purchased in New York.

Purchase, Anne and Carl Stern Gift, 1965
65.676.2

Bruno Pons identified this drawing as a study by Oppenord for the grille for the high altar of the royal abbey of Jouarre (Seine-et-Marne). The church was destroyed in the Revolution. The Rohan-Guéménée arms surmount the grille, and the royal crown appears in the oval with the cipher. Oppenord's design for the altar was engraved as the second plate of the *Livre d'autels* in the *Grand Oppenord*. Oppenord's preparatory drawings for the vases on the altar are in a private collection in Paris.

89. Design for Ornament with a Flutist

Red chalk. Ornamental framing line.
9⅝ × 14⅛ in. (245 × 359 mm). Some tears,
repaired. Verso with black-chalk design for
molding.

PROVENANCE: Walter C. Baker.

Gift of Walter C. Baker, 1962
62.578

When this drawing was acquired, it was attributed to Claude Gillot (1673–1722), the painter and designer of ornament whose major fame rests on the fact that Antoine Watteau studied and worked with him starting in 1703. However, the precise ornamentation, the crisp folds in the billowing drapery, the jaunty stance, and the small wrists and ankles on swelling arms and calves are typical of Oppenord.[1]

The ornament represented in drawings of the eighteenth century often may be ambiguous, lending itself to various interpretations. It has been suggested that this could be a drawing for a coach or for the decoration of a niche. It can be compared to drawings in the Houthakker collection[2] and in the Kunstbibliothek, Berlin.[3] The Houthakker and Berlin drawings also have arches, but their decoration fills a rectangular field as if for a cove or ceiling. This sheet is surely for the decoration of a niche: the full-blown, batwing decoration embellishes the rounded form of a niche, and the subject of an elegant musician certainly has little relevance to a coach.

NOTES

1 Elaine Dee supports the identification of this sheet with Oppenord.
2 Fuhring 1989, no. 56, repr.
3 Berckenhagen 1970, pp. 170–172, Hdz 278, 280, repr.

90. Design for a Monument to a Military Leader

Pen, brown ink, with gray wash. Framing line. 13¾ × 8¹³⁄₁₆ in. (349 × 224 mm). Slightly spotted. Lined.

PROVENANCE: [Prouté, Paris]; S. Kaufman, London; [W. R. Jeudwine, London]; purchased in London.

BIBLIOGRAPHY: Kaufman and Knox 1969, no. 76, repr.

Purchase, Harris Brisbane Dick Fund and Joseph Pulitzer Bequest, 1971
1971.513.80

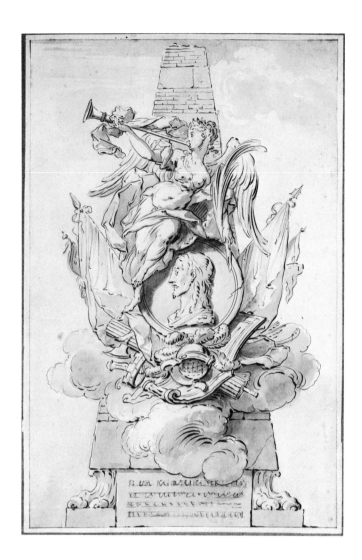

Kaufman and Knox suggest that the inscription in gray ink beneath the swirls of brown ink on the base of the monument may be read as *Ille Ego Turenius* and that, therefore, this is a monument to the great marshal of France Henri de la Tour d'Auvergne, vicomte de Turenne (1611–1675). Turenne's tomb, by Gaspard Marsy, J.-B. Tubi, and Le Brun, originally at Saint-Denis and moved to the Invalides after the Revolution, includes a Victory crowning the marshal, who lies on a sarcophagus at the base of an obelisk. Kaufman and Knox further suggest that this might be a project for a temporary monument commemorating Turenne. It is with great difficulty that the inscription in gray ink on the tablet is read as Kaufman and Knox propose. This memorial is for an as yet anonymous military leader whose exploits are extolled by the figure of Fame blowing her trumpet.

A preliminary study for this sheet is in an album in Stockholm, in the Tessin-Hörleman collection. There, the figure of Fame—in the same pose—leans against a blank medallion. Around it are weapons and banners as in this sheet.[1] Similar figures of Fame blowing her trumpet are on a sheet for what may be a study for a clock in the Musée des Arts Décoratifs[2] and on a design for a public fountain in the Kunstbibliothek, Berlin.[3]

NOTES

1 THC 5454, leaf 78 recto.
2 Inv. no. A 8462.
3 Berckenhagen 1970, pp. 167–168, Hdz 1180, repr.

91. Study for a Frame Molding

Pen, dark brown ink, over traces of black chalk. Framing line. 15 × 11 9/16 in. (381 × 294 mm). Creased vertically at left. Lined. Inlaid into cream wove paper.

PROVENANCE: [Konstantinoff, Paris]; S. Kaufman, London; [W. R. Jeudwine, London]; purchased in London.

BIBLIOGRAPHY: Kaufman and Knox 1969, no. 79, repr.

Purchase, Harris Brisbane Dick Fund and Joseph Pulitzer Bequest, 1971
1971.513.83

This design for a frame shows a cartouche with a coat of arms at the top, a cross section of the molding, two different studies for part of the bottom corner, and detailed studies of an eagle's head and talons. The arms portrayed are those of Charles de Saint-Albin, archbishop of Cambrai, a natural son of Philippe d'Orléans, the regent of France from 1715 until 1723. The archbishop's arms decorate the portal of Saint-Albin's residence on the Place des Victoires, which was published in plate 16 of the *Grand Oppenord*, in the *Livre de differentes portes, inventée par G. M. Oppenord, architecte*, of 1748–51.

The draughtsmanship in this sheet—in brown ink—is precise and regular, rather like that in preparation for an engraving. It is discussed in relation to the draughtsmanship in the black-ink fountain drawings (see Nos. 92, 93). Whereas the drawings for the fountains are dry and seem to be copies, the draughtsmanship in this sheet is fresh and lively in its precision. The drawing must date to after 1723, the year when Saint-Albin was created the archbishop of Cambrai.

92. Study for a Garden Capriccio

Pen and black ink. Framing line.
18⅛ × 11⅜ in. (460 × 289 mm). Inlaid.

PROVENANCE: [Konstantinoff, Paris];
S. Kaufman, London; [W. R. Jeudwine,
London]; purchased in London.

BIBLIOGRAPHY: Eidelberg 1968,
pp. 451ff., fig. 31; Kaufman and Knox
1969, no. 80, repr.

Purchase, Harris Brisbane Dick Fund and
Joseph Pulitzer Bequest, 1971
1971.513.84

This drawing and Number 93 are part of
a group of five very black ink drawings
for garden capriccios with fountains from the
Kaufman collection[1] that relate to a series of red-
chalk drawings (see No. 86) and to a group of
four pen-and-brown-ink drawings. In addition
to the five capriccios, there is one further draw-
ing attributed to Oppenord in the Kaufman
group for a frame in brown ink (see No. 91).
Although unsigned, the six were all catalogued
by Kaufman and Knox as drawings from
Oppenord's hand. However, there are distinct dif-
ferences between the capriccios and the drawing
for a frame. First, the capriccios are drawn en-
tirely in black ink, while the frame was executed
in dark brown ink. The draughtsmanship of the
frame, although sharing with the capriccios a
certain stiffness as if they were engraver's de-
signs, is much more spontaneous than in the
other drawings. It is also more lively, its lines
seemingly more freely composed. In these latter
qualities, the draughtsmanship of the frame is
comparable to the free and agile draughtsman-
ship of the drawings for the series of cartouches
etched by Huquier (see Nos. 81–85).

Oppenord was a draughtsman whose love for
drawing verged on compulsion, leading him to
try many different styles. Whereas drawings exe-
cuted in black ink by Oppenord are extant, the
Kaufman examples are the only ones known to
me that so strongly mimic the engraver's burin,
with the exception of the group of four brown-
ink fountain drawings signed by Oppenord that
our sheets copy (see below). However, there are
no known engravings in such a finished style ei-
ther after these or other drawings to prove that
the Kaufman group were indeed designs for the
engraver. Certainly the etchings that Huquier
made for the fountain series in the *Moyen
Oppenord* are much more like a translation by
the etcher's free needle of quite sketchy red-chalk
drawings. There is in them none of the swelling
engraver's line or the rigidity of form of the
Kaufman black-ink series.

Kaufman and Knox's idea that all the draw-
ings date after 1723 because the arms in the
drawing of the frame have the cardinal's hat and
other symbols of Charles de Saint-Albin, who
was named archbishop of Cambrai in 1723, is
not tenable if one disassociates the fountain ca-
priccios from the frame drawing. At any rate, if
one agrees with Eidelberg, as I do, that the
group of Oppenord's red-chalk drawings for-
merly in the Cronstedt collection were in
Watteau's possession by 1715, then it would have
been difficult for Oppenord after 1723 to gather
ideas into ink from those he had earlier sketched
in red chalk. This last thesis disagrees with
Eidelberg, who held that the red-chalk sketches
were made from the ink drawings. I believe that
the much more finished studies in ink were
composed from the many ideas presented in the
chalk series. It is a difficult puzzle, but I feel that
the solution which considers the black-ink group
as made by someone in Oppenord's studio after
the red-chalk series is the most plausible expla-
nation until more evidence comes to light.

Elements of the fountain under discussion
have appeared in several red-chalk drawings (or
counterproofs) and four ink drawings. It was a

92

study by Oppenord in pen and brown ink in Stockholm (not from the Cronstedt group)² that was virtually copied by the studio assistant who made this drawing. The sheet shows half of a fountain with a river god who is astride some rocks placed upon a kind of sarcophagus and who holds in each hand an urn from which water gushes forth. An arch with a herm in profile encloses the figure of the river god. To the left of

the arch and set slightly behind it is a statue of Diana, with her bow and arrows, in a running pose, set on a rather high base. The Stockholm sheet is signed by Oppenord, who adds his usual strong paraph between the *d* and *I* of *Oppenord Invenit*. The Metropolitan's drawing resembles all copies in that although the artist has consciously tried to duplicate the drawing, there are misunderstandings of the lines and areas that do not

read properly. This is especially true in the area of the foliage and trees behind Diana and behind the river god, which the copyist has rendered as many parallel curving strokes and some vertical lines—to indicate the tree trunks—which in our sheet are not legible as real trees. The area where the lines are especially weak is the decorative foliage of the sarcophagus. In the Stockholm drawing the lines clearly form broad leaves curling slightly at the edges, while in this drawing they are barely readable as such. The water spouting from the river god's urns is also much less convincing in this study. Elaine Dee has pointed out that in another sheet executed in pen and brown ink, in the École des Beaux-Arts,[3] Oppenord used the figure of the river god in the same pose holding the two urns with gushing water as in our sheet, but he is situated inside colonnaded architecture into which a wall fountain is integrated on the left, where the statue of Diana is placed in our drawing. Also in the École des Beaux-Arts[4] is a sheet in pen and brown ink in which Oppenord varied the composition even more by seating the river god in a reversed position on a rocky outcropping to the side of the fountain, which is composed of a fluted pier and fluted column, and through which one can see a nymph and two putti set within a wall fountain. Further, the background to the left is a beautiful landscape with fortress executed in ink and wash, and there is an urn on a high pedestal at the far left in the immediate foreground. Close to the second sheet from the École des Beaux-Arts and developed from it is a sheet in the Royal Institute of British Architects, London, signed by Oppenord *Oppenord Invenit*, again with the paraph between the two words.[5] In the London study, Oppenord represented the river god as in the second École des Beaux-Arts study but closed the deep landscape study to the left of the fountain, filling it in with trees and a statue of Diana with her hunting dog. At the far left foreground is a large urn similar to that in the École des Beaux-Arts study, but in place of the small putto standing next to a sphinx, in the London sheet there is a triton. A drawing in the Hermitage, Saint Petersburg,[6] has essentially the same components as the London drawing.

The motif of the river god in the previous ink studies is derived from five red-chalk studies and counterproofs from the Cronstedt Collection in the Nationalmuseum, Stockholm.[7] In a counterproof in Stockholm (Cronstedt no. 418),[8] the figure of the river god is exactly reversed from our ink drawing, indicating that the original drawing was in the same direction as our sheet. This sketch is less detailed in its architecture than our drawing, although both share similar elements: an arch, with a shell at the apex, which ends in a volute curving inward and which is composed of a rusticated inner section. A nymph stands to the right of the river god. In another counterproof, Cronstedt no. 400, the figure of the river god differs in the position of the legs and arms;[9] it is also in the reverse from ours, again indicating that the original was in the same direction. The fountain behind the river god is a low, rusticated arch, in the middle of which is an inscription, *Livre des Fontaines*, in reverse due to the reversal of the counterproof. The composition of this sketch is that of Oppenord's etched title page *Nouveau livre de fontaines inventées par le sieur Oppenor* [sic], from the *Moyen Oppenord*, and another counterproof, Cronstedt no. 435, is the reverse of another etched plate in the suite.

The complicated nature of this exposition demonstrates the rich complexity that Oppenord infused into his fountain designs.

NOTES

1 See also Kaufman and Knox 1969, nos. 81–84.
2 Inv. no. 230/1973.
3 Masson collection, inv. no. 0.1683 (through oral communication).
4 Masson collection, inv. no. 0.1683; also brought to my attention by Elaine Dee.
5 Eidelberg 1968, fig. 45.
6 Inv. no. 30524; also brought to my attention by Elaine Dee.
7 Parker and Mathey 1957, vol. I, nos. 202 (Cronstedt no. 419; a counterproof); 222 (Cronstedt no. 403; a counterproof); 227 (Cronstedt no. 435; a counterproof); 231 (Cronstedt no. 402); 232 (Cronstedt, no. 418; a counterproof).
8 Eidelberg 1968, fig. 32.
9 Ibid., fig. 37.

93. Study for a Garden Capriccio

Pen and black ink. Framing line.
17 ¼ × 11 ⅝ in. (438 × 295 mm). Inlaid.

PROVENANCE: [Konstantinoff, Paris];
S. Kaufman, London; [W. R. Jeudwine,
London]; purchased in London.

BIBLIOGRAPHY: Kaufman and Knox
1969, no. 82, repr.

Purchase, Harris Brisbane Dick Fund and
Joseph Pulitzer Bequest, 1971
1971.513.86

This is a design for a scene with a fountain that shows only the left half. On the base of the fountain is a shell with a girl's bust from which the water spurts. The base supports a sphinx, which in turn supports what appears to be an antique altar with a goat's head at the left corner; on top of this a nymph sits on a dolphin, with drapery fluttering above her. To the left is a pillar with a herm on the front, surmounted by two putti bearing tridents, each sitting upon a dolphin, and between them is a large urn with fruit. At the far left, in the middle ground, two men lean over a balustrade. In the background are sketchy trees.

This drawing is a copy of a sheet at Waddesdon Manor[1] that is signed at the upper left *Oppenord Invenit* with the paraph between the two words. Like the drawing in the previous entry, this is a stiff and rigid translation of the original.

NOTE

1 686/507, box 41.

CHARLES PERCIER
Paris 1764–Paris 1838

AND PIERRE-FRANÇOIS-LÉONARD FONTAINE
Pontoise 1762–Paris 1853

94. Design for a Plate in a Book
Commemorating the Marriage of
Napoleon and Marie-Louise
of Austria

Pen, gray ink, with gray wash over black
chalk. On wove paper. 16⅜ × 12⅛ in.
(416 × 308 mm). Inlaid.

Inscribed at bottom, *Entrée de Napoleon au
Tuileries après son Mariage par Fontaine
Architecte.*

PROVENANCE: [Prouté, Paris]; S.
Kaufman, London [W. R. Jeudwine,
London]; purchased in London.

BIBLIOGRAPHY: Kaufman and Knox
1969, no. 108, repr.; Draper and Le
Corbeiller 1978, no. 183, fig. 8.

Purchase, Harris Brisbane Dick Fund and
Joseph Pulitzer Bequest, 1971
1971.513.25

Fontaine, the son of a plumbing engineer, was
a pupil of Antoine-François Peyre, called
Peyre *le jeune*, and Jean-François Heurtier, in
whose studio he met Charles Percier, who also
studied with Guy de Gisors. Fontaine only re-
ceived a second prize in the competition for the
Prix de Rome in 1785, but on his fellow students'
urging, he was sent as a *pensionnaire* to Rome.
Percier, who won the following year, joined him
there, and the companions worked together,
drawing both the ancient monuments and con-
temporary Rome. Fontaine, returning home in
1790, found little work because of the Revolution,
so he traveled to England for several years. Back
in France, he and Percier were employed by the
Opéra designing stage sets. Percier also took on
pupils and was an ardent teacher. The two began
to design decorative art objects and furniture
and were approached by the great Georges Jacob
(1739–1814) to design furniture for his factory.
They also designed several books on the palaces
of ancient Rome, of which the first was *Palais,
maisons, et autres édifices modernes, dessinés à
Rome*, published in Paris in 1798. Another such
book of theirs was *Choix des plus célèbres maisons
de plaisances de Rome et de ses environs mesurées et
dessinées par Percier et Fontaine*, published in
Paris in 1809. But their masterpiece, which
spread their name and style throughout Europe,
was the *Recueil de décorations intérieurs compre-
nant tout ce qui a rapport à l'ameublement . . .
composé par Percier et Fontaine . . . exécutés sur
leurs dessins*, of 1801. In it, as they state in their
title, they included all that was needed by the
fashion-conscious for decorating an interior—
furniture, wall decorations, and window treat-
ments. The book rapidly became the dernier cri
for decoration.

During 1799 and 1800, the two artists came to
the attention of Josephine Bonaparte and were
put in charge of her villa at Malmaison. From
then on they were occupied with works for
Bonaparte, initially when he was first consul
and later, after he had become emperor.

They were in charge of the renovation of the
Tuileries Palace, the palaces at Saint-Cloud,
Fontainebleau, and Compiègne; built the Arc de
Triomphe du Carrousel; laid out the rue de Ri-
voli as it stands today; and were also involved in
renovating the Louvre. They were also responsi-
ble for the decor for court festivities, including

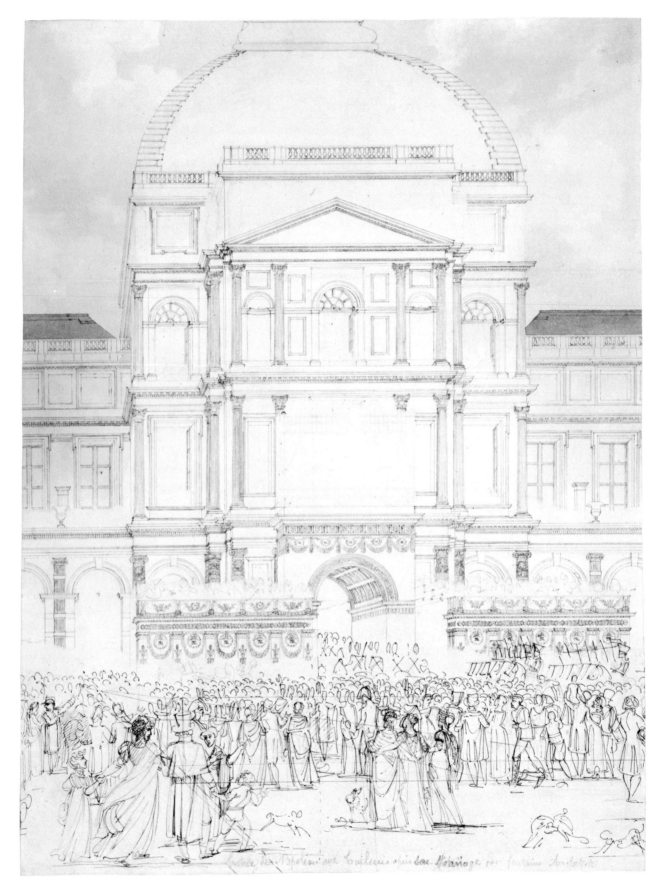

the coronation. In 1811 Fontaine alone was named *architecte de l'empereur*, Napoleon having complained that he never saw the reclusive Percier and thought him a myth. The architects continued to collaborate, the situation quite suiting the quiet Percier. Fontaine's fortunes did not decline at the Restoration, as he was retained as *architecte du roi* until he retired.

Another publication that the artists were involved in was the book detailing the marriage ceremony of Napoleon to Marie-Louise of Austria, *Description des cérémonies et des fêtes qui ont eu lieu pour le mariage de S. M. l'Empereur Napoléon avec S. A. I. Madame l'Archiduchesse Marie-Louise d'Autriche par Charles Percier et P. F. L. Fontaine*, published in Paris in 1810.[1] Napoleon married the archduchess since Josephine could not provide him with an heir. As usual for a monarch, the marriage was a lavish affair, and like other such events, it was memorialized in a sumptuous book chronicling it.

The book details the beginning of negotiations for the marriage in Austria, the letters between the betrothed, and the festive events that took place in Austria. It recounts Marie-Louise's journey to France, and then describes the wedding corteges and entrances of the bridal party, with precise details of the wedding ceremony itself. Engraved plates portraying the different parts of the ceremony illustrate the text. A list of illustrations follows to give an idea of the complex sumptuousness of the event: 1) the plan of the marriage chapel; 2) the civil marriage of the emperor and Marie-Louise in the gallery at Saint-Cloud; 3) the entrance into Paris of the emperor and the archduchess on the day of the marriage ceremony; 4) the entrance of the emperor and empress into the Tuileries garden on the day of their marriage; 5) the arrival of the emperor and the empress at the Tuileries on the day of the marriage ceremony; 6) the descent from the carriage of the emperor and empress into the vestibule of the Tuileries Palace; 7) the emperor and empress traversing the gallery of the museum in order to reach the chapel of the Louvre; 8) the marriage ceremony in the chapel of the Louvre; 9) the emperor and empress receiving the homage of the troops from the great balcony of the Tuileries as the parade passes on the day of their marriage ceremony; 10) the plan of the hall of festivities (Salle de Spectacle) in the palace of the Tuileries; 11) the imperial marriage banquet in the great hall of the palace of the Tuileries; 12) the view of the fireworks and illuminations at the Place de la Concorde; 13) the emperor and empress on their thrones receiving all the felicitations of the court the day after their marriage.

Our drawing is for plate 9, with the emperor and the empress on the great balcony of the Tuileries receiving homage from the troops. The drawing, which is in reverse of the print, is unfinished and differs in certain details from the plate engraved by Charles Normand (1765–1840) and Louis Pauquet (1759–after 1822). First, the angle of vision is different; it is sharper in the print. Also, the print shows fewer onlookers in the immediate foreground. In the drawing, the gay, lively figures of families with their dogs on an outing are more numerous, and they loom larger in the foreground. Much more in evidence in the print, the soldiers have been represented as mere *X*'s coming through the arch in the drawing. The drawing is also schematic and sketchy in the area above the first level of the arch, where the musicians and official onlookers are represented. Above the central arch is an area—left blank except for light black-chalk sketches of curtains and hangings—where the emperor and empress and their close relatives were seated. The large structure was simply decorated: the monogram of Napoleon and Marie-Louise and garlands of flowers were the main decorative motifs of the hangings.

The question of separating out which is Percier's and which is Fontaine's draughtmanship is a difficult one. Often their drawings are indistinguishable. The inscription on this drawing, in referring to Fontaine, the better known of the two artists, does not necessarily mean he was the author of the drawing.

A drawing in ink and watercolor for plate 4 showing the entrance of the emperor and empress into the Tuileries garden on the day of their marriage was recently on the French art market.[2]

NOTES

1 Berlin 1939, no. 3029. On the marriage, see the chapter in M.-L. Biver, *Pierre Fontaine, premier architecte de l'empereur* (Paris, 1964), pp. 132–146.
2 *Dessins et esquisses de maîtres anciens et modernes*, Galerie Charles et André Bailly (Paris, 1989), p. 102, repr.

CHARLES PERCIER

95. Ground Plan for an Entry in the Prix de Rome Competition

Pen, black ink, with colored wash.
20⅝ × 17¹⁵⁄₁₆ in. (524 × 456 mm).

PROVENANCE: Mr. and Mrs. Charles Wrightsman.

BIBLIOGRAPHY: Harris 1969, p. 249.

Gift of Mr. and Mrs. Charles Wrightsman, 1970
1970.736.66

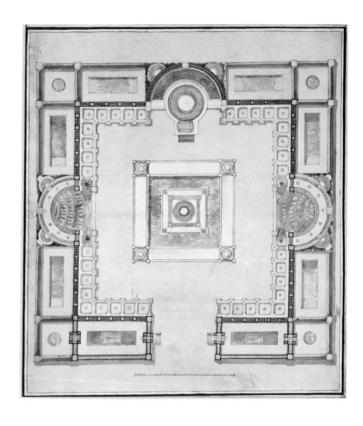

With this drawing, Percier won second prize in the competition for the Grand Prix of 1783, as runner-up to Antoine-Laurent-Thomas Vaudoyer. The program, as described in the *Procès-verbaux*, or the minutes, of the Academy, was for a menagerie in the form of a square in the park of the château of a sovereign.[1] Among the requirements were an amphitheater and open arenas for animal combat, with stairs and seats for spectators. The places set aside for the quadrupeds were to have courts spacious enough for their needs and were to communicate easily with the arena. Extended cages were also necessary. In addition, galleries and buildings for the maintenance of the regular animals and additions of rare species of animals and birds were needed. A principal pavilion without living space was required to receive the prince, and the building's services were to be underground, on the basement level. Many other small pavilions and buildings for the caretakers, servants, and porters were called for. A general plan, representing the disposition of all the buildings and courtyards, fountains and watering places, animal lodgings and cages, was required of the entrants. The scale was to be 2 *lignes* per *toise*. The Academy also required a general section on the same scale

and a separate plan of the two principal stories of the amphitheater and the pavilion of the prince on a scale of 8 *lignes* per *toise*. A section of the amphitheater and pavilion and an elevation of the pavilion only were to be executed at the same scale of 8 *lignes* per *toise*. Also required were sketches of: 1) the general plan on a scale of ½ *ligne* per *toise*; 2) a separate plan of the principal pavilion, the amphitheater, and the arena on a scale of 2 *lignes* per *toise*; 3) a section of the same pavilion and amphitheater on the same scale; and 4) an elevation of the pavilion also on the same scale of 2 *lignes* per *toise*. Nearly all the drawings are now in the collection of the École des Beaux-Arts. The pavilion for the prince is an elegant, circular, domed, and colonnaded building, whereas the amphitheater, which is at the top of the plan, is an enormous affair, completely colonnaded and with a domed forecourt. It is not clear from the plan exactly where the cages and buildings for the personnel were, but they are probably around the center of the square.

A drawing, much smaller than those demanded by the Academy for the competition, was required by the contestants for submission in

addition to the large ones, and this is such a drawing. It was not until three years later, in 1786, that Percier won the first prize in the Prix de Rome.

NOTE

1 Pérouse de Montclos 1984, p. 183. A *toise* is nearly two meters long and is divided into *pieds* and *lignes*.

96. Elevation of Rood Screen with Throne of Louis XVIII for Reims Cathedral

Pen, black ink, with colored wash. 29½ × 22 in. (749 × 559 mm). Lined.

PROVENANCE: Lincoln Kirstein, New York.

BIBLIOGRAPHY: J. S. Byrne, "The Best Laid Plans," *MMAB* (March 1959), pp. 183–195, repr.; Draper and Le Corbeiller 1978, no. 7.

Gift of Lincoln Kirstein, 1956
56.559(5)

This very elaborate drawing for the decoration of Reims cathedral for the coronation of Louis XVIII is, along with five other drawings, the only documentation of a coronation that

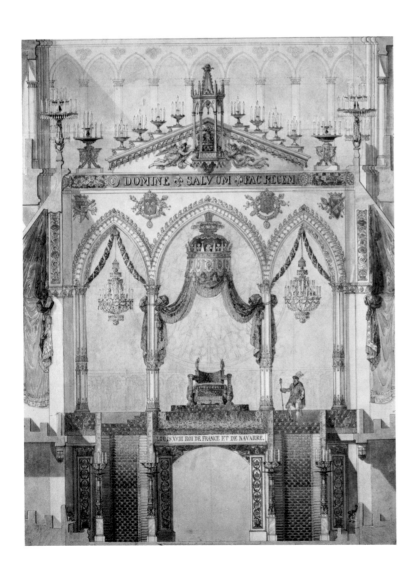

never took place. When Louis came to power in 1814, he was nearly sixty, in poor health, and nearly crippled. There could not have been an immediate coronation since the fortunes of France were still being hammered out at the Congress of Vienna, which did not end until 1815. Also, the previous two coronations had ended badly; another coronation would have revived the bad memories of a king killed by his subjects and a usurping dictator made emperor, who was now in exile. The question of who would crown the king was yet another problem. Since Napoleon had decreed that the crown was not bestowed by the church and thus had crowned himself, Louis was in a situation to do the same thing, about which he must have had strong reservations. Evidently, it was decided that he should arrive at the cathedral already wearing the crown.

The hundred days of Napoleon's return and Louis's flight put yet another damper on the ceremony. But what must have been the deciding factor was the monarch's health, as he was in no shape to withstand a ceremony lasting eight to eleven hours that included processions, kneeling in prayer, and, especially, climbing the steps to the throne shown here in this drawing.

Percier and Fontaine, the designers of Napoleon's coronation and his marriage to Marie-Louise of Austria (see No. 94), were taken up by Louis, who was not averse to using vestiges of the former reign, from its furniture to its designers of ceremonies. As the probable author of this drawing, Percier had to suppress all references to the Empire style and in its place substitute a style known as Palladian Gothic, incorporating the emblems and symbols of the Bourbons—the fleur-de-lis, the crossed *L*'s, crowns, the arms of France and Navarre, and the flames of the Order of the Holy Spirit. In the other drawings in the series, he represented figures of the former kings, further legitimizing the event.

CHARLES PERCIER (MANNER OF)

97. Studies for Two Armchairs

VERSO. Sketches of Three Chairs and
Parts of a Fourth

ca. 1800–1805

Graphite. Framing line in graphite.
4⅝ × 7⅞ in. (118 × 200 mm).

Inscribed recto in graphite at lower left,
Percier.

PROVENANCE: [Heywood Hill, Lon-
don]; purchased in London.

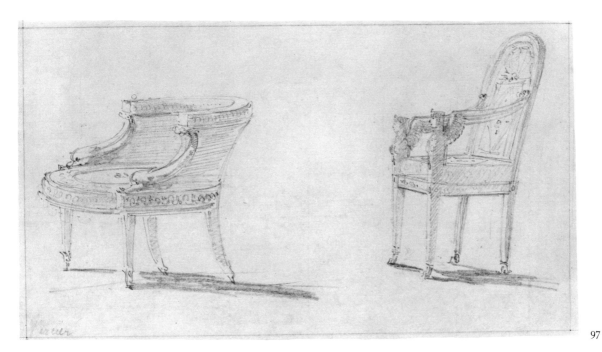

97

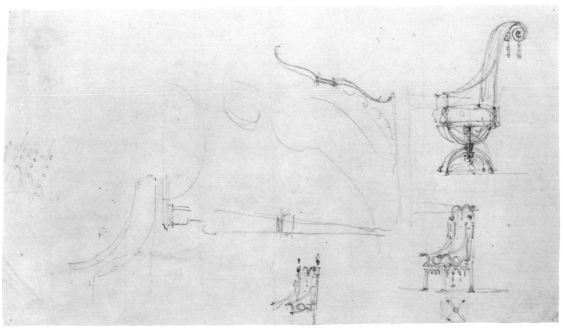

97, verso

BIBLIOGRAPHY: H. Hawley, *Neo-Classicism: Style and Motif*, Cleveland, 1964, no. 140, repr.; Draper and Le Corbeiller 1978, no. 71.

The Elisha Whittelsey Collection,
The Elisha Whittelsey Fund, 1953
53.521.11

NOTES

1 See D. Ledoux-Lebard, "The Refurnishing of the Tuileries under the Consulate," *Apollo* (September 1964), p. 205, fig. 12.
2 F. Contet, *Les sièges d'art: Époques Louis XIV, Louis XV, Louis XVI, et Empire* (Paris, 1913), pl. 49, no. 2.
3 See M. Jarry, *Le siège français* (Fribourg, 1973), p. 274, fig. 276; p. 283, fig. 277; pp. 279–283, figs. 279, 280.
4 See E. Dumonthier, *Les sièges de Jacob Frères* (Paris, 1921), nos. 23, 26, 27, 32, 34, repr.

The two chairs represent two styles popular at the time of the Empire. The one at the left is a barrel-backed chair with dolphins as arms, and the one at the right is a straight-backed chair with winged, female Egyptian heads resembling sphinxes on the arms. No specific chairs can be exactly related to these two, but there are similar examples.

There are chairs with dolphin arms in combination with open, straight backs made by Georges Jacob. Examples are at Malmaison, in the Musée Marmottan, and in the collection of Grognot et Joinel.[1] A closer example is a chair with a barrel back and dolphin arms in the collection of the English embassy in France, but it is partially open at the bottom of the back and sides.[2]

Sphinxes and winged female figures were much more common motifs for chair arms than dolphins, but nothing exactly replicating the drawing of the chair with the Egyptian female winged arms is extant, either. There is an armchair in mahogany in a private collection that shows the entire body of the sphinx in conjunction with a curved back. The Musée Malmaison has a chair whose sphinx head-and-wings motif is much closer to that in our drawing, but it also has a much more elaborate back. It was signed by Jacob Frères and was made for the empress Josephine. Another chair with the whole of the sphinx shown but otherwise differing widely from ours was made for Madame Récamier.[3] There are many other examples of sphinx armchairs. Five made by Jacob Frères are still not exactly like ours: for the most part the top of the chairs is curved. One is at Malmaison, another is at Fontainebleau, and three others are in the Mobilier Nationale.[4]

PERCIER AND FONTAINE AND WORKSHOP

98. Scrapbook of Sketches

Pen, black and gray ink, graphite, and black chalk. 15 11/16 × 10 in. (398 × 254 mm). Scrapbook bound in parchment with the label of the stationer Renault.

PROVENANCE: [Lucien Goldschmidt, New York]; purchased in New York.

BIBLIOGRAPHY: Samoyault 1975, pp. 457–465, figs. 37–39; Draper and Le Corbeiller 1978, no. 70, fig. 2.

The Elisha Whittelsey Collection, The Elisha Whittelsey Fund, 1963
63.535

This scrapbook is indeed that, an album filled with many small scraps of drawings and tracings for a wide variety of furniture, ornament, and ground plans of palaces, some Italian. The album of 125 leaves, some of whose pages have been left blank, bears the label of the stationer Renault on the inside front cover. There are neither signatures affixed to any of the drawings nor any identifications of the drawings' end products. The scrapbook may have been put together by one of Percier's students or perhaps by Percier himself. In the inventory made after his death, dated September 11, 1838, it was stated that the drawings and sketches relating to works at the Louvre, Tuileries, Saint-Cloud, and Malmaison were left to Fontaine, and other albums of drawings were bequeathed to his students and colleagues.[1]

Page 19, which is illustrated here (No. 98a), has the most important objects yet identified. There are seven drawings pasted to the page, three in yellowed tracing paper. The largest drawing in the upper left deserves the most attention. The inscriptions on the drawing are in what is under-

stood to be Percier's own hand, and therefore the drawings can be securely tied to him. Inscribed on the drawing is *boudoir*, indicating the destination for the furniture: the empress Josephine's bedroom at Saint-Cloud, whose furnishings, according to inventories of the period, correspond to the objects in the sketches.[2] On the sheet is a candelabrum, a chair with swan arms, a tabouret (stool), a pedestal, as well as such details as the tassels for the tabouret.

The chair can be securely identified with examples now in the Musée Malmaison, which were probably made for Saint-Cloud by Jacob Frères.[3] Inscribed next to the chair are the following instructions: *Les cignes blancs,/les perles, les yeux,/les côtés des ailes/ainsi que tous les bois/en or, l'étoffe en/velours rouge, les/petits détails soie et or. Les chaises sont/semblables à celles de la chambre a coucher/par leurs formes*, along with prescribed measurements and a small sketch of the chair in profile. The ornamental details of the chair—the crescents, the rosettes, and the like—were termed the *petits détails*. Although the swan motif dates back at least to the Renaissance, more immediate precedents in France include its use in 1798 by the architect Berthault on a bed for Madame Récamier's bedroom. Jean-Pierre Samoyault also connects the swan motif here with a chair that was published in 1803 by the architect Charles Normand in his *Nouveau recueil en divers genres d'ornemens . . .* that also has swan armrests.[4]

The tabouret, which is also now to be found at Malmaison, is based on antique sources while incorporating medieval details. Side and front views appear in Percier's *Recueil de décorations intérieures*, on plate 39. There, such details as the tassels are exactly the same as in this sketch. On the drawing Percier has noted *velour rouge/les détails semblable/aux fauteuils*, which implies that the tabouret is en suite with the armchair. These two pieces of furniture were immediately popular and were reproduced several times by others. P.-N. Beauvallet's *Fragmens d'architecture, sculpture, et peinture dans le style antique*, published in Paris

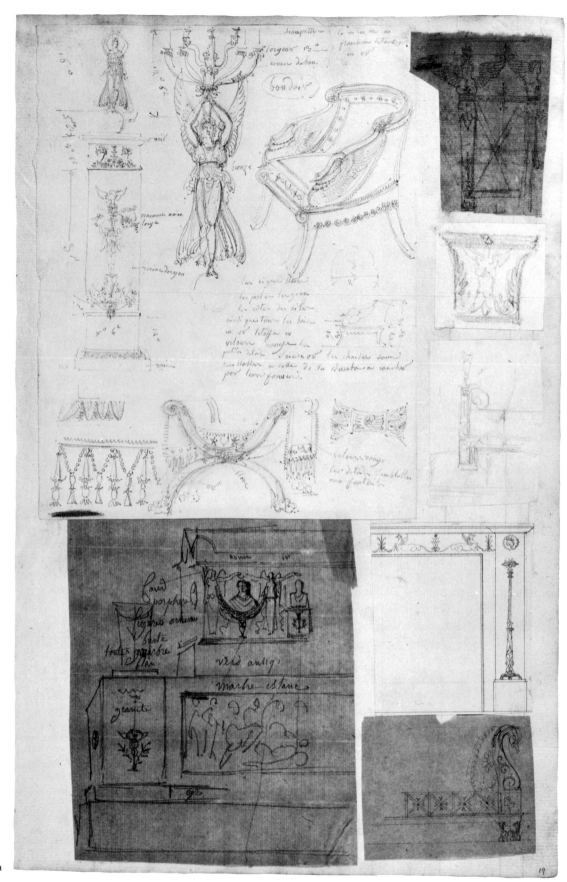

98a

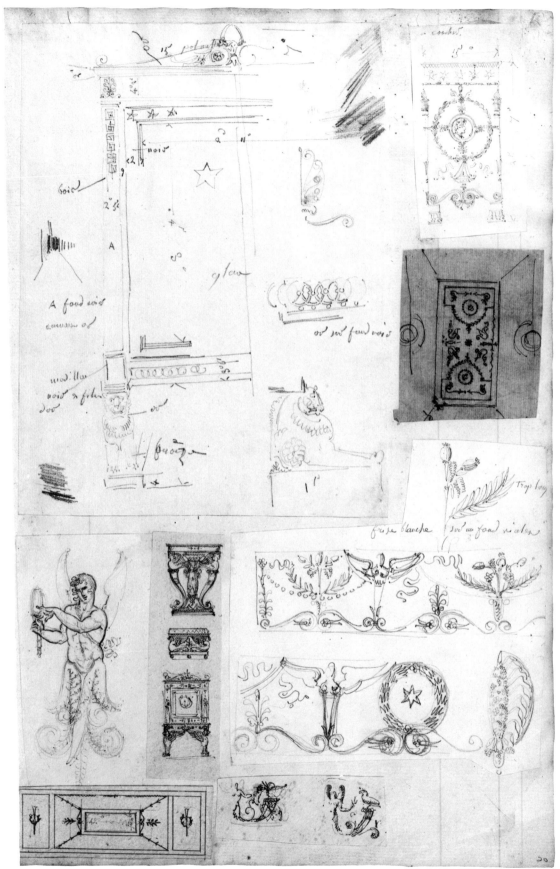

98b

in 1804, reproduced the tabouret as plate 8 of the second cahier, and the chair as plate 2 of the ninth cahier. The tabouret was reproduced again, on plate 13 of Pierre La Mésangère's *Collection de meubles et objets de goût, comprenant: Fauteuils d'appartment de bureau, chaises garnies, canapés, divans, tabourets, lits . . .* , published in Paris beginning in 1806.

The pedestal at the left, although not specifically mentioned in the inventory, was probably at Saint-Cloud as well. With the same care as in the other sketches, Percier has indicated how and with what (mahogany) it was to be made. The decorative motif of a putto supporting a coiled acanthus-leaf vine with a swan on top was taken from plate 26, the title page, of the fifth cahier of Percier's *Palais, maisons, et autres édifices modernes, dessinés à Rome*, published in Paris in 1798. And while the winged-Victory candelabrum also cannot be identified with a specific one at Saint-Cloud, it is a familiar type. Two very close examples by Thomire, in gilt bronze as the directions on the drawing specify, are now in the Metropolitan Museum.[5]

On the following leaf in the scrapbook (No. 98b) are two more items of furniture for Saint-Cloud. One is a bedside table, or *somno*, and the other is a cheval glass, a full-length mirror. Both appear in the inventory of 1807 along with the chair and the tabouret on the previous sheet. Again, Percier gives directions and measurements on the drawing, as well as a profile view of the couchant lion base of the cheval glass. The bedside table has stars in the top frieze, a cameo head of a female[6] within a wreath, torch sides, and claw feet. Measurements for it are provided as well.

NOTES

1 Archives Nationales, Minutier Central XLVI 905.
2 Samoyault 1975, p. 458, nn. 5–7.
3 Ibid., fig. 40.
4 Ibid., pp. 462–465.
5 Draper and Le Corbeiller 1978, no. 2, fig. 3.
6 The head is Diana, according to Samoyault 1975, p. 458.

JACQUES-HENRY-ALEXANDRE PERNET

Paris ca. 1763–after 1789

99. Architectural Capriccio

Pen, gray ink, with gray, brown, and
colored wash. Oval, 12⅛ × 10⅛ in.
(308 × 257 mm). Several tears, mended.

Signed in dark brown ink on stone in bot-
tom foreground, *Pernet*; inscribed at bottom
below drawing, *Pernet*.

PROVENANCE: Stieglitz Library,
Saint Petersburg; Hermitage Museum,
Leningrad; sale, Boerner's, Leipzig, May 4,
1932, lot 107; René Fribourg, New York;
Fribourg sale, Sotheby's, London, October
16, 1963, lot 598, repr.; S. Kaufman,
London; [W. R. Jeudwine, London]; pur-
chased in London.

BIBLIOGRAPHY: *Exposition des dessins
français de l'époque classique*, exh. cat.,
Stieglitz Museum, Saint Petersburg, 1913;
J. Lejeaux, *Exposition de l'art français au
XVIIIe siècle*, exh. cat., Charlottenborg Pal-
ace, Copenhagen, 1935, no. 475; Kaufman
and Knox 1969, no. 101, repr.

Purchase, Harris Brisbane Dick Fund and
Joseph Pulitzer Bequest, 1971
1971.513.20

Little is known of Pernet. He was mentioned
in the list of students at the Royal Academy
in 1783 as being twenty years old, living with his
family on the rue d'Argenteuil, and a pupil of the
painter of cityscapes de Machy. Although he was
described as a painter in the Academy lists, the
works that are known by him are exclusively
drawings. Most of them are watercolor or pastel
studies. They are almost always architectural and
landscape capriccios in a round or an oval for-
mat, such as this one, and they come in pairs.
Pernet's work was often reproduced in etchings
by Guyot or Janinet.

This sheet is typical of Pernet's work in that it
shows the strong influence of Hubert Robert
and, through him, of Piranesi. Pernet's capriccios
are usually composed of the same components:
picturesque ancient ruins—in sharp diagonal
perspective like stage sets—peopled with small
figures in classical garb and rendered in cool
tones as here.

This sheet was paired with another oval land-
scape capriccio in the Fribourg sale, where the
two were evidently separated.

ENNEMOND-ALEXANDRE PETITOT

Lyons 1727–Parma 1801

100. Two Designs for Vases

VERSO. Variant Design for a Vase

Pen, brown ink, and wash over black chalk (recto). Pen and brown ink (verso). 13⅛ × 8¹⁵/₁₆ in. (333 × 227 mm), irregular. Repaired. Lower right corner missing.

Signed in brown ink at lower right on base, *Petitot*.

WATERMARK: Indecipherable.

PROVENANCE: [Galerie Cailleux with its mark, *C..x*, in an oval (not in Lugt)]; purchased in Paris.

Purchase, Robert and Phyllis Massar Gift, 1977
1977.644

Petitot's first studies were with Soufflot in Lyons. He then attended the Academy of Architecture in Paris.[1] In 1745 he won the Prix de Rome in architecture and in 1746 arrived in Rome, where he remained until 1750. In common with his fellow *pensionnaires*, he knew and was influenced by Piranesi. His sojourn in Rome coincided with that of Le Lorrain, and, like him, Petitot designed one of the *macchine* for the festival of the Chinea in 1749 (see Nos. 63, 64).[2]

Back in Paris, Petitot designed the chapel of the Harcourt family in Notre Dame and engraved several plates for the comte de Caylus's *Recueil d'antiquités*. Caylus recommended him to the duke of Parma, who in 1753 named him the court architect. Petitot remained in Parma the rest of his life. Among his responsibilities were the design of the palace and gardens at Colorno,

the redesign of the palace gardens in Parma, plans for a new palace in Parma, and the design of the imposing Biblioteca Palatina. In 1758 he brought out a treatise on perspective, and in 1769 his designs for the marriage festivities of Ferdinand of Bourbon were published. He is best known for the set of prints he made in 1771, the *Mascarade à la grecque*, a witty and inventive set of plates that satirized the *goût grec*, which, as Erouart observes, he had helped to create.

In 1764 Petitot published his *Suite de vases*,[3] which was engraved by Benigno Bossi (1727–1792)[4] and comprised a title page and thirty-one plates, including two text dedication leaves to the first minister of the Parma court, Guillaume-Léon du Tillot, marquis de Felino. Petitot stretched the variations on the theme of the vase further than artists whose works preceded his own, such as Bouchardon, Saly, Pierre, Le Lorrain, and Vien, who, in 1760, produced a suite of elegant and restrained Neoclassic designs etched by his wife. In addition Petitot's sources were such seventeenth-century artists as Stefano della Bella and Jean Lepautre, as well as Piranesi's monumental and overscaled vases in the frontispiece to volume II of the *Antichità romane* of 1756.[5] Petitot's suite contains plates reproducing four vases he designed and realized—three in the Parma ducal gardens and one on the balustrade of the Casino allo Stradone—in a straightforward antique style, using a classical decorative vocabulary of garlands, masks, acanthus, satyrs, lions' heads, and coiled serpents. For the remaining plates, Petitot devised his own repertoire of original images, such as handles formed from grasshoppers, a putto coyly napping in a garland slung between two rams' heads, roosters perching atop a shallow vase, elephants' heads supporting nymphs, and a tortoise whose shell forms the lid, his tail the handle, and his mouth the spout of a ewer. Like Saly before him and Piranesi, Petitot employed Egyptian motifs. A variant of the sixteenth-century auricular style

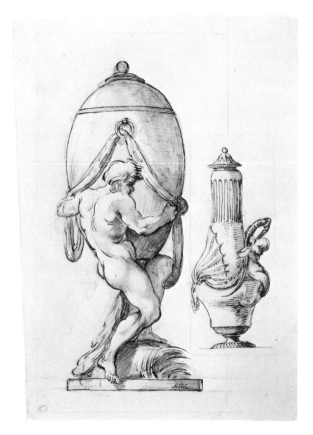

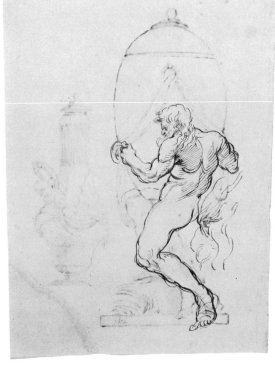

100

100, verso

(also used by Bouchardon in his set of vases) was employed to form quite grotesque masks. The set of vases has been rightly termed eccentric.[6]

The *Suite de vases* was evidently very popular, for it was reprinted in Parma twice, and Basan published reverse copies of the vases in Paris. It was also very influential on vase design. An example is the porphyry and red marble vase with gilt-bronze mounts in the Getty Museum, in which whole lions—not just their heads, as is the usual case—clutching drapery form handles that cling to the body of the vase, which rests on a coiled-serpent support.[7]

Petitot's drawings have been little studied; only a very few have been published and still fewer are reproduced. Published works include a fountain design,[8] several architectural projects for the ducal palace at Colorno,[9] two drawings for the ducal palace at Parma and a vase for the garden, two drawings for the ducal box in the theater at Parma,[10] a fireworks set piece, a country fete on the ruins of Velleia, a café and column on the Stradone, an aqueduct, two vases, three friezes, and a falcon, all in the Museo Lombardi, in

Parma.[11] A number of drawings said to be by Petitot and his workshop were sold at Christie's in Rome on December 2, 1982, and an elaborate project for a fountain, similar to that in the Museo Lombardi, appeared at Sotheby's in Monte Carlo on June 13, 1982 (lot 148, repr.). There are also drawings for vases and tombs under his name in the Kunstbibliothek, Berlin.[12]

The draughtsmanship of our drawing is entirely consistent with that of the fountain design in the Museo Lombardi: they share the distinctive hunched posture of the figures; the pen-line definition of their contours; the insistent curling of the fishtails (of the nereids in the Parma sheet and of the young triton in our drawing); and the large scale of the design relative to the size of the image as defined by its borders.

Our drawing, notable for its vigorous draughtsmanship, consists of two separate designs, each set off by a border line. In the larger design, a robust male nude balances the body of the egg-shaped vase on one bent knee while grasping in each hand a long, limp garland that trails over the knee to the base. In the smaller study, a

young triton sits on the side of the vase, his arms, which are linked through the handle, resembling long, slender fish. A fantail motif covers the other side of the vase. This is not a study for any of the engraved plates in the *Suite de vases*, but certain elements are similar to plate 21, in which two adolescent tritons, instead of the more babyish one in our drawing, flank the neck of the vase as handles. The tritons, separated by a fantail, hold swags of ribbon that crisscross the neck.

Of the several vase drawings in the Kunstbibliothek published in connection with Petitot, only the design for a vase (Hdz 469) seems possibly by Petitot's hand. It relates to plate 2 of the *Suite de vases*, although it includes garlands similar to those in plate 19. The shadow on the drawing is the reverse of that on the engraved plates. Ink has been applied by pen in very precise and deliberate lines, typical of drawings made in preparation for prints, but quite different from the vigorous pen work in our sheet. Bertini and Tassi do not reproduce any of the three drawings for vases in the Museo Lombardi that they publish: the one for the gardens of the ducal palace in Parma—part of the set of three that were engraved as the first three plates in the *Suite de vases*—is not identified by plate number. The remaining two Museo Lombardi drawings were not engraved.

The verso bears a sketch for the nude male of the larger of the two recto designs. The figure has been drawn over the outlines of that on the recto, which have come through the absorbent paper. However, Petitot adjusted the position of the leg farther back. He has also made the figure appear older by giving him a beard. To the right is a partial sketch of a face that appears to be that of a satyr.

NOTES

1 On Petitot, see M. Pellegri, *Ennemondo Alessandro Petitot, 1727–1801, architetto francese alla real corte dei Borboni di Parma* (Parma, 1965); R. Tassi and G. Bertini, in *L'arte a Parma*, pp. 250–275; G. Erouart, in *Piranèse et les français*, pp. 250–260.

2 W. Oechslin, in *Piranèse et les français*, no. 133, repr.

3 Berlin 1939, no. 1081; Guilmard 1880, p. 225; P. Arizzoli, in *Piranèse et les français*, no. 137, repr.; G. Bertini, in *L'arte a Parma*, no. 496, repr.

4 See L. Fornari Schianchi, in *L'arte a Parma*, pp. 122–149, with previous bibliography.

5 Noted in Pellegri, *Ennemondo Alessandro Petitot*, p. 83.

6 W. Rieder, in *Neo-classicism* 1972, p. 865, no. 1816.

7 "Acquisitions/1983," *J. Paul Getty Museum Journal* 12 (1984), p. 265, no. 11, repr., kindly pointed out by James Parker.

8 P. Arrizoli, in *Piranèse et les français*, no. 134, repr.; and R. Tassi, in *L'arte a Parma*, no. 473, fig. 224.

9 G. Bertini, in *L'arte a Parma*, nos. 474–476, 480, figs. 225–228.

10 Ibid., nos. 485, 488, 479.

11 G. Bertini and R. Tassi, in *L'arte a Parma*, nos. 487, 490, fig. 232, no. 493, fig. 234, nos. 494–495, 497–500.

12 Berckenhagen 1970, pp. 312–313, repr.

ENNEMOND-ALEXANDRE PETITOT WORKSHOP

101. Design for a Tomb

Pen, brown ink, with traces of red chalk.
11⅜ × 8 1/16 in. (289 × 205 mm). Lined with decorated mount.

Inscribed in brown ink on etched frame label on decorated mount, *Cava: Ennemond Alexander Petitot*; inscribed on verso in black chalk, *ed* [?] *d'inventario/55*, in brown ink, *Carolina P*, and at lower right, *Cav. Ennemond Alexandre Petitot/No 4*.

PROVENANCE: S. Kaufman (purchased in Genoa); [W. R. Jeudwine, London], purchased in London.

BIBLIOGRAPHY: Kaufman and Knox, no. 88, repr.

Purchase, Harris Brisbane Dick Fund and Joseph Pulitzer Bequest, 1971
1971.513.15

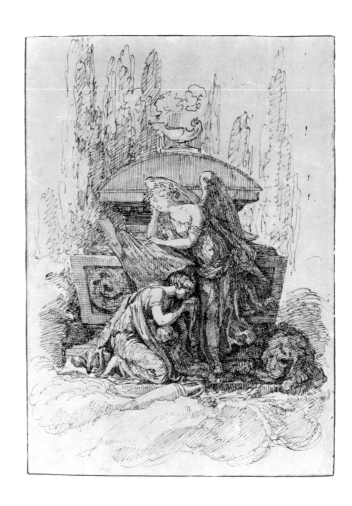

Kaufman and Knox thought that the etched frame label at the bottom of the mount with Petitot's name carefully lettered in was the artist's ex libris. By the late eighteenth century, the name of the owner would have been printed, as was the case on Petitot's visiting card,[1] and therefore it is unlikely that this was mounted by the artist. The inscriptions on the verso suggest the possibility of someone in Petitot's studio having mounted it.

It is difficult to reconcile the draughtsmanship of this sheet with that for the vases in the preceding entry. In both the pen work and the figures, the two sheets contrast markedly. Here, the use of hatching throughout and the very different contours of the figures, which fail to convey three-dimensionality, are totally at variance with the other drawing. This drawing does relate somewhat, both in draughtsmanship—the use of hatching is extensive and the figures are similar—and architectural style, with its mild version of Neoclassicism, to a tomb drawing in the Kunstbibliothek, Berlin (Hdz 2829),[2] that is probably from Petitot's workshop. In the insistence on cross-hatching throughout the design and the smooth contours delineated by parallel hatching, the draughtsmanship closely resembles that of the etching by Benigno Bossi after Petitot of an allegory for the marriage of Isabella de Bourbon and Archduke Joseph of Hapsburg.[3]

This drawing represents an angel leaning on a sarcophagus and writing on a large sheet of

parchment, while a woman in classical garb with a putto kisses the angel's drapery. A lion crouches at the lower right. The tomb is surmounted by a segmental arch topped by a smoking lamp. The sketchy, uneven foreground appears almost cloudlike, and indications of cypresslike trees appear in the background. This is a project not for a tomb but for a print. Tombs, like vases, were a favorite theme for artists of the eighteenth century, and a number of sets were engraved, for instance, by Legeay (see Nos. 60–62). This sheet and the Berlin tomb drawing may have been planned for the same suite.

Notes

1 A. Bertarelli and H. Prior, *Il biglietto di visita italiano* . . . (Bergamo, 1911), p. 185, no. 535, repr.

2 Berckenhagen 1970, p. 313. Berckenhagen compares this drawing with a vase drawing, Hdz 457, which, as it is in the same direction as plate 20 of the *Suite de vases*, is most likely a copy after the print.

3 Bedarida 1989, no. 56, repr.

ALEXIS PEYROTTE

Mazan (Vaucluse) 1699–Paris 1769

102. Ornamental Design with Fruit and Flowers

VERSO. Flower Stalk with Leaves

Black chalk with pastel (recto). Black chalk (verso). 16 1/16 × 11 1/4 in. (408 × 286 mm). Slightly wrinkled horizontally near center. Stained at left and right margins.

PROVENANCE: Unidentified collector's mark, back-to-back *C* and *G* (near Lugt 549: Sir Charles Greville?); [Augustin Fries, New York]; purchased in New York.

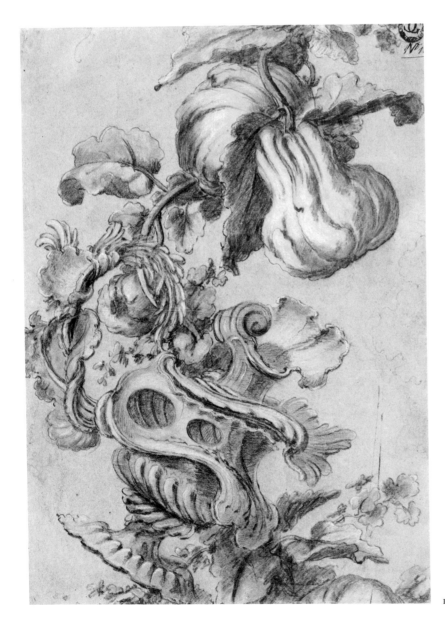

102

BIBLIOGRAPHY: Roland Michel
1984, under nos. D. 161–D. 162.

Peyrotte was a decorative painter, famous for
his flowers—not the large, perfect blooms,
such as those designed by Monnoyer for Louis
XIV—but abundant clusters of natural flowers,
such as roses, primroses, carnations, lilies, and
violets. Fruits and vegetables that are charac-
teristically ripe and full of juice accompany the
flowers. Peyrotte also painted rich chinoiseries.
He was a painter to the crown, responsible for
decorating the *petits appartements* of the king
and queen as well as the *appartement* of the dau-
phin at Versailles. In 1753 he participated in the
ornamentation of the Salle du Conseil at
Fontainebleau. He also painted decorations in
both the large and smaller châteaus at Choisy.[1]
In addition to decorative painting, Peyrotte
made designs for fabrics and tapestries. His
drawings were engraved by himself and by such
printmakers as Gilles Demarteau, Gabriel Hu-
quier, Jean-Charles François, D.-P. Pariset, and
the Tardieu family.

This sheet is an especially luxuriant example
of Peyrotte's draughtsmanship. Squashes so ripe
they are about to fall from the vine grow out of
an elaborate bit of black-chalk rocaille that is en-
livened by small violet and yellow-gold flowers.
This study is most likely a design for a textile,
but it could have been adapted for painted
decoration.

NOTE

1 On Peyrotte, see R. Caillet, *Alexis Peyrotte, peintre et
dessinateur du roy pour les meubles de la couronne*
(Vaison, 1928).

JEAN PILLEMENT

Lyons 1728–Lyons 1808

103. Chinoiserie Fantasy with Skaters
and an Exotic Figure in an Iceboat

Black chalk, and a little red chalk, blue
and red pastel, blue and red wash.
23 15/16 × 15 3/4 in. (609 × 400 mm).

Signed and dated in black chalk at lower
center, *J. Pillement / 1771.*

PROVENANCE: [Rosenberg and
Stiebel]; Lesley and Emma Sheafer.

BIBLIOGRAPHY: *Annual Report, 1974–75*, p. 48; Y. Hackenbroch and J. Parker, *The Lesley and Emma Sheafer Collection: A Selective Presentation*, exh. cat., The Metropolitan Museum of Art, New York, 1975, no. 38; Bean and Turčić 1986, no. 249, repr.

The Lesley and Emma Sheafer Collection, Bequest of Emma A. Sheafer, 1973
1974.356.47
Department of Drawings

One of the most peripatetic French artists of the eighteenth century, Pillement, who was from a family of artists in Lyons, was trained by the little-known painter Daniel Sarrabat and at the age of sixteen went to Paris, where he worked at the Gobelins tapestry works for a short period. He was a decorative painter, especially of chinoiserie, creating designs for fabrics and during his early years occasionally etching them, but more often producing works for other artists to engrave. Pillement began his wanderings with a trip to Spain and Portugal; he then went to London, where he remained from 1750 to 1760 and where a great number of his engraved works were created. Besides doing decorative work in painting and drawings in colored chalks, pastel, and gouache, he was a master at enchanting, romantic landscapes, similar to but distinct from the works of Joseph Vernet. From London he returned for a short time to Paris, then traveled again, to Italy, Spain, Austria, and Poland. He was named painter to the queen, Marie Antoinette, and to the king of Poland, Stanislaw II Augustus, and was invited to become court painter in Saint Petersburg but declined the offer.

This beguiling scene of Chinese skating figures teetering on the ice typifies the charm and elegance of Pillement's chinoiserie drawings. Scenes are set on two levels: above, a boat skims across the ice on one gliding edge, while a figure balances on its curled prow; below, a skater merrily turns while holding bells that ring out with every movement.

There is a pendant to this sheet that shows a summer scene of a young Chinese boy and girl swinging in the warm air with bells on the ropes of the swings.[1] If there were two further drawings portraying spring and autumn, they have not come to light. And no prints after these two sheets have been found in the rich collection of prints after Pillement in the Metropolitan and Cooper-Hewitt museums. Pillement did make a set of twelve allegorical months of the year but evidently no four seasons.[2]

The drawings were probably made in Paris, for in 1771 J.-J. Avril, a printmaker active there, etched several sets of prints after Pillement.[3]

NOTES

1 Acc. no. 1974.356.46; Bean and Turčić 1986, no. 248.
2 For the twelve months, see L. Riotor, *L'oeuvre de Jean Pillement* . . . (Paris, 1931), vol. I, nos. 55–66. The engraver's name is not visible on the reproductions.
3 See B. N., *Inventaire*, vol. I, p. 348, nos. 49, 50, 51.

JEAN PILLEMENT (ATTRIBUTED TO)

104. Design with Flowers and Rocaille
Swirls

Black chalk, with some red chalk, height-
ened with white, on faded blue paper.
21 × 12¼ in. (533 × 311 mm). Some
staining.

Inscribed in black chalk at bottom,
J. Pillement, and in brown ink, *A.V.*

PROVENANCE: [Norman, London];
S. Kaufman, London; [W. R. Jeudwine,
London]; purchased in London.

BIBLIOGRAPHY: Kaufman and
Knox 1969, no. 21, repr.

Purchase, Harris Brisbane Dick Fund and
Joseph Pulitzer Bequest, 1971
1971.513.41

Distinctive flowers such as these—fully open,
with their edges slightly curved up, like
shallow dishes—appear in the drawings of both
Pillement and Peyrotte (see No. 102). In the suites
of prints by Pillement, the *Recueil de fleurs de ca-
prices* and *A New Book of Chinese Ornaments, In-
vented and Engraved by J. Pillement*, published in
London and printed for Robert Sayer, similar
flowers appear, as they do in the set of prints en-
graved by Peyrotte, *Rosettes pour des commodes,
tables, plafonds . . .* , published by Pariset. In gen-
eral, however, Peyrotte employed more dramatic,
swirling foliage with rocaille forms, whereas
Pillement's forms are somewhat more restrained,
as seen here. The design is probably for a textile
but could as easily have been painted on walls.

HUBERT ROBERT

Paris 1733–Paris 1808

105. Project for a Triumphal Arch

VERSO. Alternate Study for Triumphal Arch

Black chalk. 7⅞ × 8¹⁵⁄₁₆ in. (200 × 227 mm).

WATERMARK: Bunch of grapes, upper part of stalk cut off, near Heawood 2822 and 2309.

PROVENANCE: Ernest May; [Galerie Cailleux, with its mark, *C . . x* in an oval (not in Lugt)]; purchased in Geneva, 1980.

BIBLIOGRAPHY: M. Roland Michel, "A Taste for Classical Antiquity in Town-Planning Projects: Two Aspects of the Art of Hubert Robert," *Burlington Magazine* (November 1972), advertising supplement, pp. v–vi, fig. 5; Jean Cailleux, *Un album de croquis d'Hubert Robert (1733–1808)*, exh. cat., Galerie Cailleux, Geneva, 1979, n.p., nos. 136–137, repr.

Edward Pearce Casey Fund, 1980
1980.1018

Although Hubert Robert did not enter the competition for the Prix de Rome, he reached the Eternal City in 1754, after having been invited to travel there in the company of the ambassador to the Holy See, the comte de Stainville, the future duc de Choiseul. He was allowed to live at Palazzo Mancini with the other *pensionnaires* and to participate in the life of the Academy. Gian Paolo Panini, the great Roman *vedutista* and painter of picturesque and evocative architecture and ruins who taught perspective at the Academy, profoundly influenced Robert, as

did Piranesi, whose shop was across the Corso from Palazzo Mancini and who, since the 1740s, had been close to the French. Marianne Roland Michel has discerned Piranesi's influence on Robert on two planes: the visionary, deriving especially from the *Carceri*, and the archaeological. She notes that certain studies of the ruins at Cori are dated 1763, the year before Piranesi's *Antichità di Cora* appeared, and suggests that the two artists were there together.[1] When Robert returned to Paris in 1765, the dual examples of Panini and Piranesi were the foundation on which his numerous essays in architectural and landscape capriccios were based. Pure landscape drawing, however, was also an important component of Robert's Roman oeuvre, as attest the brilliant landscape drawings that he executed *en plein air* on sketching expeditions taken with his close, lifelong friend Fragonard in the Campagna, especially at Tivoli, or around Naples.

While still in Rome, Robert had come to the attention of the most powerful of the Parisian cultural establishment: the marquis de Marigny and P.-J. Mariette ordered paintings and drawings from him. Within a year of his return to Paris, Robert was received into the Academy in unusual fashion—he was both *agrée* and *reçu* on the same day. Robert, who regularly exhibited at the Salons and who had a very successful career as a painter for a distinguished clientele, enjoyed equal success in architectural realms. He became a garden architect, a profession in which his ability to create picturesque visions found a concrete outlet, designing the gardens and probably the tomb of Rousseau at Ermenonville and his masterpiece, the gardens at Méréville, where he succeeded Belanger (see Nos. 8–13), in 1786.[2] In 1778 he was appointed *dessinateur des jardins du roi*, working with Mique on the gardens of the Petit Trianon and designing the gardens at Rambouillet. Le comte d'Angiviller, the last *directeur général des Bâtiments du Roi*, appointed him to the committee set up in 1778 to organize the

105

105, verso

royal collections into a museum to be housed in the Grande Galerie of the Louvre and named him a curator in 1784.[3] After the artist's imprisonment for eight months during the Terror, he joined the new Conservatoire in charge of organizing the museum in 1795, and in 1797 he became a member of the administrative body in charge, where he remained until 1802.

Robert was a painter and draughtsman of prodigious energy and output. The 1821 inventory of the effects of his wife lists fifty volumes of sketches by the artist, some of which were true sketchbooks, while others were albums with drawings later pasted in by him.[4] The Ernest May album, from which this drawing comes, is one of the latter and contains 152 drawings dating from about 1755 to about 1806—nearly his entire career.[5] The rich diversity of studies includes both ink and chalk drawings; Roman and other Italian as well as Parisian subjects; actual as well as imagined views; ancient statuary and vases; Roman peasants at work and play; detail studies for paintings; and a theme dear not only to him but to many of his contemporaries, especially Fragonard—the artist at work drawing.

The drawing under discussion shows a massive arch, rather low and broad, with a high, deep, central archway flanked by smaller, rectangular openings between paired columns. The arch is surmounted by indications of statuary suggesting a quadriga. The form of the arch itself and the statue atop it suggest—except for the paired columns—Percier and Fontaine's Arc de Triomphe du Carrousel. To the left of the arch, on a high pedestal, is a sculpture of rearing horses that is virtually identical to Guillaume Coustou's *Chevaux de Marly*, set in place in 1795 at the entrance to the Champs-Élysées, on the Place de la Concorde, then called the Place de la Révolution (during the Terror the site for the guillotine where the king and queen along with many other notables were executed).[6] Through the central arch a column or obelisk (the sketchy lines seem to converge toward the top) can be seen in the distance.

The combination of an arch similar to the Arc du Carrousel, finished in 1808 (the year of Robert's death), which was situated in the courtyard of the Tuileries Palace and intended as its main entrance, with the *Chevaux de Marly*, prominently featured on the Place de la Concorde, demonstrates that this drawing does not represent an actual project for one of the many architectural reorganizations of Paris during the period of the Revolution through the Empire. As Mme Roland Michel has pointed out, it is Robert's imaginative response to the many town-planning ideas formulated during this time, such as the competitions of the year VII (1799–1800) for the reorganization of the Champs-Élysées, the Tuileries, and the Place du Carrousel; the plans of 1800–1801 for a *colonne nationale* for the Place de la Concorde; a column for Place Vendôme in 1803; the Arc du Carrousel; and the Arc de Triomphe, ordered by Napoleon in 1806 and designed by Chalgrin, but only completed after Napoleon's death. This drawing combines something of Robert's picturesque, architectural landscapes with his response to the public architectural projects with which he, as a former royal landscape architect and official in charge of the national museum, was undoubtedly deeply caught up. Always a keen observer of the monuments of Paris and their vicissitudes, he must have meditated long and often on those new monuments transforming the city, as this drawing bears witness.

NOTES

1 M. Roland Michel, in *Piranèse et les français*, p. 305.

2 See Jean de Cayeux, "Hubert Robert, dessinateur de jardins, et sa collaboration au parc de Méréville," *BSHAF* (1968), pp. 127–133; and Jean de Cayeux, *Hubert Robert et les jardins* (Paris, 1987), esp. pp. 71–133.

3 See M.-C. Sahut, *Le Louvre d'Hubert Robert*, exh. cat., Musée du Louvre (Paris, 1979).

4 On these, see Jean Cailleux, *Un album de croquis d'Hubert Robert*; and V. Carlson, *Hubert Robert: Drawings and Watercolors* (Washington, D.C., 1978), no. 24.

5 Ten drawings from the album were acquired by the Swedish Nationalmuseum, for which see P. Bjurström, *French Drawings: Eighteenth Century*, vol. 4 of *Drawings in Swedish Public Collections* (Stockholm, 1982), nos. 1140–1142, 1144–1145, 1153–1157, all repr.

6 See the exhibition catalogue *De la Place Louis XV à la Place de la Concorde*, Musée Carnavalet (Paris, 1982), esp. pp. 80–101.

GABRIEL DE SAINT-AUBIN

Paris 1724–Paris 1780

106. Preparatory Study for Plate 211 in Volume II of Blondel's *Architecture française*, Paris, 1752

Pen, gray ink, with gray and pink wash, over graphite. Verso rubbed with red chalk. Lightly incised (lines do not go through to verso). One framing line in black ink. 14⅝ × 8⁷⁄₁₆ in. (372 × 214 mm), irregular. Paper slightly soiled.

WATERMARK: Near Heawood 1838.

PROVENANCE: Charles Mewès; [W. R. Jeudwine, London]; Mr. and Mrs. Charles Wrightsman.

Gift of Mr. and Mrs. Charles Wrightsman, 1970
1970.736.26

Gabriel de Saint-Aubin was one of the uniquely original artists of the eighteenth century. Although compelled on all occasions to sketch and draw, he lacked the prerequisites for official success—activity in painting and membership in the Royal Academy, which he attempted three times to enter by competing for the Grand Prix. Yet he was a member of the rival Académie de Saint-Luc and later became one of its directors and teachers. His father was an embroiderer to the king, and two brothers were successful artists. The rest of the large group of siblings also had artistic careers. A student at the Royal Academy, Saint-Aubin studied with Étienne Jeaurat, Hyacinthe Colin de Vermont, and probably François Boucher. His few paintings were not, either in subject or technique, appropriate for academic or popular success. Instead, his oeuvre consisted of thousands of sketches of the life of Paris around him, allegories, and annotated sales and Salon catalogues, which are useful to this day for identification of drawings and paintings. He died relatively young, in poverty, never having married, and having cared little for material possessions and a normal life.

One of the few positions that he ever held was that of a drawing master in Jacques-François Blondel's Architecture Academy from the age of twenty-three. He was responsible for teaching human proportions, anatomy, and allegory. Evidence that architecture was important to him is the fact that he signed himself *architecte* as witness to the marriage contract of his brother Augustin in 1764. No work by Saint-Aubin connected with Blondel's Academy has come down to us.

Peter Fuhring was the first to suggest that this preparatory drawing for Blondel's *Architecture française* might be by Gabriel de Saint-Aubin. Concurring are Kim de Beaumont and Suzanne Folds McCullogh,[1] who has seen photographs only. At first glance, nothing could be further from Gabriel's style of quick, atmospheric, sketchy pen work than this precise and tightly drawn design. However, if the figures on the upper portal are studied, they betray the lively pen line that is Gabriel de Saint-Aubin's signature.

There are a number of Saint-Aubin's drawings that can be compared with our sheet. Kim de Beaumont and Suzanne Folds McCullogh have suggested comparison with the manuscript "Mémoire sur la réformation de la police de France," of 1749, at Waddesdon Manor.[2] The manuscript contains various kinds of drawings by Saint-Aubin, including maps embellished with sketches,[3] vignettes,[4] and drawings of architecture. The latter include a sheet showing a precisely drawn corner of a building,[5] another with a row of houses with details of the roofline,[6] and various sheets with interiors.[7] All are crisply delineated, with precise details, and accord very well with the penmanship in our drawing. A

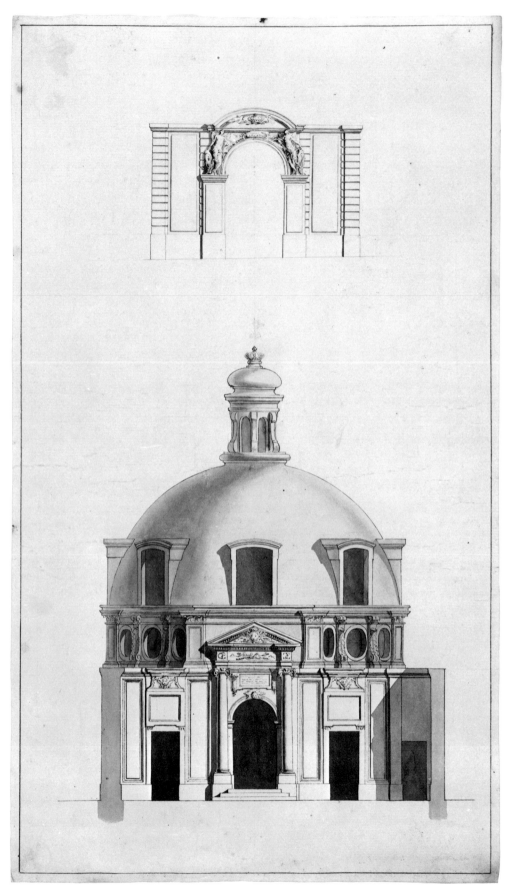

106

further comparison may be made with the design for the fireworks commemorating the marriage of the dauphin in 1747, now in the Pierpont Morgan Library.[8] The architecture is less tightly drawn than in our sheet, but the command of the delineation of architecture is nevertheless excellent, and the relationship of figures to architecture is comparable to that in our drawing. The figures in our sheet can be compared to a sheet of studies for architectural sculpture in which the stances, the draperies, and the fluent, but cursory, treatment of the bodies are similar.[9] A project by Saint-Aubin associated with Blondel is an etching of *La colère de Neptune*,[10] a sculptural group that was the center of a fountain in the Doric order. The entire fountain was engraved by Le Canu.[11]

Our drawing shows all the signs of having been prepared for transfer to the engraver's plate. It is lightly incised, and the verso has been covered with red chalk. Furthermore, the drawing is within 1 to 3 millimeters of the exact size and in reverse of the print.

The print—plate 211 in volume II of Blondel's *Architecture françoise* of 1752[12]—shows the amphitheater of the Académie Royale de Chirurgie on the rue des Cordeliers, now the rue de l'École de Médecine. The building now houses the Institut des Langues Modernes. It was built between 1691 and 1695[13] by Charles Joubert (1640–1721) and his son Louis Joubert (1676–1756). On the sheet are, above, the portal separating the street from the courtyard and, below, the courtyard view of the amphitheater itself with its imposing dome.[14] Blondel's *Architecture françoise* consisted of a magisterial four volumes devoted to French architecture.

NOTES

1 I should like to thank both Kim de Beaumont and Suzanne Folds McCullogh for their help and for bringing to my attention certain appropriate comparison drawings.

2 See *Mémoire sur la réformation de la police de France soumis au roi en 1749 par M. Guillaute . . . illustré de 28 dessins de Gabriel de Saint-Aubin*, with introduction and notes by Jean Seznec (Paris, 1974).

3 *Réformation de la police*, pp. 23–24.

4 Ibid., p. 85.

5 Ibid., p. 26.

6 Ibid., p. 115.

7 Ibid., pp. 27, 65, 66.

8 Inv. no. 1962.10. See "Gabriel de Saint-Aubin, 1724–1780," in *Thirteenth Report to the Fellows of the Pierpont Morgan Library, 1963 and 1964* (New York, 1964), pp. 105–108.

9 "Vente Mme K.," Hôtel Drouot, Paris, December 15, 1934.

10 E. Dacier, *L'oeuvre gravé de Gabriel de Saint-Aubin . . .* (Paris, 1914), pp. 119–121, no. 39. The print is dated 1767.

11 Guilmard 1880, no. 101, p. 262 [12].

12 Pp. 84–89.

13 According to Blondel; Hautecoeur, vol. II, pt. 2, 1948, p. 863, dates it to between 1691 and 1694.

14 Hautecoeur, vol. II, pt. 2, 1948, p. 862, fig. 681.

HENRI SALEMBIER (ATTRIBUTED TO)

Paris ca. 1753–Paris 1820

107. Studies for a Wall Panel

Pen, brown and gray ink, with gray and light brown wash, over traces of black chalk. Framing lines.

107a. Image: 16⁷⁄₁₆ × 5¹⁄₁₆ in. (418 × 129 mm); paper: 22⁹⁄₁₆ × 14³⁄₈ in. (573 × 365 mm).

107b. Image: 4¹⁄₁₆ × 1¹⁄₄ in. (103 × 32 mm); paper: 5¹³⁄₁₆ × 2⁹⁄₁₆ in. (148 × 65 mm).

Inscribed verso in pencil, *Henri Salembier.*

PROVENANCE: [Yvonne ffrench, London]; purchased in London.

BIBLIOGRAPHY: Fuhring 1989, under no. 230.

The Elisha Whittelsey Collection, The Elisha Whittelsey Fund, 1966
66.565.2a, 2b

107b

Salembier is a little-known engraver, designer, and painter. He left a number of sets of ornament prints after his designs with which his name is mainly connected. One set is titled *Cahier d'arabesques composés et gravés par Salembier.*[1] Those designs are upright arabesques that are more elaborate than this but that incorporate creatures supporting roundels as here.

Another pair of drawings comparable to ours, one a small sketch and the other the worked-up version of a panel with medallions and a scale, is in the Houthakker collection.[2] Fuhring describes the Houthakker drawing as a design for a wall panel, but ours looks as if it could also be for a thermometer and barometer case.

The sphinxes with baskets on their heads, the triton, the nereid, and the putto in our drawing are familiar creatures in Salembier's prints, where fantastic beings cavort gracefully.

NOTES

1 MMA acc. no. 22.84.6; pls. 51–56.
2 Fuhring 1989, no. 230, repr. Fuhring estimates that, according to the scale on the drawing, the panel measures about 2.32 by .75 meters. Ours appears to be about the same size.

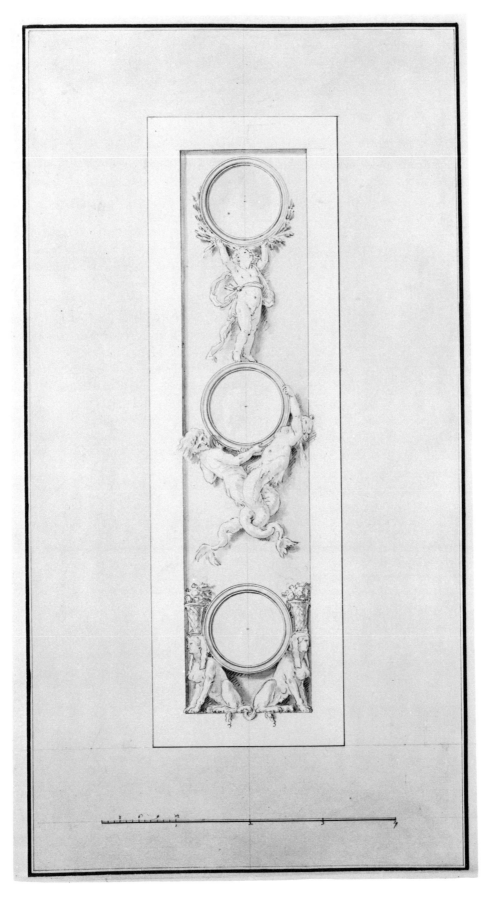

107a

GUILLAUME-THOMAS TARAVAL

Paris 1701–Stockholm 1750

108. Study for a Festival Pavilion

Pen, gray ink, and wash over traces of
black chalk. Black-ink border line.
10¾ × 7½ in. (273 × 191 mm). Inlaid into
blue paper mount.

PROVENANCE: [Colnaghi, London];
purchased in London.

Purchase, Florance Waterbury Bequest,
1970
1970.611.1

Orphaned young, Taraval was raised by the
painter Henri Guillemard, who had been a
friend of his father's and whose daughter Taraval
married. He studied under Claude Audran III.
Baptismal records of Taraval's child born in 1732
state that he was in Stockholm employed as
painter to the Swedish king, to whom he later
became first painter. He painted the ceilings in
the Swedish royal palace: in the porcelain cabi-
net, in the Salon Rouge des Gobelins, the Salon
Blanc, and the Salon Vert, as well as the audi-
ence chamber. He also decorated churches and
painted many portraits, animal still lifes, and
allegories. His painting style owed much to
François Lemoyne and François Boucher. Taraval
made trips to Paris in 1740 and 1749.

It is not known for what specific event this
festival pavilion was erected. However, it was a
royal event, as the Swedish royal arms adorn the
top of the structure. The round colonnaded tem-
ple contains a figure whose attributes are impos-
sible to determine, although the temple is the
sort that is often dedicated to Venus, and there-
fore the figure could be Cupid. The pavilion
surmounts a rocky hillock in which there is a
cavelike opening. Above the opening is a nymph
with what appear to be a lyre and a putto. If the
opening gave onto a deep recess like a cave, per-
haps performers in the fete emerged from it in
the course of the performance.

This sheet is one of four of different festival
pavilions with the arms of Sweden in the Metro-
politan Museum's collection.

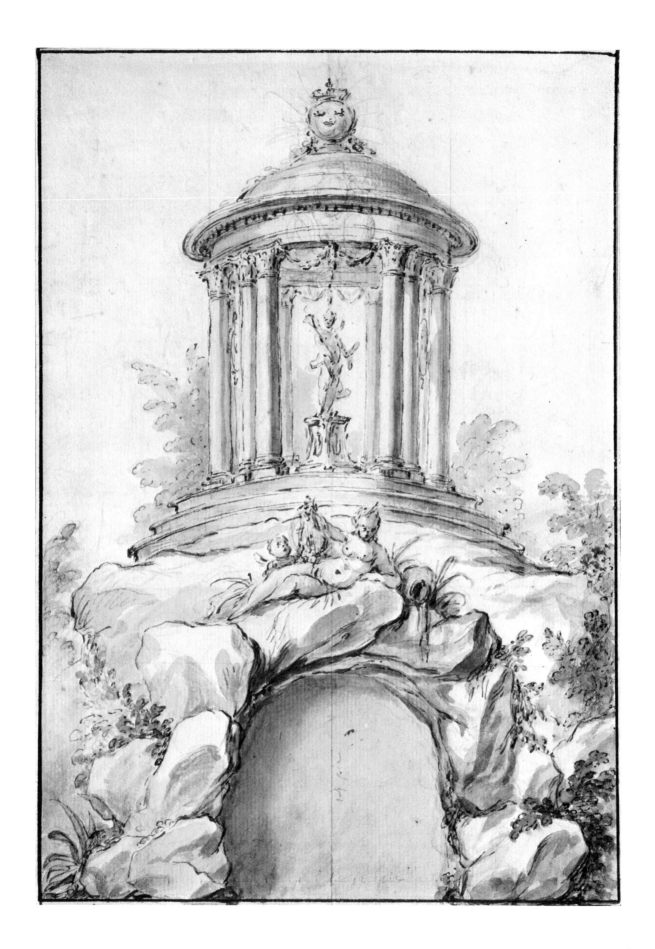

LOUIS-GUSTAVE TARAVAL
Stockholm 1739–Paris 1794

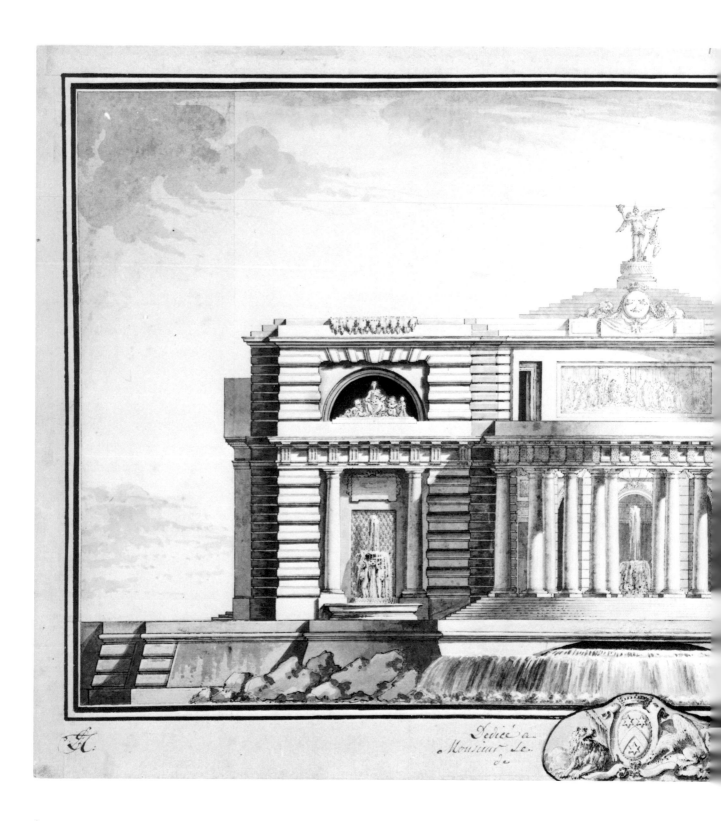

109. Study for the Print *La Source des Arts*

Pen, dark gray ink, with brown, gray, and colored wash, heightened with white. Two brown-ink framing lines on paper strips framing the drawing sheet. 10 15/16 × 20 11/16 in. (278 × 526 mm). Paper added on at left, 10 15/16 × 3 3/4 in. (278 × 95 mm). Lined.

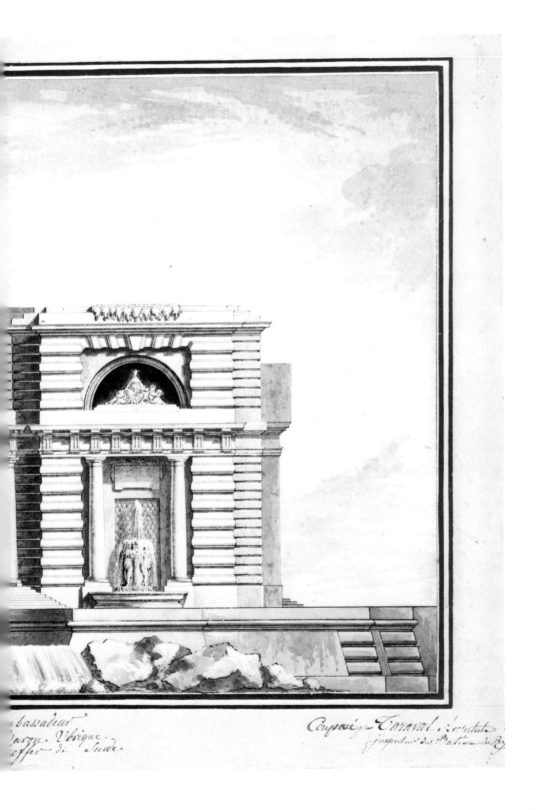

Signed in brown ink at lower left with a monogram cipher, *LGT*; inscribed around the coat of arms, at lower left, *Dediée a L'ambassadeur/Monsieur Le Baron Ulrique/de Cheffer de Suède*, and at lower right, *Composé par Taraval Architecte/Inspecteur des Batimens du Roy*.

PROVENANCE: [Lucien Goldschmidt, New York]; purchased in New York.

Purchase, Anne and Carl Stern Gift, 1963
63.707

A pupil of his father (see No. 108), Louis-Gustave Taraval went to Paris in 1754 to join his brother, the painter Hughes Taraval, and to study with Desmaisons and Boullée. He eventually was appointed *inspecteur des Bâtiments du Roi*. He is known above all today as an engraver, engraving the architectural drawings of others as well as his own. He engraved G.-P.-M. Dumont's *Suite de projets détaillés de salles de spectacles particulières . . .* in 1766 and his own *Plusieurs portails et portes composés et gravés par L. G. Taraval*. He participated in engraving Pierre Contant d'Ivry's *Oeuvres d'architecture* of 1766 and Chalgrin's *Livre d'architecture*, and engraved some drawings of the Pantheon by Soufflot. J. Le Roy engraved the frontispiece for Cauvet's *Recueil d'ornemens* after Taraval's design.

The fountain-pavilion was Taraval's design for an academy of the arts in Stockholm. For it, he chose an austere Neoclassical style. The heavy rustication recalls Ledoux's buildings at Chaux, while the central bay of columns reminds one of Boullée's houses in Paris. Taraval makes the pavilion of the arts a cool, Neoclassic, heavily dignified structure.

La Source des Arts, as the engraving is entitled, is Taraval's most notable print.[1] It was engraved in reverse by Taraval with a few changes and published by Isabey, on the rue de Gêvres in Paris. In the print he added background architecture and changed the fountains in the side niches; where there are large water jets in the drawing, there are statues in the print. The stat-

uary in the segmental arches is simplified, the rocky encrustations at the top of the roofline are absent, and the figure surmounting the structure is slightly altered in the final print. Holding a piece of paper with a ground plan on it, the figure at the top is a personification of architecture. An owl above the fountain is prominent in the print. A faint sketch of its upper part is visible in the drawing, but most of it has been blacked out with ink.

The print is dedicated to the Swedish ambassador extraordinary to France, the baron Ulric de Scheffer. Inscribed on it is the information that the building was an academy projected for Stockholm, where Taraval's father was instrumental in its foundation.

NOTE

1 It is specifically mentioned in Thieme-Becker, vol. XXXII, p. 441; and R. Portalis and H. Béraldi, *Les graveurs du dix-huitième siècle* (Paris, 1882), vol. III, pt. 2, p. 753.

JEAN-BERNARD TURREAU, CALLED TORO

Dijon 1661–Toulon 1731

110. Study for an Ornamental Panel

Pen, gray ink, and wash, with black chalk.
Black-chalk border lines. 10⅞16 × 6¹⁄16 in.
(268 × 154 mm).

PROVENANCE: A. D. Bérard
(Lugt 75); Philip Hofer.

BIBLIOGRAPHY: N. Volle, "Bernard
Turreau dit Toro," in P. Alfonsi et al.,
La peinture en Provence au XVIIe siècle,
exh. cat., Musée des Beaux-Arts, Palais
Longchamp, Marseilles, 1978, p. 151.

Gift of Philip Hofer, 1931
31.111.6

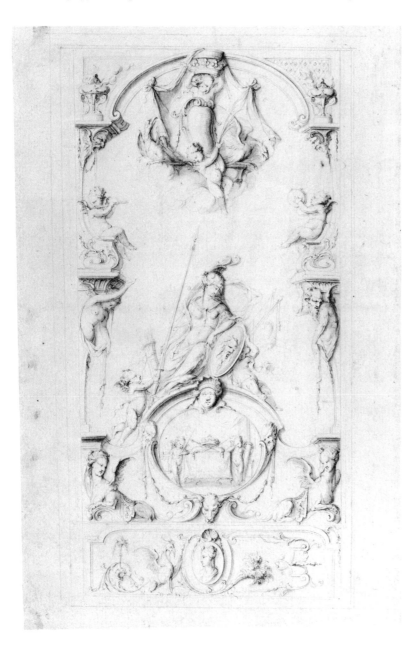

A sculptor who worked in the major towns of Provence, such as Arles, Avignon, and Aix-en-Provence, Toro was first employed as a carver at the Arsenal in Toulon. He was also an indefatigable draughtsman who produced an enormous quantity of drawings. Between 1716 and 1719, he visited Paris, where many of his drawings were engraved by C.-N. Cochin *père*, Rochefort, and Joullain and published by C.-N. Le Pas Dubuisson, Gautrot, and F. de Poilly. These prints spread his style across Europe, where they were widely copied. Returning to Provence, Toro was made master sculptor for the Arsenal in Toulon, where he served out his days.[1]

The suave elegance of his drawings is based on his use of a very fine black chalk line with extremely fine additions of gray wash or a wash of water over the black chalk. It has been widely noted that his distinctive drawings of strange creatures, often with attenuated, curving long necks, owe much to French sixteenth-century sources, especially Étienne Delaune.

This ornamental panel contains allusions to French royalty. At the top a putto holds a French ducal crown behind which falls a piece of drapery hung from the arch. A blank escutcheon with an eagle at each side is supported by another putto resting on clouds. In the center, Athena—a putto at either side—sits on a cartouche frame that encloses two putti, the royal crown, the royal scepter, and the hand of justice. The base of the panel contains an oval with a woman's head. On each side alternative designs are presented, of a winged fantastic creature at the left and a cornucopia with flowers at the right. Composing the frame are sphinxes at the base, who support herms, who in turn support consoles on which putti play musical instruments. Above the putti are another pair of consoles with grotesque masks and flaming braziers that frame the arch at the top. The design seems not to have been engraved.

NOTE

1 On Toro, see R. Brun, "Toro," in Dimier, vol. I, 1928, pp. 351–364; J. Boyer, "Une famille de sculpteurs bourguignons établis en Provence au XVIIe siècle: Les Turreau (ou Toro)," *GBA* (April 1967), pp. 201–224.

Anonymous Artist

111. Study for an Arched Alcove with a Canapé

ca. 1804–10

Pen, gray ink, with colored wash. 9⅜ × 11¼ in. (239 × 286 mm).

Inscribed in black chalk at lower right, *Senard*.

PROVENANCE: Desmond Fitz-Gerald; purchased in London.

BIBLIOGRAPHY: Draper and Le Corbeiller 1978, no. 78.

The Elisha Whittelsey Collection, The Elisha Whittelsey Fund, 1970
1970.710.1

This brilliant Neoclassic decoration, drawn with great delicacy and refinement, must be by a known artist and not merely by a hack craftsman. The name Senard does not turn up in the usual sources, and it is not known if he is the artist. However, it is unlikely. The dancing females with buoyant drapery, the finely drawn ornamentation including flying putti in medallions, the prominent swans holding swags with putti, and the filmy draperies are all typical of the Pompeiian style. These elements recall those designed for the house bought in 1803 by Napoleon for his stepson, Eugène de Beauharnais, now the German embassy. The cost of the renovation was a million and a half francs by 1806, infuriating Napoleon.

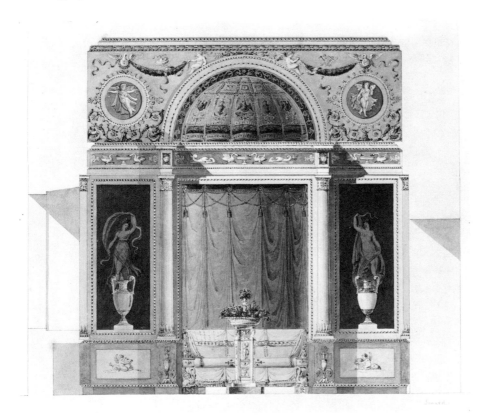

ANONYMOUS ARTIST

112. Study for an Arabesque with
Cupid and Psyche

1720–40

Pen, gray ink, and gray wash. 12½ × 8¼
in. (318 × 210 mm). Creased horizontally
at center.

WATERMARK: Difficult to decipher:
escutcheon surmounted by Maltese
cross(?).

PROVENANCE: Beurdeley (his mark,
Lugt 421); Beurdeley sale, May 31, 1920,
no. 132, as Gillot; [Colnaghi, London];
S. Kaufman; [W. R. Jeudwine, London];
purchased in London.

BIBLIOGRAPHY: Kaufman and
Knox 1969, no. 16, repr., as Gillot.

Purchase, Harris Brisbane Dick Fund and
Joseph Pulitzer Bequest, 1971
1971.513.38

By the early eighteenth century, the arabesque
was a favorite decorative device. An adaptation from ancient paintings that were discovered
in the grottoes of Rome and taken up by
Raphael, arabesques were often employed by
Jean Berain l'aîné during the reign of Louis XIV.
Such artists as Claude Audran III (1658–1734)
and Claude Gillot (1673–1722) took them up enthusiastically. Audran was a painter-decorator
who also designed tapestries for the Gobelins
factory and whose work is now mainly known
through his drawings. The head of a team of
painters who executed his designs (including,
briefly, Watteau), Audran created much lighter
and more inventive patterns than Berain. Gillot,
with whom Watteau also worked, created arabesques like Audran's. They involved fantastic
flights of fancy and included gods and goddesses, acrobats, animals, especially monkeys, and
birds, caught up amid festoons, curling tendrils,
and branches that support platforms often balanced dizzily within the design.

Although this arabesque is drawn using
Gillot's vocabulary and style and must be by an
artist familiar with his work, it lacks the witty
elegance of his figures. The central platform on
which Psyche reclines while Cupid hovers over
her has a baldachino festooned with garlands
and urns with flowers. At the top of the sheet is
a trelliswork design with inset busts. At the side
of Psyche's platform are female figures carrying
baskets of flowers on their heads; below is a
fountain. The side borders of the sheet contain
gardening tools, rakes, shovels, watering cans
amid draperies, ribbons, and more flowers.
Kaufman and Knox point out that the print of
Flora in Gillot's set of prints the *Livre de portières*
has gardening tools, specifically spades. The artist of this design was certainly attentive to Gillot's
style and work.

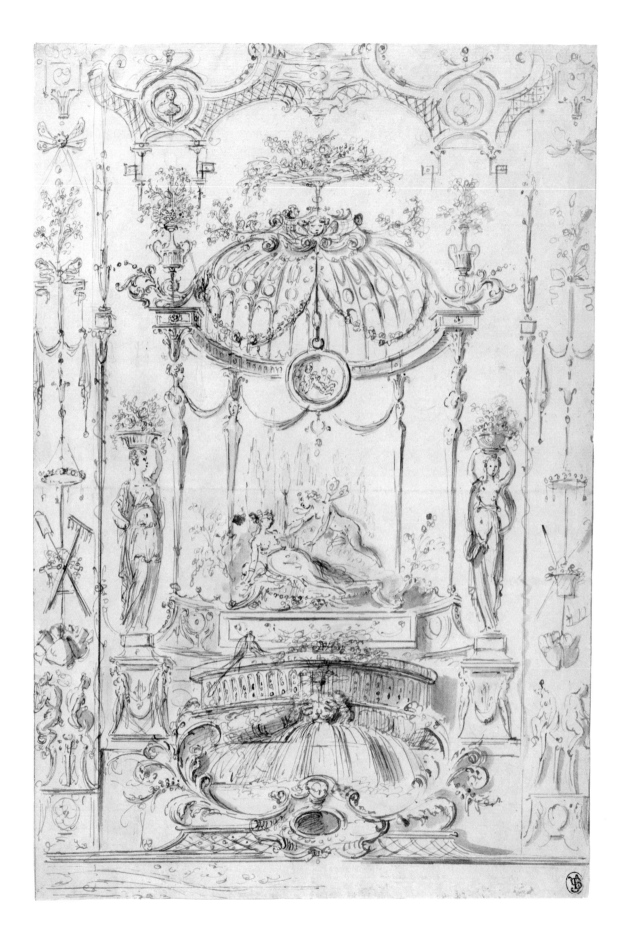

ANONYMOUS ARTIST

113. Study for a Cartouche Representing Winter

1735–55

Red chalk over traces of black chalk. Red-chalk border line. 13¾ × 10⅜ in. (349 × 264 mm). Creased vertically at center. Compass marks.

Inscribed in graphite on verso, *dessin provenant de la maison Jacquemard fabricant du papier peint faubourg Saint Antoine successeur de la maison Reveillon. Ce dessin sont de Boucher* [------] [----] [---] [-----].

WATERMARK: AYRIBE------[?]

PROVENANCE: [Lucien Goldschmidt, New York]; purchased in New York.

Rogers Fund, 1969
69.552.1

This is a study for a cartouche with the oval center left blank. The oval has been formed by a compass, the marks of which have been left visible. At the top of the wreath of holly leaves forming the cartouche is a flaming brazier, and below is the head of Winter, with icicles hanging from his beard. The upper portion of the outer design consists of an uneven batwing motif or perhaps a representation of flames, with slender strands of foliage and a rope of leaves forming the sides. A pendant (see next entry) represents Spring.

This drawing presents several mysteries, tentative solutions to which contradict one another. The inscription on the verso of this sheet says that the drawing belonged to the Maison Jacquemard, in 1792 the successor to the distin-guished wallpaper firm of Reveillon, and that it is by Boucher. It is certainly not by Boucher. The format of a blank cartouche does not suggest a wallpaper design or even a study for a panel of a screen; therefore it is unlikely that this kind of drawing would be kept in reserve for use by the wallpaper manufacturer. Furthermore, the Rococo design of the cartouche predates the house of Jacquemard by decades.

The form of the cartouche resembles those in drawings by Watteau, the *Birth of Venus* and *Autumn*, in the Hermitage Museum, Saint Petersburg, in which decorative elements surround interior ovals meant to contain figural compositions. The scene of the Birth of Venus was actually carried out in the one drawing.[1] However, Watteau left the designs incomplete on the left, only suggesting the finished, symmetrical compositions. Also in contrast to our sheet is the free and vibrant draughtsmanship of the Watteaus. Our design has more careful and somewhat boring draughtsmanship.

Gabriel Huquier (1695–1772), the distin-guished etcher, print publisher, dealer, and collec-tor who contributed to the spread of the Rococo style through his publication of the prints of Gillot, Watteau, Boucher, Lajoüe, Meissonnier, and others, made engravings after both the *Birth of Venus* and *Autumn*.[2] Indeed, the closeness of compositional type between our two sheets and those of the Watteaus and Huquier's prints after them have suggested a connection with Huquier. However, Huquier's drawings are much richer, freer, and more audacious than our two sheets. In a series of arabesques after Watteau, the high quality of Huquier's lively draughtsmanship— in striking contrast to our sheets—becomes evident.[3]

Finally, Alastair Laing has pointed out that there is a print after the *Winter* in a set of four entitled *Nouveau livre de panneaux propre aux peintres, pour orner une sale, à Paris chez Roguié graveur rue de la Clef, faubourg Saint-Marcel au Boisseau d'or*, which contains rather clumsy pseudo-Watteauesque *conversations galantes*

within the cartouche. There is no indication on the prints who designed or engraved them. Roguié is a little-known publisher who before 1730 issued the print *L'Occupation Champêtre, [P.] de Rochefort Sculp., A Paris, chez Roguié rue St. Jacques au Boisseau d'or, C.P.R.*[4]

NOTES

1 M. M. Grasselli and P. Rosenberg, *Watteau, 1684–1721*, exh. cat., National Gallery of Art (Washington, D.C., 1984), nos. 40, 41, repr.

2 Ibid., no. 40, fig. 1; no. 41, fig. 1.

3 M. Trudzinski, *Die italienischen und französischen Handzeichnungen im Kupferstichkabinett der Landesgalerie* (Hannover, 1987), nos. 135–138, repr.

4 E. Dacier and A. Vuaflart, *Jean de Jullienne et les graveurs de Watteau au XVIIIe siècle* (Paris, 1922), vol. III, *Catalogue*, no. 312. Nagler's *Neues Allegemeines Künstler-Lexikon* (Munich, 1843), vol. XIII, p. 367, cites Füssly, who notes that a Roquier [*sic*] made prints after Boucher about 1760. Roguié also appears in the list of publishers of Boucher in Jean-Richard 1978, p. 429.

114. Study for a Cartouche Representing
Spring

Rogers Fund, 1969
69.552.2

Red chalk over traces of black chalk. Red-chalk framing line. 13½ × 10⅜ in. (343 × 264 mm). Creased vertically at center. Compass marks.

WATERMARK: Bunch of grapes, near Heawood 2099.

PROVENANCE: [Lucien Goldschmidt, New York]; purchased in New York.

See the preceding entry.

The attributes of spring—a basket of flowers surmounting the oval cartouche, which has garlands of flowers encircling it, and a female's head also encircled with flowers—denote the subject of this drawing. As is the case with its pendant, the central oval has been drawn with a compass, the lines of which are still visible.

ANONYMOUS ARTIST

115. Decorations for the Fete Celebrating the Birth of the Dauphin

1781–82

Pen, black ink, with gray, brown, and colored wash and gouache. Framing lines. 14 15/16 × 23 11/16 in. (379 × 603 mm). Lined.

Inscribed at bottom, *Décoration du Feu d'Artifice pour la Naissance de Mgr. le Dauphin. 1781.*

PROVENANCE: [Galerie de Bayser et Strolin, Paris]; purchased in Paris.

The Elisha Whittelsey Collection, The Elisha Whittelsey Fund, 1965
65.607

On October 22, 1781, the long-awaited birth of a dauphin to Louis XVI and Marie Antoinette, married since 1770, took place. There was much rejoicing in the realm, and plans were made for a great fete to celebrate the joyous event. The city of Paris was especially eager to sponsor a celebration, which was planned for January 21, 1782.[1] This grand fete lasted several days and included fireworks, masked balls, and the like. The events took place on the Place de Grève, opposite the Hôtel de Ville. A temporary pavilion for the feasts and other activities was built perpendicular to the Hôtel de Ville. Its construction was designed by Moreau-Desproux, the city architect (see No. 79). All over the city, palaces were decorated with lights. There was a grand ball for the people at the Halle au Blé, whose courtyard was covered with a huge dome of light construction.

The fireworks machine portrayed here, which was also designed by Moreau-Desproux, was a

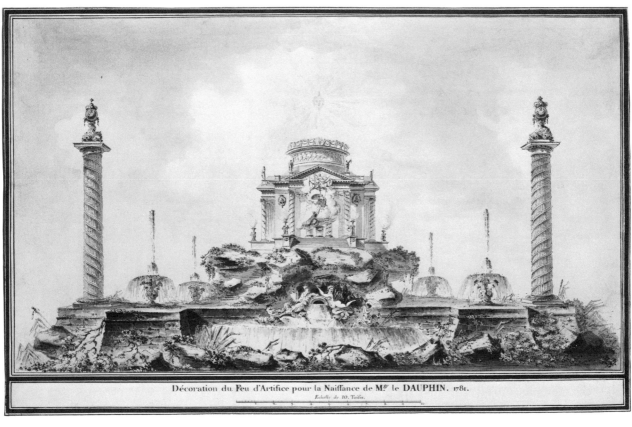

Décoration du Feu d'Artifice pour la Naiſſance de Mgr le DAUPHIN. 1781.
Echelle de 10. Toiſes.

Temple of Hymen. Its configuration is that of a classical pavilion having porticoes of columns surmounted by pediments on each of its four sides. The entire structure is crowned by a circular attic decorated with dancing putti carrying torches. On the porch is the figure of Hymen, accompanied by Peace and Abundance, handing over the infant dauphin to the figure of France. The design of the temple belongs to a long tradition that included such festival structures as Le Lorrain's Chinea *macchine* (see No. 63).

The temple rests on a subbasement of rocks, which in turn rests on a platform situated on more rocks. On the platform fountains splash, and at the corners of the platform rise gigantic fluted columns decorated with spiral garlands and surmounted by dolphins supporting orbs. These orbs are decorated with the fleur-de-lis and topped by royal crowns. In the center a river god and nymph adorn a fountain representing the Seine rejoicing in the birth of the dauphin.

There is a drawing by Moreau-Desproux similar to ours in the Musée Carnavalet,[2] and a large number of prints were made of the festivities. One, a Temple of Hymen that accords in most respects with our drawing, was engraved by Voisard after a drawing by Desrais. Moreau *le jeune* produced several prints of the fireworks taking place.

NOTES

1 On the fete, see G. Mourey, *Le livre des fêtes françaises* (Paris, 1930), pp. 277–283; Gruber 1972, pp. 115–132.
2 Gruber 1972, fig. 70.

ANONYMOUS ARTIST

116. Design for a Jewel Coffer on a
Writing Stand

1770–75

Pen, black ink, with gray and colored
wash. 14 ⅛ × 9 ⅜ in. (359 × 239 mm).

Inscribed in black ink at top, *A dessus du
coffre*, in brown ink at middle left, *P*, and
in red ink at bottom right, *101*. Scale in
pieds.

WATERMARK: Van der Ley.

PROVENANCE: Duke Albert of
Sachsen-Teschen; Prince Charles de
Ligne; Armand Sigwalt; Sigwalt sale,
Gilhofer & Ranschburg, Lucerne,
November 28–29, 1934, lot 362; Raphael
Esmerian.

BIBLIOGRAPHY: C. C. Dauterman
and J. Parker, "The Kress Galleries of
French Decorative Arts: The Porcelain
Furniture," *MMAB* (May 1960), pp. 275,
281, fig. 3; C. C. Dauterman, J. Parker,
and E. Standen, *Decorative Art from the
Samuel H. Kress Collection at The Metro-
politan Museum of Art . . .* , [London],
1964, pp. 128, 130, fig. 99; P. Huisman
and M. Jallut, *Marie Antoinette*, New York,
1971, p. 100, repr.

Gift of Raphael Esmerian, 1959
59.611.2

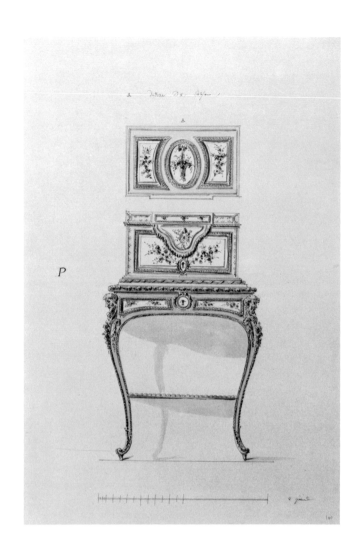

This sheet is part of a group of drawings of
furniture, vases, clocks, girandoles, decora-
tive hardware, and so forth that belonged to
Duke Albert of Sachsen-Teschen and his wife
Maria-Christina, a sister of Marie Antoinette,
joint governors of the Low Countries from 1780
to 1792, who were furnishing their palace,
Laeken (built between 1780 and 1785, now the
royal palace), near Brussels, during this period.
This drawing is nearly an exact replica of two
pieces of furniture in the Metropolitan Museum
(see fig. 2),[1] while other drawings in the group,
of furniture, clocks, and porcelains, also replicate
existing works (see entries following). This sug-
gests that our group of drawings was a kind of
mail-order catalogue sent to the duke by a
marchand-mercier, the unique French dealer cum
tastemaker and interior decorator, to order from.
The *marchand-mercier* Simon-Philippe Poirier

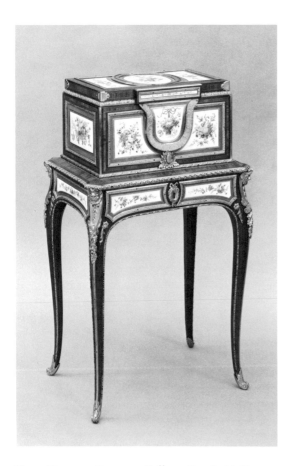

Fig. 2. MARTIN CARLIN, Coffer on Stand with Sèvres
Porcelain Plaques. The Metropolitan Museum of Art,
Gift of Samuel H. Kress Foundation, 1958

and his successor, Dominique Daguerre, had the
monopoly on selling Martin Carlin's furniture
with Sèvres porcelain plaques, of which this
writing stand with coffer is probably an example.
It has also been suggested that the group of
drawings was, instead, a kind of inventory of the
duke's collection, but some of the drawings have
measurements and other indications that they
were part of the process of creation. For instance,
one drawing of a vase is shown half completed,
while another drawing exists depicting the com-
pleted vase, which suggests that the drawings
were models to be executed and therefore a kind
of sales catalogue, which the duke, the founder
of the Albertina, the great print and drawings
collection in Vienna, preserved. The furnishings
of Laeken were not so fortunately preserved:
when the governors were forced to leave Laeken
after their defeat by the French at the battle of
Jemappes in 1792, some of their possessions sank
with a ship during their transport to Hamburg.

Porcelain-fitted furniture was considered
among the most exquisite furnishings to be had
during the period. One of the major cabinet-
makers who executed it was Martin Carlin, born
about 1730 in Freiburg im Breisgau, Germany. In
Paris he worked for another German cabinet-
maker, Jean-François Oeben. Carlin became a
master cabinetmaker on July 30, 1766. He died
March 6, 1785. Carlin's furniture was bought
by the great dealers Poirier, Daguerre, and
Darnault, who sold his furniture to Marie
Antoinette, the comte de Provence, the comte
d'Artois, Louis XV's unmarried daughters, the
Mesdames de France, Madame du Barry, and the
duchesse de Mazarin, among others. The two
examples in the Metropolitan Museum are deco-
rated with thirteen Sèvres porcelain plaques with
designs of sprays and bouquets of flowers. The
coffer and stand are made of oak veneered with
tulipwood and marquetry woods and are fitted
with gilt-bronze decorations that enclose the por-
celain plaques and major parts of the pieces of
furniture. Gilt-bronze masks, which are visible
on the drawing, are fitted to the sides of the legs.

There are four such jewel coffers known from
eighteenth-century records. Louis-Joseph, prince
de Condé, owned one, as did the duchesse de
Mazarin, the comte de Provence, and Madame
du Barry. The top of the coffer is shown on the
drawing above the entire piece. It has a basket of
flowers in the central oval plaque and sprays of
flowers on the side plaques.

NOTE

1 MMA acc. nos. 58.75.41, 58.75.42.

ANONYMOUS ARTIST

117. Design for an Upright Drop-Front
Secretary

ca. 1780

Pen, black ink, and gray and colored
wash. Framing lines. 15½ × 9 in.
(394 × 229 mm).

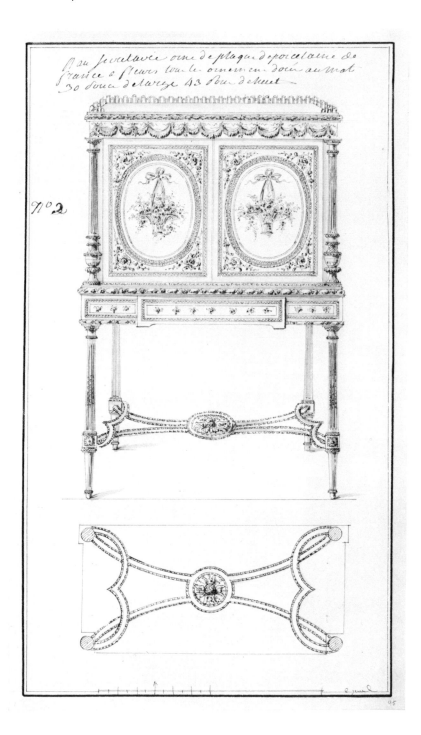

Inscribed in brown ink at top, *Rare* [?]
*Secretaire orné de plaque de porcelaine
de/France a fleurs tous les ornamens dorés au
mat/30 Pouce de large 43 Pouce de haut,*
and at left, *No. 2.*

WATERMARK: Van der Ley.

PROVENANCE: See Number 116.

BIBLIOGRAPHY: C. C. Dauterman
and J. Parker, "The Kress Galleries of
French Decorative Arts: The Porcelain
Furniture," *MMAB* (May 1960), p. 281,
fig. 10; C. C. Dauterman, J. Parker, and
E. Standen, *Decorative Art from the Samuel
H. Kress Collection at The Metropolitan
Museum of Art . . .* , [London], 1964,
p. 161, fig. 127; P. Huisman and M. Jallut,
Marie Antoinette, New York, 1971, p. 100,
repr.; R. J. Baarsen, "Rond een Neder-
landse Lodewijk XVI secretaire op Het
Loo," *Antiek* (February 1986), pp. 390–391,
fig. 7; [Galerie] Yves Mikaeloff, separately
published section of the catalogue of the
14th International Biennial Exhibition of
Antiquaries, Grand Palais, Paris, 1988,
p. 20, repr.

Gift of Raphael Esmerian, 1959
59.611.4

This fall-front secretary with an interlaced
stretcher has porcelain plaques on the front
and the face of the apron and gilt-bronze
mounts around the top and the apron as well as
on portions of the legs. A gilt-bronze rosette is
the centerpiece of the interlace of the stretcher.

A somewhat similar secretary is in the
Metropolitan Museum,[1] but instead of the two
oval plaques, it has one large porcelain plaque on
the front with small medallions of Wedgwood
at its sides. Its apron has a curved center, while
that of the drawing is a plain rectangle. The in-
terior of the secretary is fitted with four drawers
and five cubicles. The piece is unsigned, but
it is suggested that it was the work of Adam
Weisweiler as a subordinate to the *marchand-
mercier* Dominique Daguerre, who ordered the
components, including the Sèvres and Wedg-
wood plaques and the gilt-bronze mounts, and
then had them assembled in Weisweiler's shop.

NOTE

1 MMA acc. no. 58.75.57. See C. C. Dauterman, J. Parker,
and E. Standen, *Decorative Art from the Samuel H. Kress
Collection at The Metropolitan Museum of Art . . .*
([London], 1964), pp. 154–161, no. 28.

ANONYMOUS ARTIST

118. Design for a Mounted Chinese Vase

1750–85

Gouache, with brown and gray ink.
9¼ × 14⅞ in. (235 × 378 mm).

Inscribed at upper left, *2. Pied. 3 pouces. 2
Lignes.*, below, *No. XIII. Une piece. 1 Pied
4. pouces./Les Ornements en Rameaux de
fleurs et de joncs de ce Vase sont un peu en
relief. Il est d'un verd un peu plus foncé que
les Suivants/et tirant sur le gris. La monture
est en bronze.*, and at bottom right in red
ink, *20.*

WATERMARK: Fleur-de-lis within an
escutcheon above GR.

PROVENANCE: See Number 116; Sig-
walt sale, lot 359.

BIBLIOGRAPHY: Sir Francis Watson,
Chinese Porcelains in European Mounts, exh.
cat., China House Gallery, New York,
1980–81, no. 32c; sale, Christie's, London,
December 3, 1981, repr. under lot 33; Sir
Francis Watson, *Mounted Oriental Porce-
lain*, exh. cat., International Exhibitions
Foundation, Washington, D.C., 1986, no.
49, repr.

Gift of Raphael Esmerian, 1961
61.680.1(7)

From the middle of the seventeenth century,
Chinese objects held special appeal for
Europeans. This preference grew to almost craze
proportions, the vogue for Chinese porcelains
mounted in gilt bronze arriving at its apogee in
the middle two decades of the eighteenth cen-
tury. This drawing of a mounted porcelain vase

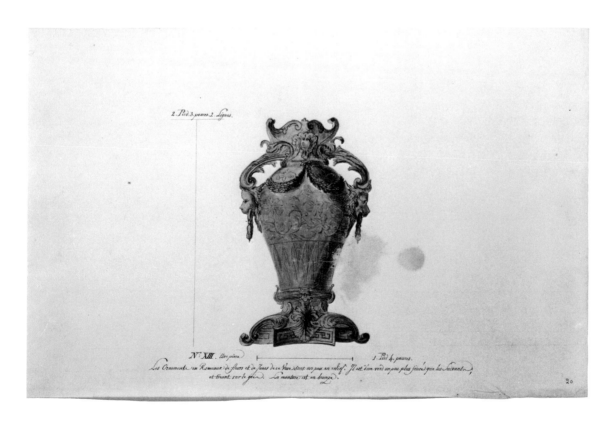

was part of the collection of Duke Albert of Sachsen-Teschen. It depicts a celadon vase with incised decoration mounted with two handles, a lip, animal masks, and a complex foot of gilt bronze incorporating a Greek key design with C- and leaf scrolls.

About five or six versions of this vase and mounts exist.[1] One is in the Musée Carnavalet (Collection Henriette Bouvier Bequest, no. 89 [with the original vase replaced]). Another similar vase and mounts was sold at Sotheby's in London on December 13, 1974 (lot 137, repr.). A vase from the C. Stein collection (Stein sale, Galerie Georges Petit, Paris, May 10–14, 1886, lot 279), may be the one and the same as the Sotheby's version. Another version similar to that sold at Sotheby's was on the Paris art market in 1989.

NOTE

1 According to the cataloguer of the Christie's London sale catalogue, December 3, 1981, lot 33.

ANONYMOUS ARTIST

119. Design for a Clock

1775–85

Pen, black ink, with gray and colored wash. 13¾ × 9⁹⁄₁₆ in. (349 × 243 mm).

Inscribed at left in brown ink, *No K*, and below right in red ink, *63*. Scale in pieds.

WATERMARK: Fleur-de-lis.

PROVENANCE: See Number 116. Sigwalt sale, lot 363.

Gift of Raphael Esmerian, 1960
60.692.7

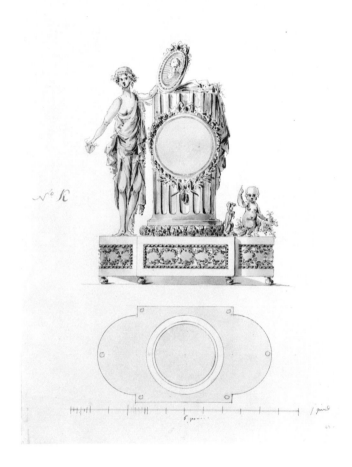

This drawing depicts a half-clad female figure personifying Friendship, who leans on a truncated column, holding two hearts in one hand and a portrait medallion in the other hand, while on the other side of the column a putto representing Love plays with a begging dog. On the side of the column is a circle surrounded with foliage and flowers intended for the clock face. The base is rectangular with rounded ends, as shown by the plan on the sheet. The female figure, the dog, and the Cupid are drawn in yellow wash, which is also the color for the floral decorations on the clock. The yellow areas would be translated into bronze in the actual object, and the green color on the column, the clock face, and the base would probably be translated into the *bleu céleste* of Sèvres porcelain.

This clock exists in a number of examples, one of which is in the Metropolitan Museum (fig. 3).¹ Others are in the Walters Art Gallery, Baltimore (two examples); the Philadelphia Museum of Art; the Museum of Fine Arts, Boston (formerly in the Forsyth Wickes collection);

and the Wallace Collection, London. One, which was commissioned for Marie Antoinette, is now at Versailles, and two others are mentioned in sale catalogues.

There are minor differences between this drawing and the clock in the Metropolitan Museum. The clock lacks the medallion with the portrait of a woman held by the figure of Friendship. The latter figure is proportionately shorter in the drawing, and the putto, whose right hand appears to point skyward, and dog are drawn in a much straighter and stiffer fashion in contrast to the more relaxed, curvilinear

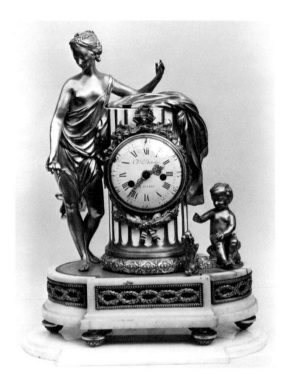

Fig. 3. Clock (Movement Maker: CHARLES DUTERTRE), ca. 1780–90. The Metropolitan Museum of Art, Gift of Ann Payne Blumenthal, 1943

figures of the clock. In the drawing there are tassels at the bottom of the foliage framing the clock face that are not on the clock itself.

The theme of love and friendship was a popular one in the eighteenth century. It was the subject of a series of etchings drawn and executed by Madame de Pompadour after the intaglios incised by Guay. Although none of the prints exactly corresponds, elements from different prints are combined in the clock.[2]

NOTES

1 MMA acc. no. 43.163.24a; Gift of Ann Payne Blumenthal.
2 See P. Verdier, "Eighteenth-Century French Clocks— Of Love and Friendship," *Connoisseur* (June 1960), pp. 281–284.

ANONYMOUS ARTIST

120. Design for a Clock

Pen, black ink, with gray and colored wash. 13¾ × 9⁹⁄₁₆ in. (349 × 243 mm).

WATERMARK: Van der Ley.

PROVENANCE: See Number 116. Sigwalt sale, lot 363.

Gift of Raphael Esmerian, 1960
60.692.3

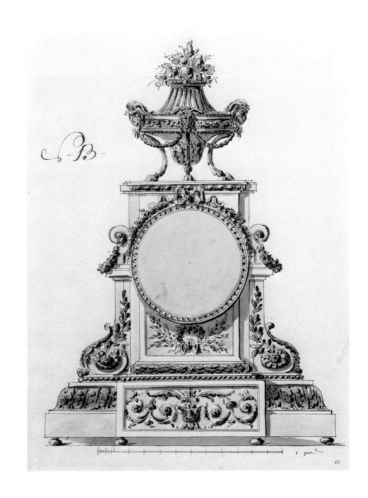

This clock was executed in marble and gilt bronze. It is a drum clock that is set in a corbeled, upright, rectangular gilt-bronze case decorated with laurel sprays and floral garlands and surmounted by a four-legged urn embellished with rams' heads and topped with fruit. The clock and case rest on a rectangular base decorated with foliate ornament on bun feet. There is a clock that corresponds exactly to this drawing in the Musée des Arts Décoratifs in Paris (inv. no. GR 113). Another identical clock was sold at Parke Bernet, New York, between January 23 and 25, 1947 (lot 526, repr.), while a similar but not exact version (there are pinecone finials at the sides of the urn) was sold at Christie's on May 14, 1970 (lot 30, repr.).

ANONYMOUS ARTIST

121. Design for a Clock in the Form of
a Lyre

1775–85

Pen, black ink, with gray and colored
wash. 14⁵⁄₁₆ × 10⁹⁄₁₆ in. (364 × 268 mm).

Inscribed at left in brown ink, *N L*, and
at bottom right in red ink, *64*. Scale in
pieds.

WATERMARK: Fleur-de-lis above VDL.

PROVENANCE: See Number 116.
Sigwalt sale, lot 363.

Gift of Raphael Esmerian, 1960
60.692.8

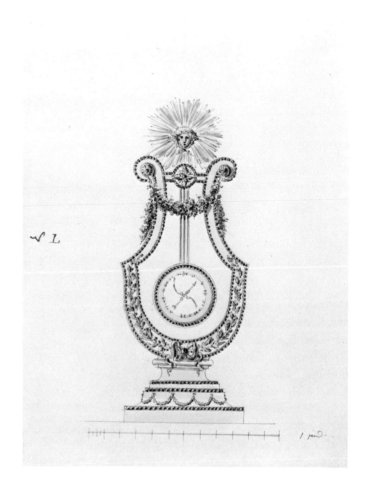

Lyre clocks were extremely popular in the
eighteenth and nineteenth centuries. Here,
the lyre, poised on an oval base, is richly deco-
rated with garlands and pearls in gilt bronze
and surmounted by a mask in a sunburst.

Lyre clocks were made of different materials.
Some were marble and gilt bronze, and others
were of Sèvres porcelain. A marble and gilt-
bronze lyre clock is at Waddesdon Manor,[1] and a
lyre clock in Sèvres porcelain is in the Musée
National de Céramique de Sèvres.[2] Geoffrey de
Bellaigue lists a number of lyre clocks made in
the eighteenth century, including a gilt-bronze
version of a slightly different design, which is
now in Drottningholm Palace, and another of
marble, which was delivered to the king's apart-
ments at Fontainebleau in 1783. There was also a
lyre clock in the palace at Versailles, according to
a clock inventory of 1788. It was recorded that
Louis XVI bought porcelain lyres, which were

probably intended for clocks. A lyre clock in
Sèvres porcelain from Versailles is now in the
Louvre (inv. no. OA. R. 483).

NOTES

1 Geoffrey de Bellaigue, *The James A. de Rothschild Collec-
tion at Waddesdon Manor: Furniture, Clocks, and Gilt
Bronzes* (Fribourg, 1974), vol. I, no. 22, repr.
2 M. Brunet and T. Préaud, *Sèvres: Des origines à nos jours*
(Paris, 1978), p. 212, no. 264.

ANONYMOUS ARTIST

122. Designs for Door Hardware

1775–85

Pen, brown ink, with brown, yellow, and blue wash. Framing lines. 10³⁄₁₆ × 16¼ in. (259 × 413 mm).

Inscribed in brown ink below keyhole escutcheons, from left, *No 2, No 3, No 1*, at bottom right, in red ink, *84*.

WATERMARK: Fleur-de-lis above blank escutcheon.

PROVENANCE: See Number 116. Sigwalt sale, lot 360.

Gift of Raphael Esmerian, 1961
61.680.3(1)

This drawing is part of the group of drawings that belonged to Albert, duke of Sachsen-Teschen. It is hypothesized that they formed a kind of catalogue (see Nos. 116–121) from which the duke and his wife could order furniture and household objects. As today, house decor in the eighteenth century received careful attention at all levels. Here, the designs for items of door hardware—keyhole escutcheons, knobs, and lock plates—are in the latest, Neoclassical style, with leaf moldings and pearls bordering surfaces decorated with acanthus and other foliate and ribbon-bow motifs. The pieces would have been executed in blued steel and gilt bronze, probably in the same size as the drawing.

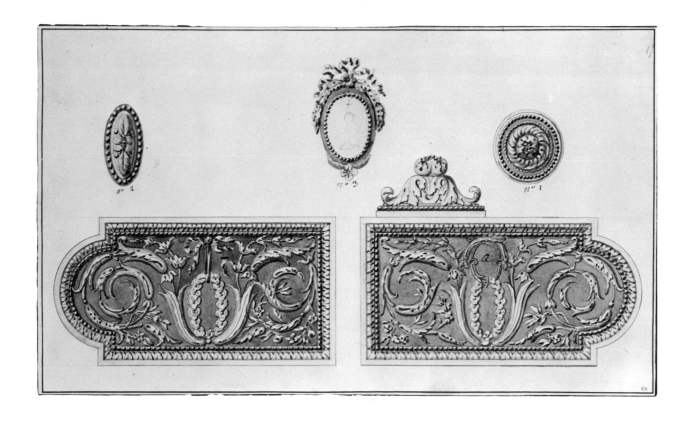

ANONYMOUS ARTIST

123. Designs for Top and Four Sides of
a Snuffbox

ca. 1784–89

Gouache, on heavy tan paper. Lining
partially removed.
1. 1 × 3 5/16 in. (25 × 84 mm); tear at lower
 right and corner missing.
2. 3 1/32 × 2 3/8 in. (24 × 60 mm).
3. 1 × 3 5/16 in. (25 × 84 mm); upper and
 lower right corners missing.
4. 1 × 2 3/8 in. (25 × 60 mm).
5. 2 1/2 × 3 7/16 in. (64 × 87 mm).

PROVENANCE: [Walter Schatzki,
New York]; purchased in New York.

The Elisha Whittelsey Collection, The
Elisha Whittelsey Fund, 1965
65.600.1(1–5)

These five drawings were, in the truest sense,
designs for the top and four sides of a
snuffbox, since the drawings themselves, covered
with glass, would have been set into the frame of
a gold or silver box. The subject represented on
the five drawings is a balloon ascent taking place
outside the walls of a large and imposing château
surrounded by a moat. The drawing for the top
of the box (5) shows the balloon, decorated with
what seem to be crossed L's in honor of the king
and held down on four sides by ropes, with a
fire below it for warming the air inside and thus
creating the lighter air needed for the ascent. A
large crowd of onlookers watch the preparations,
some under pitched tents. Two men (playing
cards?) sit at a table in a tent, while a mother
walks with her young son, who is rolling a hoop.
In the foreground are two men on rearing
horses. The drawings for the long sides of the

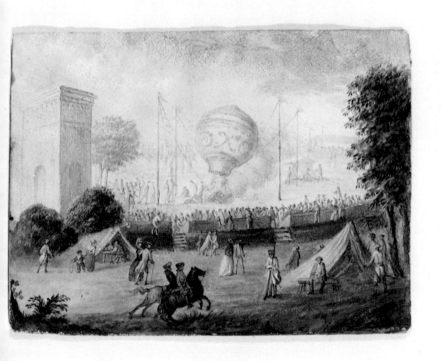

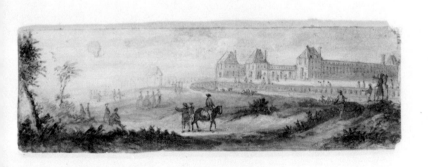

box (1 and 3) show the balloon rising in the distance, with the château fully visible. On the two drawings for the short sides (2 and 4) are scenes of the balloon as it begins to disappear into the distance.

The château represented is Montceaux-en-Brie, near Meaux (Seine-et-Marne).[1] At its fullest development the château consisted of a main building with two perpendicular wings closed by a low arcade, in the middle of which was a distinctive open, domed entrance pavilion. Four pavilions stood at each corner of the moat. However, the château began as a single building that was erected on the orders of Catherine de' Medici between 1547 and 1559, possibly by Philibert de l'Orme. Henri IV bought it from her estate for his mistress, Gabrielle d'Estrées. It was reacquired by the king from the latter's heirs in 1601 and given to his new queen, Marie de' Medici. From 1609, Salomon de Brosse was the architect in charge of the renovation of the château; he transformed the small building into the imposing ensemble shown in seventeenth- and eighteenth-century engraved views and in these drawings. The château remained in the possession of the crown until 1783, when Louis XVI presented the run-down château to the prince de Conti, in whose possession it was when these drawings were made (in truth, the king rid himself of a virtual ruin). The prince used just one of the four pavilions, that on the northeast, known as the Pavillon Conti, for himself, fixing it up as a hunting lodge, and relegated the rest of the buildings to storage for his horses, hunting dogs, and hunting paraphernalia. In 1793 the château and grounds were confiscated, and by 1799 most of the buildings were demolished. Only the Pavillon Conti remains and is inhabited today.

The first balloon ascents were met with frenzied interest on the part of the public. It was, after all, the first time that man had traveled in the air, although the search for a means to do so had preoccupied scientists for at least three centuries. Leonardo's experimental drawings are well-known examples of this fascination. It was the brothers Étienne and Joseph Montgolfier, from a family of distinguished paper manufacturers in Annonay, near Lyons, who enabled humans to fly through the development of hot-air balloons.

After several trial attempts with a stationary balloon and with empty free-flying ones, a hot-air balloon designed by the Montgolfiers and containing the first aeronauts—a rooster, a duck, and a sheep—made the first public flight with passengers on September 19, 1783. The balloon ascended from the palace of Versailles gardens as the king and queen looked on, and landed safely several miles away, opening the way for flights with people on board.[2] The first manned flight, also in a Montgolfier balloon, which gave the name *montgolfières* to hot-air balloons, took place two months later, on November 21, 1783. The passengers were François Pilâtre de Rozier and the marquis d'Arlandes, who ascended from the garden of the royal château of La Muette, the seat of the court of the young dauphin at the western edge of Paris, near Passy. Benjamin Franklin was looking on, and he described the event in a letter in which he prophesied both the peaceful and, especially, the dreadful warlike uses the balloon could be put to as a new means of transportation. The balloon crossed Paris with the men having to stoke the fire with straw and set down southeast of the city, at the Gobelins tapestry works. These two ascents, or *expériences* as the French called them, took place under the auspices of the Royal Academy of Sciences at the king's behest. The crossed *L*'s, the cipher of Louis XVI, appeared on the balloons of both these ascents. Competing flights were made in balloons filled with hydrogen, an invention of the distinguished physicist J.-A.-C. Charles, with the aid of the brothers A.-J. and M.-N. Robert. The first unmanned ascent of their balloon took place from the Champs de Mars on August 27, 1783; the second, with Charles and M.-N. Robert as passengers, lifted from the Tuileries gardens on December 1. The hydrogen balloons, known as *charlières*, were also named after their inventor.

The balloon ascents captured the imagination of the public, attracting huge crowds at each *expérience*, and ballooning became the rage. Indeed, a veritable *folie de ballon* ensued that inspired not only the many prints and caricatures that chronicled the events,[3] but also the decoration on fans, fabrics, even the forms of dresses, as well as hatboxes, cane handles, snuffboxes, watches,[4] dishes, tiles, and countless other objects.

The use of balloon imagery was not only exceedingly widespread but also ranged in scale from the intimate, as here, to the monumental. In Rome, a huge architectural and painted construction that was part backdrop, a "machine" (*macchina* in Italian) for fireworks, was set up in the Piazza SS. Apostoli, opposite the Palazzo Colonna, for the festival, La Chinea, that took place each year on the feast of Saints Peter and Paul, on June 29. The Chinea machines, which were destroyed by the fireworks, were routinely engraved, furnishing a record for posterity. The design for the machine for the year 1785 represented a place for pleasurable delights and recreation. In the center of the construction was a huge balloon being prepared for launching.[5] Just a year earlier, on September 15, 1784, it was a Neapolitan, Vincent Lunardi, a secretary to the Neapolitan ambassador, who made the first balloon flight in England.

Also on a heroic scale, befitting its importance, was a sculptural monument ordered by Louis XVI in December 1783 to commemorate the first balloon flights. It was to have been erected in front of the Tuileries Palace (the site of the Charles and Robert ascent), and a competition was to have determined its creator. Among the nine sculptors involved, the best known today are Pajou, Houdon, and Clodion. The monument was never erected, probably because in ensuing months, the number of ascents had increased so enormously that they lost their novelty. None of the terracotta models for the monument have survived, except two by Clodion, one in the Metropolitan Museum and another whose present location is unknown.[6]

Balloon ascents became so widespread that they came to be performed on a small and often private scale, as these drawings for a snuffbox to mark an ascent at the Château Montceaux bear witness. It has not been possible to identify the event shown in the drawings, which underscores again the large number of ascents and the immense popularity ballooning so rapidly attained.

Notes

1 On the building's history, see Coope 1959; and idem, *Salomon de Brosse and the Development of the Classical Style in French Architecture from 1565 to 1630* (London, 1972), pp. 226–234. Adam Perelle etched a low bird's-eye view of the château and part of the forecourt (Coope 1959, pl. 8c). Israel Silvestre etched a bird's-eye view of the château and the grounds (Faucheux 1857, no. 254[1]; Coope 1959, pl. 8a); a view of the château and forecourt (Faucheux 1857, no. 254[2]; Coope 1959, pl. 8d); a view of the château from the side of the park (Faucheux 1857, no. 254[3]); and a view of the château with figures in the foreground (Faucheux 1857, no. 254[4]). Jacques Rigaud made large and beautiful etchings, including a view of the south facade that shows the distinctive, detached pavilion and gatehouse (Coope 1959, pl. 8b).

2 On balloon ascents, see F.-L. Bruel, *Histoire aéronautique par les monuments peints, sculptés, dessinés, et gravés dès origines à 1830* (Paris, 1909); G. Tissandier, *Histoire des ballons et des aéronautes célèbres* (Paris, 1887–90). One of the most recent books, both a serious historical and scientific study, is C. C. Gillispie's *Montgolfier Brothers and the Invention of Aviation, 1783–1784* (Princeton, 1983), with previous bibliography. On balloons in art, see W. L. Marsh, *Aeronautical Prints and Drawings . . .* (London, 1924). Several exhibition catalogues on the subject of ballooning include W. T. Topkins, *Ballooning: A Loan Exhibition at the Museum of Fine Arts, Boston* (Boston, 1971), which includes twelve snuff- and patch boxes; P. Jean-Richard, *Le petit journal des grandes expositions: Estampes "au ballon" de la Collection Edmond de Rothschild au Musée du Louvre*, Réunion des Musées Nationaux (Paris, 1976); M. Waldfogel, C. C. Gillispie, and B. M. Stafford, *The Balloon: A Bicentennial Exhibition*, University Art Museum, University of Minnesota (Minneapolis, 1983), which was organized primarily from the Colonel Richard Gimbel Aeronautics History Collection conserved in the United States Air Force Academy Library, Colorado Springs. I would like to thank Lyndel King, the director of the University Art Museum, who generously provided me with the last copy of the most excellent out-of-print catalogue.

3 For example, the prints by Moreau *le jeune* representing the ascent of Charles and Robert from the Tuileries (E. Bocher, *Jean-Michel Moreau le jeune*, 6th fasc. of *Les graveurs françaises du XVIIIe siècle* [Paris, 1882], nos. 262–264).

4 An example of gold, enamel, pearls, and diamonds, by Daniel Vauchez and dating from about 1790, is in the Metropolitan Museum, for which see Waldfogel, Gillispie, and Stafford, *The Balloon: A Bicentennial Exhibition*, no. 12, repr.

5 The architect for this machine was Giuseppe Palazzi. It was engraved by Francesco Barbazza, for which see S. Boorsch, "Grand Occasions: Rome, Presentation of the Chinea," *MMAB* 29 (January 1971), p. 240, repr.

6 On the competition and the Clodion model, see P. Remington, "A Monument Honoring the Invention of the Balloon," *MMAB* 2 (April 1944), pp. 241–248, repr. on pp. 244–245.

ANONYMOUS ARTIST

124. Design for a Box Lid

ca. 1750

Pen, black ink, with light orange flowers and background of green wash, over touches of black chalk and graphite. Border line in black ink with narrow band of orange wash. 1 11/16 × 2 3/8 in. (43 × 61 mm).

PROVENANCE: D. David-Weill, Paris; sale, Sotheby's, Geneva, November 14, 1984, part of lot 219; [Armin B. Allen, Inc.]; purchased in New York.

BIBLIOGRAPHY: *The Art of Design, 1575–1875 . . .* , Armin B. Allen, Inc., New York, 1985, no. 38, repr.

The Elisha Whittelsey Collection, The Elisha Whittelsey Fund, 1986
1986.1007.1

Scattered flowers, including a tulip, forget-me-nots, and a cornflower (or carnation), form a design for the lid of a rectangular gold box, whose surface may have been entirely enameled or, more likely, bore enameled flowers against a gold ground. It is also possible, but unlikely, that the drawing could have been executed in gold of varied colors, the green and orange washes in the drawing indicating the different colors of gold. Clare Le Corbeiller dates the drawing to about 1748, as its oblong shape, usually executed with straight sides, is one that occurred most frequently in the late 1740s, and it closely resembles a number of boxes of that time. If the box had been made with enameled flowers against an enameled ground, it would have resembled a rectangular gold box by Jean Moynat in the Thyssen collection, dated to 1748–50.[1] Each side of the Thyssen box is chased with a central cartouche that frames a spray of enameled flowers with stems and leaves *en basse-taille* enamel and is bordered by enameled flowers, all against a dark green enamel ground. Another box with enameled flowers set against dark green enamel, also in the Thyssen collection, dates from between 1747 and 1750.[2] This box has enameled areas that are divided into diamond shapes by wavy, chased gold lines. The sides of the box are slightly bombé.

From this period there are numerous examples of gold boxes in which enameled flowers are scattered over backgrounds of chased gold. The most alluring of these, by Jean Moynat and dated to 1747–49, is in the Metropolitan Museum.[3] Snowman describes it perfectly as "enchanting." Against a ground of chased gold in a basket-weave pattern lie the enameled flowers, a rose on the lid, a peony, a tulip, and a daffodil on the sides, painted in naturalistic colors. The edges of the box are raised in a braided design that reinforces its basket image and appear to be wrapped in ribbons of blue-and-white enamel that tie in bows at the corners. Also by Jean Moynat and dated to 1749–50 is a handsome box with a spray of large carnations in enamel against a ground of gold incised in a zigzag pattern, with a border of an enameled morning-glory vine.[4] A box by Paul Robert, decorated with enameled chrysanthemums raised in relief on a chased ground of diagonal bands, is dated to 1747–48.[5] Its composition of flowers strewn across the lid lacking a border is very similar to that of the drawing. By the mid-1750s the taste for boxes decorated with flowers seems to have waned. A box probably by Jean Frémin, dating to 1752–56, has a spray of blue flowers on green stalks on a ground rather deeply engraved in a diaper pattern, and a border decoration of green leaves interspersed with single blue flowers.[6]

In the unlikely instance that the box had no enameling and its design was executed entirely by chasing and engraving, it would have resembled the one in the Metropolitan Museum made

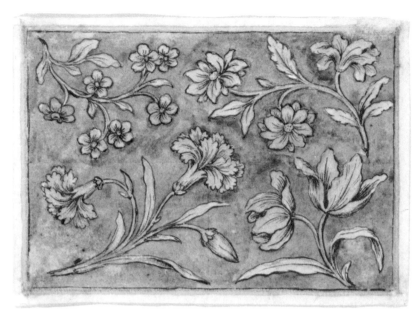

Slightly larger than actual size

in Paris, dating to 1749–50.[7] On both the lid and the sides, sprays of flowers in relief fill cartouches composed of opposite-curving scrolls.

NOTES

1 Somers Cocks and Truman 1984, no. 48, repr. (color).
2 Ibid., no. 47, repr. (color); formerly in the J. Ortiz-Patino collection. See A. Kenneth Snowman, *Eighteenth Century Gold Boxes of Paris: A Catalogue of the J. Ortiz-Patino Collection* (n.p., n.d.), p. 41, no. 15, repr. (color).
3 Le Corbeiller 1966, fig. 34; Snowman 1966, fig. 219 (color).
4 Le Corbeiller 1966, fig. 33; sale, Sotheby's, London, June 10, 1974, lot 51, repr.
5 In the Victoria and Albert Museum, London; Snowman 1966, fig. 196.
6 In the Thyssen collection. See Somers Cocks and Truman 1984, no. 58, repr. (color).
7 Le Corbeiller 1966, fig. 21.

ANONYMOUS ARTIST

125. Design for a Snuffbox Lid

ca. 1750

Pen, brown ink, with rose, olive green, and yellow-brown wash. Two brown-ink border lines. 2⅜ × 3³⁄₁₆ in. (60 × 81 mm).

PROVENANCE: D. David-Weill, Paris; sale, Sotheby's, Geneva, November 14, 1984, part of lot 219, repr; [Armin B. Allen, Inc.]; purchased in New York.

BIBLIOGRAPHY: *The Art of Design, 1575–1875* . . . , Armin B. Allen, Inc., New York, 1985, no. 39.

Purchase, Leon Lowenstein Foundation, Inc. Gift, 1986
1986.1006

The pattern of this study for a snuffbox lid, with alternating undulating bands of roses and forget-me-nots on a diagonal, resembles that of a gold box in the Wrightsman Collection in the Metropolitan Museum, dated to 1750–51.[1] Each side of the box is decorated with alternating straight bands of flowers in translucent enamel over a granulated ground. The continuous design—from the lid to all sides of the box—was a typical way to decorate gold boxes during that period. In the Wrightsman box, the undulating motif is used for the raised edges of the box and for the gold borders of the bands of enameled flowers. The colors of the enameling are dark green and orange, similar to those used in the design for a box lid, Number 124. Armin Allen notes in his catalogue that the box made from this design could have been executed in the *basse-taille* technique, by which the enamel lies in an incised space and is therefore level with the gold, or in a technique in which the enamel of the flower bands would have been painted in low relief upon the gold surface.

NOTE

1 See Le Corbeiller 1966, fig. 31; Snowman 1966, fig. 270; Watson 1970, p. 132, no. 7, repr.

Slightly larger than actual size

Works Cited in Abbreviated Form

Annual Report
 The Metropolitan Museum of Art.
 Annual Report of the Trustees. New York, 1870–.

L'arte a Parma
 Bruno Adorni et al. *L'arte a Parma dai Farnese ai
 Borbone.* Exh. cat., Palazzo della Pilotta.
 Parma, 1979.

Bean and Turčić 1986
 Jacob Bean and Lawrence Turčić. *15th–18th Century
 French Drawings in the Metropolitan Museum of Art.*
 New York, 1986.

Bedarida 1989
 Paul Bedarida, ed. *Feste, fontane, festoni a Parma nel sette-
 cento. . . .* Exh. cat., Galleria della Piazza Navona.
 Rome, 1989.

Berckenhagen 1970
 Ekhart Berckenhagen. *Die französischen Zeichnungen der
 Kunstbibliothek Berlin.* Berlin, 1970.

Berlin 1939
 Staatliche Museen zu Berlin. *Katalog der Ornamentstich-
 sammlung der Staatlichen Kunstbibliothek Berlin.* Berlin
 and Leipzig, 1939.

B. N., *Inventaire*
 Bibliothèque Nationale, Département des Estampes.
 Inventaire du fonds français: Graveurs du XVIIIe siècle.
 Paris, 1930–.

Briquet
 C. M. Briquet. *Les filigranes. Dictionnaire historique des
 marques du papier dès leur apparition vers 1282 jusqu'en
 1600: A Facsimile of the 1907 Edition. . . .* Amsterdam,
 1968.

Campbell 1983
 Richard J. Campbell. "Jean-Guillaume Moitte: The
 Sculpture and Graphic Art, 1785–1799." Ph.D. diss.,
 Brown University, 1982.

Churchill
 W. A. Churchill. *Watermarks in Paper in Holland,
 England, France, etc., in the XVII and XVIII Centuries.*
 Amsterdam, 1935.

Cohen
 Henry Cohen. *Guide de l'amateur de livres à gravures du
 XVIIIe siècle.* 6th ed. Revue, corrigée, et considérable-
 ment augmenté par Seymour de Ricci. Brueil-en-Vexin,
 Yvelines, 1973.

Coope 1959
 Rosalys Coope. "The Château of Montceaux-en-Brie."
 Journal of the Warburg and Courtauld Institutes 22, nos.
 1–2 (1959), pp. 71–87.

Coutts 1986
 Howard Coutts. "French Eighteenth-Century Decora-
 tive Drawings in the Victoria and Albert Museum."
 Apollo (January 1986), pp. 24–29.

Dennis 1960
 Faith Dennis. *Three Centuries of French Domestic Silver:
 Its Makers and Its Marks.* 2 vols. New York, 1960.

Desjardins 1885
 Gustave Desjardins. *Le Petit-Trianon: Histoire et descrip-
 tion.* Versailles, 1885.

Dimier
 Louis Dimier, ed. *Les peintres français du XVIIIe siècle:
 Histoire des vies et catalogue des oeuvres.* 2 vols. Paris and
 Brussels, 1928–30.

Draper and Le Corbeiller 1978
 James Draper and Clare Le Corbeiller. *The Arts under
 Napoleon.* Exh. cat., The Metropolitan Museum of Art.
 New York, 1978.

Eidelberg 1968
 Martin P. Eidelberg. "Watteau, Lancret, and the Foun-
 tains of Oppenort." *Burlington Magazine* (August 1968),
 pp. 447–456.

Erouart 1982
 Gilbert Erouart. *L'architecture au pinceau. Jean-Laurent
 Legeay: Un Piranésien français dans l'Europe des Lumières.*
 Paris, 1982.

Faucheux 1857
 Louis-Étienne Faucheux. *Catalogue raisonné de toutes les
 estampes qui forment l'oeuvre d'Israel Silvestre.* Paris, 1857.

Fitz-Gerald 1963
 Desmond Fitz-Gerald. *Juste Aurèle Meissonnier and
 Others.* Exh. cat., Seiferheld Gallery. New York, 1963.

Fuhring 1989
 Peter Fuhring. *Design into Art: Drawings for Architecture
 and Ornament: The Lodewijk Houthakker Collection.*
 London, 1989.

Goncourt
 Edmond de Goncourt and Jules de Goncourt. *L'art du
 dix-huitième siècle.* 3rd ed. 2 vols. Paris, 1880–82.

Grandjean 1975
 Serge Grandjean et al. *Gold Boxes and Miniatures
 of the Eighteenth Century.* Vol. VII of *The James A. de
 Rothschild Collection at Waddesdon Manor.* Ed. Sir
 Anthony Blunt. London, 1975.

Gruber 1972
 Alain-Charles Gruber. *Les grandes fêtes et leurs décors à
 l'époque de Louis XVI.* Geneva, 1972.

Guiffrey and Marcel
Jean Guiffrey and Pierre Marcel. *Inventaire général des dessins du Musée du Louvre et du Musée de Versailles: École française.* 10 vols. Paris, 1907–28.

Guilmard 1880
Désiré Guilmard. *Les maîtres ornemanistes. . . .* 2 vols. Paris, 1880.

Harris 1969
John Harris. "Architecture and Décor in the *Dix-Huitième*." *Apollo* (September 1969), pp. 246–249.

Hautecoeur
Louis Hautecoeur. *Histoire de l'architecture classique en France.* 7 vols. Paris, 1943–57.

Heawood
Edward Heawood. *Watermarks, Mainly of the 17th and 18th Centuries. . . .* Hilversum, Holland, 1950.

Helft 1966
Jacques Helft. *French Master Goldsmiths and Silversmiths from the Seventeenth to the Nineteenth Century.* New York, 1966.

Jean-Richard 1978
Pierrette Jean-Richard. *L'oeuvre gravé de François Boucher. . . .* Vol. I of *Musée du Louvre, Cabinet des Dessins, Collection Edmond de Rothschild. Inventaire général des gravures: École française.* Paris, 1978.

Kaufman and Knox 1969
Sullivan Kaufman and George Knox. *Fantastic and Ornamental Drawings: A Selection of Drawings from the Kaufman Collection.* Exh. cat., Portsmouth College of Art and Design. Portsmouth, 1969.

Le Corbeiller 1966
Clare Le Corbeiller. *European and American Snuff Boxes, 1730–1830.* New York, 1966.

Lugt
Frits Lugt. *Les marques de collections de dessins et d'estampes. Marques estampillés et écrites de collections particulières et publiques. Marques de marchands, de monteurs, et d'imprimeurs. Cachets de vente d'artistes décédés. Marques de graveurs apposées après le tirage des planches. Timbres d'édition. Etc. . . .* Amsterdam, 1921.

Lugt Suppl.
Frits Lugt. *Les marques de collections de dessins et d'estampes. . . . Supplément.* The Hague, 1956.

Neo-classicism 1972
The Age of Neo-classicism. Exh. cat., Royal Academy of Arts and Victoria and Albert Museum. London, 1972.

Nolhac 1914
Pierre de Nolhac. *Le Trianon de Marie-Antoinette.* Paris, 1914.

Notable Acquisitions
The Metropolitan Museum of Art, Notable Acquisitions. New York, 1965(?)–85.

Nyberg 1969
Dorothea Nyberg. *Oeuvre de Juste Aurèle Meissonnier.* Bronx, N.Y., 1969.

Parker and Mathey 1957
Karl Theodore Parker and Jacques Mathey. *Antoine Watteau: Catalogue complet de son oeuvre dessiné.* 2 vols. Paris, 1957.

Pérouse de Montclos 1984
Jean-Marie Pérouse de Montclos. *"Les Prix de Rome": Concours de l'Académie royale d'architecture au XVIIIe siècle.* Paris, 1984.

Piranèse et les français
Pierre Arizzoli et al. *Piranèse et les français, 1740–1790.* Exh. cat., Villa Medici/Palais des États de Bourgogne/Hôtel de Sully. Rome/Dijon/Paris, 1976.

Portalis 1877
Roger Portalis. *Les dessinateurs d'illustrations au dix-huitième siècle.* 2 vols. Paris, 1877.

Réformation de la police
Mémoire sur la réformation de la police de France soumis au roi en 1749 par M. Guillauté . . . illustré de 28 dessins de Gabriel de Saint-Aubin. With introduction and notes by Jean Seznec. Paris, 1974.

Roland Michel 1984
Marianne Roland Michel. *Lajoüe et l'art rocaille.* Neuilly-sur-Seine, 1984.

Rosenberg 1978
Pierre Rosenberg. "Louis-Joseph Le Lorrain (1715–1759)." *Revue de l'art*, nos. 40–41 (1978), pp. 173–202.

Samoyault 1975
Jean-Pierre Samoyault. "Furniture and Objects Designed by Percier for the Palace of Saint-Cloud." *Burlington Magazine* (July 1975), pp. 457–465.

Sérullaz, van de Sandt, and Michel 1981
Arlette Sérullaz, Udolpho van de Sandt, and Régis Michel. *David e Roma.* Exh. cat., Accademia di Francia a Roma. Rome, 1981.

Snodin 1984
Michael Snodin, ed. *Rococo Art and Design in Hogarth's England.* Exh. cat., Victoria and Albert Museum. London, 1984.

Snowman 1966
A. Kenneth Snowman. *Eighteenth Century Gold Boxes of Europe.* London, 1966.

Somers Cocks and Truman 1984
Anna Somers Cocks and Charles Truman. *Renaissance Jewels, Gold Boxes, and Objets de Vertu: The Thyssen-Bornemisza Collection.* New York and London, 1984.

Stern 1930
Jean Stern. *À l'ombre de Sophie Arnould. François-Joseph Belanger, architecte des Menus Plaisirs, premier architecte du comte d'Artois.* Paris, 1930.

Thornton 1984
 Peter Thornton. *Authentic Decor: The Domestic Interior,
 1620–1920*. London, 1984.

Verlet 1982
 Pierre Verlet. *The Savonnerie: Its History. The Waddesdon
 Collection*. Vol. X of *The James A. de Rothschild Collection
 at Waddesdon Manor*. London, 1982.

Watson 1970
 F. J. B. Watson and C. C. Dauterman. *Furniture, Gold
 Boxes; Porcelain Boxes, Silver*. Vol. III of *The Wrightsman
 Collection*. New York, 1970.

ABBREVIATIONS

BN Bibliothèque Nationale

BSHAF Bulletin de la Societé de l'Histoire de l'Art français

GBA Gazette des Beaux-Arts

MMA The Metropolitan Museum of Art

MMAB The Metropolitan Museum of Art Bulletin

MMAJ Metropolitan Museum Journal

INDEX

à la Grecque. See goût grec

Abundance, personification of, 194

Académie de France à Rome. *See* French Academy (Rome)

Académie de Peinture de Marseille, 106

Académie Royale de Chirurgie, 177

Académie Royale (Rouen), 95, 108

Adam, Lambert-Sigisbert, 90

Adam, Robert (English Neoclassical architect), 53

Aeneas, 82

L'âge de fer; ou, Le règne de la fraude, la sédition, la désunion, l'erreur, l'ambition, la chicane, etc., etc. (Delafosse), 60

Age of Neo-classicism, The (London; exhibition, 1972), 53

Albert of Sachsen-Teschen, Duke, 195, 200, 205

Albertina Collection (Vienna), 196

Album with Engraved Frontispiece and 53 Drawings on 35 Leaves (Cauvet), 36–39

Alembert, Jean Le Rond d', 24, 65

alentour (decorative surround), 50

Allegory of History, 122

Allen, Armin, 212

Amidei, F., 96

Ancient style, 104

Angiviller, comte d', *directeur général des Bâtiments du Roi*, 78, 172–74

Anonymous artists, 187, 188–89, 190–92, 193–94, 195–96, 197–98, 199–200, 201–2, 203, 204, 205, 206–9, 210–11, 212

Antichità di Cora (Piranesi), 172

Antichità romane (Piranesi), 100

Antiquarian movement, 21

L'antique noblesse; ou, Le fantôme de la noblesse (Delafosse), 60

Apollo, 29, 80, 116

Arabesque, Study for an, 92–93

Arabesque with Cupid and Psyche, Study for an, 188–89

Arc de Triomphe (Napoleon's), 174

Arc de Triomphe du Carrousel, 149, 174

Arched Alcove with a Canapé, Study for an, 187

Architectural Capriccio, 161

Architectural fantasies (Legeay; 3), 96–98, 99–100, 101

Architectural Fantasy (Challe), 40–41

Architectural Fantasy: Frontispiece for a "Recueil des vues du Petit Trianon" (Châtelet), 42–45

Architecture Academy of Jacques-François Blondel, 175

L'architecture de jardins (Galimard), 128

L'architecture françoise (Blondel), 9, 24, 51, 175

L'architecture françoise (Mariette), 24

L'architecture moderne (Briseux), 24–25

Argenville, Dezallier d', 24, 47

Arlandes, marquis d', 208

Arnould, Sophie, 12

Arsenal (Toulon), 186

L'art de bâtir des maisons de campagne (Briseux), 9, 128

Artois, comte d' (later Charles X of France), 12, 18, 19, 196

Ashmolean Museum (Oxford), 68

Athena, 186

Audran, Claude, III, 50, 180, 188

Auguste, Henry, 1–3, 6, 7, 122, 123, 124
 Grand Vermeil service, 1, 2, 123
 orfèvre du roi, 1
 pot à oille, 2
 workshop, 4–8, 95, 122

Auguste, Robert-Joseph, 1

Aumont, duc d', 13

Auricular style, 104, 162–63

Autumn (Watteau), 190

Avril, J.-J., 170

Babel, Peter, 11

Babel, Pierre-Edme, 9–11

Bagatelle (pavilion in Bois de Boulogne), 12, 18–19, 80

Balloons, 206–9

Baroque style, 104, 106
 late Baroque character, 76
 Roman, 133

Barriere, Jean-Joseph, 90

Barrière d'Enfer, 122

Basan (publisher), 163

Baudour, Château de, 12

Beauharnais, Eugène de, 187

Beaulieu, Pierre-François-Matis de, 130

Beaumont, Kim de, 175

Beauvais (tapestry works), 16

Beauvallet, P.-N., 157–60

Beckford, William, 122

Belanger, François-Joseph, 12–20, 80, 172
 drawing (signed) *bon S. Foy, le 21 May 1779*, 12
 Plan d'un Pavillon à Bâtir à la Campagne . . . Aux Environs de Venise sur les Bords de la Brenta, 12

Bella, Stefano della, 36, 118, 162

Bellaigue, Geoffrey de, 204

Bellicard, Jérôme-Charles, 21–23, 51, 96

Beloeil, Château de, 12

Belvédère (Petit Trianon), 43, 45

Berain, Jean, *l'aîné*, 82, 188

Bérard collection, 58

Berckenhagen, Ekhart, 25, 26

Bernini, Giovanni Lorenzo, 133, 135

Berthault (architect), 157

Bertini, G., 164

Biblioteca Estense (Modena), 44

Biblioteca Palatina (Modena), 162

Bibliothèque Nationale, 108, 109, 110, 111, 113
 Cabinet des Estampes, Robert de Cotte albums, 140

Biennais, 2

Birth of Venus (Watteau), 190

Blarenberghe, Louis-Nicolas van, 125

bleu celeste, 201

Blin de Fontenay, Jean Baptiste, 50

Blondel, Jacques-François, 9, 24–29, 34, 47, 51, 53, 65, 78, 84, 128

Blondel, Jean-François, 24

Bobeches, 124

Boffrand, G.-G., 9, 47, 128

Bombé (shape), 69, 210

Bonaparte
 Josephine, *see* Josephine (empress)
 see also Napoleon

Book Vignette, Study for (Babel), 9–10

Bordeaux, Academy of, 53

Borromini, Francesco, 133

Bossi, Benigno, 162, 165

Bouchardon, Edme, 30–31, 56, 60, 104, 162, 163
 Circle of, 32–33

Boucher, François, 9, 26, 40, 56, 67, 68, 88, 90, 106, 175, 180, 190

Boulle, André-Charles, 104

Boullée, Étienne-Louis (architect), 96, 108, 184

Bourbon
 Ferdinand of, 162
 Isabella de, 165
 Louis-Stanislas-Xavier de, 34

Bourgogne, duc de, 77

Bourguignon, Hubert-François. *See* Gravelot

Bourguignon d'Anville, J.-B., 67

Bouville, comte de, 108

Box Lid, Design for a, 210–11

Briseux, C.-É., 9, 24, 128

British Museum, 68
Brongniart, Alexandre-Théodore, 13, 52
Brosse, Salomon de, 208
Brutus (David), 52

Cahier d'arabesques composés et gravés par Salembier, 178
California Palace of the Legion of Honor (San Francisco), 4
Campbell, Richard (J.), 4, 8, 122, 123
Candelabrum, Design for a (Moitte), 124
Candelabrum or Torchère, Design for a (Le Barbier), 94–95
Candelabrum with Alternative Designs for Branches (Auguste workshop), 4–5
Capriccios, 55, 87, 138, 140, 145–47, 148, 161, 172
Carceri (Piranesi), 100, 172
Caricature of a Printseller, Design for a (Delafosse), 63
Caricature of an Engraver, Study for a (Delafosse), 60–61
 title: *Le graveur*, 61
Caricature of an Engravings Printer, Study for a (Delafosse), 61
Caricature of Engravers à la Grecque, Study for a (Delafosse), 62
Carlin, Martin, 196
Carpet, Study for a (Belanger), 19–20
Carpets for Hôtel de Mazarin, studies for (Belanger; 2), 14–16, 16–17
Carracci, Annibale, Cries and Trades of, 60
Carracci, the, 106
Cartouche, Design for a (Oppenord), 136
Cartouche, Study for a (Oppenord), 11
Cartouche Representing Spring, Study for a, 192
Cartouche Representing Winter, Study for a, 190–91
Cartouches, studies for (Oppenord; 4), 134, 135, 136–37
Cartouche-shaped Gold Box, Design for a (Gravelot), 69
Cascade at Tivoli, 44
Casino allo Stradone (Parma), 162
Catherine II, Empress, of Russia, 44, 65
Cauvet, Gilles-Paul, 34–39, 93
Caylus, comte de, 30, 102, 162
Ceiling, Study for a (Marot), 116–17
Ceiling of a Salon in Hôtel de Mazarin, Study for a (Belanger), 14
Ceiling of a Salon in Hôtel de Mazarin, Study for the (Belanger), 12–14
Ceilings, studies for (Lagrenée le jeune; 2), 80–83
Centre Canadien d'Architecture (Montreal), 40

Cestius, Caius, pyramid of, 51
Chalgrin, Jean-François-Thérèse, 174, 184
Challe, Charles-Michel-Ange, 12, 40–41, 102
 dessinateur de la Chambre et du Cabinet du Roi, 40
Chambers, William, 96
Champeaux, Alfred de, 128
Charles, J.-A.-C., 208, 209
Charles II of Spain, 69
charlières, 208
Charonnet, Louis, 68
Chartres, duc de (later duc d'Orléans), 47
Châtelet, Claude-Louis, 42–45
Chavannes, Jacques de, 132
Chefs-d'oeuvre dramatiques; ou, Recueil des meilleures pièces du théâtre françois . . . (Marmontel), 66
Chereau, the widow, 118
Chevaux de Marly (Coustou), 174
Chimneypiece, Design for a (Delafosse), 53–54
Chimneypiece and Overmantel with a Clock, Study for a (Hubert), 75–76
Chinea, the (Roman festival), 102, 162, 194, 209
Chinoiserie Fantasy with Skaters and an Exotic Figure in an Iceboat (Pillement), 169–70
Choisy, châteaus at, 168
Choix des plus célèbres maisons de plaisances de Rome et de ses environs mesurées et dessinées par Percier et Fontaine, 149
Christie's
 London, 203
 Rome, 163
classé designation, 110
Clement XII Corsini, Pope, 30
Clérisseau, C.-L., 93
Clermont, J.-F., 125
Clifton, William, 74
Clock in the Form of a Lyre, Design for a, 204
Clocks, designs for (2), 201–2, 203
Clodion (sculptor), 89, 209
Cochin, C.-N., *fils*, 10, 21, 26, 34, 125
Cochin, C.-N., *père*, 134, 135, 136, 137, 186
La colère de Neptune (Saint-Aubin), 177
Colin de Vermont, Hyacinthe, 175
Collection de meubles et objets de goût, comprenant: Fauteuils d'appartment de bureau, chaises garnies, canapés, divans, tabourets, lits . . . (La Mésangère), 160
Colonna, Prince, 102
Colorno, ducal palace at, 162, 163
Le colosse à tête d'or et pieds d'argile; ou, L'antique momie du clergé (Delafosse), 60
Compiègne, château de, 21, 149

Condé, prince de. *See* Louis-Joseph, prince de Condé
Congress of Vienna, 154
Conservatoire, 174
Contant d'Ivry, Pierre, 12, 46–48, 184
Contes et nouvelles (La Fontaine), *fermiers généraux* edition, 66
Conti, prince de, 13, 208
contraste, 118
conversations galantes, 190
Cooper-Hewitt Museum (New York), 10, 11, 58, 95, 133–34, 170
Cori, ruins at, 172
Corigliano, Calabria, viaduct at, 44
Corinthian capitals, 55
Corneille, 67
Corner of a Decoration, Study for the (Lajoüe), 89
Cotte, Robert de, 87, 88
Cours d'architecture (Blondel), 24
Coustou, Guillaume, 174
Covered Tureen on a Footed Stand, Design for a
 from Auguste Workshop, 4–5
 by Henry Auguste, 1–2, 3
Coypel, Antoine, *premier peintre du roi*, 49, 50
Coypel, Charles-Antoine, 49–50
Croÿ, duc de, 45
Crozat, Pierre, 133
Crozet, René, 52
Cruet Frame, Design for a (Auguste), 3
Cupid, 68, 69, 90, 180, 188, 201
 wearing Mambrino's helmet, 50

Daguerre, Dominique, 196, 198
Dandrillon, P.-B., 11
Daphne, 29
Darnault (furniture dealer), 196
Daullé (engraver), 68
Daumont (publisher), 128
David, Jacques-Louis, 51–52, 122
De la distribution des maisons de plaisance et de la décoration des edifices en général (Blondel), 24, 25, 26, 27–29
de l'Orme, Philibert, 208
De Wailly, Charles, 1, 52, 64–65, 96, 132
Decameron (Boccacio), 67
Dee, Elaine, 95, 139, 147
Delafosse, Jean-Charles, 34, 53–63
Delaunay, Nicolas, 66
Delaune, Étienne, 186
Demarteau, Gilles, 168
Demidoff, Count Nicolas, 2, 7, 123
Descamps, director, Royal Academy of Painting and Sculpture, 108
Description des cérémonies et des fêtes qui

ont eu lieu pour le mariage de S. M.
l'Empereur Napoléon avec S. A. I.
Madame l'Archiduchesse Marie-Louise
d'Autriche par Charles Percier et P. F.
L. Fontaine, 151
Desmaisons (architect), 184
Desportes, François, 50
Desprez, Louis-Jean, 55, 79
Desrais (artist), 194
Dessein de la décoration pour les tragédies du
Collège Louis le Grand (Le Maire), 86
Diana, 146, 147
Diderot, Denis, 24, 65
Dido, 82
Dining Rooms of the Hôtel de Montholon,
Longitudinal and Cross Sections of
(Lequeu), 110–11
Dining-Room Ceiling of Bagatelle Pavilion,
Study for (Belanger), 18–19
Directoire style, 123
Divers décorations de cheminée (Daumont
publisher), 128
Diverse maniere d'adornare i cammini e ogni
altra parte degli edifizi (Piranesi), 54
Domenichino (Domenico Zampieri), 106
Don Quixote, tapestry series based on
(Coypel), 49
chair and sofa seats woven as well, 50
The Memorable Judgment of Sancho
Panza in Metropolitan Museum,
49, 50
Door Hardware, Designs for, 205
Doyen, Gabriel-François, 106–7
Drottningholm Palace, 204
du Barry, Mme, 35, 196
Dubuisson, C.-N. Le Pas, 186
Ducrollay, Jean-Charles, 71
Duflos, Louis-Jean, 21
Duflos, P.-F., 96
Dughet, Gaspard (Gaspard Poussin), 98
Dugourc, J.-D., 19
Dulcinea, 50
Dulin, Nicolas, contrôleur des Bâtiments du
Roi, 47
Dumont, Gabriel-Pierre-Martin, 102, 128,
184
Dumont, Jacques (le Romain), 102
Dusseaux (painter), 18
Dutertre, Charles, 202
Duvaux, Lazare (marchand-mercier), 71

ébéniste du roi, 133
École (Nationale) Supérieure des Beaux-
Arts (Paris), 8, 11, 13, 37, 104, 116–17,
122, 124, 147, 152
Edict of Nantes, revocation of, 116
Egyptian decor, 113, 162

Eidelberg, Martin, 138, 145
Eisen, Charles-Dominique-Joseph, 66
Élévation en Perspective d'une Chapelle Sé-
pulcrale (Jardin), 51
Elizabeth, Empress, of Russia, 80, 104
Empire, French, 122
Empire style, 123, 154, 156
en basse-taille, 210, 212
en large, 118
en plein air, 172
Encyclopédie, 24, 47, 65, 66
English embassy in France, collection of, 156
Engraving . . ., Design for the (Moreau le
jeune), 125–26
Entry in the Prix de Rome Competition,
Ground Plan for an (Percier), 152–53
Erouart, Gilbert (art historian), 98, 162
Esmerian, Raphael, 44
Estrées, Gabrielle d', 208
État des ouvrages de peinture fait pour le roi
de 1716–1729, 50
Ewers, designs for (Delafosse; 2), 56, 57

Fables (La Fontaine), 26
Fame blowing her trumpet, 135, 143
Fates, Three, 90
faux marbre, 111
Ferdinand, Archduke, 44
Ferdinand of Bourbon, 162
Festival Machine, Study for a (Hubert), 77
Festival Pavilion, Study for a (Taraval),
180–81
Fete Celebrating the Birth of the Dauphin,
Decorations for the, 193–94
Feth Ali, shah of Persia, 123
Fine Arts Museums (San Francisco), 11
Fitz-Gerald, Desmond, 75–76
Flowers and Rocaille Swirls, Design with
(attr. to Pillement), 171
Fogg Art Museum (Cambridge), 51
Folding Screen, Design for a (Lajoüe),
88–89
Folie Sainte-James (Neuilly), 12
Fontaine, Pierre-François-Léonard, 53, 154
architecte de l'empereur, 151
architecte du roi, 151
Charles Percier and, 149–51
and Percier and workshop, 157–60
Fontainebleau, château de, 21, 149, 156
king's apartments, 204
Salle du Conseil, 168
Fountain Surmounted by Three Nymphs,
Study for a (Bouchardon), 30–31
Four Seasons, set of, 88
Fragmens d'architecture, sculpture, et peinture
dans le style antique (Beauvallet),
157–60

Fragonard, Jean-Honoré, 172, 174
Frame Molding, Study for a (Oppenord),
144
François, Jean-Charles, 168
Franklin, Benjamin, 208
Frederick Augustus, duke of York and
Albany, 4
Frederick the Great, of Prussia, 96, 97
Frémin, Jean, 210
French Academy (Rome), 21, 42, 51, 93, 96,
102, 172
Fribourg sale, 161
Friendship, personification of, 201
Frontispiece for a Suite of Vase Designs (Le
Lorrain), 102–4
Fruit and Flowers, Ornamental Design with
(Peyrotte), 167–68
Fuhring, Peter, 11, 119, 120, 175, 178
Funeral Ticket, Design for a (Gravelot),
73–74
Fyodorovna, Maria, countess of Württem-
berg, wife of Grand Duke Paul
Petrovich, 44, 45

Gabriel, Ange-Jacques, 42
Galimard, P.-J., 128
Garden Capriccio, Study for a (Oppenord),
138–39
Garden capriccios, studies for (Oppenord
Workshop; 2), 145–47, 148
Gardens à l'anglais, 43
Gautrot (publisher), 186
Gazette de France, 72
Frontispiece pour le Journal/La Gazette
de France. Année 1766 (Gravelot), 72
genre pittoresque, 24, 84, 118
defined, 118
see also Rococo style
Geoffrin, Madame, 104
George III, of England, 4
Gerusalemme liberata (Tasso), 82
Carlo and Ubaldo, 82
Rinaldo and Armida, 80, 82
Gessner, Salomon, 95
Getty Museum, J. Paul (Malibu), 8, 40,
122–23, 163
Gillot, Claude, 35, 142, 188, 190
Gisors, Guy de, 149
Gobelins tapestry manufactory, 49, 170,
188, 208
Gold Watchcase Showing Front and Eleva-
tion, Design for a (Gravelot), 70
Golitzin, Prince Vladimir, 2, 6
Gordon, Alden R., 21–23
goût grec, 35, 54, 62, 102, 104, 132, 162
Govaers, Daniel, 69
Graces, the, 80

Grand Oppenord, 140
 Livre d'autels, 140
 Livre de differentes portes, inventée par G.M. Oppenord, architecte, 144
 Livre de Mr. Oppenord contenant des tombeaux, 140
Grand Prix de Rome, 21, 40, 51, 93, 96, 102, 132, 149, 152–53, 162, 172, 175
Grand Vermeil (service), 1, 2, 123
Grande Galerie, Design for a (Delafosse), 54–55
Grandjean, Serge, 70
Gravelot (Hubert-François Bourguignon), 67–74, 127
Gravers, 62
Grognot et Joinel collection, 156
Grotto (Petit Trianon), 43, 44, 45
Gruber, Alain (art historian), 125
Guay (etcher), 202
Gueridons, 111, 112, 113
Guiart (caster of bronze plaques), 65
Guillemard, Henri, 180
Guilloches, 16, 17, 19, 20
Guyot, Laurent, 93, 161

Halle au Blé, 12, 193
Hameau (Petit Trianon), 43
Harcourt family, 162
Harrach, counts (of Vienna), 44
Harris, John, 78–79
Hathor (Egyptian goddess), temple of (Dendera; ancient Tentyra), 23
Hautecoeur, Louis, 34
Headpiece of the "Gazette de France," Design for (Gravelot), 72
Heinemann collection, 51
Hémery, Antoine-François, 38
Henri IV, 208
Herculaneum, 21, 23, 34, 82
Hermitage (Saint Petersburg), 33, 37, 38, 68, 139, 147, 190
Herms, 19, 114, 122, 140, 146, 148, 186
Heurtier, Jean-François, 149
Holland, R., collection, 51
Holy Spirit, Order of, 154
Horizontal Frieze, Study for a (Cauvet), 35–36
Hôtel Bullion, 93
Hôtel de Chavannes, Paris, Façade of (Moreau-Desproux workshop), 131–32
Hôtel de Kinsky, 34
Hôtel de la Monnaie (the Mint), 78
Hôtel de Mailly-Nesle, 34
Hôtel de Montholon, 108–10, 110–11, 112–13, 113–15
Hôtel de Noailles, 34

Hôtel de Salm, 122
Hôtel de Ville, 193
Hôtel Grimod de la Reynière, 93
Hôtel Louveciennes, 93
Hôtel Louvois, 93
Hôtel Soubise, 47
Houdon, Jean-Antoine, 209
Houghton Library (Harvard University), 68
Houthakker collection (Amsterdam), 11, 58, 116, 142, 178
Hubert, Laurent, 75–77
Huquier, Gabriel, 31, 32, 89, 118, 133, 134, 136, 137, 138, 145, 168, 190
Huvé, Jean-Jacques, 78–79
 mayor of Versailles (1792), 78
Hymen, 194

Illusionistic ceilings, 116
Imperial Academy of Saint Petersburg, 125
Institut des Langues Modernes, 177
Invalides, 143
Ionic columns (pilasters), 110, 112, 125, 132
Isabey (publisher), 184
Isis (Egyptian goddess), 23

Jacob, Georges, 149, 156
Jacob Frères, 156, 157
Jacquemard, Maison, 190
Janinet (etcher), 161
Jardin, Nicolas-Henri, 51, 102
Jardin de Malte, 93
Jeaurat, Edme-Sébastien, 10, 11
Jeaurat, Étienne, 175
Jemappes, battle of (1792), 196
Jeu de Bague (Petit Trianon), 43–44
Jewel Coffer on a Writing Stand, Design for a, 195–96
Joly (engraver), 59
Jombert, Charles-Antoine, 24, 25
Joseph of Hapsburg, archduke, 165
Joseph II, emperor, 44, 45
Josephine, empress, 2, 149, 156, 157
Joubert, Charles and Louis, 177
Joullain, François, 26, 186

Kaufman and Knox, 88, 143, 145, 165, 188
Kaufman collection, 145
Kaufmann, Emil, 96, 108
Korshunova, Miliza, 45
Krafft and Ransonnette, 109
Kretzschmar, F. J., 48

Kugel, Jacques, 4
Kunstbibliothek (Berlin), 11, 25, 26, 54, 86, 90, 93, 98, 104, 117, 128, 133, 142, 143, 163, 164, 165
Kunsthaus (Zurich), 100
Kupferstichkabinett, Dahlem (Berlin), 98

La Bretonne, Restif de, 125
La Fontaine, Jean de, 26, 66
La Grange, marquis de, 109
La Live de Jully, 34, 104
La Mésangère, Pierre, 160
La Muette, château of, 208
La Rochefoucauld, vicomte de, 78
La Rue, Louis-Félix de, 90–91
La Suze, comtesse de, 78
La Tour d'Auvergne, Henri de, vicomte de Turenne, 143
Laeken Palace (near Brussels), 195, 196
Lagrenée *l'aîné*, Louis-Jean-François, 80
Lagrenée *le jeune*, Jean-Jacques, 12, 80–83
Laing, Alastair, 11, 24–25, 190
Lajoüe, Jacques de, 24, 84–89, 190
Lancret, Nicolas, 86
Laugier, Père, 132
Lauragais, comte de, 12
Lavallée, Étienne de (called Lavallée-Poussin), 92–93
Le Barbier, Jean-Jacques-François, 94–95
Le Bas, Jacques-Philippe, *dessinateur du roi*, 66, 125
Le Brun, Charles, 95, 143
Le Canu (engraver), 177
Le Corbeiller, Clare, 6, 68, 90, 130, 210
Le Lorrain, Louis-Joseph, 34, 102–5, 125, 162, 194
Le Maire (architect), 86
Le Roy, Julien, 128, 184
 La Maison de, 128
Leaf in a Suite of Vase Designs, Study for a (Le Lorrain), 105
Lecomte, Félix, 2
Lecomte, Madame, 93
Leda, 57
Ledoux (architect), 52, 108, 184
 barrières, 121–22
Lefrançois, Thierry, 50
Legeay, Jean-Laurent, 12, 21, 65, 96–101, 102, 104, 166
 4 sets of etchings: *Fontane; Rovine; Tombeaux; Vasi*, 96, 100
Lélu, Pierre, 106–7
Lemoine, François, 40, 180
Lemoyne, J.-B., 121
Leonardo, 208
Lepautre, Jean, 35, 56, 162
Lequeu, Jean-Jacques, 108–15

Leroy, Julien David, 12
Leszczyńska, Marie, queen, 126
Ligne, prince de, 12
Liottier, Elise Caroline, 35, 37
Livre d'architecture (Boffrand), 9, 128
Livre d'architecture (Chalgrin), 184
Livre de portières (Gillot), 188
Livres de tableaux et rocailles (Huquier), 89
Louis XIV, 168, 188
 grand goût of, 34
 motifs, 35
Louis XV, 30, 84, 133, 196
 statue by Pigalle, 125
Louis XVI, 1, 12, 18, 35, 77, 193, 204, 208,
 209
 period of, 109
 style of, 53
Louis XVIII, 153–54
Louis-Joseph, prince de Condé, 106, 196
Louvre, 39, 51, 52, 65, 70, 87, 100, 128, 133,
 149, 151, 157, 204
 Cabinet des Dessins, 30
 Galerie d'Apollon, 80
 Grande Galerie, 174
Love, personification of, 201
Lowendal, abbé de, 21
Ludovik, P., 11
Lunardi, Vincent, 209

McCullogh, Suzanne Folds, 175
de Machy (painter), 161
McKendry, John J., 35
McNab, Jessie, 128
de Mailly, comte, 65
Maisons de plaisance. See *De la distribution
 des maisons de plaisance et . . . général*
Malmaison, Château de, 1
Mansart, Jules Hardouin, 133
marchands-merciers, 195, 198
Maria (artist), 10
Maria-Anna of Bavaria-Neuburg, 69
Maria-Beatrice d'Este of Modena, 44
Maria-Christina (sister of Marie
 Antoinette), 195
Marie Antoinette, 17, 18, 35, 42, 44, 45, 66,
 170, 193, 196, 201
Marie-Louise of Austria, 149, 151
Mariette, Pierre-Jean, 24, 30, 172
Marigny, marquis de, 50, 172
Marmontel, Jean-François, 66
Marot, Daniel, 116–17
Marsy, Gaspard, 143
Mascarade à la grecque (Petitot), 35, 60, 62,
 162
Mascarons, 6, 123, 124
Mathey, J., 138
May, Ernest, album, 174

Mayor, A. Hyatt, 116
Mazarin
 duchesse de, 13, 16, 19, 20, 196
 Hôtel de, 12–17, 80
Mecklenburg-Schwerin, duke of, 96
Medici
 Catherine de', 208
 Marie de', 208
Meissonier, Juste-Aurèle, 9, 24, 69, 75, 84,
 118–20, 127
 *dessinateur de la Chambre et du Cabinet
 du Roi*, 118
 orfèvre du roi (1724), 118
"Mémoire sur la réformation de la police
 de France" (Saint-Aubin), 175
Mentmore, 2
Menus Plaisirs, 12, 13
Mercure, 66, 75
Mercure de France, 72, 118
Mercy-Argenteau (minister of Joseph II),
 44, 45
Méréville, gardens at, 172
Mesdames de France, 196
Metropolitan Museum of Art, The, 4, 19,
 42, 98, 100, 109, 146, 160, 170, 180, 195,
 196, 198, 201, 209, 210
 Wrightsman Collection, 68, 69, 109, 212
Michelangelo, 51
Ministry of the Interior, 108
Mique, Richard, 43, 44, 172
Mobilier National (Paris), 50, 156
Moitte, Jean-Guillaume, 2, 4, 6, 8, 95,
 121–24
Molière, 26, 125
Mondhare (publisher), 96
Monnoyer (flower painter), 168
Montceaux-en-Brie, Château de (Meaux
 [Seine-et-Marne]), 208, 209
 Pavillon Conti, 208
Montgolfier, Étienne and Joseph, 208
montgolfières, 208
Montholon, Nicolas de, 108, 109
Monument, Elevation of a (Huvé), 78–79
Monument du costume (Moreau le jeune),
 125
*Monument to a Military Leader, Design for
 a* (Oppenord), 143
Moreau, Jean-Michel (*le jeune*), 125–26,
 128, 194
 dessinateur des Menus Plaisirs du Roi, 125
 dessinateur et graveur du Cabinet du Roi,
 125
Moreau, Louis, 125
Moreau, Pierre, 51
 works attributed to, 127–30
Moreau-Desproux, Pierre-Louis (work-
 shop), 96, 128, 131–32, 193, 194
 maître des bâtiments de la ville de Paris,
 132

Moser, George Michael, 68
Mounted Chinese Vase, Design for a, 199–
 200
Moyen Oppenord, 133, 134, 135, 136, 137,
 138, 145
 *VIIIe livre de M. Oppenort contenant des
 cartouches, propre aux édifices et aux
 ouvrages de tous les beaux Arts*, 134
 *Nouveau livre de fontaines inventées par le
 sieur Oppenor*, 147
Moynat, Jean, 69, 210
Muse Clio, The (Daullé), 68
Musée Baron Martin (Gray), 87
Musée Carnavalet, 60, 132, 194, 200
Musée de Blérancourt, 65
Musée de la Révolution Française (Gren-
 oble), 65
Musée des Arts Décoratifs (Paris), 25, 26,
 28, 28–29, 37, 50, 53, 54, 58, 68, 104,
 118, 128, 138, 143, 203
Musée des Beaux-Arts (Lille), 90
Musée des Beaux-Arts (Rouen), 52
 Hédou Collection, 90
Musée Malmaison, 156, 157
Musée Marmottan (Paris), 156
Musée National de Céramique de Sèvres,
 204
Museo Archeologico Nazionale (Naples),
 23
Museo Lombardi (Parma), 163, 164
Muses, the, 80, 116
Museum of Fine Arts (Boston), 201

Napoleon, 1, 6, 53, 113, 123, 149, 151, 154,
 187
*Narrazione delle solenni reali feste fatte cele-
 brare in Napoli da Sua Maestà il Re
 delle Due Sicilie . . . per la nascita del
 suo primogenito*, 102
National Gallery of Canada (Ottawa), 116
Nationalmuseum (Stockholm), 138
 Cronstedt Collection, 138, 145, 146–47
 Tessin-Hörleman Collection, 143
Navette, Design for a (Gravelot), 71
Navettes (shuttles), 71
Neoclassic(al) style, 1, 2, 10, 13, 17, 53, 55,
 57, 68, 102, 104, 130, 140, 162, 165, 184,
 187, 205
Neptune, 77
Nereids, 178
*New Book of Chinese Ornaments, Invented
 and Engraved by J. Pillement, A*, 171
Nord, comte and comtesse du, 44
Nordenfalk, C., 138
Normand, Charles, 151, 157
Notre Dame, chapel of Harcourt family
 in, 162

*Nouveau et IVe cahier concernant l'or-
 phèverie, bijouterie, et emeaux . . . com-
 posé et gravé par P. Moreau,* 127
*Nouveau livre de panneaux propre aux
 peintres, pour orner une sale, à Paris
 chez Roguié graveur rue de la Clef,
 faubourg Saint-Marcel au Boisseau
 d'or,* 190–91
*Nouveau recueil en divers genre d'ornemens
 . . .* (Normand), 157
Nouveaux tableaux d'ornements et rocailles
 (Huquier), 89
Nouvelle Héloïse (Rousseau), 67, 125
*Nouvelle iconologie historique; ou, Attributs
 hiéroglyphiques qui ont pour objet les
 elemens, les saisons, les quatre parties
 du monde, et les diverses complexions
 de l'homme* (Delafosse), 53, 58, 60

Oath of the Horatii (David), 52
*Obelisk at Port-Vendres, Study for Decoration
 of* (De Wailly), 64–65
 designs for bronze reliefs on obelisk's
 sides, 65
Oberkirch, baroness d', 45
objets de vertu, 127, 128
Observations sur l'architecture (Laugier), 132
*Observations upon the Antiquities of the
 Town of Herculaneum, Discovered at
 the Foot of Mount Vesuvius, with Some
 Reflections on the Painting and Sculp-
 ture of the Ancients. And a Short De-
 scription of the Antiquities in the
 Neighborhood of Naples* (Bellicard and
 Cochin *fils*), 21
*L'Occupation Champêtre, [P.] de Rochefort
 Sculp., A Paris, chez Roguié rue St.
 Jacques au Boisseau d'or, C.P.R.,* 191
Odiot, J.-B.-C., 1, 2, 7, 122–23
 Maison, 1, 2, 8, 124
Oeben, Jean-François, 196
Oeuvre (Meissonnier), 69, 75–76, 118, 119,
 120
 Cabinet de Mr. le Comte Bielenski, 75–
 76
Oeuvres d'architecture (Contant d'Ivry), 184
Oeuvres (Molière), 26
Oeuvres (Voltaire), 67
Opéra, stage sets for, 149
Opere varie (Piranesi), 102
Oppenord, Gilles-Marie, 24, 26, 133–44
 directeur général des bâtiments et jardins,
 133
 workshop, 145–48
Orléans
 duc d', 47, 50
 duchesse d', 50

house of, 47
 Philippe, duc d', 133, 144
Ornament Design (Meissonnier), 118–19
Ornament with a Flutist, Design for
 (Oppenord), 142
Ornamental Panel, Study for an (Toro), 185–
 86
*Ornamental Panel for "Recueil d'ornemens,"
 Design for an* (Cauvet), 34–35
Oudry, Jean-Baptiste, 26
Oval Gold Box, Design for an (Gravelot),
 67–68

Paestum, 44
Pajou, Augustin, 209
*Palais, maisons, et autres édifices modernes,
 dessinés à Rome* (Percier and Fon-
 taine), 149, 160
Palais Royal, 34, 47, 133
 Galerie d'Enée in, 50
Palazzo Colonna, 209
Palazzo Mancini, 172
Palladian Gothic style, 154
Panini, Gian Paolo, 55, 172
Pantheon, 108, 121
 drawings of (Soufflot), 184
Paris and Helen (David), 52
Pariset (publisher), 171
Pariset, D.-P., 168
Parizeau (etcher), plates by, 90
Parke Bernet (New York), 203
Parker, James, 39
Parma
 ducal palace at, 162, 163, 164
 duke of, 162
Parte di ampio magnifico Porto (Piranesi),
 40
Paul Petrovich, Grand Duke (later Czar
 Paul I), 44, 45
Pauquet, Louis, 151
Pavlovsk Palace, 45
Peace, personification of, 194
Percier, Charles, 53, 152–54
 and Fontaine and workshop, 157–60
 manner of, 155–56
 and Pierre-François-Léonard Fontaine,
 149–51, 174
Pernet, Jacques-Henry-Alexandre, 161
Petit (engraver), 68
Petit Trianon, 42, 43–44, 45, 80
 gardens, 172
 pavilions in, 43–44
Petitot, Ennemond-Alexandre, 35, 56, 60,
 62, 162–64
 workshop, 163, 165–66
Peyre, Antoine-François (*le jeune*), 149
Peyre, Antoine-Marie, 65, 96

Peyrotte, Alexis, 167–68, 171
Philadelphia Museum of Art, 201
Pierpont Morgan Library (New York), 40,
 134, 177
Pierre, Jean-Baptiste-Marie, 93, 95, 104, 162
Pigalle, Jean-Baptiste, 121, 125
Pilâtre de Rozier, François, 208
Pillement, Jean, 169–70
 attributed to, 171
 painter to Marie Antoinette, 170
 painter to Stanislaw II Augustus, of
 Poland, 170
Pineau, Nicolas, 24, 29, 84, 88
Piranesi, Giovanni Battista, 21, 40, 51, 53,
 54, 93, 96, 102, 161, 162, 172
 Diversi maniere, 113
*Plate 41 in "Maisons de plaisance," Vol. II,
 Preparatory Study for* (Blondel), 27–28
*Plate in a Book Commemorating the Mar-
 riage of Napoleon and Marie-Louise of
 Austria, Design for a* (Percier and
 Fontaine), 149–51
*Plate 7 of Bouchardon's "Premier livre de
 vases," Study for* (Circle of Bouchar-
 don), 32
*Plate 7 of Bouchardon's "Second livre de
 vases," Study for* (Circle of Bouchar-
 don), 33
*Plate 211 in Volume II of Blondel's "Architec-
 ture françoise," Paris, 1752, Preparatory
 Study for* (Saint-Aubin), 175–77
*Plates 90 and 91 of "Maisons de plaisance,"
 Vol. II, Preparatory Studies for*
 (Blondel), 28–29
*Plusieurs portails et portes composés et gravés
 par L. G. Taraval,* 184
Poilly, F. de, 186
Poirier, Simon-Philippe, 195, 196
Poisson de Vandières, Abel-François, mar-
 quis de Marigny, 21
pommes de carosse, 119
Pompadour, Madame de, 42, 66, 68, 84,
 202
Pompeii, 35, 82
Pompeiian style, 187
Pons, Bruno, 140
Porta San Paolo, Aurelian city wall at, 51
Portici, royal museum at, 23
Portières (Gillot), 35
Port-Vendres (France), 64, 65
Poussin, Nicolas, 51, 93
*Premier cahier d'arabesques et de décorations
 propres aux artistes de ce genre, des-
 sinées par Mr. J. M. Moreau et à Rome
 par Mr. Lavallé Pousin,* 93
Première, Madame, 125
Principes d'ornemens (Gillot), 35
Print "La Source des Arts," Study for the
 (Taraval), 182–84

Le printemps (Watteau), 88
Prisons (Piranesi). See *Carceri*
Prix de Rome. *See* Grand Prix de Rome
Provence, comte de, 196
Psyche, 188
Putti, 10, 13, 14, 19, 37, 47, 49, 56, 68, 69, 71, 74, 77, 90, 93, 104, 120, 123, 134, 135, 137, 147, 148, 160, 162, 166, 178, 180, 186, 187, 194, 201
Pyramid, Study of a (David), 51–52

Quadrigas, 19

Raccolta di vasi dedicata al signora Geoffrin (Le Lorrain; Watelet), 104
Racine, 67
Rambouillet, gardens at, 172
Raphael, 51, 106, 188
Récamier, Madame, 156, 157
Recueil d'antiquités (Caylus), 162
Recueil de décorations intérieurs comprenant tout ce qui a rapport à l'ameublement . . . composé par Percier et Fontaine . . . exécutés sur leurs dessins, 149, 157
Recueil de fleurs de caprices (Pillement), 171
Recueil d'ornemens à l'usage des jeunes artistes qui se destinent à la décoration des bâtiments (Cauvet), 34, 35, 36, 37, 38, 184
Recueil nouveau de differens cartouches (Lajoüe), 89
Régence (style), 35
Registry Office (Paris), 108
Reims Cathedral, 153
Renaissance, 106, 157
Renault (stationer), 157
Repoussé Cane Handle, Design for a (Meissonnier), 120
Repoussé work, 120
Restoration, 151
Restout, Jean, 67
Reveillon (wallpaper manufacturer), 190
Revolution, French, 106, 108, 122, 125, 140, 143, 149
the Terror, 174
Revolutionary Art Commission, 125
Rinceaux, 35
Riopelle, Christopher, 55
Robert, A.-J. and M.-N., 208, 209
Robert, Hubert, 19, 43, 55, 161, 172–74
dessinateur des jardins du roi, 43, 172
landscape paintings by, in Metropolitan Museum, 19
Robert, Paul, 210
Rocaille style, 11, 70, 84, 119, 168, 171

Rochefort (engraver), 186
Rocher (Petit Trianon), 43
Rococo style, 10, 24, 29, 34, 35, 47, 66, 68, 69, 76, 84, 88, 104, 133, 190
high, 69
Roederer collection, 68, 72
Roguié (publisher), 190–91
Rohan-Guéménée arms, 140
Roland Michel, Marianne, 84, 86, 87, 88, 89, 119, 172, 174
Roma (Venuti), 21
Roman Campagna, 51
Roman views, set of (published by Amidei), 96
Rood Screen with Throne of Louis XVIII for Reims Cathedral, Elevation of (Percier), 153–54
Roof and Section of a Pavilion in the Château de Saint-Cloud Gardens, Plan of (Contant d'Ivry), 46–48
Rosebery, Lord, 2
Rosenbach Foundation (Philadelphia), 68
Rosettes pour des commodes, tables, plafonds . . . (Peyrotte), 171
Rostral columns, 40
Rothschild, James A. de, 31
Rotrou, Jean de, 66
Rotunda of a Palace, Study for the (Lajoüe), 86–87
Rouen Academy. *See* Académie Royale (Rouen)
Rousseau, Jean-Jacques, 67, 125
tomb of, at Ermenonville, 172
Royal Abbey of Jouarre (Seine-et-Marne), 140
Royal Academy of Architecture, 21, 24, 40, 42, 47, 48, 55, 65, 78, 84, 87, 95, 128, 152, 162
Royal Academy of Painting and Sculpture, 49, 65, 80, 90, 95, 102, 108, 121, 125, 161, 172, 175
Salon of 1789, 122
Royal Academy of Sciences, 208
Royal Institute of British Architects (London), 147
Royal Library (Stockholm), 44
ruris Amor, 35

Saint-Albin, Charles de, archbishop of Cambrai, 144, 145
Saint-Aubin, Augustin, 175
Saint-Aubin, Gabriel de, 175–77
Saint-Cloud, palace at, 149, 151, 157, 160
Sainte-Foix, Radix de, 12–13
Sainte-Geneviève (later the Pantheon), 108
Sainte-James, Claude-Baudard de, *trésorier général de la Marine*, 12, 80

Saint-Germain-des-Prés, altar for, 133
Saint-Luc, Académie de, 9, 34, 53, 75, 90, 175
Saint-Morys, comte de, 106
Saint-Non, abbé de, 42
Saint-Sulpice, 133
Saint-Vaast, church of (Arras, Pas-de-Calais [Normandy]), 47
Salembier, Henri (attributed to), 178–79
Salon de Crozat at Montmorency, 86
salons à l'italienne, 86
Salons of the Hôtel de Montholon, Longitudinal and Cross Sections of (Lequeu), 112–13
Saly, Jacques, 56, 102, 104, 162
Samoyault, Jean-Pierre, 157
Sarrabat, Daniel, 170
Saulx, M. de, 125
Savonnerie (tapestry works), 16
Sayer, Robert, 171
Scheffer, Baron Ulric de, 184
Scott, Barbara, 12–13
Scrapbook of Sketches (Percier and Fontaine and workshop), 157–60
Second livre de tableaux et rocailles (Huquier), 89
Second livre de vases (Bouchardon), 32
Sedaine (architect), 52
Seiferheld Gallery (New York), 75
Senard (artist), 187
Sérullaz, Arlette, 51
Servandoni, G. N., 65
La servitude en France abolie (Servitude Abolished in France) (De Wailly), 65
Sèvres
lyre clocks of porcelain, 204
Manufacture de (royal porcelain manufactory at), 80, 90
porcelain plaques, 196
Shakespeare, 67
Silver, Designs for (Moitte), 121–23
Slodtz brothers, 125
Small Dining Room of the Hôtel de Montholon, sections and plans of (Lequeu; 2), 113–15
Snodin, Michael, 70
Snowman, A. Kenneth, 210
Snuffbox Lid, Design for a, 212
Sotheby's
London, 200
Monte Carlo, 163
Soubeyran, Pierre, 26
Soufflot, François (*le Romain*), 108, 109
Soufflot, Jacques-Germain, 108, 162
La Source des Arts (L.-G. Taraval), 182–84
Stage Sets, studies for (Lajoüe; 2), 84–86
Stainville, comte de (future duc de Choiseul), 172
Stein, C., collection, 200

Stern, Jean, 80
Stockholm
 Academy of Arts in, 184
 Nationalmuseum, 138, 143, 145, 146–47
 Royal Library, 44
Stosch, Philip, 30
Subleyras, Pierre, 102
*Suite de projets . . . de salles de spectacles par-
 ticulières* (Dumont), 128, 184
Suite de vases (Petitot), 162, 163, 164
Suite des ruines d'architecture . . . (Dumont),
 128
surtout de table, 76
Swedish royal palace (Stockholm), 180

Tailpiece, Study for a (Eisen), 66
Tapestry Sofa Seat, Design for a (Coypel),
 49–50
Taraval, Guillaume-Thomas, 180–81
Taraval, Hughes, 184
Taraval, Louis-Gustave, 182–84
 inspecteur des Bâtiments du Roi, 184
Tardieu family, 168
Tassi, R., 164
Tasso, Torquato, 82
Tatting, 71
tazze, 122, 124
Teatro San Carlo, 102
Temple de l'Amour (Petit Trianon), 43, 45
Temple of Hymen, 194
Temple of the Sibyl, 44
Terpsichore, 68
Tessin, Count C. G., 102–4, 138
Théâtre de l'Odéon, 65
Thièry, L.-V., 109, 110
Thomire (sculptor, designer of decorative
 bronze work), 160
Thornton, Peter, 16
Thyssen-Bornemisza collection (Lugano),
 118, 210
Tillot, Guillaume-Léon du, marquis de
 Felino, 162
Time, personification of, 137
Tinney, John, 73, 74
toises, 152
Tomb, Design for a (Petitot workshop), 165
Tomb and Flaming Brazier, Study with a
 (Oppenord), 139–40
*Top and Bottom of a Rectangular Gold
 Enameled Box with Canted Corners,*

Two Separate Designs for (attr. to
 P. Moreau), 130
*Top and Bottom of a Small Rectangular
 Box, Designs for* (La Rue), 90–91
*Top and Four Sides of a Snuffbox, Designs
 for,* 206–9
Toro, Jean-Bernard, 185–86
Tour de Marlborough, 43
Traité de perspective à l'usage des artistes
 (Jeaurat), 10
Trajan, Column of, 44
Trevi Fountain, 30
Tritons, 147, 164, 178
Triumphal Arch, Project for a (Robert), 172–
 74
Trophées divers, 59
Trophies, designs for (Delafosse; 4), 58, 59
de Troy, Jean-François, 102, 128
Tubi, J.-B., 143
Tuileries Palace, 149, 151, 157, 174, 209
 gardens, 151, 208
Turgot, Michel-Étienne, 25
Turreau, Jean-Bernard. *See* Toro
Two Armchairs, Studies for (manner of C.
 Percier), 155–56

University of Michigan Museum of Art,
 76
*Upright Drop-Front Secretary, Design for
 an,* 197–98

Valentinois, duchesse de, 13
Van Der Ley paper, 122
*Varie Inventioni/de Paese Bosci/et Cascade;
 di Giovani Lorenso Le Geay/Primo
 Architetto del/re et intagliate da/lui
 stesso,* 100
Varie vedute di Roma (Piranesi, Legeay,
 Duflos, Bellicard), 21
Varin brothers, 125
Vases, Two Designs for (Petitot), 162–64
Vaudoyer, Antoine-Laurent-Thomas, 152
Venceslas, tragedie (Rotrou), 66
Venus, 39, 68, 69, 90, 180
Verlet, Pierre, 16
Vernet, Joseph, 102, 170
Versailles, 42, 201, 204
 Bâtiments du Roi at, 78

Petit Trianon at, 42, 43–44, 45, 80
 see also Petit Trianon
Vertue, George, 67
Vézelay, Bouret de, 13
Victoria and Albert Museum (London), 16
Victory, personification of
 Triumphant, 106, 107
 winged, 160
Vien, Joseph-Marie, 51, 102, 162
Vieusseux, Jn. Ml., 70
*Views of the Excavations at Herculaneum
 and of Other Italian Cities, Notebook
 with* (Bellicard), 21–23
Vignola (author), 128
Villacerf, marquis de, *surintendant des bâti-
 ments,* 133
Vitruvian scrolls, 104
Voisard (engraver), 194
Voltaire, 66, 67, 79
Vorontsov, Michael Illarionovich, count, 50
Le voyage pittoresque de la France (de La
 Borde), 65
*Voyage pittoresque; ou, Descriptions des
 royaumes de Naples et de Sicile* (Saint-
 Non), 42, 44
vues d'optiques, 86

Waddesdon Manor, 11, 31, 38, 119, 148, 175,
 204
Wall Panel, Studies for a (attr. to Salembier),
 178–79
Wallace Collection (London), 201
Walters Art Gallery (Baltimore), 201
Watelet, Claude-Henri, 93, 104
Watteau, Antoine, 138, 145, 188, 190
Wedgwood medallions, 198
Weisweiler, Adam, 198
Wenceslas, King, of Poland, 66
William of Orange, Prince (later William
 III of England), 116
Wilson, G., 123
Wine Cooler, Design for a (Auguste work-
 shop), 7–8
Winter (Lagrenée), 80
Wladyslaw, Prince, of Poland, 66
Wrightsman Collection (Metropolitan
 Museum), 68, 69, 109
*Wrought-Iron Entrance Grille of a Chapel,
 Design for* (Oppenord), 140–41
Wunder, Richard, 76